world
photography

world
photography

Ernst Haas

Lee Friedlander

Jill Freedman

Don McCullin

Elliott Erwitt

André Kertész

Arnold
Newman

John Blakemore

Burk Uzzle

Stephen Dalton

Manuel
Alvarez Bravo

Henri
Cartier-Bresson

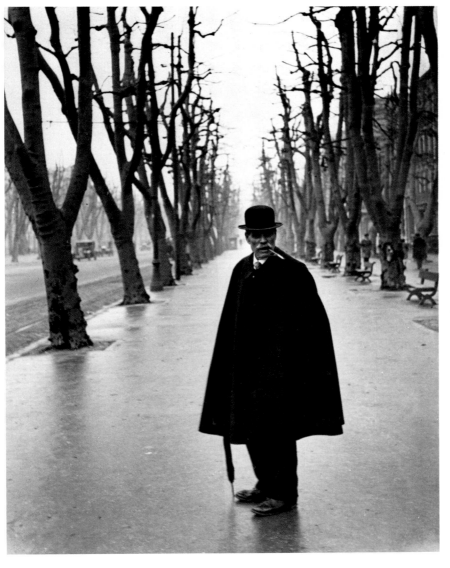

Bill Brandt

Heather Angel

David Bailey

William Klein

Hiroshi Hamaya

Josef Koudelka

Burt Glinn

Thomas Höpker

René Burri

Ian Berry

Ralph Gibson

Brassaï

Joel Meyerowitz

editor Bryn Campbell

Ziff-Davis Books
New York

*I should like to thank Peter MacDonald, my
editor at Hamlyn, who shared my problems in
dealing with so many contributors and had the
further chore of managing me. I am also grateful
to Ian Muggeridge who designed the book and
patiently handled the layout suggestions and
demands passed on to him from photographers. I
am indebted to them both for their constant help,
advice and understanding.*

Bryn Campbell

Library of Congress Catalog Card Number 81-50869

ISBN 0-87165-113-0

Printed in Italy by A. Mondadori, Verona
First printing 1981

Published by Ziff-Davis Books
One Park Avenue
New York, New York 10016

Contents

Introduction

There is no good reason why we should expect great photographers to be able, or even to want, to write fluently about their photography. Their chosen medium of expression is a visual not a verbal one and words may be inadequate to communicate the values and the problems with which they are concerned. So it is understandable that some of them think it basically futile to discuss their work. Others are happy enough to talk about it but avoid the more formal activity of writing anything. Some are reluctant to pry too closely into the source of their inspiration and perhaps put it at risk, or to over-intellectualize the creative process. Many feel they have little to say since their judgements are essentially intuitive. A few are inhibited by an almost morbid fear of sounding pretentious, an attitude that becomes quite endearing after a period of being exposed to a different breed of contemporary photographer who cannot show you a print without a relentlessly lengthy and self-congratulatory commentary on its conception and execution. They talk a great picture.

While respecting many of the reasons for photographers' reticence, our curiosity about how and why they create their work is equally understandable and is only further excited by the difficulty of satisfying this interest. We also know that the most enlightening, influential and authoritative statements on the subject have been made by the more articulate photographers rather than by other commentators.

In producing this book we hoped to persuade many of the people we most admire to show a selection of their finest pictures and to reveal something about what inspires them, their philosophies and techniques. A gratifyingly large number agreed to participate, whatever their qualms and reservations. The final choice of photographs was always made or approved by the contributors themselves, who sometimes also suggested, or even insisted on, a particular layout.

But, as expected, it was the words that led to the greatest problems. Almost everyone found it hard to complete the text to their satisfaction and some went through genuine and protracted agonies of labour. Often it was a job that had somehow to be squeezed into a busy schedule of travel and substantial assignments. No doubt several regretted that they had ever become involved with the project but some at least found the effort ultimately rewarding. One of them said, 'I figured this article would require about 4 or 5 hours to write. From start to finish it took three days.

But it was worth it. I've been able to describe my attitudes and creative reasons better and more completely than I have ever been able to do before.' A couple of the photographers had never previously committed themselves so openly and at such length in print and naturally they were especially apprehensive. There were crises and compromises but eventually the book fell into place without losing anyone who had agreed to provide a portfolio.

The selection of contributors was very much left to the editor within certain broad guidelines relating to the book's international market. Given the opportunity, no doubt every enthusiast would compile his or her own distinctly individual list of names. The choice in this book too is a personal one, but it is intended to represent photographers of varied ages, nationalities, interests and accomplishments. For several reasons it was impossible to include all the personalities one would ideally like but, as mentioned earlier, we were agreeably surprised by the overwhelmingly favourable response in general to our approaches. If any of your especial favourites are missing, I am sorry. So are some of mine.

If anything, choosing the photographers to be featured in the Introduction was even more difficult. The intention was to give credit to those who have most influenced photography in recent years or to mark their own outstanding achievement. It made it possible to include major figures who have just died and also photographers who for other reasons could not contribute to the portfolio section. There were occasional disappointments when a photographer or an agent made demands we found unacceptable but fortunately this was rare. No selection on this scale can possibly be comprehensive and it should not be considered as such. It is a selection of some of the most significant figures from various areas of modern photography. It is an introduction to the subject and not a history.

The words I hope are of interest. The photographs I am sure will be a delight.

Bryn Campbell

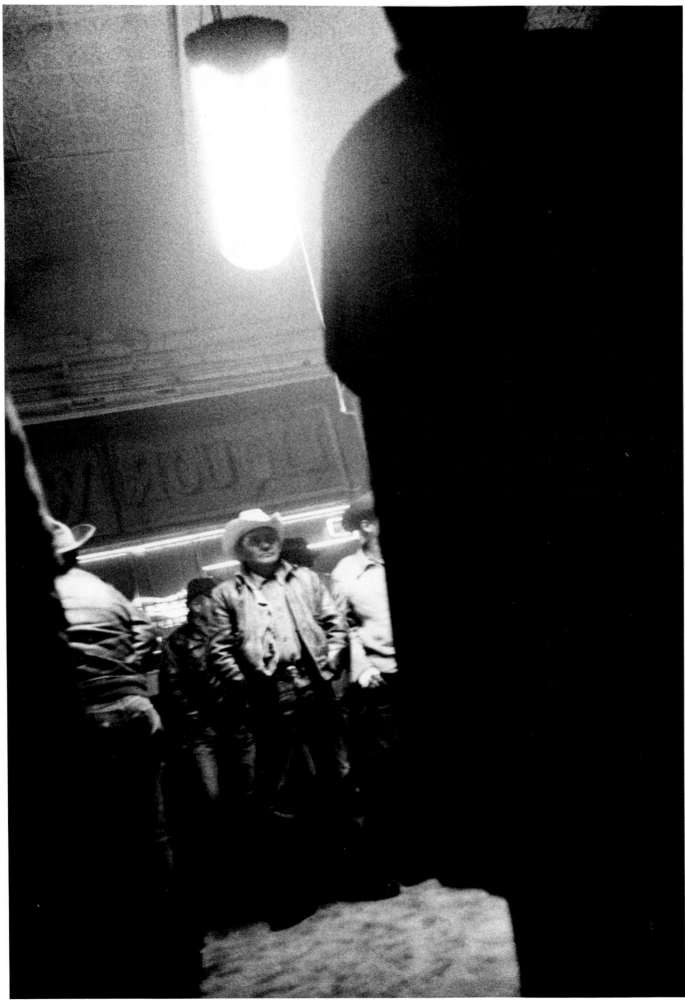

Robert Frank

Robert Frank's book *The Americans* smouldered for years before its flames were finally seen. A few of his contemporaries lit their own torches from it but a new generation was warmed by its fire and saw by its light.

First published in Paris by the remarkably perceptive Robert Delpire in 1958, the Grove Press edition appeared in the USA the following year. Its reception was largely hostile, partly because the Americans resented what they saw as an unfairly critical picture of themselves by someone they had just welcomed into their society, and partly because they interpreted Frank's technique as slapdash and as a deliberately provocative rejection of traditional skills and values. In the latter respect, no doubt similar accusations were levelled at James Joyce, Tom Wolfe and Jack Kerouac, who wrote the introduction to *The Americans*. His own experience on the road made him especially sympathetic to the book's vision. 'Robert Frank, Swiss, unobtrusive, nice, with that little camera that he raises and snaps with one hand he sucked a sad poem right out of America onto film, taking rank among the tragic poets of the world.'

It is curious that of the two photographers who were most iconoclastic and innovative during this period—the mid to late fifties—one was Swiss and living in America, the other (William Klein) was American and living in France. Both at one time also worked as fashion photographers and later concentrated on making films.

Frank was not a photographic primitive. The work that resulted in his book was financed by a Guggenheim award, and he had earned his living as a professional photographer. His methods did not spring from ignorance but from considered choice. And yet it is easy to see why purists were offended by his style. This photograph taken in a bar in Gallup, New Mexico, is anything but elegant. An out-of-focus figure obscures much of the foreground, the image as a whole is none too sharp and it is distinctly tilted to one side. There is no risk of confusing it with one of the immaculately composed photographs of Henri Cartier-Bresson or an impeccably crafted print by W. Eugene Smith. But its apparent faults make it the more real. It is closer to life than to art. It has the raw immediacy of a normal, sudden observation. One's attention is drawn to a particular situation but in the full knowledge that life is flowing around and about both the subject and the viewer. As a document, it is more believable than a formal image, it has a more spontaneous energy.

Such photographs seemed to allow a more personal response to individual experience, uninhibited by any external aesthetic discipline, and therefore perhaps a purer, more direct means of communication.

Frank also revealed the symbolic potential of mundane contemporary products such as the car, the television set and the juke-box. He had the ability to record significant moments of revelation and also to evoke an atmosphere of subtle mystical sensation. His influence has been incalculably fertile. Suddenly, in his prime, he abandoned still photography but continued to make movies.

W. Eugene Smith

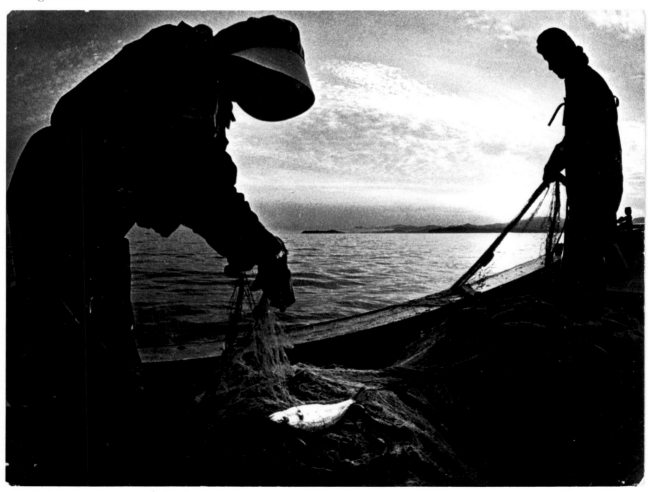

Because of his association with *Life*, **W. Eugene Smith** was committed to producing structured picture stories and he was very aware of how their emphasis could be altered according to the selection and layout of the photographs. He felt personally responsible for the integrity and strength of his published work, and he fought constantly for more control over the shaping process. His refusal to compromise must have made him a prime nuisance to the editors but it made him a hero to many photographers.

Gene Smith often became heavily emotionally involved with his stories and never more so than in his coverage of the tragedy of Minamata, a small Japanese community horribly poisoned by industrial pollution. It was a story that became a personal crusade for Smith and led to him being savagely beaten up by thugs. This picture is a key one because it focuses our attention on the fish that formed the staple diet of the people and so helped to pass on the poisons. The composition of Smith's photographs was largely a matter of tonal balance, as is obvious here. The strong, dark, graphic shapes surround and dramatize the isolated tonal contrast of the fish, and create a mood of melancholy and foreboding. He was a superb printer and could make the most of such a subject.

The story of Gene Smith's life, his good intentions and his sad mistakes, is a complex one still obscured by the legend of the man. But he did express a sense of idealism that had been muted in photography and he sacrificed much in fighting for the basic principle of personal responsibility for the integrity of one's work.

Garry Winogrand has been generous in acknowledging his debt to other photographers. He said that seeing the pictures of Walker Evans changed his life, and Robert Frank too was a distinct influence. But whatever he took from their work, he thoroughly digested and made a part of himself. Now he is firmly established as a major figure in his own right – perhaps indeed the most significant photographer of his generation, as his much-respected admirers claim.

His output has been prolific and adventurous. He once explained, 'When you put four edges around some facts, you change those facts. The frame creates a world and photography is about finding out how it can create a world. That's why I'll try anything.'

He revels in the camera's unique ability to collect facts. As he says, 'It's omnivorous.' He uses the wide-angle lens to gather in and describe great chunks of information. Sometimes his images are loose to the point of seeming lax, sometimes they are tightly layered and complex, as in this photograph taken in 1971 at the reopening of the Waldorf-Astoria Peacock Alley in New York. It comes from his book *Public Relations* published in 1977. One could easily do him less than justice by jumping to conclusions after seeing one large segment of his work. His range is considerable and occasionally his talent is seamed with genius. There is no other way to describe instinctive reactions of such acute visual intelligence and wit.

Garry Winogrand

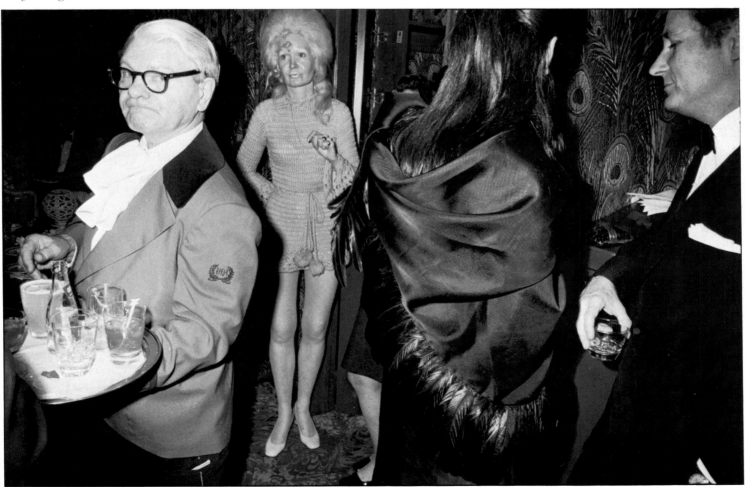

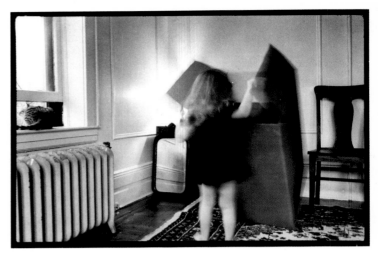

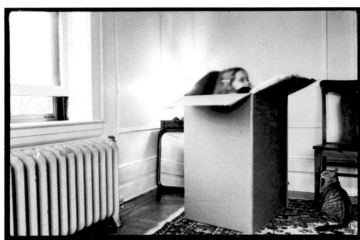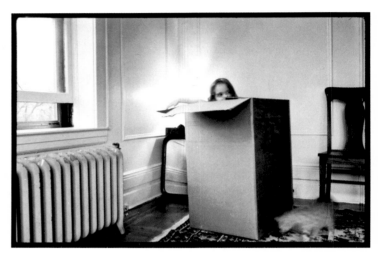

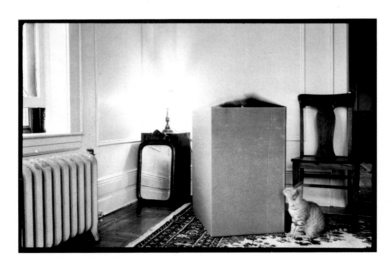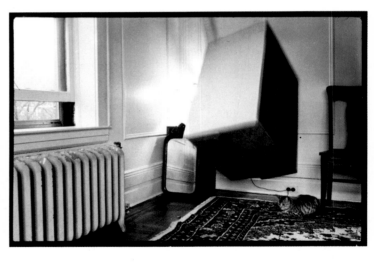

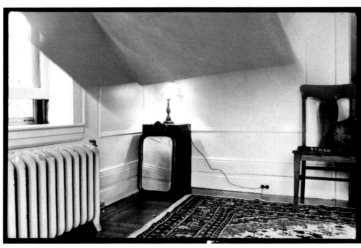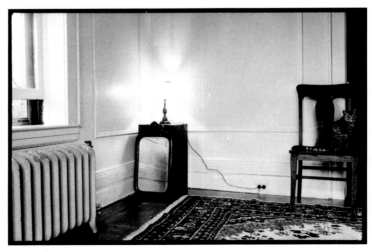

Duane Michals

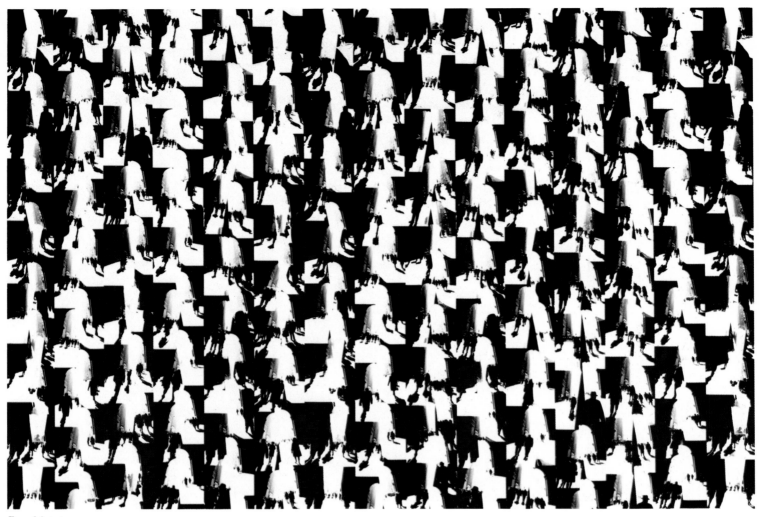

Ray Metzker

Duane Michals is one of those photographers who have always felt constricted by the need to express themselves in a single image, a frustration usually caused by the difficulties of telling a story satisfactorily. They found their way around the problem by a variety of means: through the explanatory caption; through the picture story, with or without words; through simple 'before-and-after' comparisons, and through high-speed sequences made possible by the development of motorized film-wind equipment. For many people the obvious solution was to make movies, and a number of important still photographers have also excelled in that medium—Bravo, Strand, Erwitt, Frank and Klein are a few names that immediately jump to mind.

As the limitations of photography were tested and stretched in the sixties, almost inevitably the concept of picture sequences was widely explored, both from narrative and aesthetic viewpoints. Duane Michals was one of the pioneers. He used an apparently straightforward story-board form to construct a number of disquieting little fantasies. The very simplicity of the basic narrative scheme helps the idea to unfold in a credible way. One small twist in the plot leaves us floundering between illusion and reality. Here, for instance, a small child finds a box, climbs into it, the lid closes, the box rises into the air and disappears. This fable, as disturbing as it is seemingly ingenuous, illustrates all too clearly how credulously we react to the photographic image.

Duane Michals produced many of these surrealistic tales, often quietly sinister, before moving on to experiment with other visual ideas.

Ray Metzker's discontent with the single image encapsulating an isolated moment was the result of its visual rather than its narrative limitations. He felt that the individual frame had become too predictable in its results and so he turned to the composite as a way of developing new patterns and rhythms. Within these formal structures he has tried to control a sum of visual experience instead of a unique instant. He said that, 'Where photography has been primarily a process of selection and extraction, I wish to investigate the possibilities of synthesis.'

His methods include combining, repeating and superimposing images through the use of the camera, darkroom techniques and means of presentation. He describes his work to date as falling into three categories: '1. Repetition with tonal variation in printing. 2. Juxtaposed images formed at different moments but linked in the camera by the interval between frames. 3. Overlapping successive exposures on rollfilm so that the entire film is seen as one print.'

In assembling these related moments he works within a discipline that is distinctly photographic. The element of chance is controlled rather than eliminated.

Many of his pieces are quite large, the original of this one, for example, measuring 45 × 59 inches. It is called *Arches* and is in the collection of the Philadelphia Museum of Art. Part of a body of work carried out in the mid-sixties, it was completed in 1967. Its bold, fragmented shape echoes mosaic design.

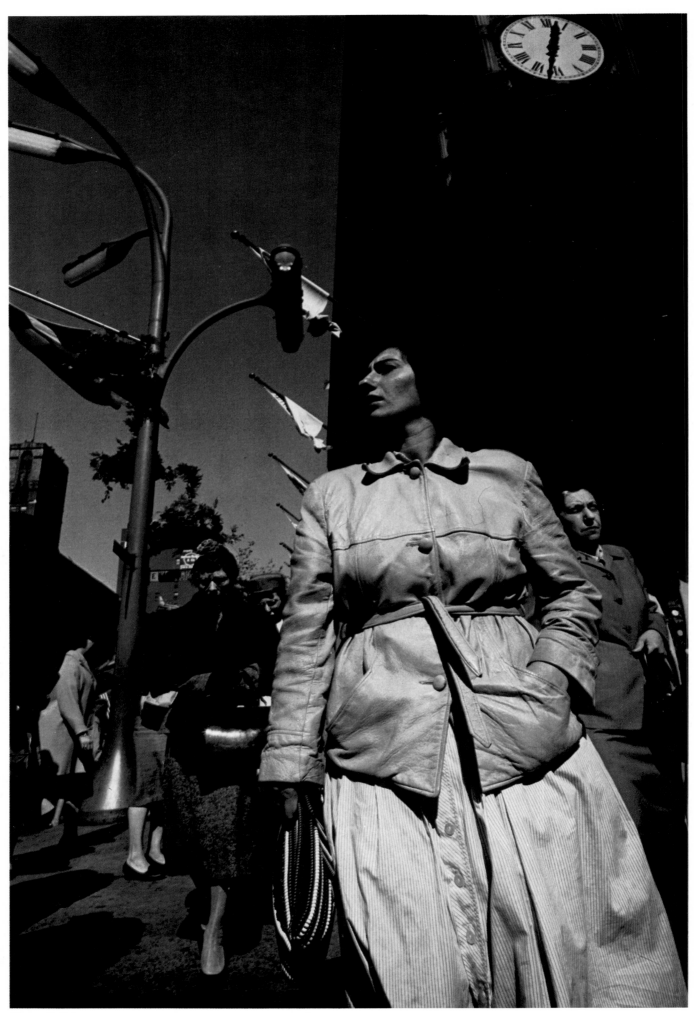

Harry Callahan

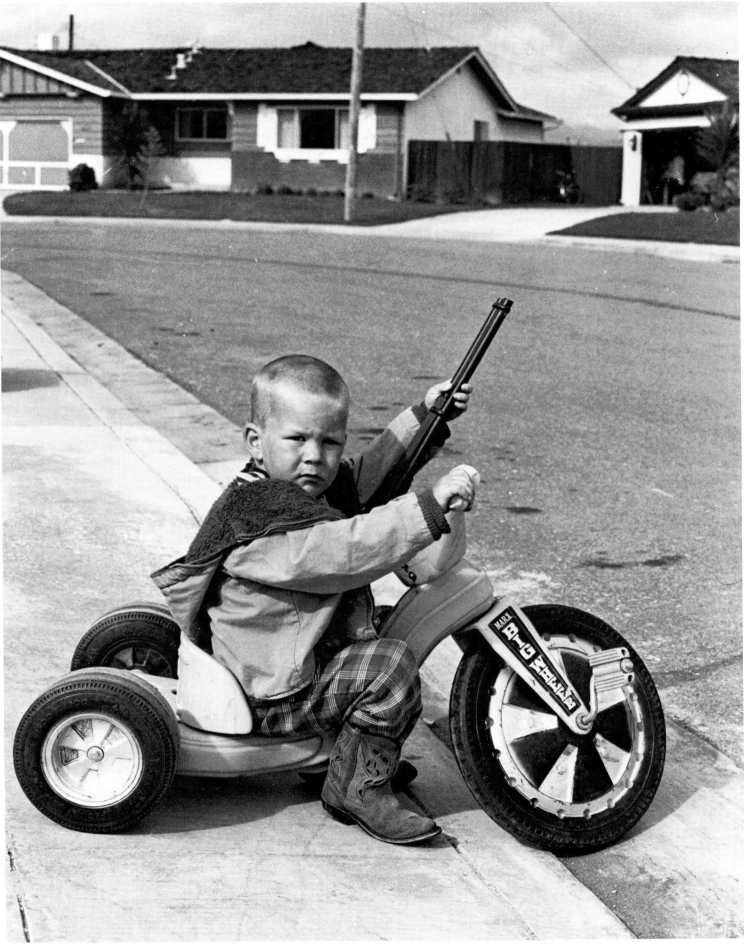

Bill Owens

In an interview with A.D. Coleman in 1971, **Harry Callahan** talked of what he admired in the work of other photographers, and concluded, 'I'm sure that I've been influenced but I think my pictures that are any good come out of *me* somewhere. You go out and try someone else's way, but pretty soon you drift off and something happens that's yours instead, if it has any strength.'

The individual quality of Callahan's work is undeniable and yet not superficially obvious. A photograph may obviously belong to a particular series by him, but he does not have an easily identifiable overall personal style, perhaps because of the range of his interests and the variety of his technique. But looking at this breadth of activity as a whole, one can see certain fundamental similarities of approach, notably a very objective view of his subjects and a predominant concern with form and composition.

In this photograph taken in Chicago, 1961, the sense of detached observation is all the more remarkable because of the close physical viewpoint to the subject. The conspicuously low camera angle makes one immediately aware of a calculated difference of visual experience. People's faces become a continuation of shape rather than a prime focus of interest, and one studies the seams and wrinkles of a jacket and the way collar-points turn up, with the same fascination as the tilt of a head. The people become primarily an accumulation of described detail and elements of pictorial structure, but the picture also leaves a definite emotional 'after-taste', possibly because of one's instinctive response to this romantically 'lost' figure.

While the usual route to fame in photojournalism has been via the national or international press or picture agencies, **Bill Owens** made it specifically because he worked on a local Californian newspaper. He began in 1968 and visited hundreds of homes in the course of his job. 'The people I met enjoy the life-style of the suburbs. They have realized the American Dream. They are proud to be home owners and to have achieved material success.' He describes his initial reactions as a form of culture shock and he photographed enthusiastically. The idea for a book grew out of his experiences and it took him two years to complete. His pictures show people mostly in their own homes or gardens, but occasionally socializing. They are usually posed, but quite informally. He used medium-format cameras (6 × 7 and 6 × 9cm), and fill-in flash for the indoor shots, to produce images that are clear and detailed. The photographs are captioned with the subjects' own comments about themselves.

The eventual book was called *Suburbia* and its undoubted success depended on its blend of photographs and words, and on the overall picture that it drew of an area of middle-class America – a section of the population hitherto rather neglected by photographers. Few of the images were individually striking but their cumulative effect was substantial. However, this particular portrait of a young boy is remarkable in itself. With his close-cropped scalp, intense glance and ready-for-anything air, he looks like a baby marine. When he grows up, he wants to be a policeman.

Owens subsequently produced a complementary book illustrating the activities of the many varied social groups in the community.

Ken Josephson

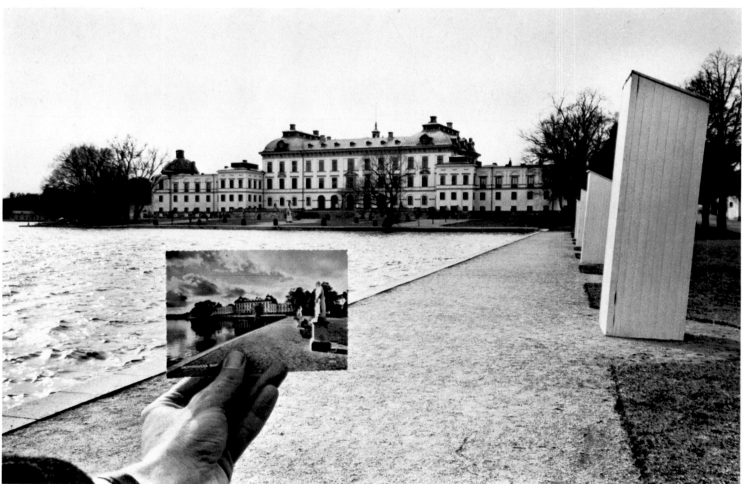

Ken Josephson has clearly expressed his own function. 'My role as a photographer is the same as that of most artists: to communicate visual ideas to others. I have found photography to be the most direct and satisfying means of doing this.' And also, 'From the very beginning, photography has revealed the importance of that which has been considered insignificant. I enjoy the more banal aspects of society, and they are reflected in my work.'

Some of his most telling and witty images have dealt with the illusory quality of the photograph, as in this picture, *Postcard Visit*, Stockholm 1967. He introduces a postcard view of a scene into the foreground of his own photograph of that scene taken from a very similar viewpoint. The diagonal of the postcard is carefully aligned with the diagonal of the photograph. Instinctively we read the postcard as an image, that is as non-real, but the photograph itself as somehow real. The implications of the picture soon dawn on us and we can savour the nuances of illusion. Josephson confuses us into awareness. The differences in the views are intriguing in themselves; the postcard taken in summer, the trees in full leaf, the sky fecund with clouds, the lake bordered by statues; the photograph taken in the slump of the year, with bare trees, thin sunshine, barren sky, and statues boxed up for the winter.

Another photograph by Josephson on the same theme shows a postcard of a ship against the background of the 'real' sea, lined up along its horizon.

One of the basic messages of contemporary photography is 'Let the viewer beware,' the photograph creates its own reality.

The industrial landscape has aroused widely different responses in photographers. Many have studiously avoided the subject, others have variously documented, romanticised and condemned it. It is a theme that tends to stimulate very emotional reactions, instinctively bringing to mind images of one extreme or another, the monumental or the squalid.

But **Lewis Baltz**'s approach was much more dispassionate. Indeed, modern light-industrial factories such as he photographed offer little scope for heroic symbolism of any kind. Yet from such seemingly prosaic material, Baltz produced a series of intriguing images. This particular picture is an excellent example of his classically restrained technique. There is little initial visual impact but as one studies it more closely its inter-relating patterns of shape, line and tone become clearer. One finds great satisfaction in the overall balance of the design and in its fine detail.

Baltz is not simply interested in the formal structure of objects in themselves but in the way they are represented by the camera. He wrote, 'If photographs automatically formalize their content, as is often asserted, then the formal qualities of the photograph can be taken for granted as a condition of the photograph's being and the discussion of formalism as intentional aesthetic posture would be academic. What may not be academic is how the forms in a photograph contain and describe the forms and events of the external world.'

Lewis Baltz

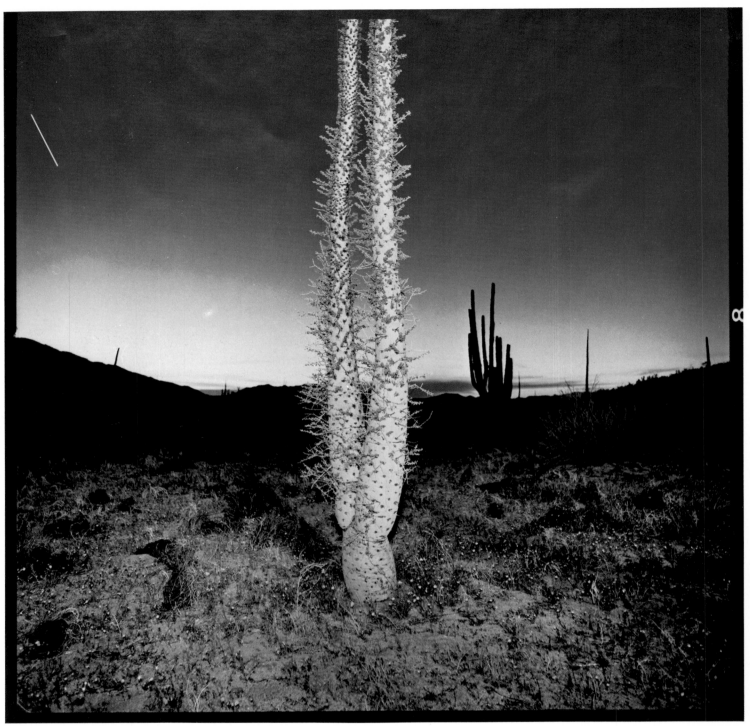

Richard Misrach

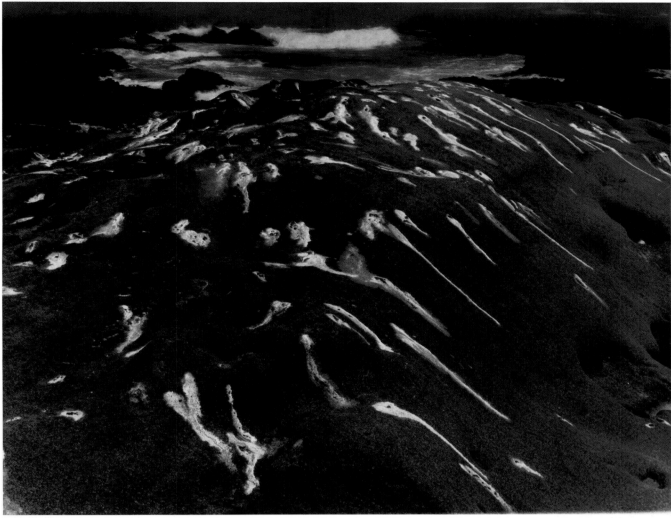

Minor White

It is a measure of the sense of adventure in contemporary landscape photography that **Richard Misrach** can go out into the desert and take flash pictures of cacti that he can barely see in the evening light. The idea may sound absurd, but it worked.

This example is from a series produced over a four-month period from 1975 to 1976. However bizarre, what is there to criticize in a technique that can make us stop and marvel at such an extraordinary plant, and at photography's unique ability to describe it? Like some close relative of a 'Triffid', it inhabits a landscape sympathetic to hallucinations. As one critic noted, some of this series could easily be mistaken for underwater pictures.

Misrach has conjured up a vision that is dreamlike and dramatic. The subject is strongly centred, and illuminated by the last remnants of evening light and by flash. Notice the star trail at the top left, resulting from the time exposure. Because of the darkness, he can not fully previsualize such images, and it is only when he fires the flash that he has the first real idea of what to expect. He makes notes to remind himself of his impressions and uses this information as he works on his prints. His jottings show that this plant reminded him distinctly of 'giant carrots, parsnips, turnips etc.'

The original prints are difficult to reproduce satisfactorily because they are carefully toned to enhance their illusory effect. Recently, Misrach has been working more in colour, including a series taken at night in the Hawaiian jungle. This offered even less chance for previsualization.

Minor White was something of a guru in American photography, with considerable influence as a teacher, editor, critic and photographer. He helped to found *Aperture*, was appointed editor and ran it as a vehicle for his own views and enthusiasms. His philosophy was rooted in an intense religious mysticism and he spoke without embarrassment of his personal convictions and of his efforts to move closer to his Creator through his work. He believed that 'the ultimate experience of anything is a realization of what's behind it', and he searched for that understanding and for ways to communicate it. As a teacher, he inspired great devotion among his pupils, always trying to reveal rather than merely to inform. 'I'm teaching seeing, not photography.'

He emphasized that the photograph could be used not just as a document but as a metaphor, to evoke something else – that is, as an 'equivalent', to use Stieglitz's term – and as an oblique way of expressing ideas, emotions and intuitions. It was not an original concept but White preached it with singular passion and success. The image was a looking-glass through which one entered a world of shared mystical experience.

Like most photographers of his generation he had a proper respect for craft-skills, appreciating that technical control of the medium increases one's expressive range. This facility is obvious in pictures such as *Birdlime and Surf*, 1951. The white shapes lie like stranded fish on some dread beach. By eliminating the sky, he concentrates the reader's attention and also the effect of the exaggerated tonal contrast.

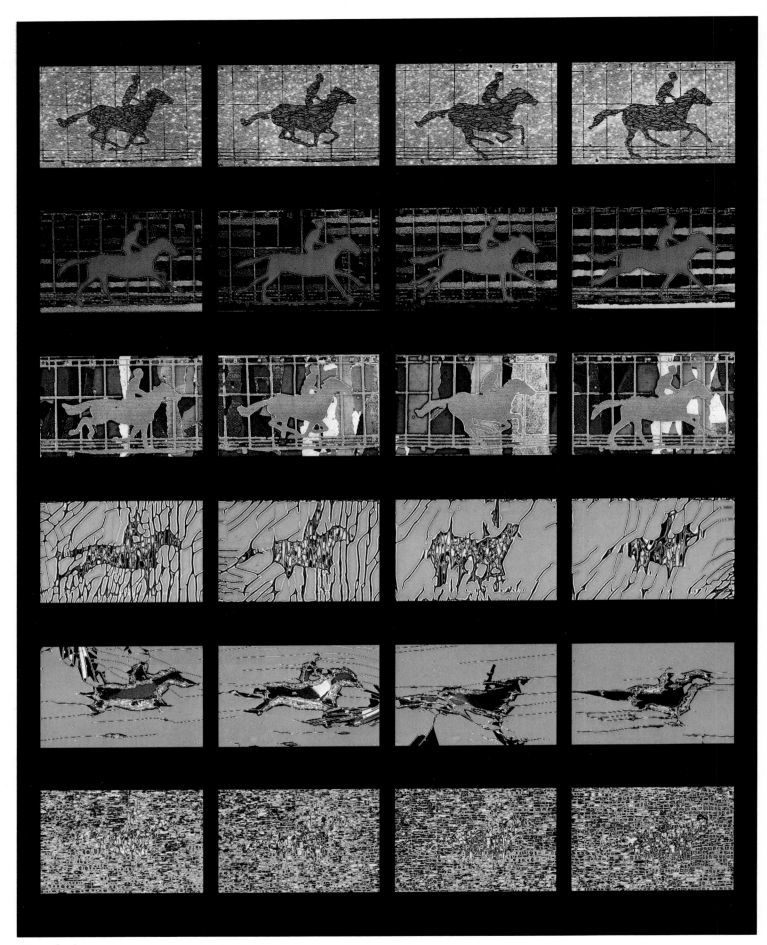

Pierre Cordier

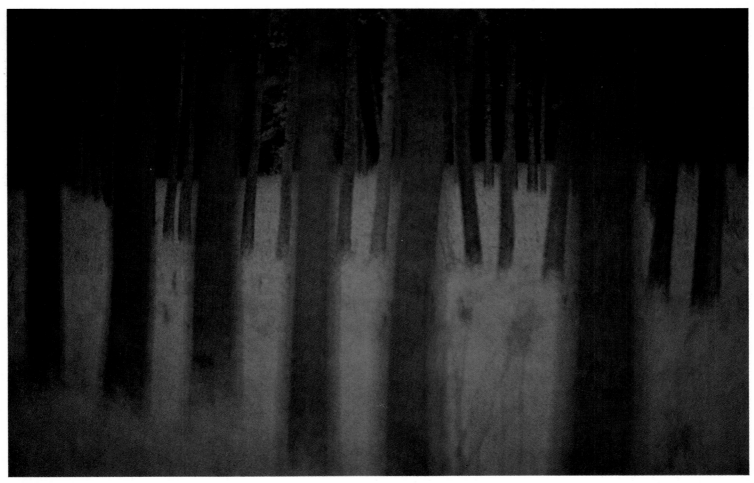

André Martin

The work of **Pierre Cordier** exemplifies the widespread fascination for experimenting with unusual photographic processes, whether old or new. He invented the chemigram in 1956 and the photo-chemigram seven years later. Understandably, he prefers to keep his exact techniques secret, but basically a chemigram is produced by the localized action of chemicals on a photo-sensitive surface, without the use of a camera, enlarger or even a darkroom. In a photo-chemigram he combines this chemical process with a photographic image, as in this picture, *Homage to Muybridge*.

'The chemigram', says Cordier, 'results from the encounter of two chemistries: one is solid, that of the photo-sensitive surface; the other is liquid, that of the developer and fixer. The developer is the equivalent of the pencil: it produces the blacks and the colours. The fixer, used before the developer, neutralizes its effect and thus produces the white; its role is similar to that of an eraser which, in this case, precedes the pencil.

'Like a camera, the localizing substances determine the forms and structures of the chemigram. These substances are numberless: they can be hard, soft, oily, dry, sticky or brittle. By varying these three elements separately or together (photo-sensitive surfaces, localizing substances and developer-fixer) the possibilities available to the chemigram process are infinite.'

The colour range of the early chemigrams was rather limited but today Cordier uses the dyes that are part of photo-colour emulsions, and this gives him endless scope. He still sometimes returns to the original chemistry because the results are permanent. Some dyes are less stable and he specifies that chemigrams made with them should not be exposed to broad daylight.

André Martin's landscape work falls between two extremes. Landscape photographers in general tend to favour medium or large-format cameras since quality of description is more important to them than speed or convenience of handling. Sometimes the slow, deliberate process of using a view camera is considered an advantage in itself, as John Blakemore mentions in his article. But a totally different approach to landscape photography can be seen in the work of many photojournalists who produce colour essays on travel for major magazines and also books. Usually they prefer 35mm equipment because it is more portable and versatile – the landscape being just one element in a comprehensive coverage of a particular region. Slow, high-definition colour films, together with a wide range of lenses, enable them to take photographs of superb technical and imaginative quality. Their principal interest is in visual rather than abstract ideas, with a conspicuous sensitivity to colour and form.

These are the extremes between which the work of André Martin falls, with a leaning towards the latter. He uses long focal-length lenses on a 35mm camera to isolate and compress detail, and also to soften shape and colour through differential focus. The overall effect is decidedly romantic. The colour is sometimes bold and primary, sometimes a misty blend of subtle pastel shades, and sometimes almost monochromatic. He often makes strong use of pattern, as in this picture: the bare verticals of the carefully cropped tree trunks precisely organized against the colour wash of the background. The foreground is quite blurred and even the middle-distance is not entirely sharp. Only the far line of trees is completely in focus. This technique prevents the design from becoming too harshly abstract.

William Garnett

William Garnett has been an enthusiastic flier for more than 30 years, and has done more than anyone to win respect for aerial photography as an art-form. Until quite recently, it was considered useful rather than expressive. One saw the occasional beautiful view or curious design, but no substantial body of work to suggest that the medium could adequately compare with normal landscape photography. But Garnett proved its potential and received a Guggenheim award in 1953, the first ever given for aerial photography. He was further honoured in 1956 and 1975.

The possibility of creating visual surprise by recording familiar objects from unusual angles is well known. It becomes even harder to recognize a subject if it is isolated from its context and if no clues are given to its size. It is an obvious technique for the aerial photographer to exploit. The patterns of both natural and urban landscape also acquire a fresh interest seen from the air, and the photographer enjoys a much greater freedom of manoeuvre than on the ground, where his view is frequently obscured. Garnett took full advantage of these opportunities, often simply celebrating natural spectacle but sometimes also producing more complex images through his control of perspective, scale and lighting. His pictures can excite as much by the quality of their underlying ideas as by the sharpness of his observation. Sometimes it is quite a challenge to read his images accurately.

To get this photograph of snow geese and the sun, taken over Buena Vista Lake, California, in 1953, Garnett had to chase after the geese for almost an hour. By that time, he was short of fuel and managed to take just the one shot.

Surprisingly little about Mario Giacomelli has been published in the international photographic press. His pictures have appeared regularly in photo-magazines, annuals and group exhibitions such as *The Land* or *The Romantic Landscape* since the early sixties, but he is not given to making statements about his work and he has not received the critical attention he deserves.

It is easy to forget how recently the explosion of interest in photography has occurred, together with an enthusiastic, uninhibited exploration of the medium's full expressive potential. Only 25 years ago, ambitious young photographers almost inevitably gravitated towards photojournalism, portraiture or advertising, and highly respected photographers who worked outside these areas and seemed at all avant-garde found it very difficult to have books published. In Europe, with its powerful documentary tradition, a handful of photographers somehow managed to survive largely isolated from this mainstream of activity. Above all, there was Bill Brandt in England, who has often said that *Perspective of Nudes* would not have appeared were it not for the efforts and encouragement of one man, editor Norman Hall. Then scattered throughout the Continent were a very few younger figures such as Mario Giacomelli in Italy. His early pictures of people already showed a strongly visual rather than narrative emphasis and his more recent landscape photographs extend this concern with design and graphic effect. Sometimes the form becomes so two-dimensional that the landscape lies like a patterned beach-towel spread out on the ground to dry.

Mario Giacomelli

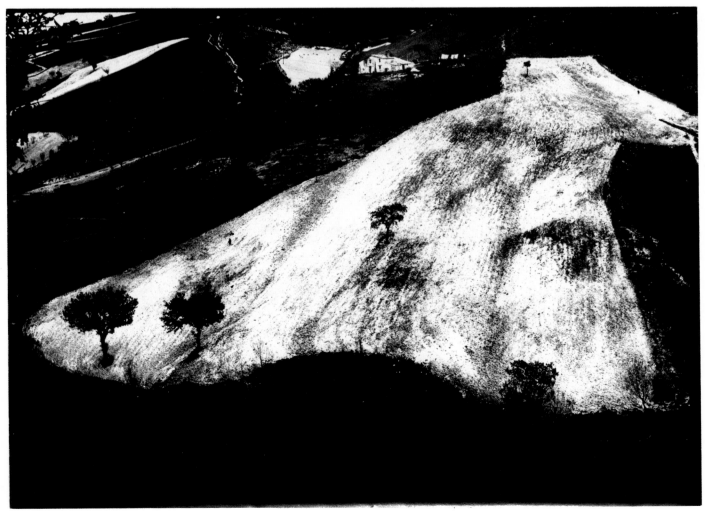

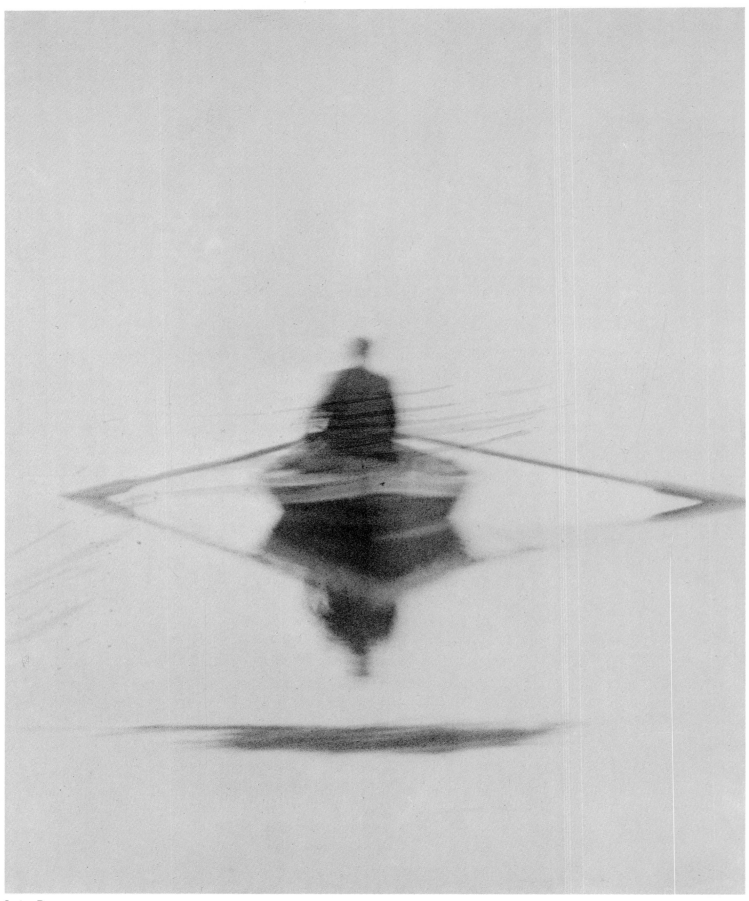

Irving Penn

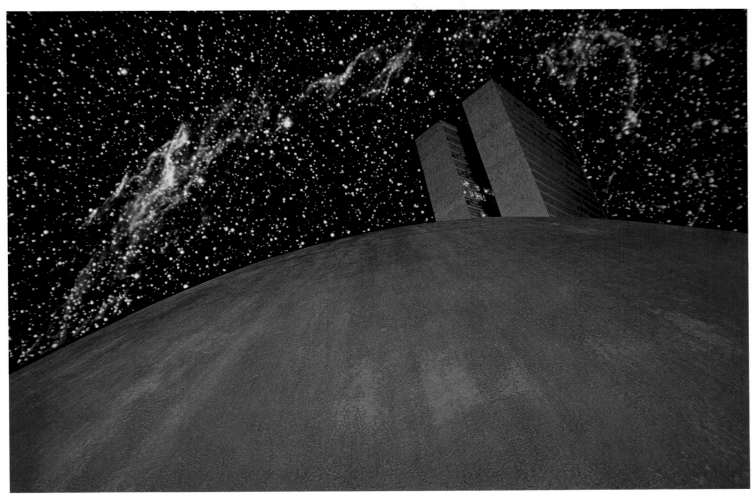

Pete Turner

Irving Penn has been at the height of his profession for decades, and his enthusiasm shows no sign of flagging. Indeed some of his recent pictures have challenged our preconceived ideas more than his earlier work. There was considerable controversy over his series of platinum prints showing close-ups of cigarette ends. How did one evaluate photographs of such extraordinarily fine image quality and such a totally trivial subject? How seriously should one take them? Was Penn showing us unsuspected hidden beauty or was it just a brilliant, and even mischievous, technical exercise? Was the real subject the beauty of the photographic process itself? Was he demonstrating that an image, whatever its original subject, has to be considered on its own aesthetic terms? The arguments kept on the bubble for some time. However provocative conceptually, the photographs lacked nothing in formal dignity – a characteristic of Penn's style.

His portraits have a quality of restrained simplicity that denotes confidence. Often his subjects have been so exotic that no further trimmings were needed – a plain background and straightforward illumination, daylight when possible, were enough. But even in his pictures of more famous people he has generally kept to a similar formula, though making more use of close-ups. Penn achieves a strong rapport with his subjects so that they present themselves confidently to the camera. In his earlier years, some of his colour pictures, such as this one taken in 1953, were very avant-garde but he never followed them through. They suggested relationships between form and colour, and between form and the structure of colour emulsions, that have still not been thoroughly explored.

Few photographers have been as uninhibited in their approach to technique and colour as **Pete Turner**. Undeterred by any 'purist' taboos, he experiments enthusiastically with any means of creating visual surprise in his editorial illustration and advertising pictures. Some of the methods he helped to pioneer are now quite conventional by professional standards – for example, the use of extreme focal length lenses – but not many people handle them with such flair.

He has been especially adventurous in working with filters and superimposition. Filters are frequently used in black and white photography to produce special tonal effects, but in colour work their predominant function is corrective, to compensate for various imbalances of colour temperature in illumination and film sensitivity. But Turner uses them to introduce deliberate colour distortions. For instance, the filters normally employed with black and white film give pronounced overall casts on colour material.

Turner was also quick to realize the imaginative possibilities of superimposing one image on another. But he never clutters up a picture with confusing detail. The technique may be elaborate and the colour even outlandish, but the shape will usually be simple and bold. The combination guarantees considerable initial impact.

The photograph reproduced here was made in Brasilia in 1979. It was first duplicated, then Turner made a film positive to block out the sky, placing it in registration with the original. Next he used a blocking mask for the bottom part of the scene and double-exposed the star field, finally adding blue to the foreground.

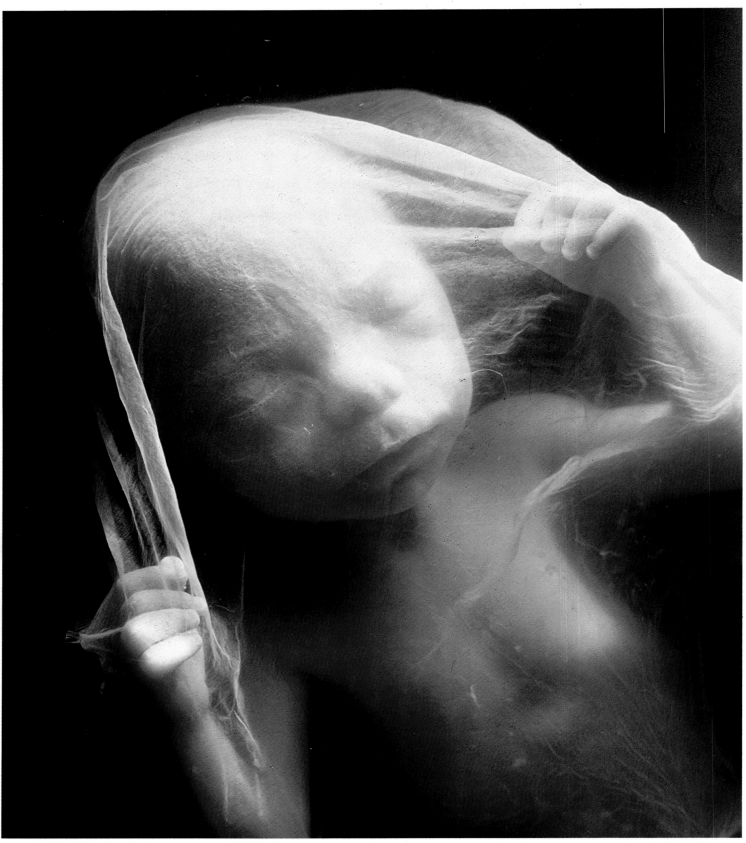

Lennart Nilsson

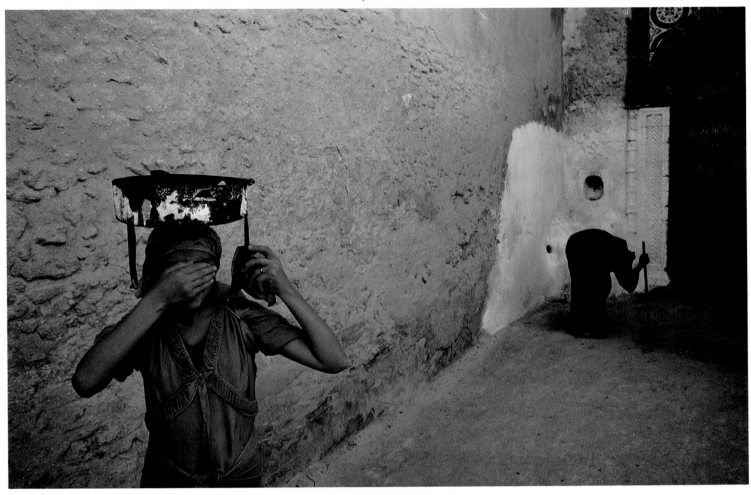

Harry Gruyaert

If any photographs taken on Earth can arouse in us the same sense of awe as those produced in Outer Space, it must be those taken by **Lennart Nilsson** of our own Inner Space. Using minute, ultra wide-angle lenses and fibre optics to transmit light, he has photographed within the most vital organs of the human body itself, even showing a living baby inside its mother's womb.

This picture of a four-month-old foetus asleep in its amniotic sac was part of a series that took ten years to complete and was first published in *Life* as a 16-page feature, *The Drama of Life Before Birth*. Ralph Graves, Managing Editor of *Life* at that time, said recently that he still thinks it was 'probably the most incredible essay that we ever ran, in terms of sheer surprise, coupled with beauty, coupled with something that had never been seen before.'

Nilsson began as a photojournalist before developing his interest in medical matters into a full-time specialization some 25 years ago. Now he carries out his research at the Karolinska Institutet, Stockholm, with the wholehearted co-operation of many doctors who recognize the value of his work. He himself has been awarded an honorary doctorate.

Much of his equipment is specially designed for him and he also uses a vastly expensive scanning electron microscope. But as he told Lisbet Nilson who interviewed him for *American Photographer*, 'Above all, I am still a photographer. All this is photography like any other photography – except that it also ends up being basic research because of the technology involved. I'm just a photographer who's gotten himself some different buttons to push. That's all.'

The last thirty years has seen an enormous increase in the use of colour in magazines and books. Many photographers would have preferred to continue working in black and white but had to change to colour out of professional necessity. They often found it stimulating and yet not wholly satisfying. There was a general feeling that colour itself was irrelevant, if not an outright hindrance, for more serious communication. There was no great tradition of colour work to measure up to and the most respected black and white photographers had scarcely a kind word to say about this sibling medium.

This prejudice is very, very slowly being eroded by a handful of people who have approached colour with a more positive attitude, trying to understand and control its own special values and possibilities. **Harry Gruyaert**, a Belgian who worked in Paris for various magazines before becoming a director of photography for Belgian television, is one of these. Some of his early colour pictures were photographed direct from a TV screen into 35 mm film from which 10 × 8 inch internegatives were made. Then colour-corrected contact prints on type C paper were pasted down on glass as multiple images several square feet in size.

He has also worked extensively in Morocco on a book of photographs from which this picture is taken. The images are strongly colour saturated, with bold but precise composition. Their appeal is essentially visual rather than narrative.

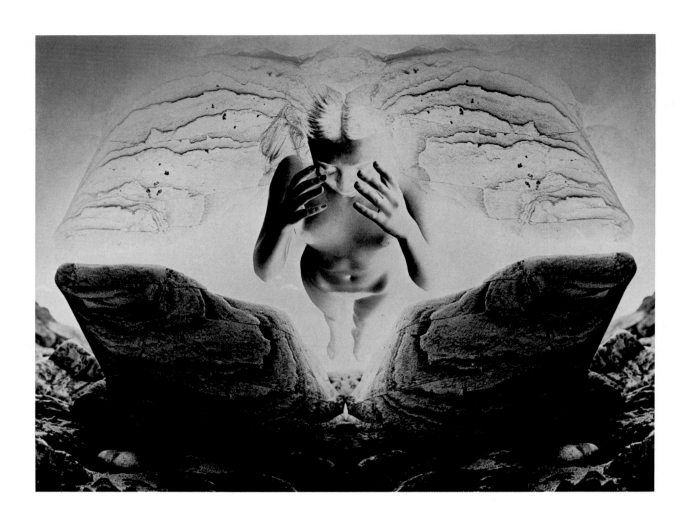

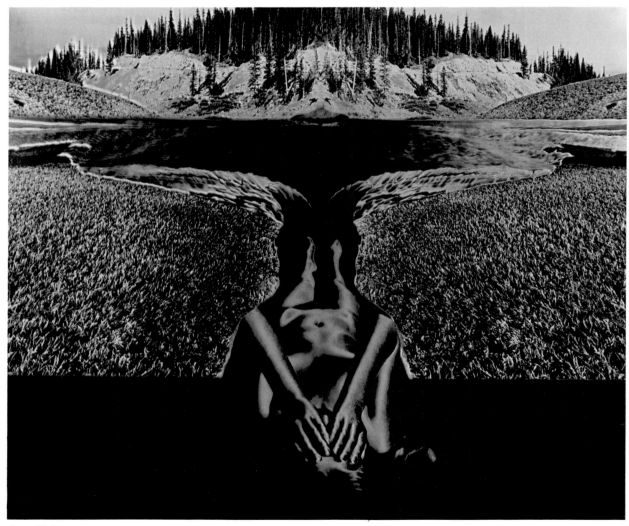

Jerry Uelsmann

Jerry Uelsmann works with the manipulated image, a form which photographers have often seemed to reject with moral distaste rather than mere aesthetic disapproval – perhaps because they feared that it compromised the integrity of the medium, its special relationship with reality. But as the actual nature of that intimacy was better understood, and as the possibilities of the photograph as metaphor were further explored, it became more obviously illogical to object to such openly illusive techniques except in terms of artistic judgement. Uelsmann's pictures are the more acceptable because they follow the work of Minor White (under whom he studied), Aaron Siskind and others of that generation. Like White, he collects fragments of experience to use for their cumulative effect, but he combines them in one image instead of in a picture sequence.

In an illuminating article in the Lustrum Press book *Darkroom*, he wrote, 'I truly believe that the quality of the moment which we traditionally associate with the camera experience can be very much part of the darkroom experience also.' He has an extraordinary talent for multiple printing, building up a picture smoothly and gradually, working by instinct rather than following a previsualized plan. 'I like the idea of letting the medium have a say in the image as it evolves.'

His gift is not only in the fertility of his imagination but in his ability to create and blend a remarkable range of distinct and powerful symbols. Sometimes witty and playful, his photographs often also communicate feelings of latent menace, perhaps because they so effectively disturb our fundamental sense of reality.

Among the distinguished photographers who have also proved influential teachers is **Aaron Siskind**. The role of the photographer/teacher in modern photography has been a crucial one, especially in the USA where competition has flourished as much in the intellectual arena as in the commercial market-place. Free from narrowly vocational restraints, staff and students have been able to explore the medium more fully as an art-form. The academic environment has encouraged the development and spread of new ideas, even across the borders of different disciplines, leading to healthy cross-fertilization. Sometimes this specialization has led to a certain preciousness and to occasional misguided intellectual snobbery, but the overall effect has been hugely beneficial.

Siskind was very much in the van of the post-war movement in photography from a documentary towards an interpretative approach. At an early stage he wrote, 'The emphasis of meaning has shifted from what the world looks like to what we want the world to mean.' He realized what creative opportunities existed once one understood that the photograph is a world in its own right and not a simple record of the external world. Once photographed, 'the only life the object possesses is expressed within the picture space.' The most mundane subject-matter can be transformed through the intuition and imagination of the skilled photographer. He himself has found inexhaustible inspiration in the surface detail of ordinary urban walls. His photographs separate areas of interest from their context and reveal their own expressive energy. As images they acquire a significance unrelated to their original existence.

Aaron Siskind

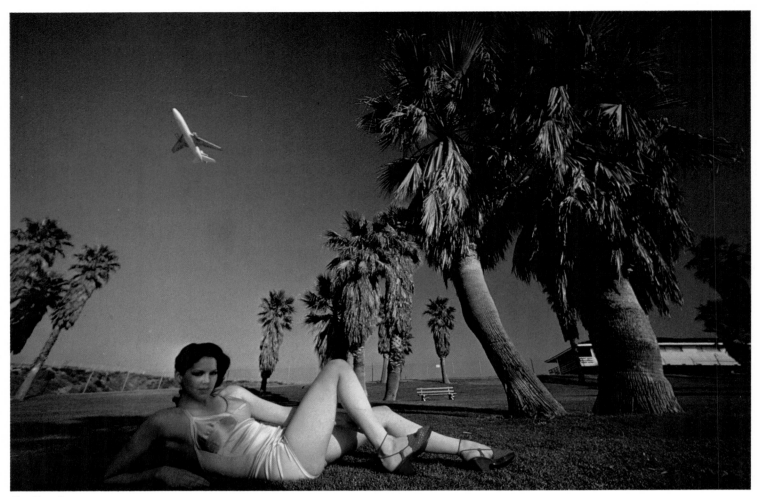

Guy Bourdin

Style is tantalizingly indefinable. However, we can recognize it instinctively, even in skills, people and products we know little about. But wherever we see it—in the performing arts, in sport, in design, in dress or even in simple gestures—it seems to reflect the very essence of a particular activity or purpose. It is a quality that is easiest to describe by example, as any fashion magazine editor knows. Every so often some journalist revitalizes the old topic of who and what does and does not have style. And whatever the basic value of this ingredient in other areas of life, it is fundamentally important in the world of fashion.

Guy Bourdin's fashion photographs have unrivalled style. When a major French shoe manufacturing company decided in 1967 to change their image, it was to Bourdin that they turned. It is a testimonial to the power of photography in general, and to the photographs of Bourdin in particular, that in the space of two years the brand image of Charles Jourdan—until then classical and indeed somewhat staid and conventional—had undergone a fundamental change and was completely rejuvenated. In the context of advertising photography these pictures stand out as being unorthodox, even startling. The actual product being advertised—the shoes—could hardly be said to feature prominently in, let alone dominate, the pictures; but the campaign was so successful that the company continues to employ Bourdin for its publicity work.

The example reproduced above is from the campaign of 1976. Bourdin went to Los Angeles and, working as he always does in complete secrecy, spent six weeks shooting the series. Some of the photographs are more surrealistic than this one, having a pronounced overall colour cast or

being taken from an unusual angle; others are technically less bizarre, although the composition is always striking.

The quality of these photographs depends on how essentially visual they are. Their effectiveness can no more be expressed verbally than the smile on the Mona Lisa. Their pleasures may stem from one tiny, frozen moment in a quiet, still, open expanse; from an amusing and even distorted outline; from the choice and balance of colour, or from a hundred other things that only appeal to the eye. Bourdin takes risks that less gifted photographers would never dare, sometimes in the brashness of his approach, sometimes in its subtlety. He uses very wide-angle lenses to great effect, exploiting rather than avoiding their tendency to distort: the palm trees on opposite sides of the picture reproduced here are almost at right-angles to each other, and the airliner appears to be rising almost vertically. Bourdin has no qualms about altering any element of a situation in order to perfect the image as he envisages it. Few people in any branch of photography have such an intuitive flair and visual judgement.

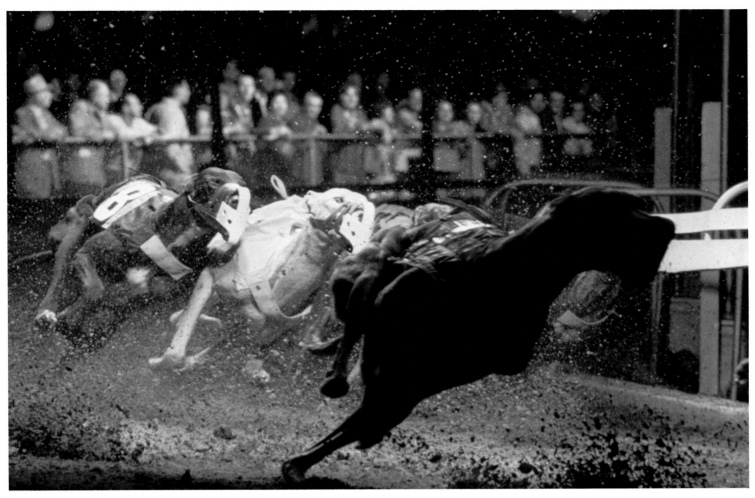

John Zimmerman

This photograph by **John Zimmerman** typifies the enterprise and ingenuity used in sports photography. It is a subject that covers a broad spectrum of interest – recording incident and achievement; describing shape, tone and colour; interpreting movement in a variety of ways; revealing the reactions of both competitors and spectators; suggesting the mood of an occasion; portraying personalities formally and informally, and creating carefully planned spectacular pictures. It involves a relentless search for novelty, a continual need to produce exciting images from subjects that have been seen and photographed over and over again. But this constant repetition of action also has its advantages – one knows in advance where, when and for how long an event is going to happen. Because of the fundamentally competitive nature of sport, one can also be certain that most of the participants will be giving of their best. The experienced photographer can be properly prepared and in position to concentrate on any aspect of the proceedings. It is also easier to perfect an idea when one can experiment over a period of time in a number of fairly similar situations.

Sports specialists are renowned for their resourcefulness, creative flair and technical expertise in contriving striking images. They push existing equipment and materials to the limit and adapt all manner of apparatus to their needs. They investigate every conceivable viewpoint, either for themselves or by a remote-control camera, and are ever on the alert for any possible new approach. Few other photographers, except perhaps in advertising, develop such a blend of varied skills.

Life and *Sports Illustrated* set the standard in this field, through the talents of John Zimmerman, George Silk,

Mark Kauffman, and later, Neil Leifer and Co Rentmeester, among others. For the photograph reproduced above John Zimmerman used a motor-driven 35mm camera with 180mm lens, Kodachrome film, and six electronic flash units, two to light the dogs and four on the crowd. The reader is made to feel right at the heart of the action. The low camera angle is on a level with the dogs, the telephoto lens has compressed the spectacle and brought it closer, and the electronic flash has frozen the movement so that one can study detail normally invisible to the eye. The sand and dirt thrown up by the leading greyhound, just disappearing from the frame, and the dark foreground shape of another runner, add to the sense of drama.

This quality of visual surprise often depends on unusual perspective, shrewd choice of lens – frequently of extreme focal length – control of lighting, and, of course, an adventurous original idea. Sometimes specialized equipment is also a help, such as motorized film-wind and zoom lenses – now quite commonplace; remote-control units for triggering camera and flash; underwater and panoramic cameras, and all kinds of exotica. Zimmerman, an obsessive worker like many others in this line of photography, is famous for modifying equipment and innovating techniques, some giving the most fascinating, bizarre results. Although best known for his sports pictures, he has also turned his hand to more general commercial practice, and to photo-journalism as a whole.

Arnold Newman

Born:
1918, New York City.

Education:
1936-38: Studied art under a scholarship at the University of Miami.

1938:
Began his photographic career in chain portrait studios.

1941:
Began experimenting in environmental portraiture.

1946:
Moved to New York City and opened his studio, establishing himself as one of the most widely exhibited and collected photographers working today. Formerly Adjunct Professor of Advanced Photography at Cooper Union, he now lectures extensively in the US and elsewhere.

Books:
1967 *Bravo Stravinsky*.
1974 *One Mind's Eye: The Portraits and Other Photographs of Arnold Newman*.
1978 *Faces USA*.
1979 *The Great British*.
1980 *Artists: Portraits from Four Decades*.

Exhibitions:
Newman's work has been exhibited all over the world and is represented in many permanent collections. His major one-man exhibitions include the following.
1945 *Artists Look Like This*, Philadelphia Museum of Art.
1972 International Museum of Photography, George Eastman House, Rochester, NYC.
1979 *The Great British*, National Portrait Gallery, London, England.

After four decades of working in portraiture, I am less certain now than when I began of what a portrait is or what it is supposed to be. Nor do I care in the academic sense. I am sure of one thing—that the very need to create a definition is destructive and inhibiting.

From the first I have always assumed that a good portrait must first be a good photograph. Actually this holds true in all so-called branches of photography, and I have worked in many—still-life, landscape, photo-journalism as well as realism and abstraction—and have never found well defined lines between them. To insist upon definitions, dividing lines, rules and regulations is to create official schools and academies needed by the unimaginative but deadly to creativity.

Throughout history many in the arts have made up golden rules and laws for composition, yet not one great image has ever been created by their application. In a practical sense composition simply means arranging an image so that it works. As a young man I watched Mondrian at work and, just as with a realist, it was experiment with change, judgement by inner feeling as well as intellect.

The theorist, regardless of the success of the application of his ideas, can only be judged upon the viewing of his work. And theories are no better than the ability to apply them.

But portraiture as it is generally thought of and in all its forms, has, by practice and the public's understanding of it, taken on an entirely different meaning—even when it does not deserve it. And this misleading idea of what a portrait is, when accepted, limits its execution and creative opportunities. With popular usage and in some art circles as well, the word 'portrait' has come to mean an image deliberately distorted and altered to flatter a subject's ego and to cater to his or her fantasies. Therefore, those who practise any form of portraiture are automatically under suspicion as artists and their work frequently segregated from all accepted forms of art, regardless of whether it deserves such a judgement or not. Considering the expectations of the public and the willingness of some artists eager and willing to distort their work for money, this attitude is understandable. But this blanket pre-judgement is destructive when applied to all.

Throughout time almost all the great painters, sculptors and photographers made portraits and delighted in it—from Rembrandt to Picasso, Michelangelo to Mondrian, Julia Margaret Cameron to Alfred Stieglitz, Man Ray, Edward Weston, Larry Rivers, George Segal. The list is endless. There was a need and a joy to use their ideas in their work and to make statements about individuals or mankind in general. The artist's intent and the result are what is important—not the preconceived expectations of others.

Art cannot be defined—there is only good art or varying degrees of lesser to bad art, and this is also true of portraiture.

For convenience I use the word 'portrait' only in its most general and unrestrictive sense. A better phrase is 'a photograph of a person or people', but this is also incomplete. Consider multiple images, collage, mixed

media and the many other ways of working which enlarge the photographer's opportunities and also bring him to a point close to, or even overlapping with, the painter and sculptor—who in turn has used the photographic image.

There are no definitions, no dividing lines—there is only art. And art is ideas and the artists' execution of their ideas. The great ones build upon the past, changing and adding to it until it becomes uniquely theirs. The past is but a starting point. The artist cannot be derivative. He or she creates and builds ideas from within. We do not make photographs with our cameras. We make them with our minds, with our hearts, with our ideas.

I make photographs because of the kind of person I am—because of my parents, my childhood, schooling and later mature influences and personal experiences. I do not say my way is the only way; it is simply my way because of the kind of person I am. It is an explanation of myself. It should reflect me, my fascination with people, with the world around me and with the exciting medium with which I work.

I always feel that when I teach, should any of my students begin to imitate me, then I am a failure as a teacher. Each of us must find his own way. To be fashionable, to be 'with it' means that one lacks confidence in one's own self and will be doomed always to follow the lead of the moment and of others, and this changes with the season.

There are many photographs of mine in my files, and unfortunately among those that are often published, which embarrass me. As a professional working under deadline and budget restrictions, I seldom have had the luxury of reshooting an off-day. Even when doing my own work, unlike a composer or painter, I cannot rescue lesser efforts by reworking at a later time. One can only discard and remain unafraid of change and experimentation.

In all art forms there are many who repeat a single idea time and time again until it hardens into a rigid formula, as opposed to a natural, ever-developing style. Tragic is the over-influenced photographer who rigorously holds true to unyielding principles or ideas, limiting his or her horizons. I see scores of photographers whose works in magazines and exhibits are brilliant and beautiful, but I am left with the realization that I have seen it all before. Rarely does one of them contain an original idea.

Personally I—and all the great artists I know and know of—prefer the risk of failure in experimentation to the alternative of boredom. Not change for its own sake or shock value, but for the exploration that may lead to new concepts and new ways of expressing the love of one's ideas and medium. That also is what our art is all about.

As a photographer my influences were common to most artists. Childhood and student images soon clashed and were supplanted or absorbed by new and, at that time, controversial ideas. These ideas—cubism, abstractions, surrealism and that which came before and after—surrounded young artists working in the mid to late thirties. And when the depression pushed me out of art school into a commercial photography studio, I fell

In the introduction to his book *One Mind's Eye*, **Arnold Newman** is quoted as follows: 'A preoccupation with abstraction, combined with an interest in the documentation of people in their natural surroundings, was the basis upon which I built my approach to portraiture. The portrait of a personality must be as complete as we can make it. The physical image of the subject and the personality traits that image reflects are the most important aspects, but alone they are not enough. . . . We must also show the subject's relationship to his world either by fact or by graphic symbolism. The photographer's visual approach must weld these ideas into an organic whole, and the photographic image produced must create an atmosphere which reflects our impressions of the whole.'

The statement is a clear guide to his interests and intentions. It is important to note his early preoccupation with abstraction and also how he emphasizes that the various elements that compose a portrait must be visually fused 'into an organic whole'.

He does not simply provide more information about a subject by photographing him against the background of his work or way of life, a formula much used by lesser photographers. Newman's achievement, at its finest, is to take all the separate components and to work them together into a strong, unified image that has a symbolic and not merely a documentary value. The photographer's role becomes much more complex—to interpret and not just to record.

There is an interesting parallel with the work of Henri Cartier-Bresson who has also written of 'the organic co-ordination of elements seen by the eye' and of the impossibility of separating content from form.

With refreshing honesty, Arnold Newman makes no inflated claims for the photographic portrait. 'I'm convinced that any photographic attempt to show the complete man is nonsense, to an extent. We can only show, as best we can, what the outer man reveals; the inner man is seldom revealed to anyone, sometimes not even to the man himself.'

He has talked with similar frankness about equipment and technique. 'Cameras, lights and photographic materials are tools to be selected as needed, depending upon the creative and technical problems. It is pointless to discuss specific cameras or other equipment or material, since they always change and improve. . . . Since 1940, my basic camera has been the 4 × 5 view camera used on a tripod. For professional and creative reasons, I have purchased and used every size up to 8 × 10. In recent years, particularly as a result of technical advances,

an increasingly larger portion of my work is shot with single lens reflex 35 mm cameras. The principal reason is that it enables me to be freer while retaining a "view camera" image, even when working handheld in fast-moving situations.

'I prefer natural lighting with all its delightfully infinite varieties, indoors and out. When needed, I augment it with artificial light or reflectors and, on rarer but sometimes necessary occasions, with strobe. When I use "artificial light" exclusively (floods, sometimes a spot or two), they are generally bounced (reflected) off walls, ceilings, or, when colour is important, sheets. Bouncing is more "natural"; it makes the lighting effective but unobtrusive. Lighting is a personal tool and I keep experimenting.

'Like most professionals, I standardize my developing and printing, keeping it as simple as possible in order to concentrate on the creative problems. I work from contact sheets, analyzing and at times rethinking and changing my original compositions, often to a hair-splitting degree. For depth of field and other problems, I often use only a portion of a negative, but the original cropping is always invisibly present. My prints are archivally finished and are mounted on pure rag board.'

He concludes, 'There are no rules for techniques, only solutions. Today's darkrooms may soon be replaced with electronic consoles. Yet after thirty years, Stieglitz's advice to me remains constant: "The only thing that matters is the finished photograph."'

in love with the medium and discovered for myself Stieglitz, Steichen, Sheeler, Man Ray and importantly, the Farm Security Administration, particularly the work of Walker Evans. I recognized that with the camera, it was not just *what* one photographed but *how* one photographed. I began to explore photography for myself between my chores as a studio photographer making one-shot forty-nine cent portraits. Three years later in 1941 I had a two-man show in New York with my childhood friend Ben Rose. My photographs in that exhibit reflected all those earlier influences and also included several abstractions and collages—but no portraits.

But the incorporation of these same concepts, and the application of them, into photographing people was beginning to form in my mind. I admired the portraits of Stieglitz, Steichen and Man Ray but their approach was not exactly what I had in mind. Encouraged by Beaumont Newhall, who purchased the first photographs of mine for the Museum of Modern Art, and by the interest shown in me by Alfred Stieglitz, I decided to move from my home in Florida and to remain in New York in order to experiment with my ideas of photographing people.

I have been called an innovator of environmental portraiture, but this description is both misleading and incomplete. It is also another artificial and restricting label. It describes neither my real intent nor the work I produce.

The environment had been used before in photography, but generally as a record or as a convenience when the traditional studio could not be used. It was my purpose deliberately and collectively to use the environment as part of the creative whole.

For me the studio was sterile. I wanted to go beyond the simple solution of placing the subject in his or her milieu. The portrait had to be bonded in a visual concept, the very composition had to be complete in itself, yet reflect my attitude to or concept of the subject. Chagall was theatrical and turbulent in his person and in his work; Mondrian was stiff, formal and linear, and my portraits of them had to reflect this. The interiors were not only environments, but symbolic as well.

The design elements and compositions had to augment the statement I wished to make.

At times my subject is not available in his environment, such as when I was commissioned by *Harper's Bazaar* to photograph Stravinsky in 1946. He was visiting New York, staying at a hotel. Reflecting upon my love of the shapes of musical instruments I had begun to photograph gave me an idea of where I could begin. The grand piano is strong but beautiful in a linear manner—an abstract symbol of what Stravinsky's music means to me. I found a piano in the perfect simple setting, lit the background wall to complement (a counterpoint) the Maestro and the instrument, and made what is probably my best-known portrait. In this image there is no environment, nor does the viewer seek or need it—it is seen as intended, not real but symbolic. So is Mondrian's easel and his carefully placed wall decorations. Environment and personal objects also become symbols of

the subject, and in some photographs the subject becomes a symbol of himself or what he or she represents. The image of a Head of State in his office at 10 Downing Street or in front of the White House could be replaced by his or her predecessor or successor. Therefore environments or symbols are but a supportive part of a portrait—it begins and ends with the reality of the subject and his personality, and as the photographer sees and interprets him. Despite the opinions of some, the successful portrait also bears the personality of the photographer; otherwise it is not an interpretation but just a record.

My portrait of Krupp, depicting him as Satan in his own Hades—his factory—received enthusiastic acceptance by the public, but also Krupp's wrath. My concept of him was influenced and substantiated by history. This portrait is a statement, not a record.

Not all my subjects are famous, but the better known are more frequently reproduced, giving a false impression of the scope of my work. I enjoy working in other areas of photography, but photographing people is still my basic love. All people fascinate me—those with ideas, those who create and those who do things with their lives. It is what they are, not who they are, that fascinates me.

Photographing the well-known is not as easy as is often stated. My interpretation of a famous figure must compete with the preconceived opinions of the public. A photograph of an unknown must be taken on faith by the viewer. It is only the basic and indefinable integrity of the artist's concept that convinces or does not. Such portraits are not only of individuals, but often a symbol of all such subjects. Again, it is not *what* but *how*. The final image is a concept of a multitude of intangible ideas making for a creative interpretation complete within itself. No rules, no definitions, no restrictions can achieve this—only a deeply felt, honest search.

For me photography is intellectual excitement, a joy and the occasional experience of rich satisfaction in creating an image that pleases me as well as others. Is it a portrait? Is it art? That is up to others to decide and debate. I am pleased just to make a good photograph.

© Arnold Newman 1981

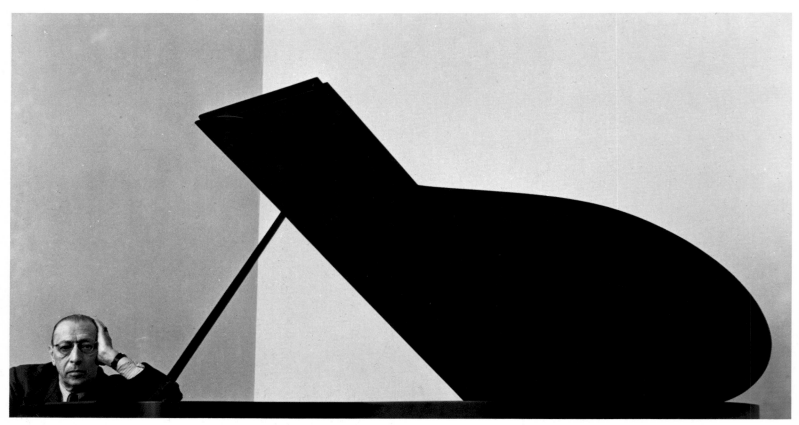

Stravinsky, 1944

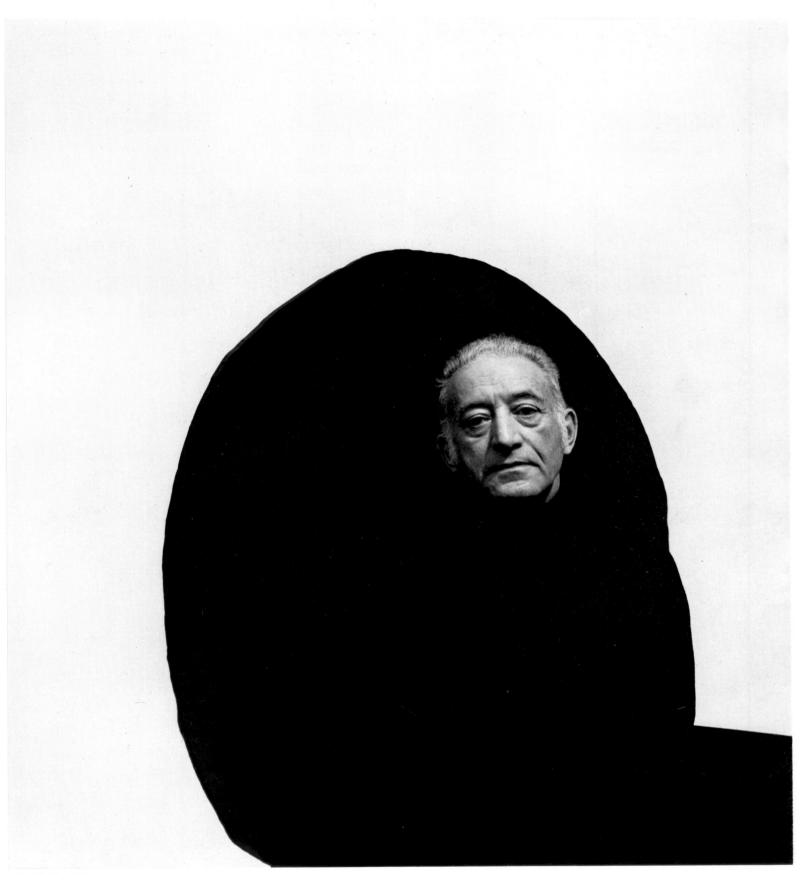

Adolph Gottlieb, 1970

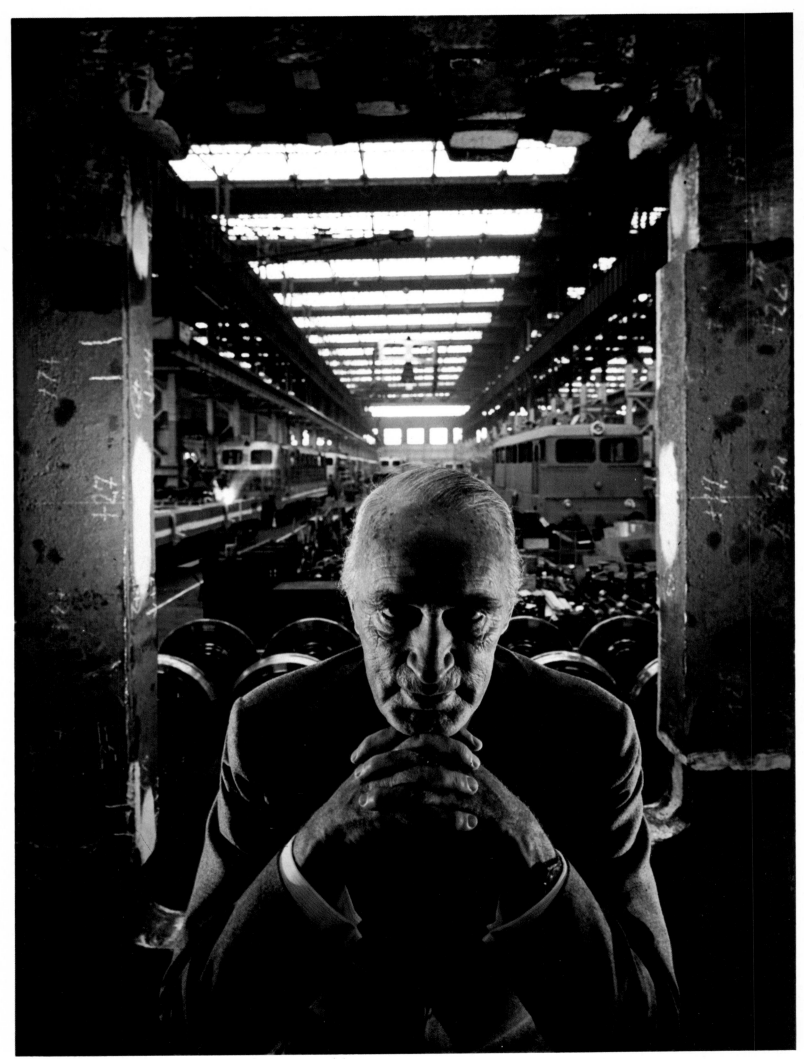

Alfred Krupp, 1963

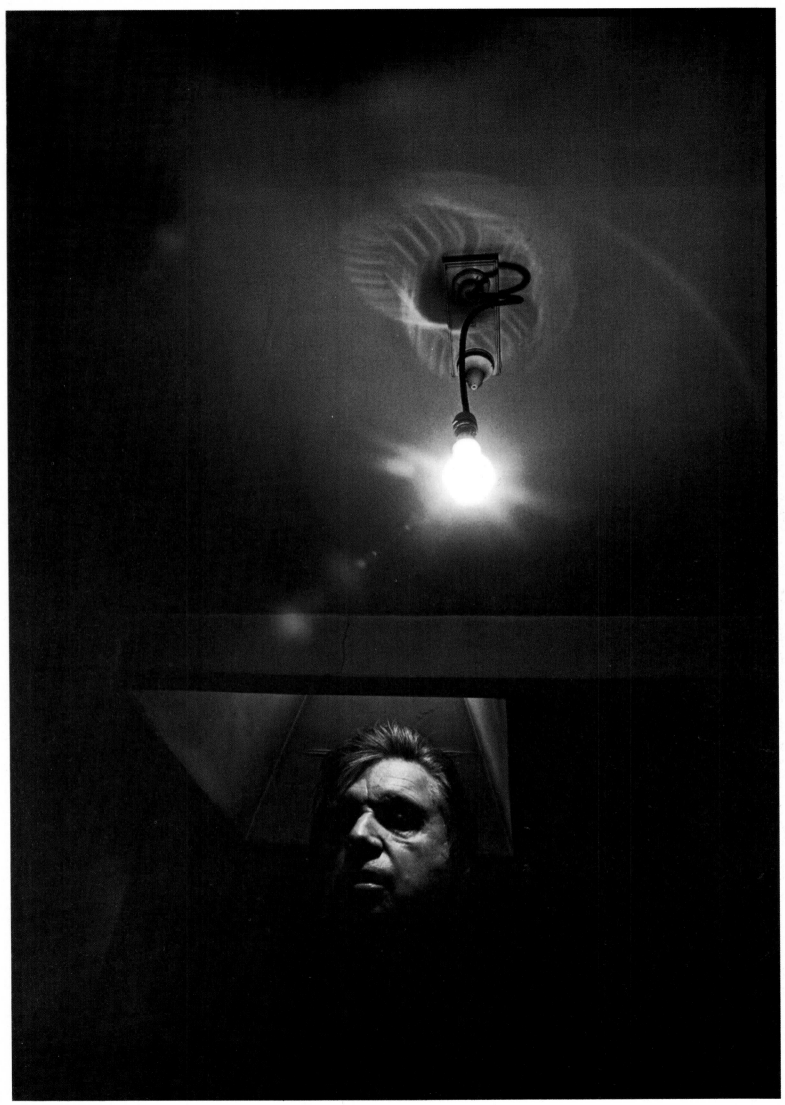

Francis Bacon, 1976

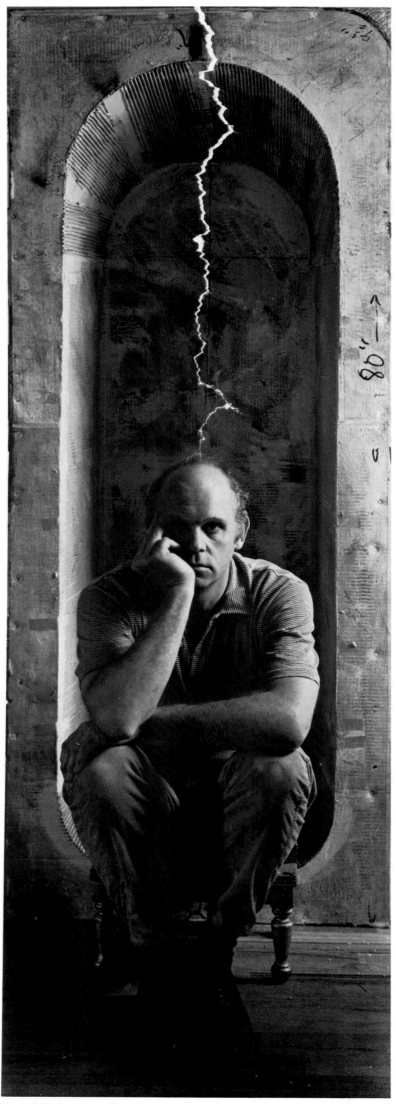

Claes Oldenburg, 1967/72

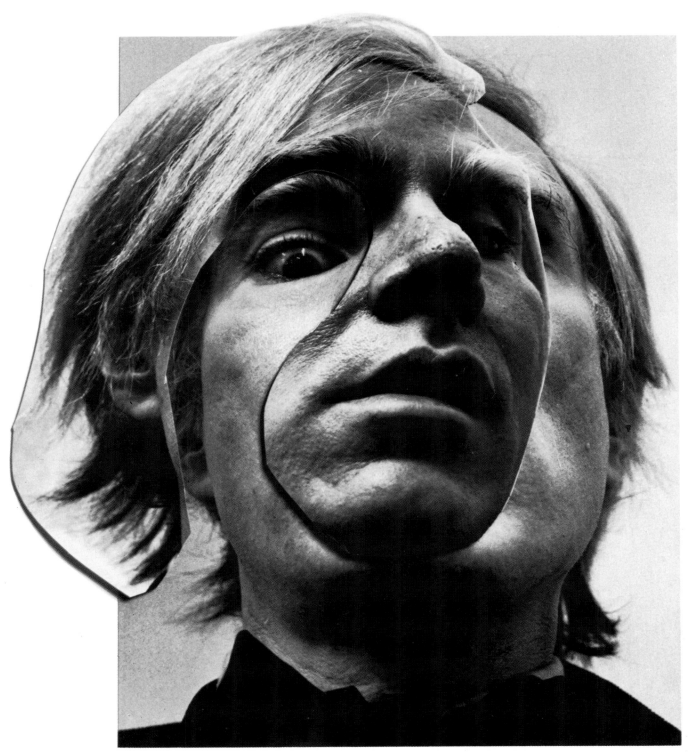

Andy Warhol Collage 5, 1973/74

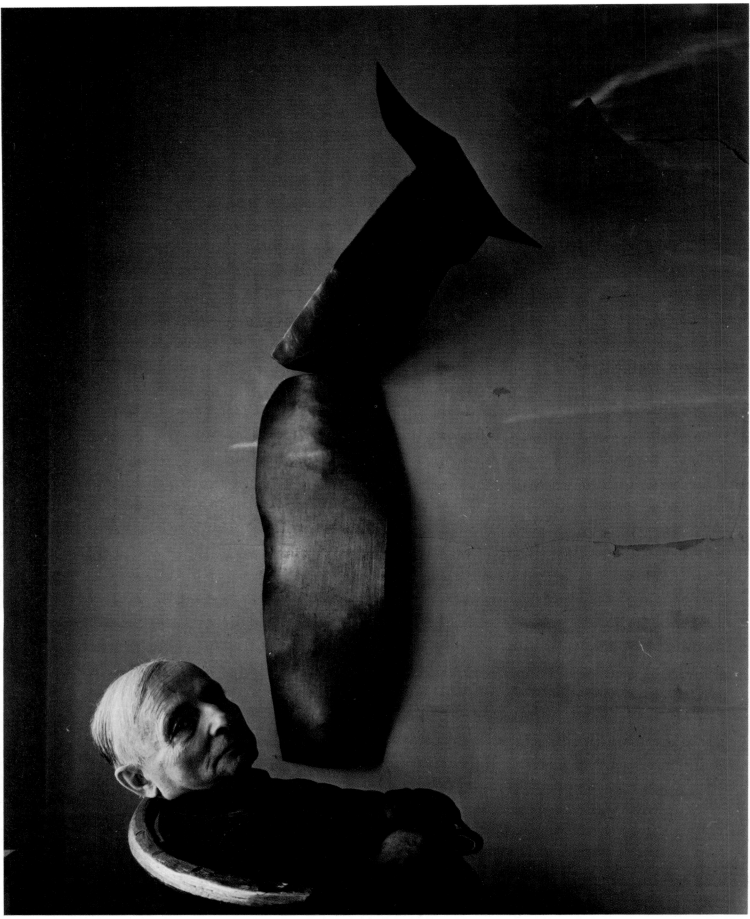

Frederick Kiesler, 1962

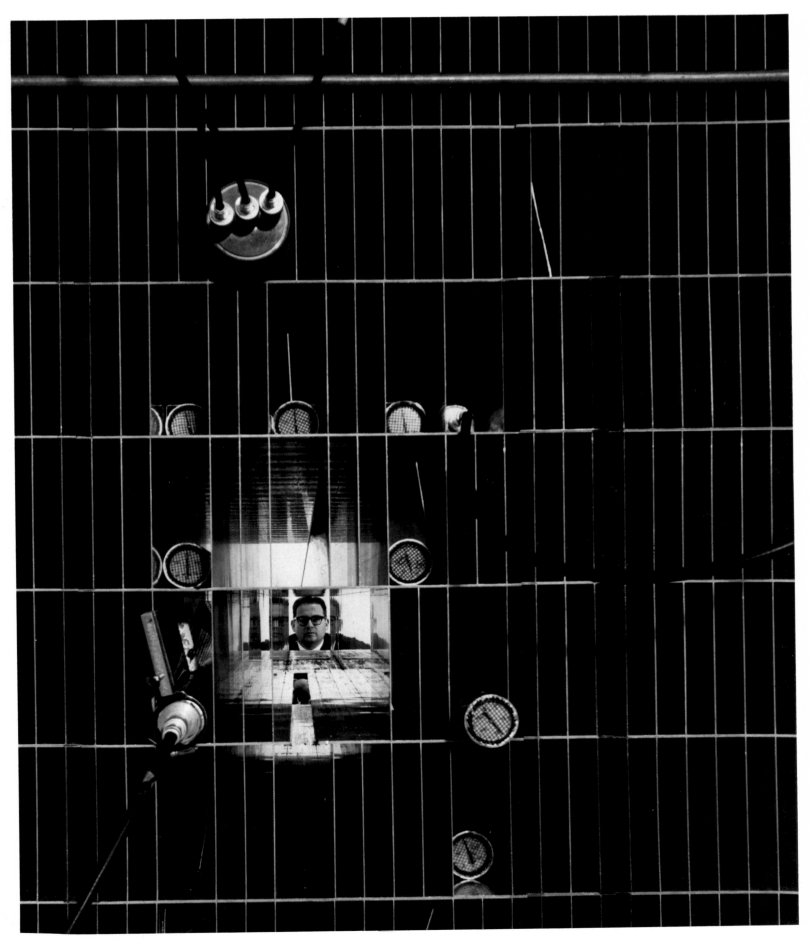

Dr Frederic de Hoffmann, 1962

them found their milch-cow in illustrating corporate annual reports. Highly competitive and highly paid, it is work that offers a real professional challenge, but rarely above the craft level. Deeper satisfaction had to be pursued elsewhere.

Burk Uzzle has been more successful than most in bridging these two worlds of utterly commercial and intensely personal photography. His early background was solidly in photojournalism, working first on a newspaper then as an agency freelance, and becoming *Life*'s youngest contract photographer when he was only twenty-three. Five years later he became a member of Magnum.

He plunged vigorously into the annual report market and its demands refined his work as a whole, making him visually more alert and sharpening his skills. The industrial scene intrigued him. As he said, 'I never really related to the country. My pictures are about sidewalks and factories and Central Park funny people. I'm not Edward Weston. A shopping center is my Point Lobos.'

If anything he was too successful. The strains were enormous and although at first they keyed him up creatively, they became increasingly difficult to balance with the demands of his private life and personal photography. He had to make changes and so in recent months he has reduced his commercial output and spent more time on his own projects. He also accepted a few important magazine assignments that he seemed to relish.

His annual report work was in colour but he prefers black and white for his personal pictures. He has a remarkable ability to compose in depth, using the wide-angle lens with special flair, and exploiting its depth of field to the full. But whatever lens he chooses, the image is precise, elegant, often complex and sometimes witty.

He works solely with Leica rangefinder cameras because the clear view they give of the subject allows him to co-ordinate several elements of the design at once. The single-lens reflex concentrates his attention more narrowly and he loses track of the whole.

The 50mm standard lens is his favourite but he also uses the 21mm, 35mm and 90mm. He feels that extreme focal length lenses overpower the subject rather relentlessly and soon become boring. He no longer even owns an SLR camera or any exotic lenses.

client's needs, and it is possible and even lucrative to bring commercial considerations to personal needs, it is seldom that exterior, commercial, and marketplace considerations do not impair the context of the gift – so wondrously given by a sensibility that simply must share vital feelings for the sake of *only* those vital feelings.

Commercial considerations enhance craft and client and diminish attention to self. It can teach tricks and deception, craft and discipline. Be very careful. A constructive balance between commercial and personal considerations in work can aid in learning expression and self-definition, if schizophrenia can be avoided. Humour helps.

Basically, my definition of commercial work is pegged to taking money for the origination of work, and the marketplace dynamic is the same no matter whether we call the marketplace a magazine, gallery, agency or museum. Something is bought and sold.

Personal work is related to interior urgencies answerable only to the terrible and demanding primacy of who and what we are. We take it all in through the windows of perceptions and the door of vulnerability; our largest challenge is to return the gift of life.

America is my home and I live in it. It is what formed me and it is those values I take everyplace I go. Many countries and many people have happened since to offer the layers of experience that later become pictures.

My work is a collage of sometimes contradictory, sometimes harmonious parts in search of order and meaning.

I love humour, beauty, silliness, and the greatness of meaningful commitment. My life is a swirl of parts that are both accidental, circumstantial, and personally controlled. I use them all, I put them together. They are me, they are my pictures. My work is my visible love.

Shopping center, Los Angeles, California

Mummers' parade, Philadelphia

Central Park, New York

Coney Island, New York

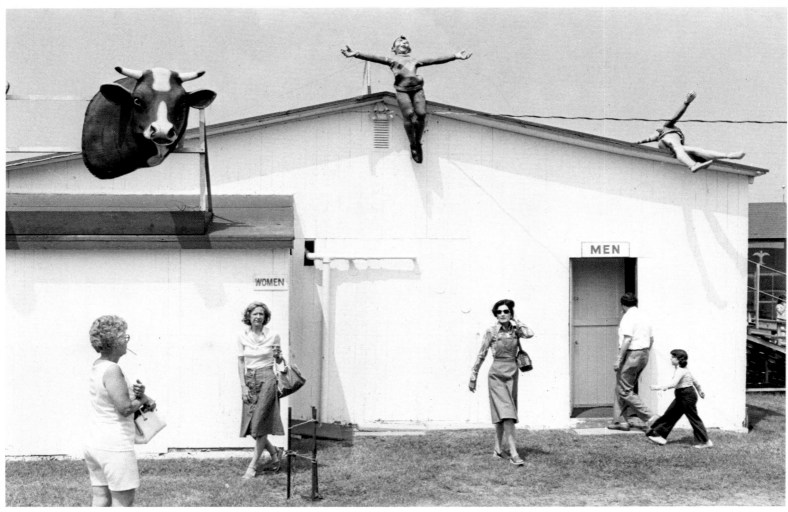

Danbury State Fairground, Danbury, Connecticut

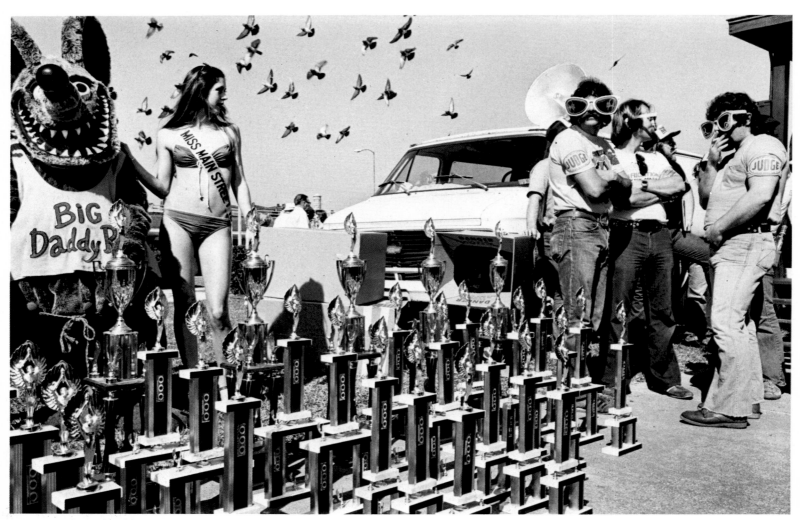

Daytona Beach, Florida

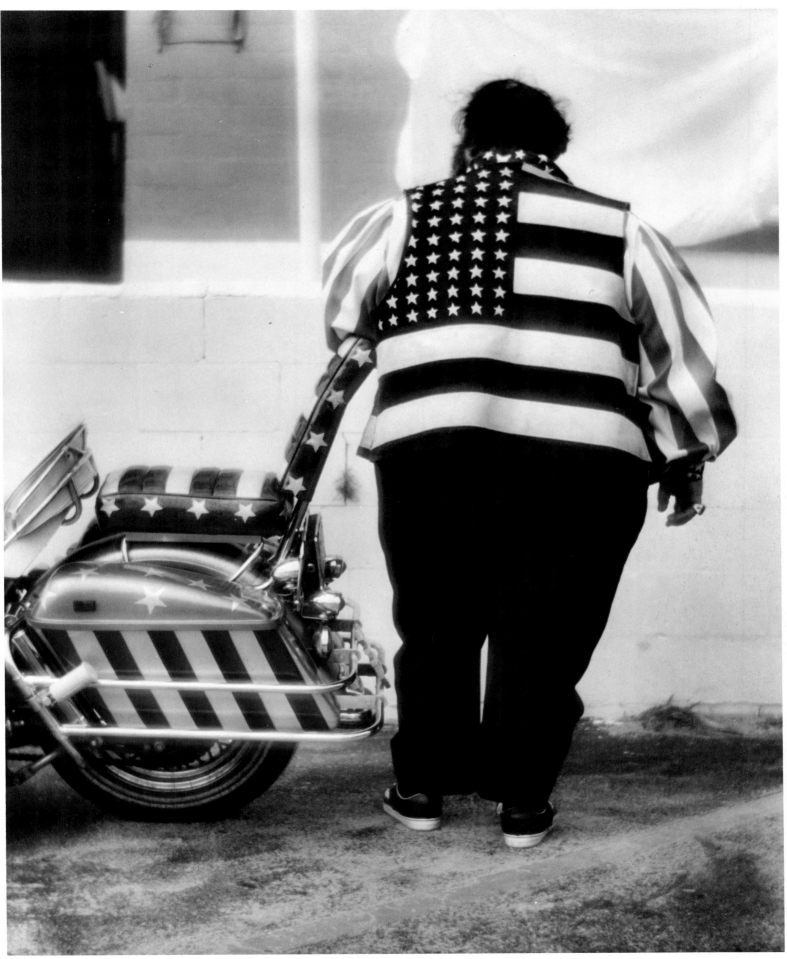

Daytona Beach, Florida

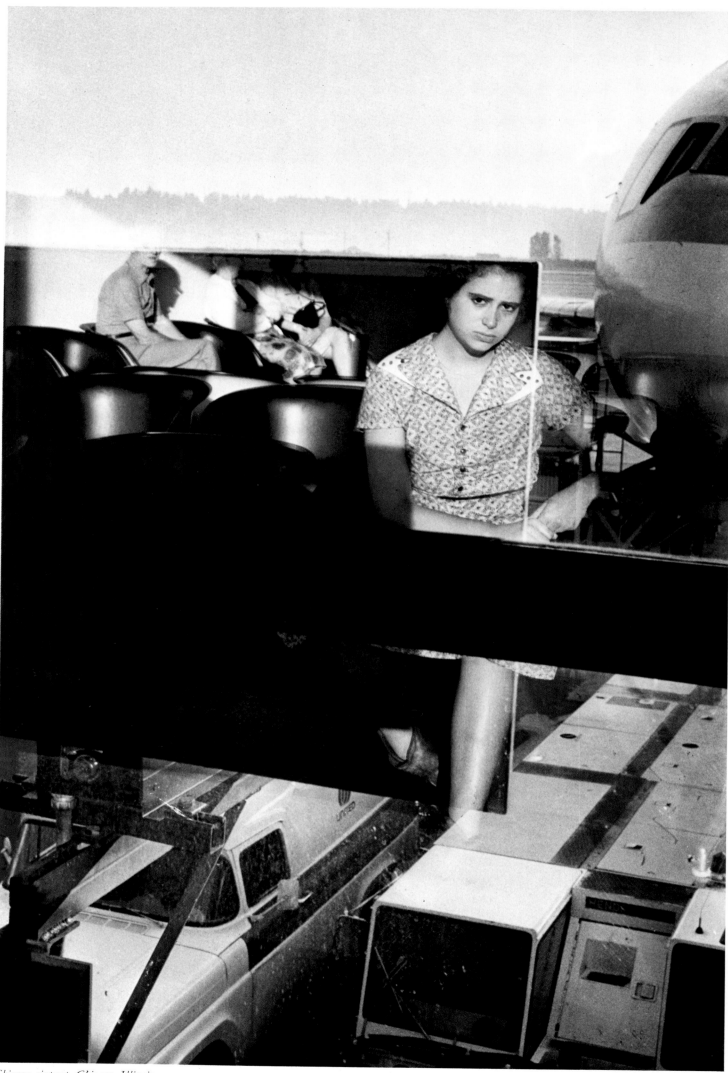

Chicago airport, Chicago, Illinois

Oil refinery, USA

Denver, Colorado

St Patrick's Day Parade, New York City

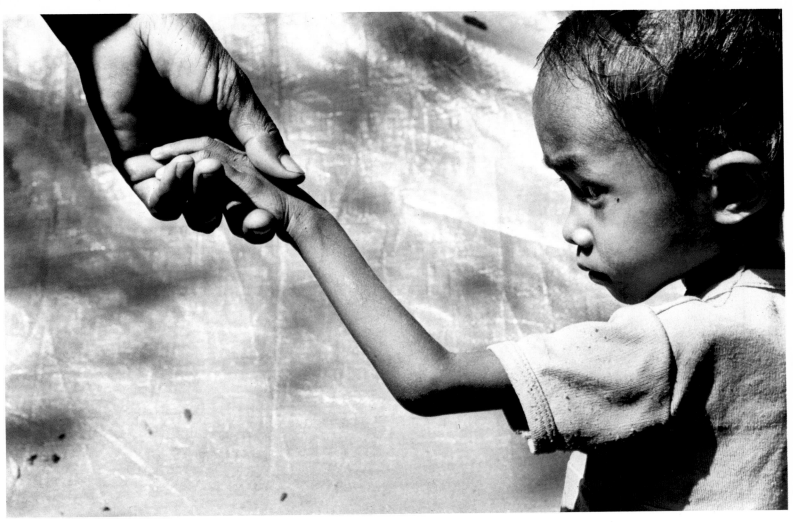

Cambodian refugee camp

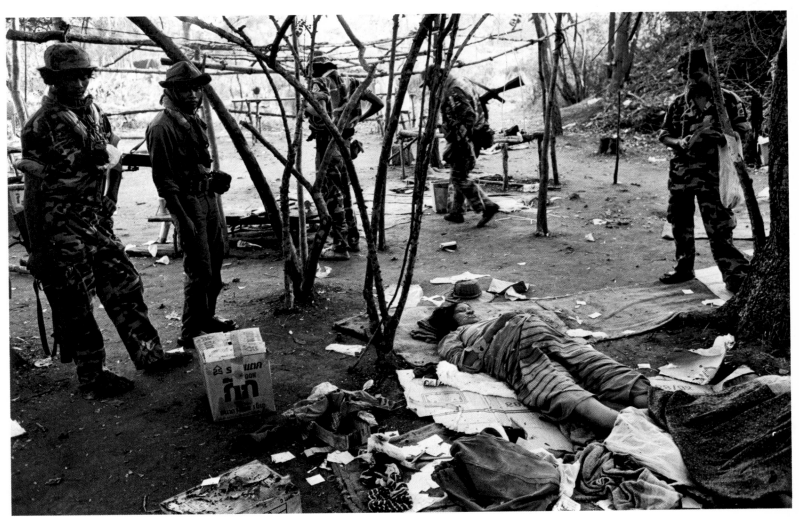

Dead pregnant woman, Cambodian refugee camp

John Blakemore

Born:
1936, in Coventry, England.

Education:
1961-64 Coventry College of Art.

1956-58:
Freelance photographer.

1958-64:
Worked as a commercial photographer at various studios in Coventry.

1964-68:
Part-time teacher at Coventry College of Art; also employed by Courtaulds Ltd.

1969:
Commercial photographer.

1970 on:
Full-time teacher at Derby Lonsdale College.

Books:
1977 Monograph *John Blakemore* (British Image No. 3) published by the Arts Council of Great Britain.

Exhibitions:
John Blakemore's work has been featured in sixteen group exhibitions worldwide, as well as in the following one-man exhibitions:
1964 *Area in Transition*, Coventry.
1965 *Girls' School*, Coventry.
1966 *West Side Story*, Coventry Cathedral.
1972 Midland Group Gallery, Nottingham.
1975 *A Vision of Landscape*, York.
1976 *Stand before the World*, Arnolfini Gallery, Bristol; Photographers' Gallery, London, then touring.
1979 *Spirit of Place*, Cardiff, then touring.
1980 *Lila*, Photographers' Gallery, London, then touring.

When I was five, on my first day at school, I made a chalk drawing of a herd of galloping horses. When I was thirteen I was caned for drawing horses in an exercise book intended for arithmetic. These two incidents, separated from each other by eight years, and now 30-odd years in my past, nevertheless serve to illustrate attitudes still significant to my work: a compulsive need to make images, and an obsession with narrow areas of subject matter. A love of nature, of being alone in the landscape, was also a part of my childhood, and when finally I was released from a process of education which I found both repugnant and inappropriate I spent two years working as a farmhand. National service ended my farming career, and it was whilst serving as a nurse with the Royal Air Force in Libya that I discovered photography. In my mail I received a copy of *Picture Post* which contained a selection of photographs from Steichen's exhibition *The Family of Man*. I sent home for a copy of the book; I intended to be a photographer. My national service experiences had confirmed an innate pacifism, I was active in the humanist movement, and photography seemed the ideal medium to explore the state of human society, a possible way of promoting social change. The next six months were spent reading anything I could find about photography, and saving to buy my first camera. Soon I was taking photographs, and enjoying it. On my return to England I got together a portfolio and began to freelance. However I found the life of a freelance difficult and uncongenial; I disliked the constant necessity of pursuing work. I wanted to photograph the things which concerned me, in greater depth than my meagre assignments allowed. In 1958 I began work in a studio, and for the next 10 years worked as a commercial photographer whilst pursuing my own work in my spare time. For a number of years I photographed things of concern in my own locality and exhibited the photographs wherever I could, so that they could be seen by members of the community. The shift in concern, in subject matter, was gradual, paralleling both a diminished belief in the efficacy of the photograph as a tool for social change, and a more introverted concern with self-development rather than social development as the significant catalyst of change and with the use of photography as an expressive medium.

In 1968 I spent the winter in Wales, in a house overlooking the Mawdach Estuary. The decision to winter in Wales was an arbitrary one, generated by the need to escape the pressures of London. It was a time of change; I had decided not to continue working as a commercial photographer; I was uncertain of what to do, was seeking a new direction, a new impulse. It was a time of personal crisis following the break-up of my first marriage. The landscape of Wales was different to any I had previously known. In a notebook of that period I wrote:

A land of paradox, harsh lunar landscapes, running with gurgling water, and supporting everywhere a riotous life. From the very rocks trees thrust upwards, life at its most tenacious, gripping convulsively at the unyielding rock, and raising twisted arms into the unrelenting wind. Limbs green with the parasitic growths of moss and lichen, which weld

tree and rock into one entity. Trees grey and armoured as the rock itself, wood metamorphosed into rock by the struggle for life, and over all a sky as subtle and everchanging as the landscape itself.

The landscape was at once harsh and fertile, aloof and welcoming. I wandered the hills and beaches, aware as I had never been before of the landscape as an active, vital process. I did not take photographs, but I absorbed the experience, felt spiritually at one with the area. To have attempted to make photographs would have seemed both unnecessary and an act of presumption. It was anyway a time of creative stagnation, but when the urge to make images reasserted itself it was to the same land-scape that I returned, and it is from the experiences of that winter that my landscape work has developed.

To use a medium fully is to define for oneself, to accept, both its potential and its limitations. The fundamental limitation of photography, and for me its greatest strength, is its reliance on subject. The camera must be pointed away from the self, towards the world. The basis of meaningful photography is then, for me, intensity of relationship, an obsessive fascination with subject, with the attempt to see more deeply. To move from the visible to the invisible, from surface to process. The photograph occupies a space, makes connection between our interior and exterior worlds. To see is both a physiological and a psychological process. To see may be also to understand. The landscape of my photo-graphs, my landscape, is narrowly defined – a length of river valley, a stretch of beach, a wooded hillside. Areas which in some way speak to me, and which I visit again and again, to learn to see, to allow the possibility of communion, of understanding. Yet paradoxically, though my photograph is built around this ritual of intimacy with place, I do not see my photographs as concerned with place in a purely descriptive, a geographical sense. What I try to evoke in my photographs is the dynamic of the landscape, its spiritual and physical energy, its livingness, its essential mystery. To be in the landscape, to be alone with nature, is to feel awe, is to experience the isolation of being human, connected with, finally dependent upon yet separated by self-consciousness from, the flow of life. To make images can become a process of renewing connection. Photography can serve to break down the barriers between self and other; the camera is a link, a means of concentration, a channel for both communion and communication. The categories frozen in language may yield in the image to a flux, the seemingly separate to a unity.

To break one's conditioned habits of seeing, to extend one's ability to respond, is the continuing problem. It demands an opening of oneself to subject, to see with innocence, with a sense of wonder, of newness. For me this possibility grows out of the development of a work ritual, out of the sense of familiarity, of communion with place.

When I first photographed rivers I became aware of the power and complexity of the sounds produced by running water, and for a number of years now it has been my habit to begin a period of work by listening to the sounds generated by the area I am in. I have favourite spots where I

John Blakemore's photographs of the landscape are much more complex than a simple celebration of natural beauty. They are meant to work on different levels.

Frequently the landscape that he shows is indeed sensuously appealing, but sometimes it is sinister. There is magic in Nature; there is also melancholy and menace. The images reveal too the beauty of black and white photography itself, its richness of tonal gradation, its powers of description, and its capacity to hold an emotional charge.

The pictures are intended not merely to describe a scene, but also to make us aware of the constant process of change within the landscape and of the natural energy that shapes it. Blakemore has observed that '. . . by working in fairly limited areas and by selecting one's viewpoint carefully, one can transform the scale so that quite small subjects can become symbolic of much larger, much huger forces.'

He also relates this process to our own experience. In his own words, 'What basically interests me in the landscape is the idea of cycle – the cycles of growth, decay, regeneration and so on, and how these processes can be seen as a metaphor of the processes which one goes through as an individual. So that they are external processes, processes of Nature, but also processes of which one is oneself a part, and which one can identify with. In photo-graphy one needs to find something in the external world which corresponds to an idea one wants to express.'

He likes to use the minimum of equipment, a large-format camera and a single lens – a combination that encourages precise decisions, in contrast with a small camera where '. . . one tends to shoot around the subject, using the actual process of photo-graphing to arrive at the expression one wants.' By working regularly with just one lens, he conjures up '. . . a sort of mental rectangle which one can put over the world, to find out what this lens can do and push that to the limit.'

Sometimes he experiments with specific-ally photographic techniques to produce different interpretations of a subject both visually and conceptually – for example, the varied use of exposure in photographing a stream. A very short exposure will stop the movement and give one impression of water. In a long exposure the movement will continue and patterns of constant flow will be recorded within a general blur. But one can also break down the long exposure into a succession of short exposures, and the cumulative effect will be quite different again. The changes in the appearance of the subject are striking and they symbolize the action of time and natural energy in the landscape.

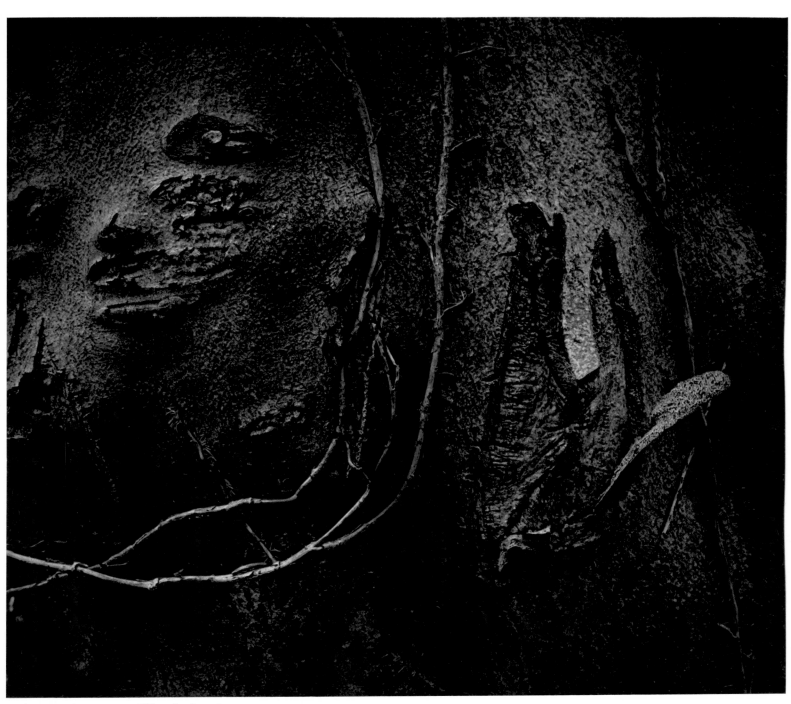

Wales 1971, from sequence 'Wounds of trees'

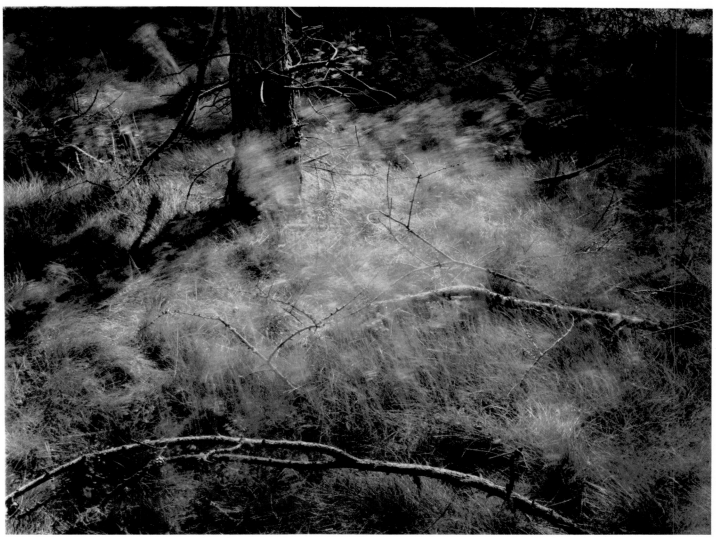

Derbyshire 1978, from sequence 'Lila'

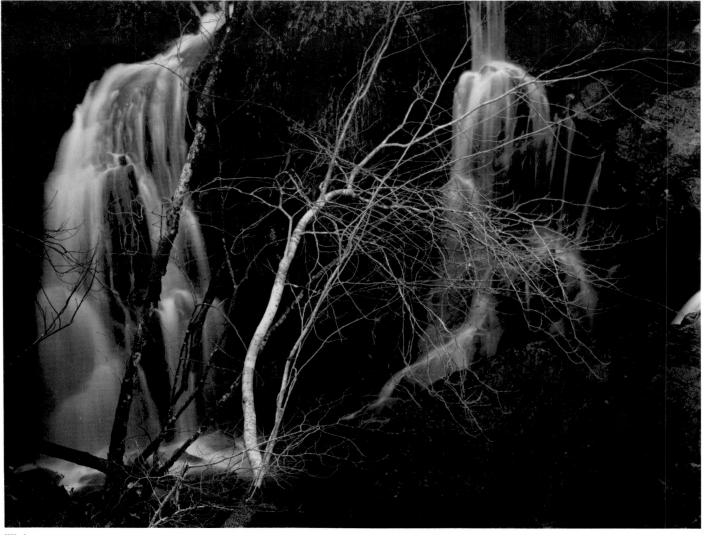

Wales 1977

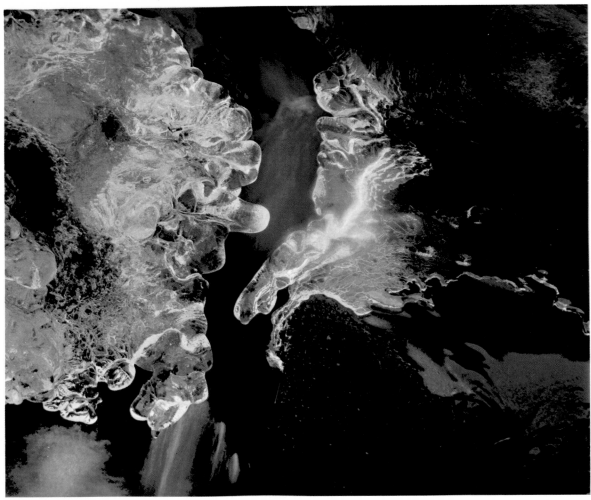

Linch Clough, Derbyshire 1972, from sequence 'Metamorphoses'

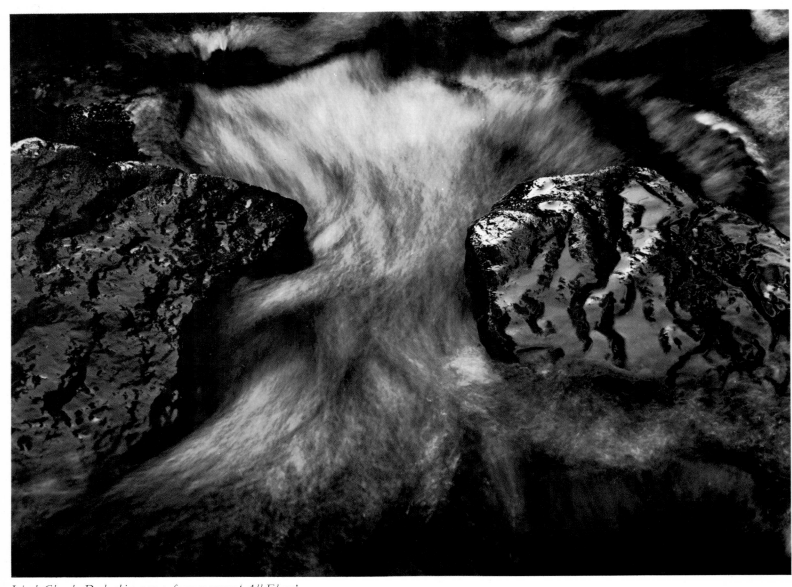

Linch Clough, Derbyshire 1974, from sequence 'All Flows'

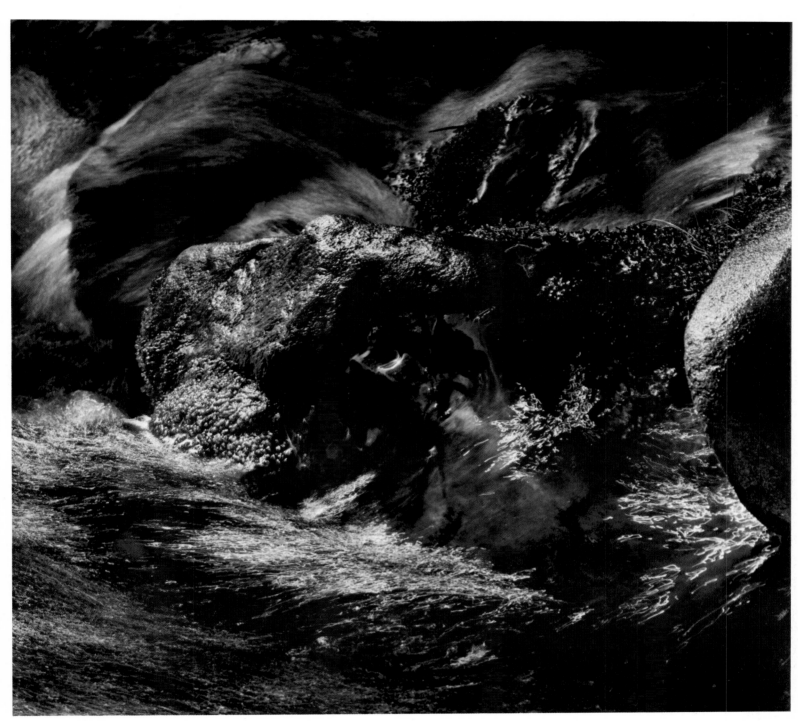

Linch Clough, Derbyshire 1974, from sequence 'All Flows'

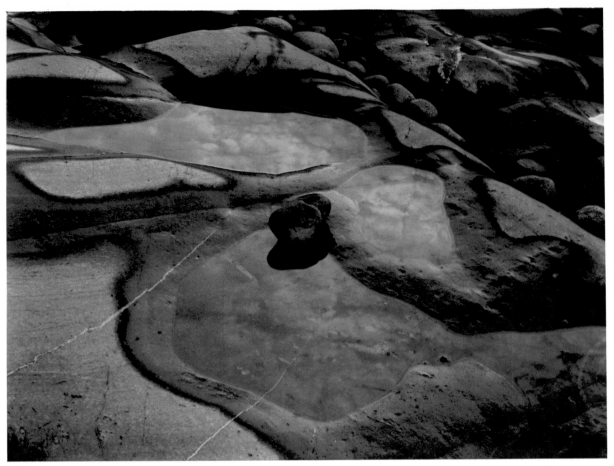

Wales 1975

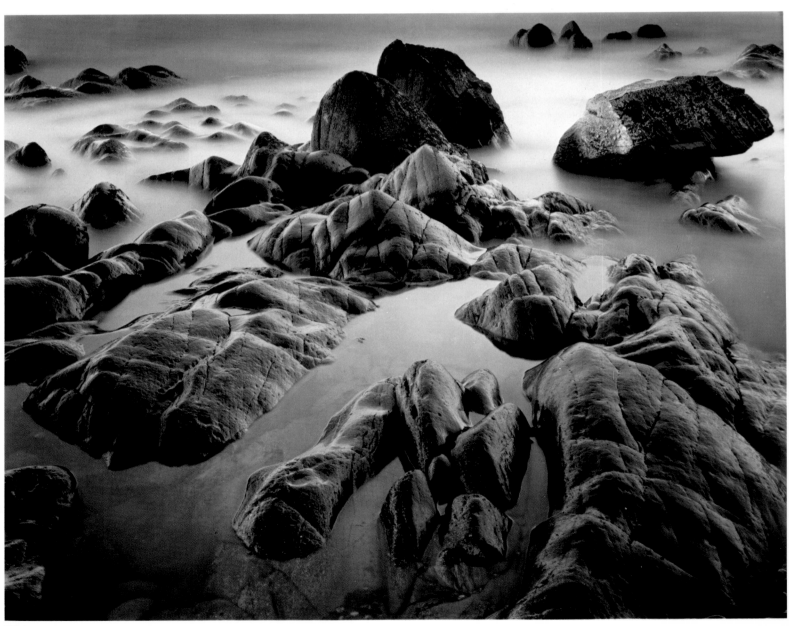

Wales 1977

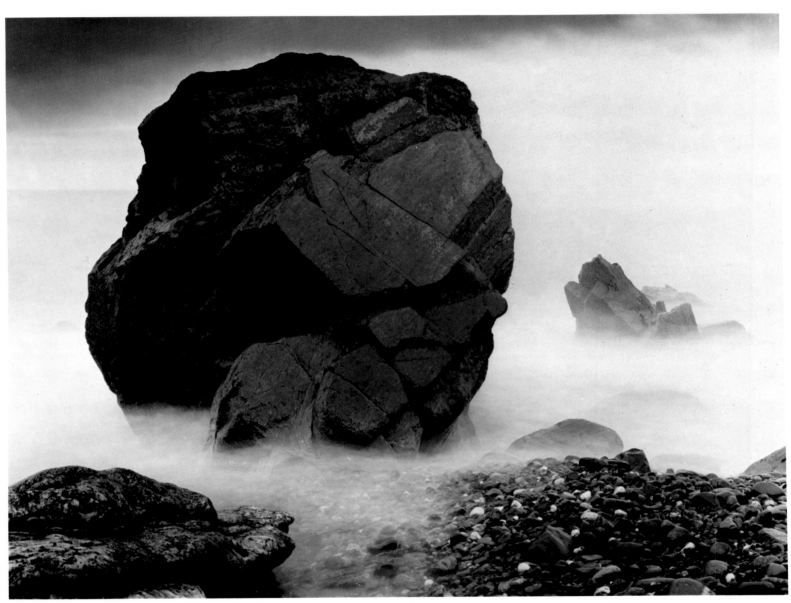

Wales 1977

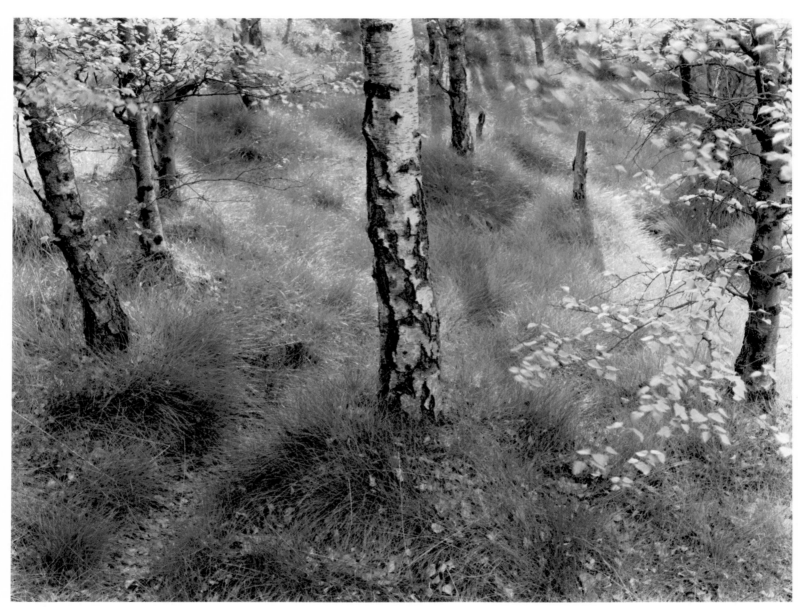

Ambergate, Derbyshire 1979, from sequence 'Lila'

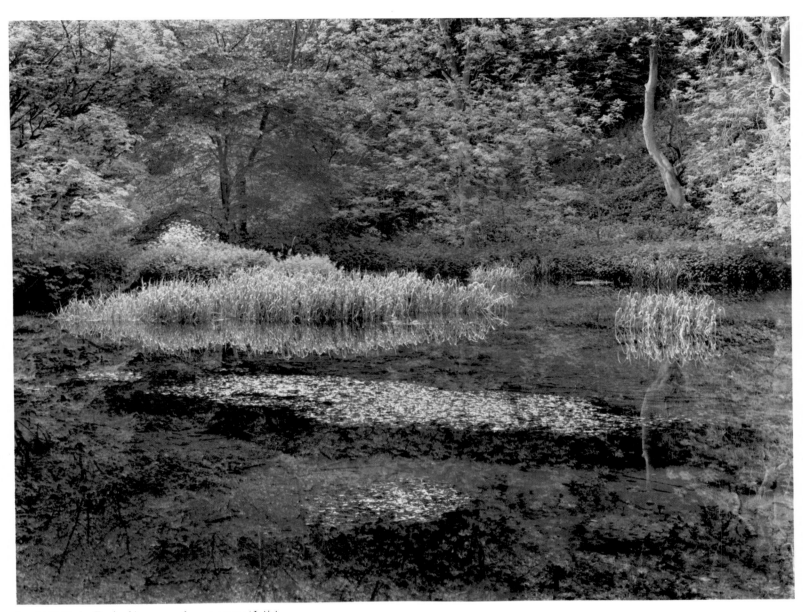

Lathkill Dale, Derbyshire 1979, from sequence 'Lila'

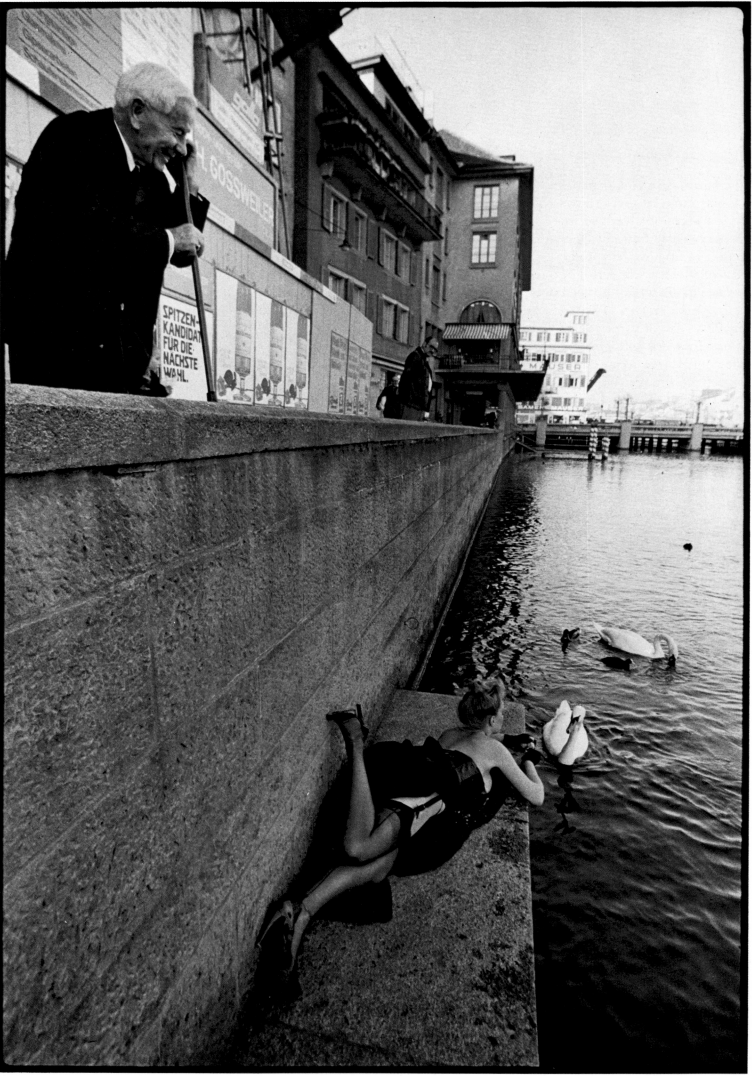

Zurich 1976

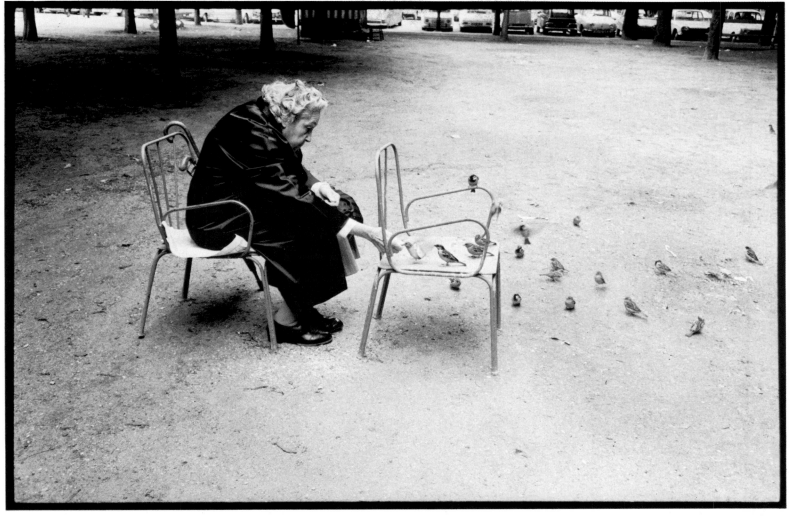

Paris 1969

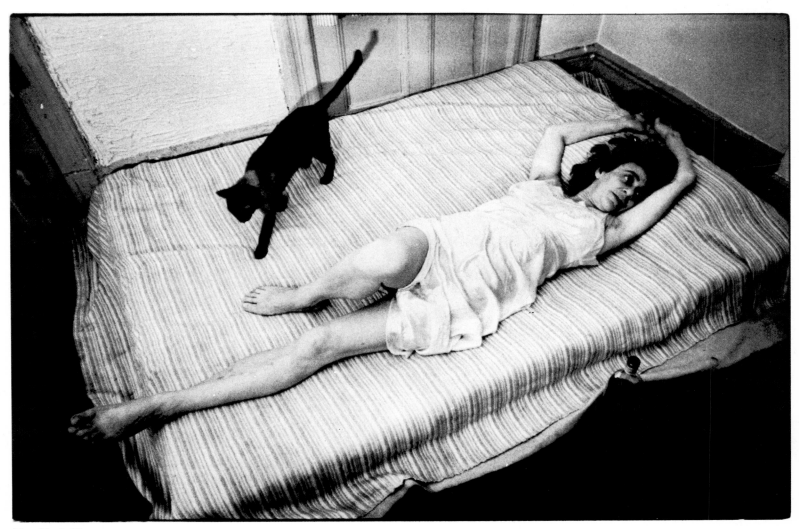

New York City 1971

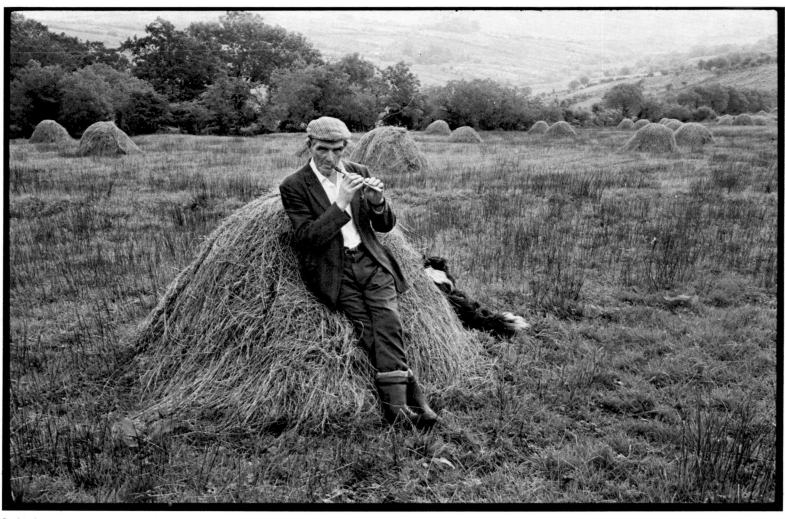

Ireland 1974

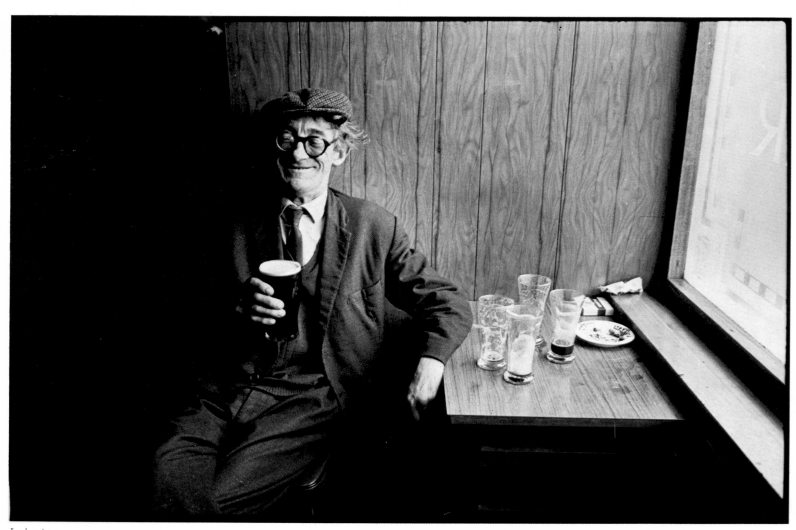

Ireland 1973

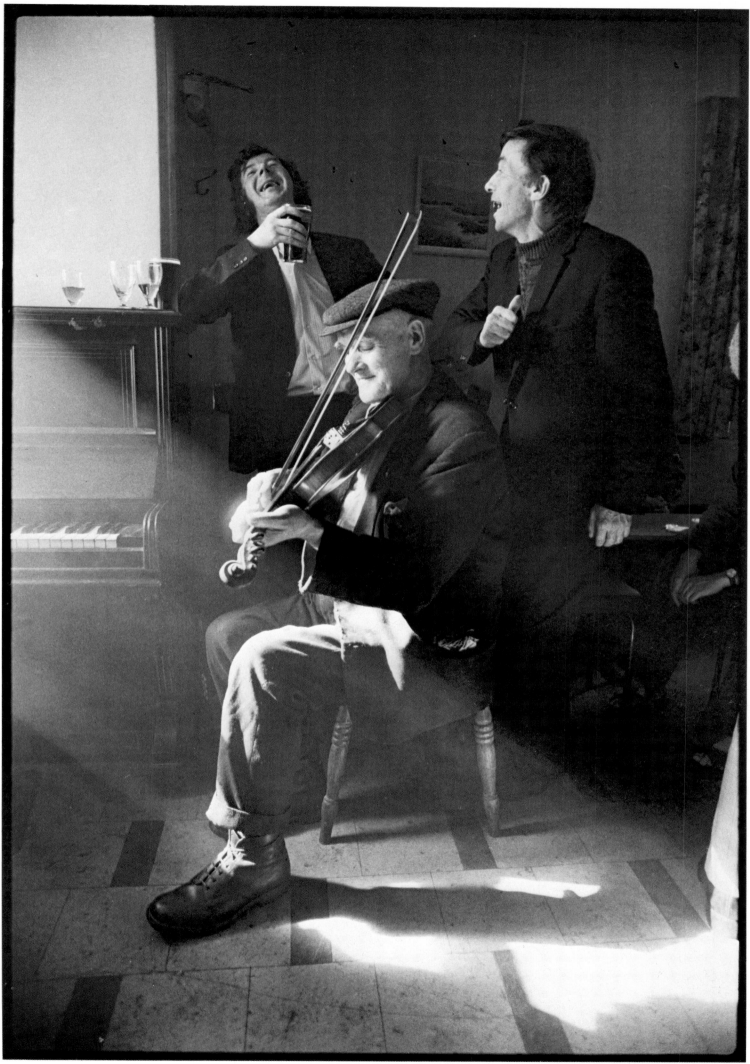

Ireland 1973

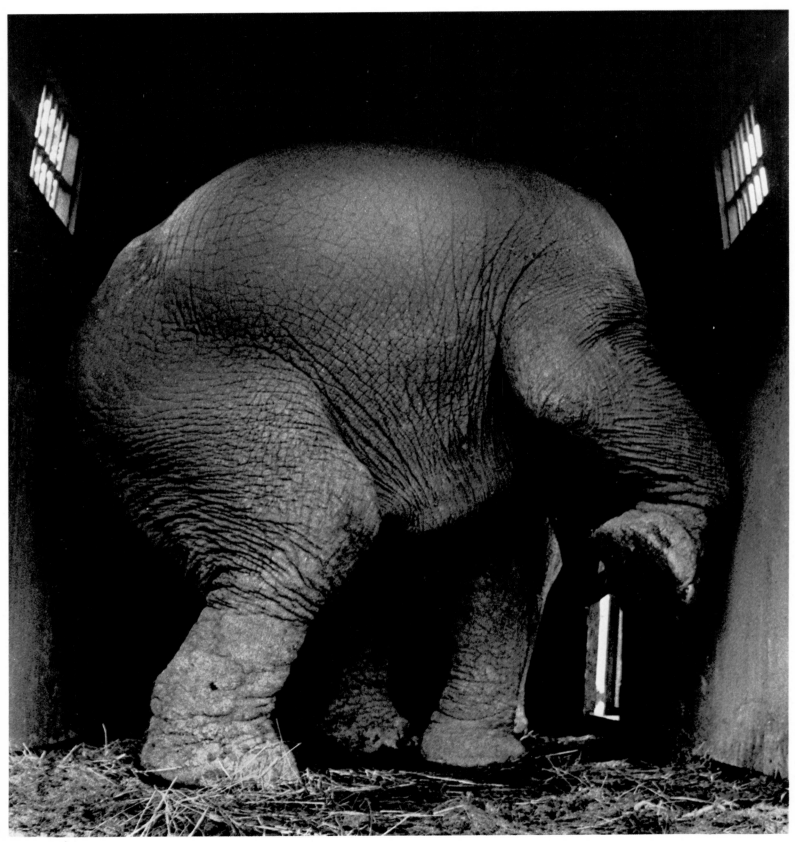

From 'Circus Days', 1971

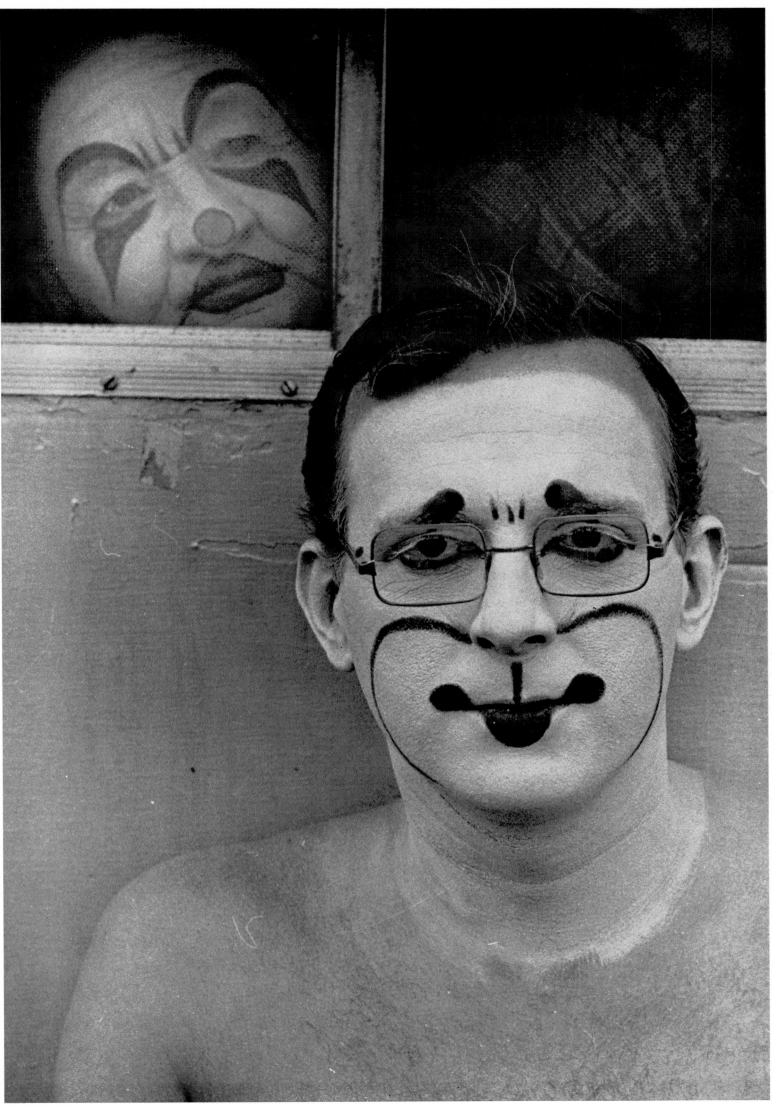

From 'Circus Days', 1971

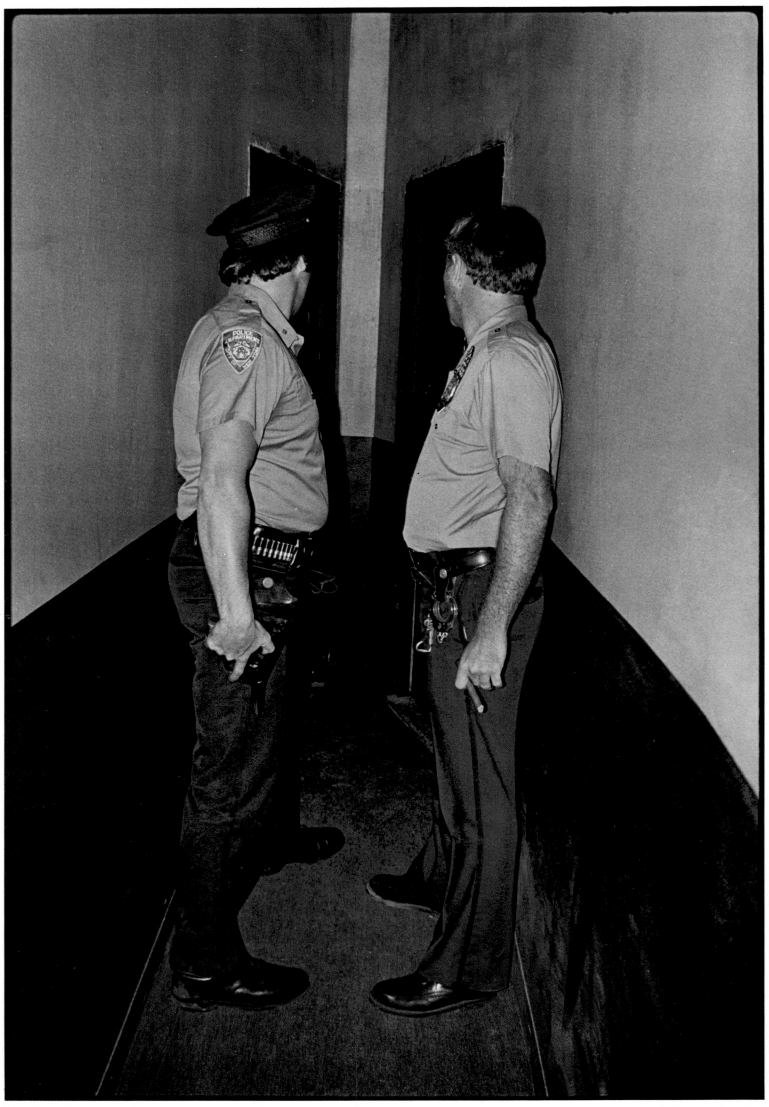

New York City 1978

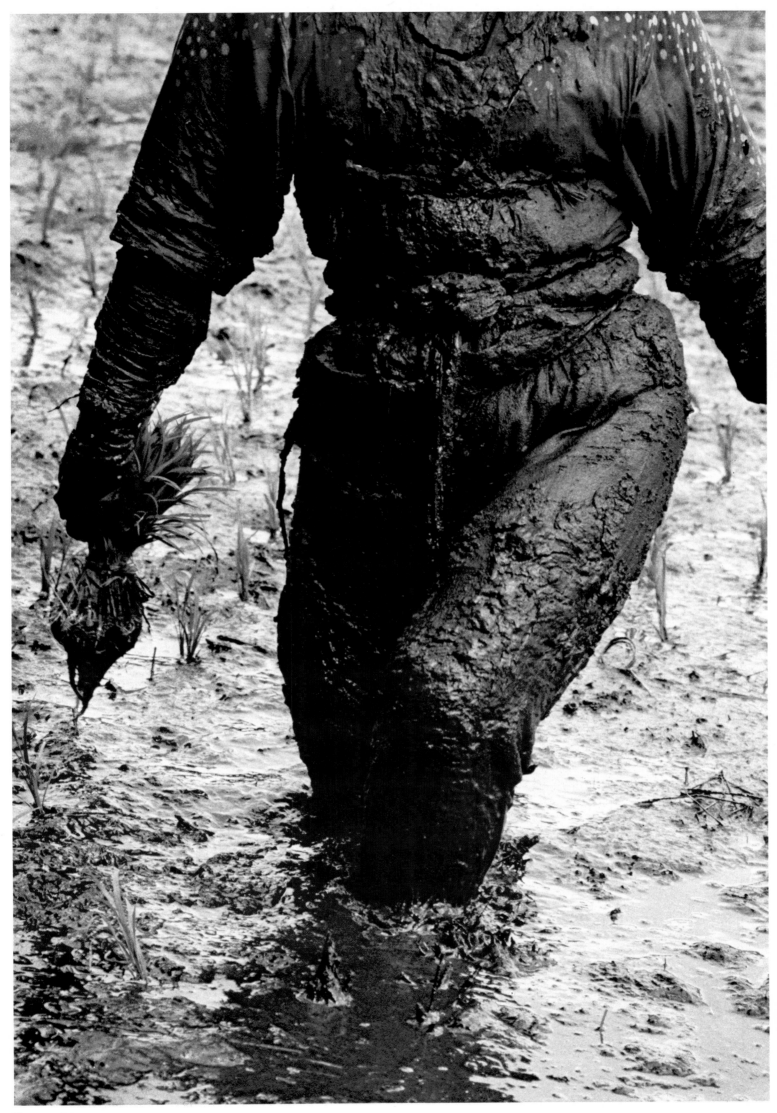

Toyama, Japan 1955

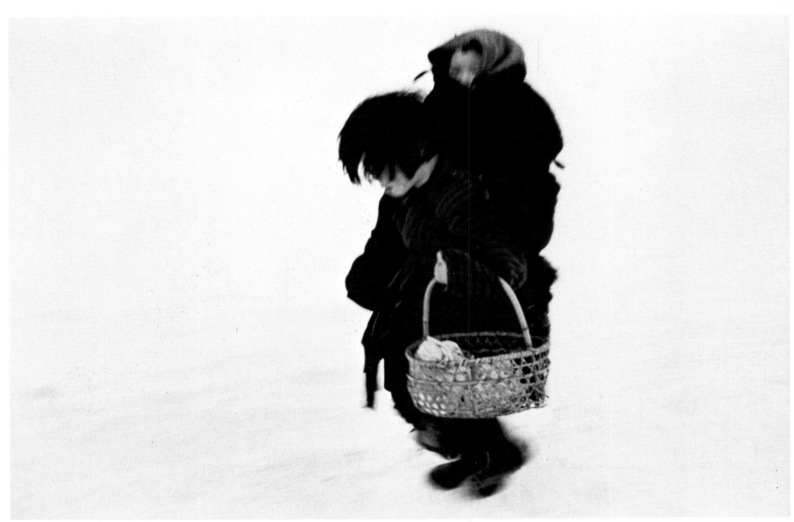

Aomori, Japan 1955

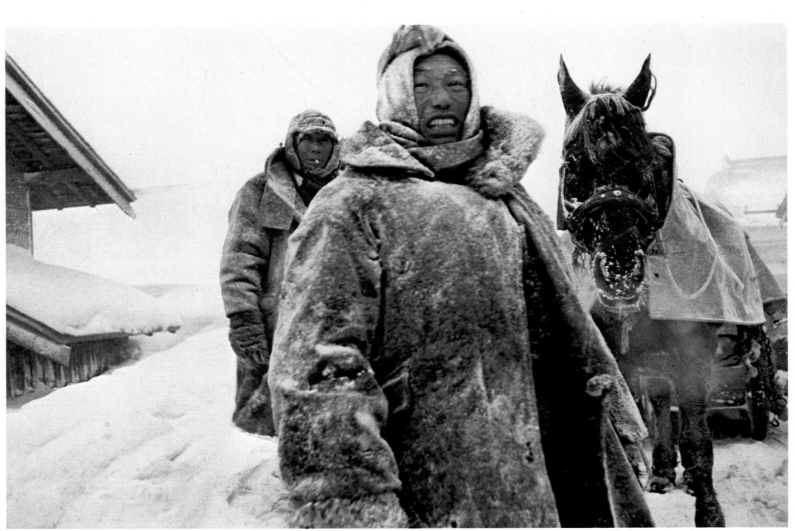

Aomori, Japan 1955

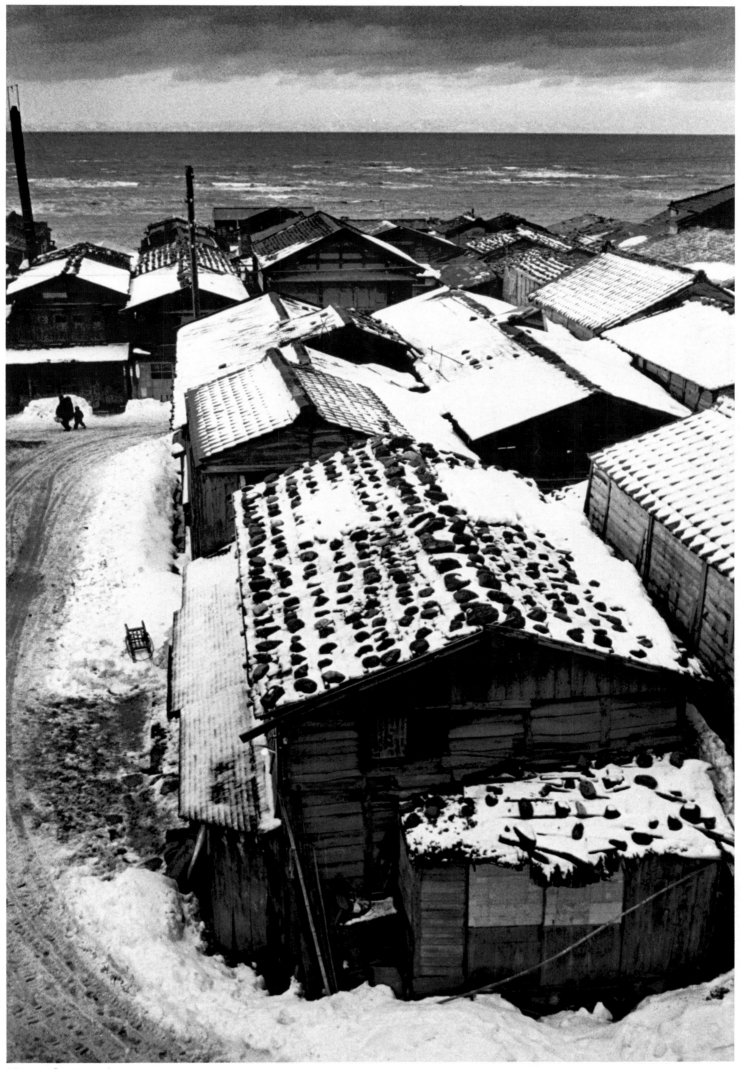

Niigata, Japan 1956

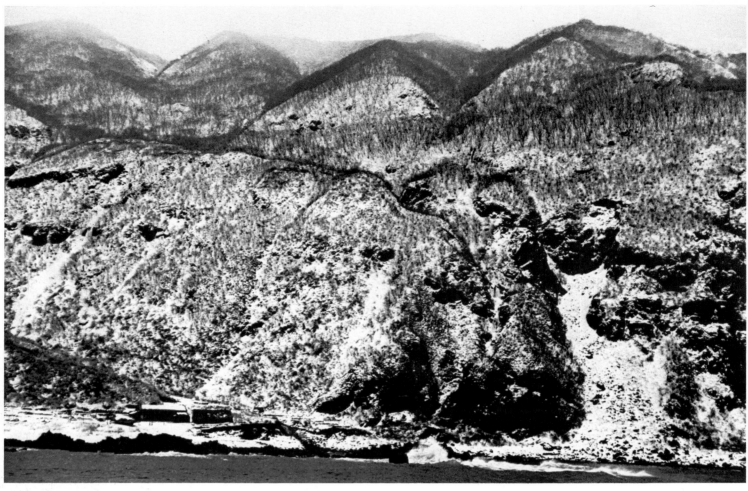

Akita, Japan 1955

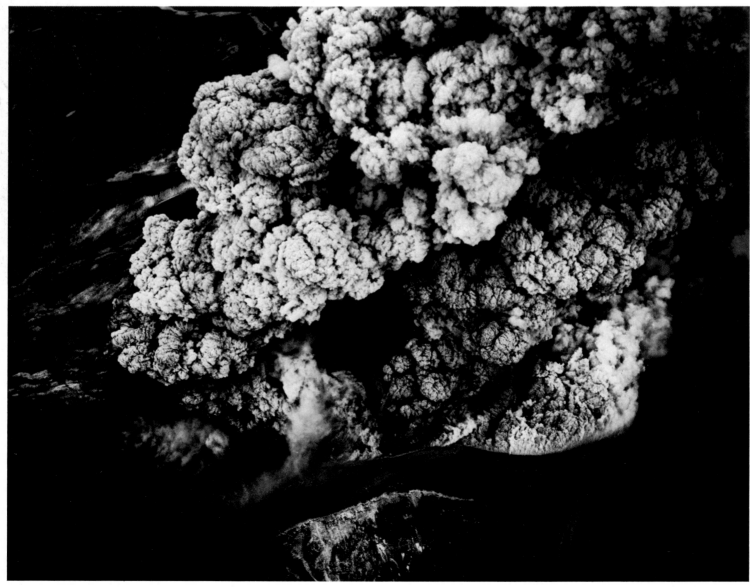

Hokkaido, Japan 1962

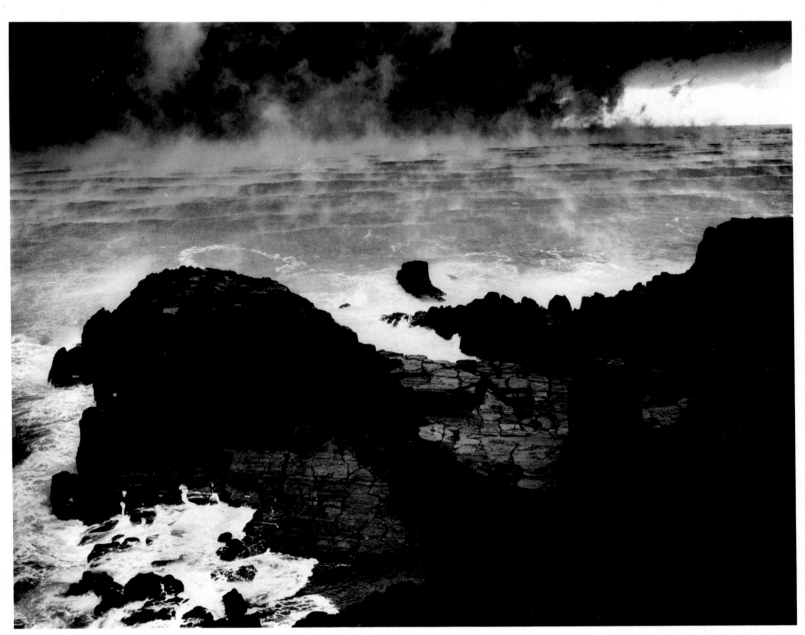

Fukui, Japan 1960

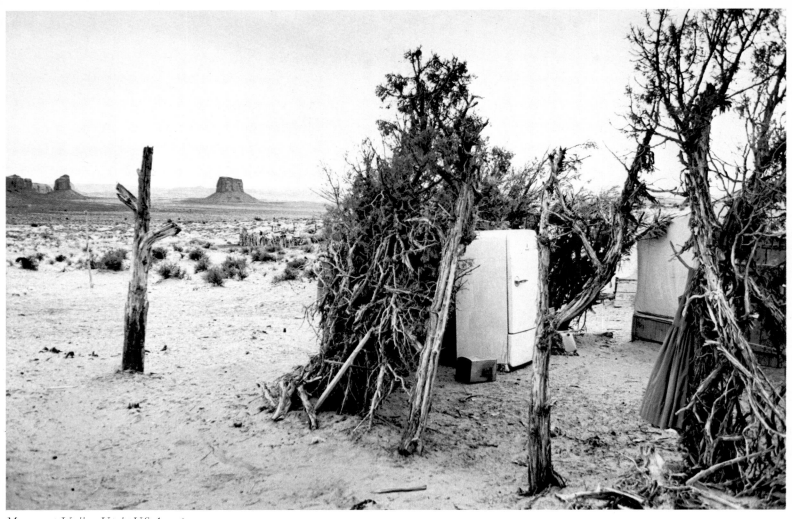

Monument Valley, Utah; USA 1967

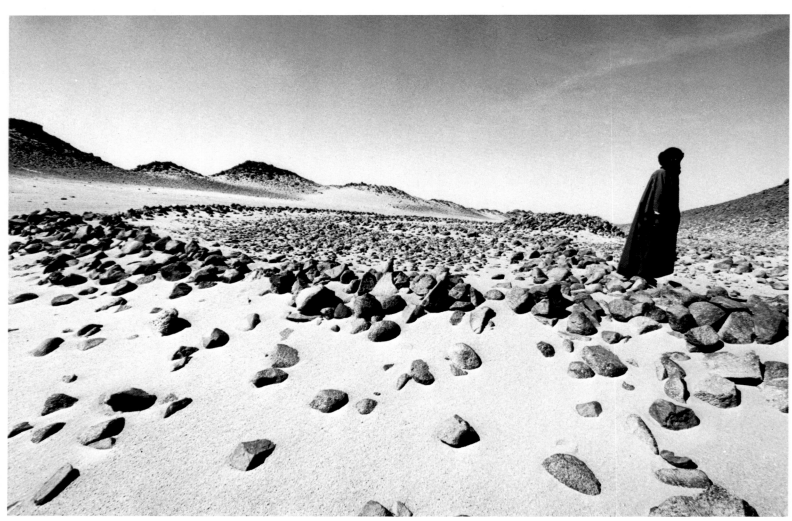

Djanet, Algeria 1979

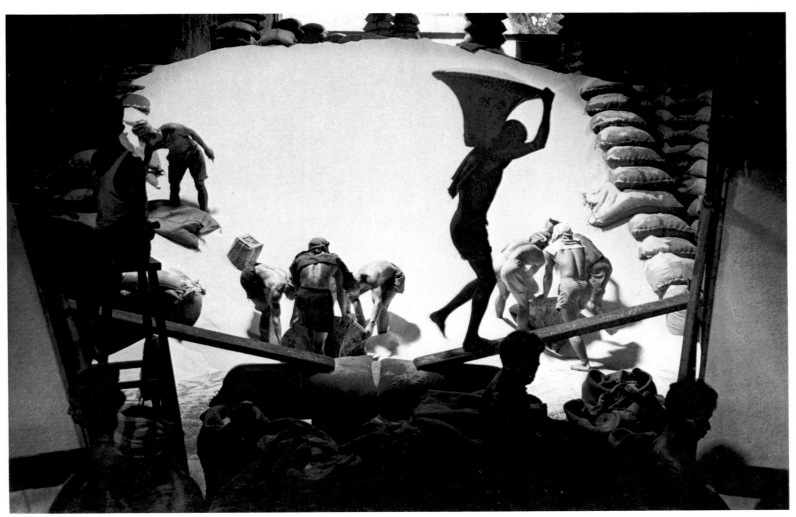

Bangkok, Thailand 1960

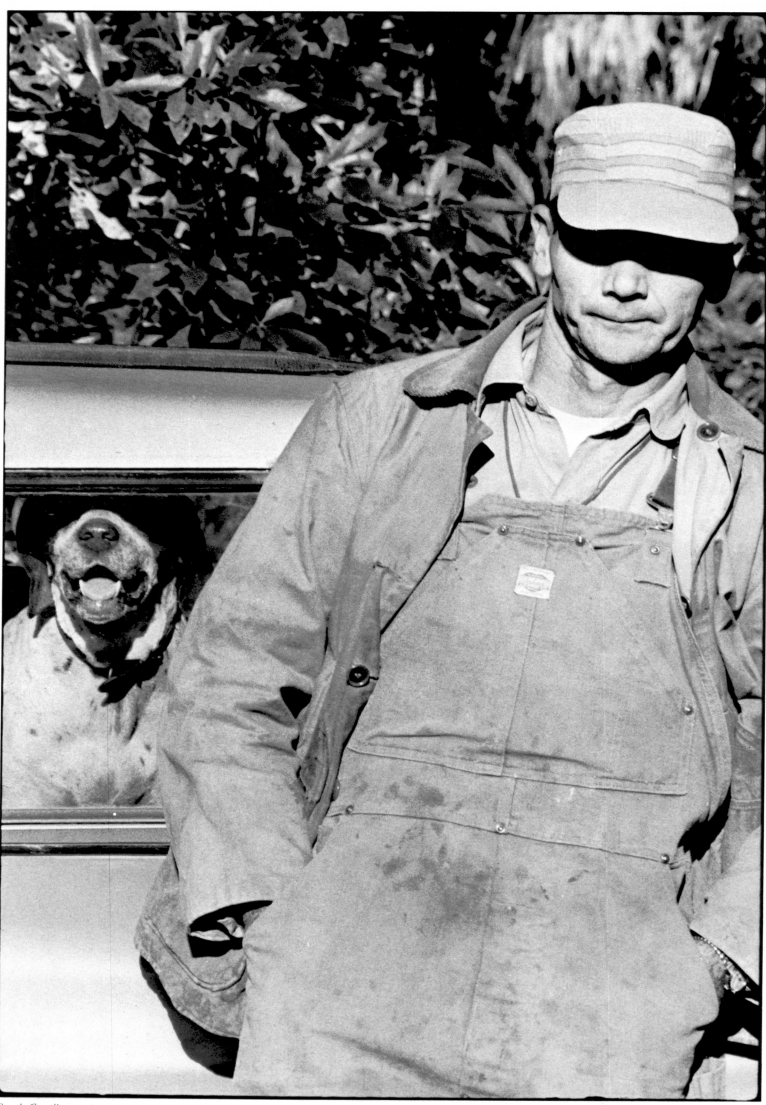

South Carolina 1962

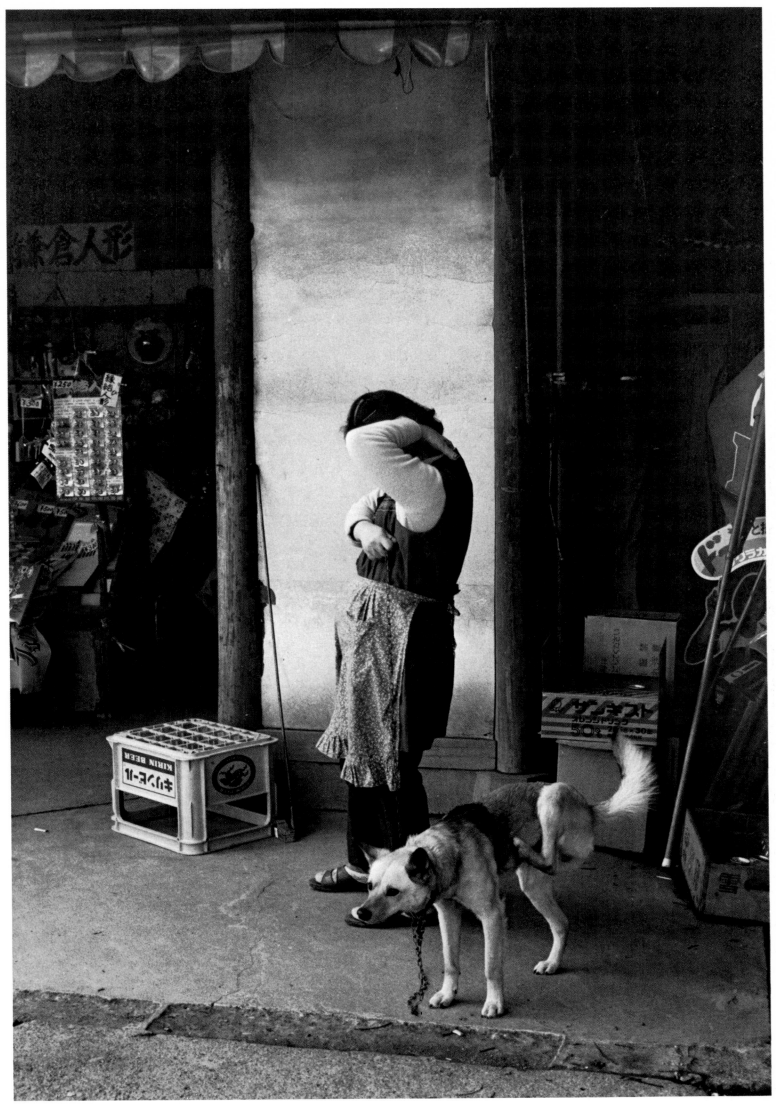

Kyoto 1977

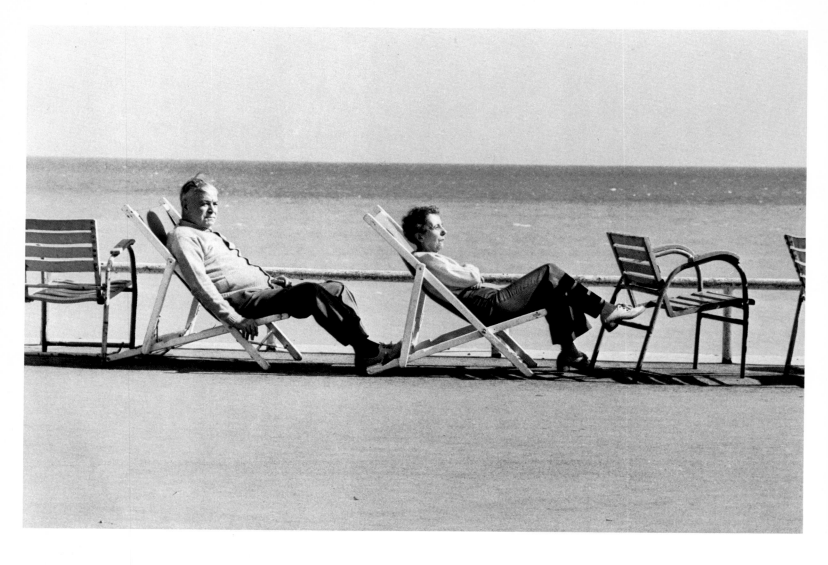

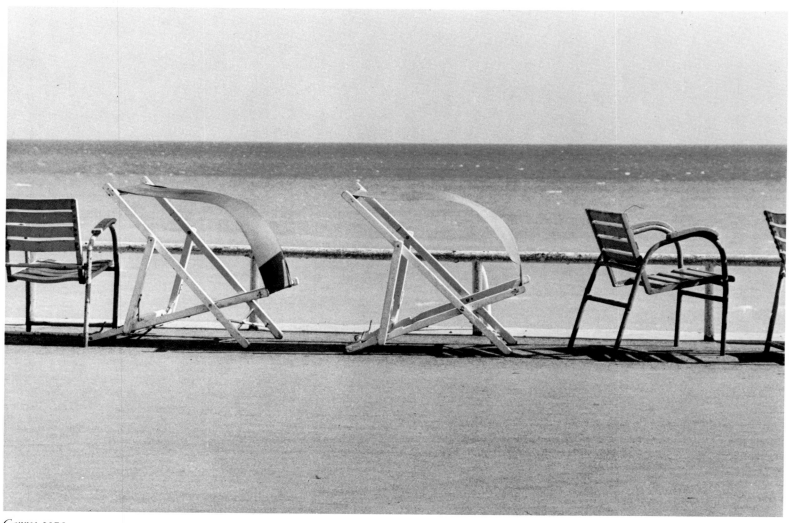

Cannes 1975

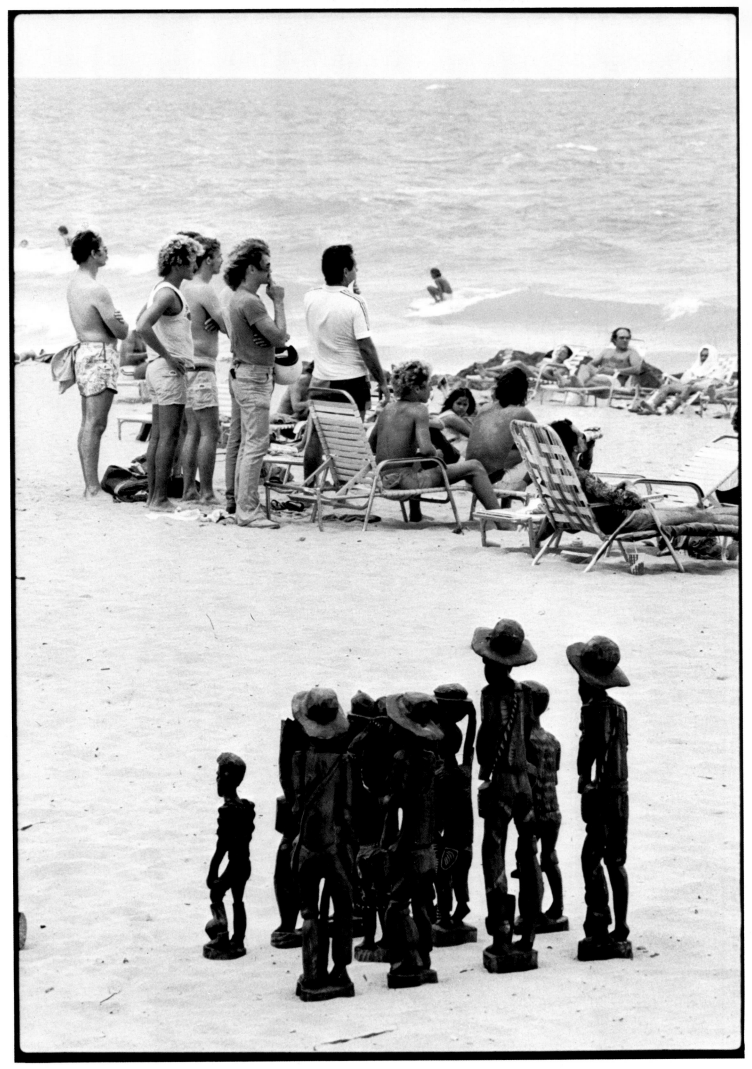

San Juan, Puerto Rico 1978

Normandy 1965

Newhaven 1955

Kent 1968

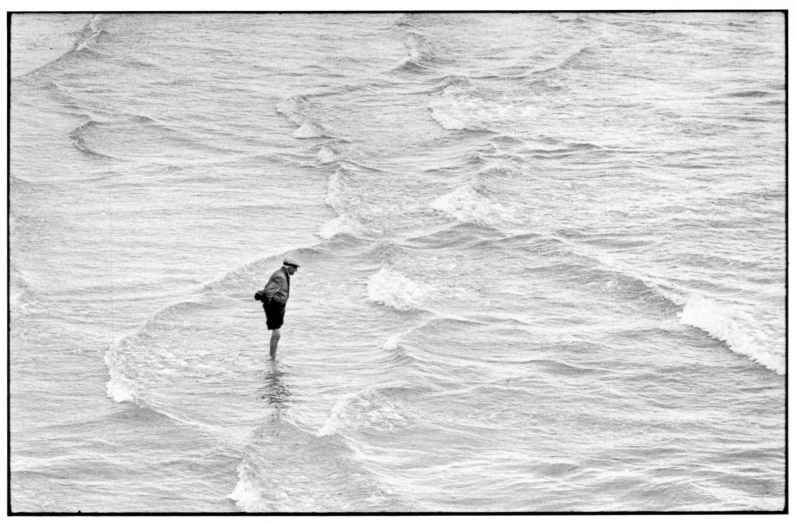

Brighton 1966

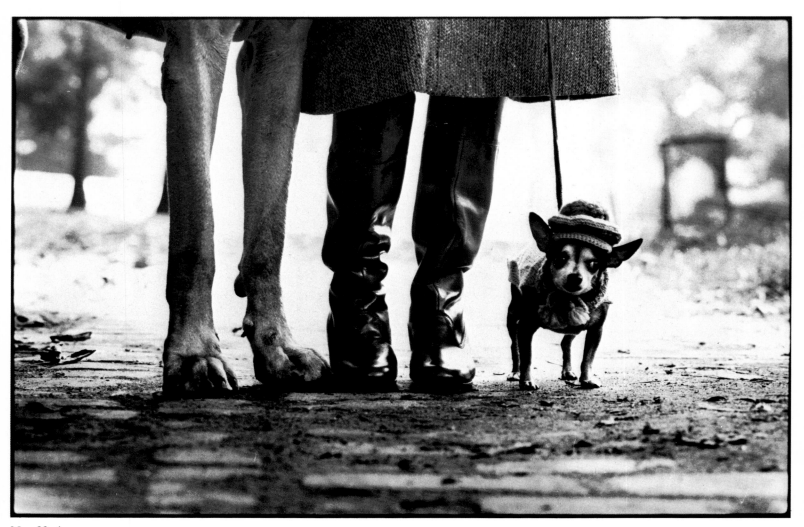

New York 1974

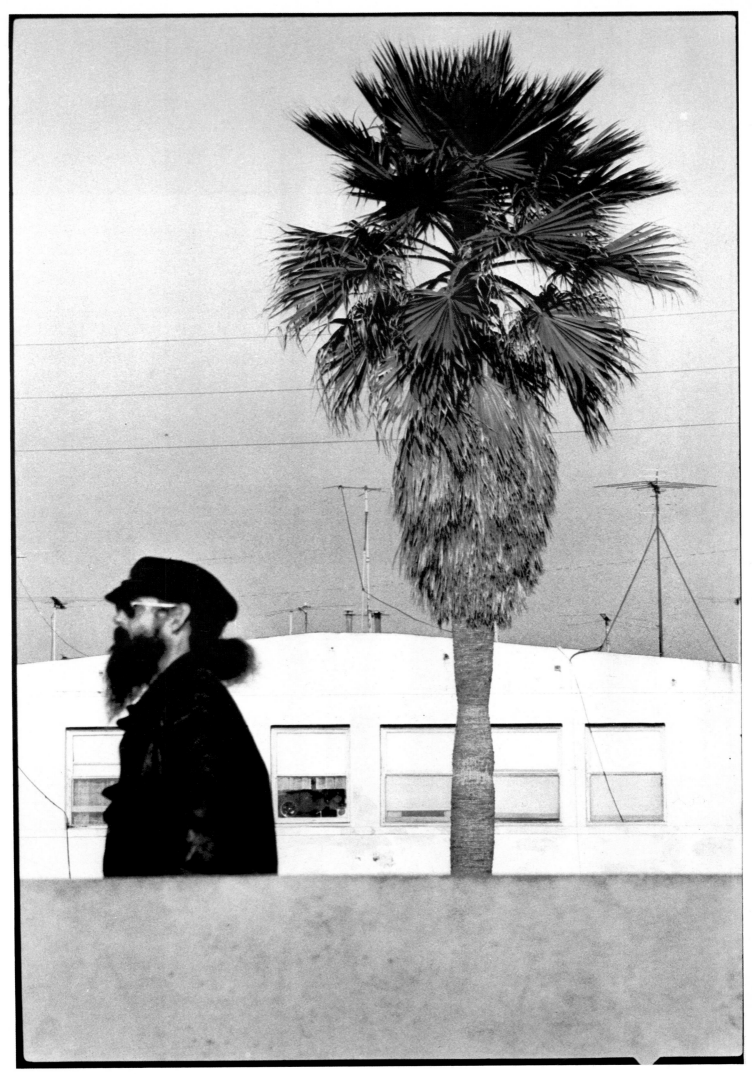

Venice, California 1976

René Burri

Born:
1933, Switzerland.

Education:
Kunstgeweberschule, Zurich.

1959:
Became member of Magnum. Since then he
has travelled continually throughout the
world.

His major reportage includes stories for
Look on Nasser's Egypt and Castro's Cuba,
and for *Life* on China.

Burri's interest in design is reflected in his
essays on Brasilia and Picasso, and a study
of Le Corbusier and his architecture, which
was published by *Du* magazine. His port-
folios on Japan, Thailand, the Argentinian
Gaucho, Brazil and Chicago were published
by the same magazine.

During the seventies Burri spent much time
in the Middle East and has continued to
work on his own stories that are published
in such magazines as *Life, Stern, The Sunday
Times Magazine* and *Geo*.

His industrial clients have included many of
the world's most famous companies. He
has also produced a number of prize-
winning films and television documentaries.

Publications:
1962 *The Germans*.
1968 *The Gaucho*.

Exhibitions:
His work has been widely exhibited, with
one-man shows in Chicago, New York,
Zurich, Paris and Brussels. A special
exhibition of his personal work, together
with a book, is planned for 1982.

I came into photography quite by accident. I had an early talent for
drawing and when I finished school it was accepted that I would enter
one of the departments of the art college. I was taken round on a guided
tour and when I went into the photography department I saw all the
lights and equipment set up, and it reminded me very much of a movie
studio. I had always been crazy about making movies, so I decided to
take up photography.

Until then I had only taken a few simple snaps, but I was given the
chance to join the department. The lecturer handed me a Leica, gave me a
brief explanation of how it worked, and sent me out to take pictures.
Perhaps because of some natural artistic ability, whenever I drew I could
see the lines of a subject very clearly. So much so, that I was surprised
when other people could not see them as clearly defined. But now when I
went out with a camera, I realized that I did not have this same ability in
photography. I could not 'see the lines'.

I took the pictures as best I could, then the lecturer showed me how to
develop the film. It proved to be almost completely blank, because of an
error in exposure. I was virtually determined there and then to abandon
photography for ever. But I was persuaded to have another go and the
lecturer agreed to give me another chance. After a second brief lesson in
the basic techniques, off I went again. This time I was able to 'see the
lines' rather more clearly. The pictures were more successful and I
enrolled in the photography department.

At the end of my college life, I had a variety of jobs in graphic design
but found myself gravitating back towards photography. I was friendly
with Werner Bischof, already a well-known photographer, and this helped
in my early association with Magnum.

When I first began to take photography seriously, I got involved with
photographing façades, architectural detail, patterns and so on. It was
Henri Cartier-Bresson who showed me how it was possible to photograph
life, how to cope with movement, with vitality, with things going on;
where to point the camera, instead of just setting it up to take formal
pictures of stationary objects, things that had no relationship with the
spontaneity and urgency of actual life. This was one of the first and most
important lessons that I learned from Henri.

He was very strict in his criticism of all photography and especially of
our work. Sometimes I would be absolutely mad after he had been
particularly severe about my pictures, but I would go and work off that
anger. Later I would realize how important the criticism and the discipline
were to me.

But there was some instinct within me that told me that there were
other ways of taking pictures than according to this doctrine. For
instance, the frame that was so sacrosanct to Henri was for me something
to be manipulated where necessary. I was perfectly happy to enlarge just a
section of a picture if I felt that would improve it, and I was enthusiastic
to use a variety of lenses instead of just concentrating on the 50mm and
occasionally the 35mm. Gradually I realized that I was moving further

and further away from Cartier-Bresson's direct influence, and developing my own individual approach.

Du magazine was also an early influence for me. The editorial decisions of Manuel Gasser were important in instructing me and in building up my reputation through being published in such a prestigious magazine. But Gasser had his own very definite ideas, and it was hard for me to develop my own ideas as to how my pictures should be presented, and what photography meant to me as a whole. It was another experience that had to be balanced, that had to be outgrown.

Another great photographer whose work proved very important to me was W. Eugene Smith. I first became aware of his pictures when I was a student. I would find second-hand copies of *Life* in old bookshops and I was greatly struck by the photographs that occasionally appeared by Smith. They influenced not just my work, but also my attitudes as a person. There was something about Gene's approach that made me think about those private matters that we all have to face up to psychologically. His pictures made me question myself in that way.

Somewhere in Italy there is a place where people gather once a year and carry huge stones up the mountain. It symbolizes their sins and serves as some kind of penance. Somehow this is the light in which I saw Smith. He always seemed to be carrying some enormous rock up a mountain, almost crucifying himself. I could feel this very early on through his pictures, and I became increasingly aware of it as I came to know him better both in America and in Japan.

One of the things I most admire about Cartier-Bresson is his ability to keep a distance between himself and the subject, a detachment from what he is trying to communicate. You could go mad in this business if you took on to yourself all the loads, all the worries, all the agonies of the people that you photograph.

I became a member of Magnum in 1959 and it continues to be very important to me, both in terms of the way it allows me to organize my life, and even more because of its underlying philosophy and because of the very optimistic view that I have of its development and its potential. It gives me so much in spiritual inspiration.

My book *Die Deutschen* was published in 1962. It was not directly commissioned, but I was given a very small advance on the understanding that I would produce it over a longish period. I managed to finance it by visiting Germany several times on various magazine stories. I would shoot an assignment and then take what pictures I could for myself. I was encouraged to finish the book by Robert Delpire, who was in the process of building up his own publishing company. He had already produced Robert Frank's *The Americans* and my book was to be the second in a series.

I have always thought of myself very much as a working photographer. I do not separate my work into two sections, the professional and the private. I work on assignment and sometimes I produce a picture that for me goes beyond merely fulfilling an editorial brief. These few images

René Burri was one of the earliest of the second generation of Magnum photographers, a relationship rather like being adopted by a famous family. The advantages were the sense of belonging to an honourable and continuing tradition, the companionship, the education, the name and the commercial benefits. The main problem, ultimately, was to win respect for his individual talent, for his distinctly personal opinions and approach. It was important to him for his ideas, however much they might differ from those of his colleagues, to be respected by them as equally valid.

Basically, his attitude to photography was freer and more adventurous. He was eager to explore the creative possibilities of different focal length lenses and also of colour. He was less anxious about working inconspicuously and less respectful of the untouched purity of the image. Some of his early initiatives would be controversial even today, but over twenty years ago they were unthinkably bold.

No doubt he was much influenced by his understanding of fine art, film and graphic design. His irreverence for doctrine was coupled with a keen eye for pattern and form. It gave him a facility for immaculate composition, for producing images that were striking, clean-shaped and elegant. But sometimes he felt that they lacked warmth, that they had surface brilliance but little depth. He learned to be wary of this easy talent for design, realizing that it did little justice to the subject or himself. The best of his work has a more substantial quality of human observation and visual surprise.

Even by the standards of an itinerant profession, he is exceptionally well travelled. Most of his assignments are editorial but he has tackled a wide range of commercial and industrial commissions. Today he works almost exclusively in colour, using Kodachrome whenever possible and Ektachrome if he needs more speed.

The cinema has always been an influence on him and he himself has won several important awards for television documentaries and films. But his present ambitions at least are concentrated on still photography.

Like many Magnum photographers, his early preference was for Leica M-series cameras but now he has switched his affections to the Nikon FM single-lens reflex, with a battery of lenses from 20mm to 180mm focal length, and a ×2 tele-extender. He is not at all inhibited about using flash but takes advantage of its convenience and unique effects. His sense of curiosity is too active for him to be restricted by dogma, either in his choice of equipment or in his overall philosophy.

emerge occasionally and naturally out of my professional activity. I am content that my work, my life and my artistic ambitions are integrated in this way.

Ninety percent of my work today is editorial and all of it is in colour. I dearly love black and white and would like to shoot more of it, but sometimes I wonder if in fact this is just nostalgia.

Almost from the beginning of my career I have travelled incredibly widely. Sometimes I am asked if I am not tired of it after 25 years. Certainly there are moments when I do tire of the actual travel, but not of what I find when I get there. I still have an insatiable curiosity about the way that people live, and a constant wish to photograph this. In no way have I become cynical or blasé about experience and I still find a certain magic about photography itself.

When I was young I was taken mountain climbing. The whole party of us was roped together and we walked slowly up the slope. Suddenly I could not contain myself any longer. I just had to detach myself from the rope and run ahead to the top. Naturally I was accused of being over-competitive, and I used to worry that this was probably a justifiable charge. But now I realize that my basic motive was this incredibly strong sense of curiosity. I just couldn't wait any longer to find out what was there. That has been the way life has been for me ever since – racing ahead with a great sense of urgency, and when I get there I find new worlds to discover, new curiosities I have to satisfy.

Having travelled so widely and having experienced political extremes of all kinds, I have a strongly international feeling of the relationship that exists between people as individuals rather than as nationalists of any sort. Also, being brought up in a country so narrow in many ways, physically and in outlook, meant that I had to work to overcome certain inhibitions. In other ways, too, my life and my work have been simple reactions to my early years in Switzerland.

I am very aware of the dangers of being trapped within any one individual style. I know how easy it is for me to design pictures, probably an ability that stems from my background knowledge and experience of graphics. I get considerable satisfaction from pictures of mine that have been painstakingly composed, but I do not want to build up a reputation as just a design virtuoso. These images are not warm enough for me. My involvement with people is on a much more direct, more human level than just using them as elements of composition. So even though shape and pattern figure prominently in all of my pictures, I try to avoid being dominated by this element of my work. There is a danger too of taking an Olympian view of existence, observing other people's lives and feeling separate from it all. Professionally one may have to stand outside the experience one is recording, but privately I want to be more a part of it.

I am increasingly sensitive to the passage of time, and how short a span we have to achieve anything. Yet perversely, as photographers what we are trying to do is to snatch slices of this time and hold it to be studied and enjoyed – and yet time itself is marching on. I like to keep myself

busy, and I hate to think of the remote possibility of no longer having any work that makes demands on me.

When I was younger I was very conscious of missing pictures, and of the risk of missing pictures. I would chase here and there and worry about every one that I knew I'd missed. But today if I have learned nothing else, I have learned that the picture I am chasing may well just be standing behind me. I don't run after pictures any more, but I am ready for them. I am ready to take advantage of the possibilities that offer themselves. In relaxing, I can be far more myself than in chasing after pictures, when my response might be hurried and not as deeply considered.

In my early thirties I did go back to my first dreams of being a movie-maker. I made a few films, but I soon realized that for me still photography was probably the more practical and more satisfying medium. But my love of movies, and my experience in making them, still influence my work – for instance, in the way that I instinctively shoot horizontal pictures.

I used to work with Leica cameras, the coupled rangefinder type. Now I prefer the single-lens reflex. I carry two or three Nikon FM bodies and perhaps five lenses, from 20mm up to 180mm. I have just sold my 500mm lens because I felt rather uncomfortable working with anything longer than the 180mm. Maybe I'll regret it, but I don't think so. I also carry a ×2 tele-extender which allows me to convert the 180mm lens when necessary into a 360mm.

I use the 20mm lens very precisely, almost architecturally. It is a lens you have to handle like a very fast car. You have to be exact or the distortions are extraordinary, lines exploding all over the place. It is the 28mm that I think of as 'my lens'. I use it for most of my work. It allows me to get in close and yet relate the subject to its environment. There is also much less risk of distortion than with the wider focal lengths. I use the 35mm occasionally, but I do not find it as easy to tie up subject and background as with the 28mm. Sometimes the 85mm lens also comes in handy, but these days I very rarely turn to the 50mm.

I carry a small Gitzo tripod fitted with a Leitz ball and socket head, and I also pack a Vivitar flashgun. Flash is playing a bigger part in my work now. Earlier I would have thought twice about using flash at all, but today I am using it in more and more situations. It lets me, for instance, shoot Kodachrome even in the underground, and it gives a harder edge to my colour than would otherwise be possible. I have the flash adjusted so that I can bounce it, or use it on a cable at arm's length. I 'paint in' light where I need it, instead of using it in a crude, direct way.

The importance of technique is obvious; as photographers we are all craftsmen to some extent. But the technique should never be obtrusive, the craft should never distract – the *means* should clarify, and not confuse, the *end*.

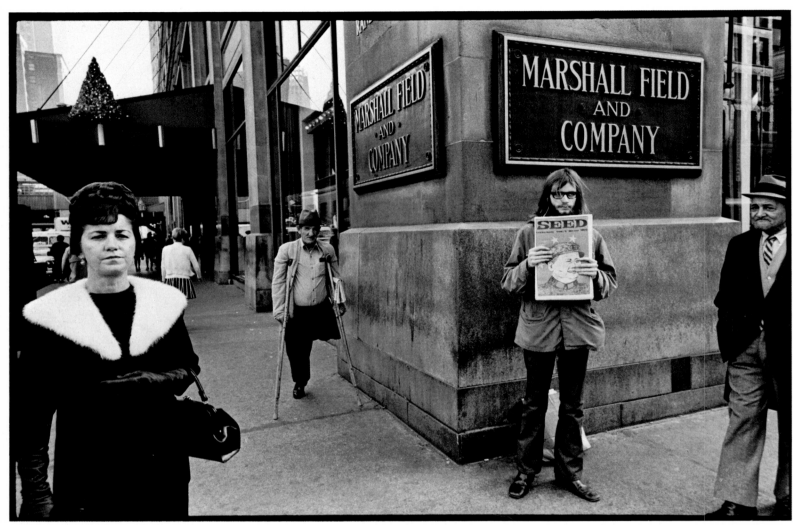

Chicago 1970

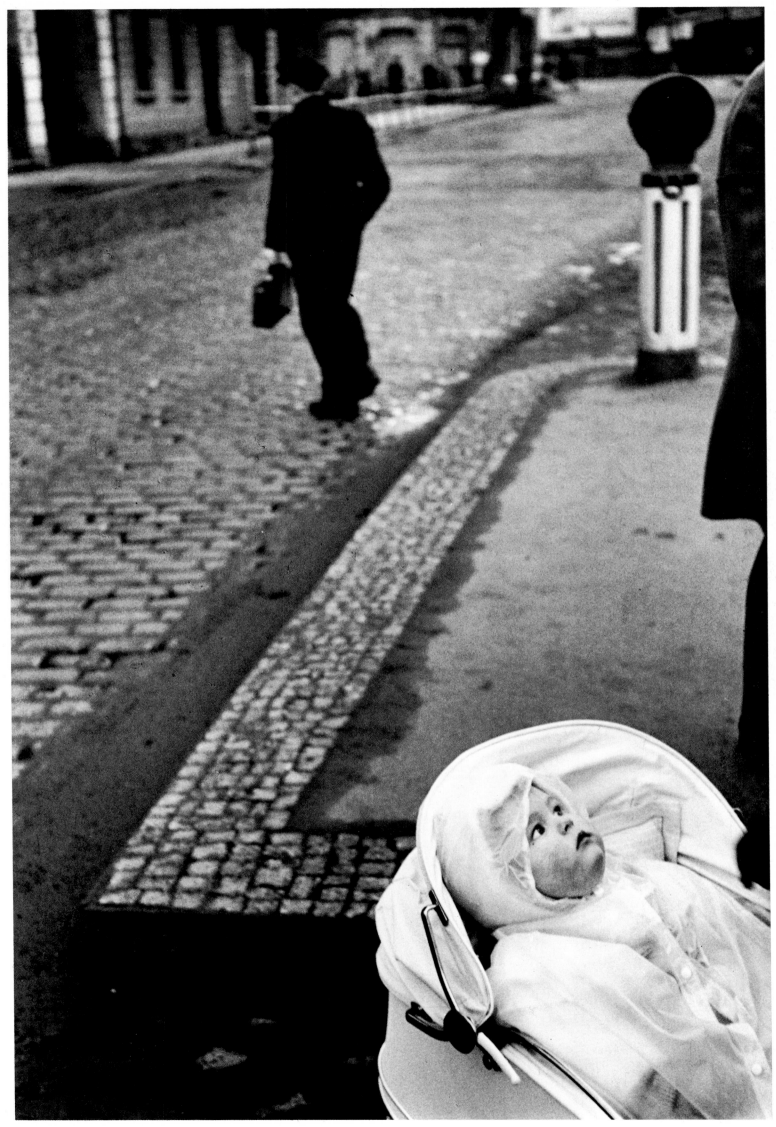

Essen 1960

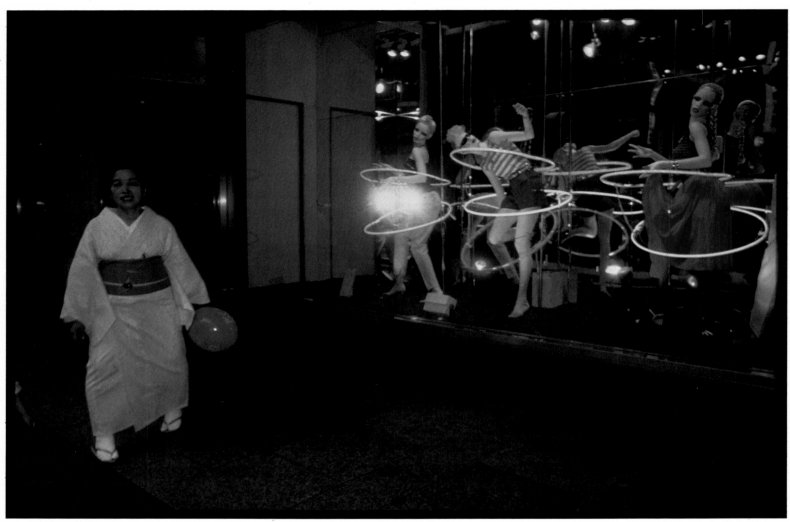

Ginza, Tokyo 1980

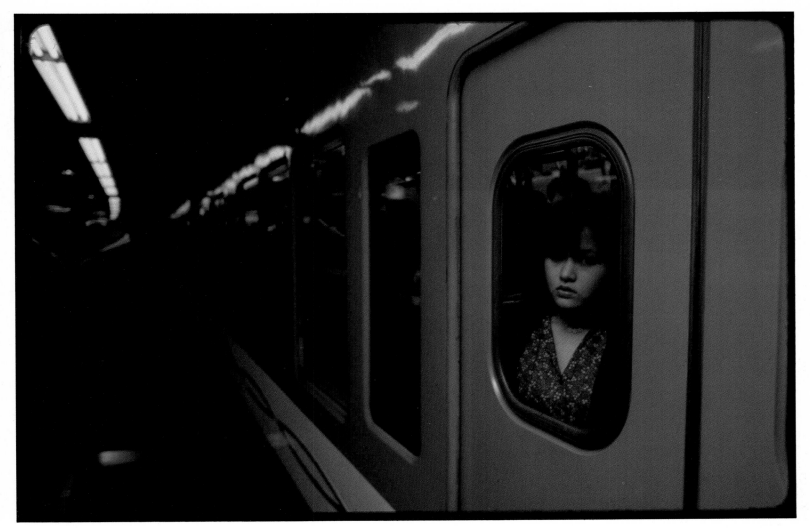

Subway, Tokyo 1980

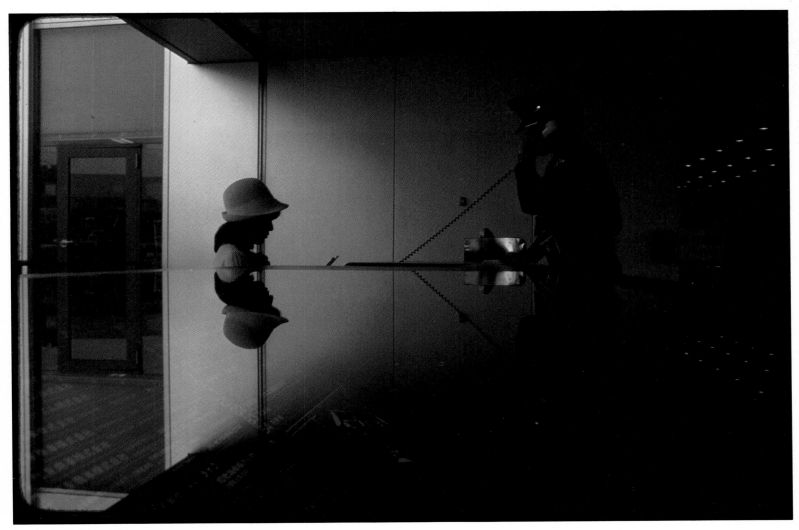

Sumitomo Building, Tokyo 1980

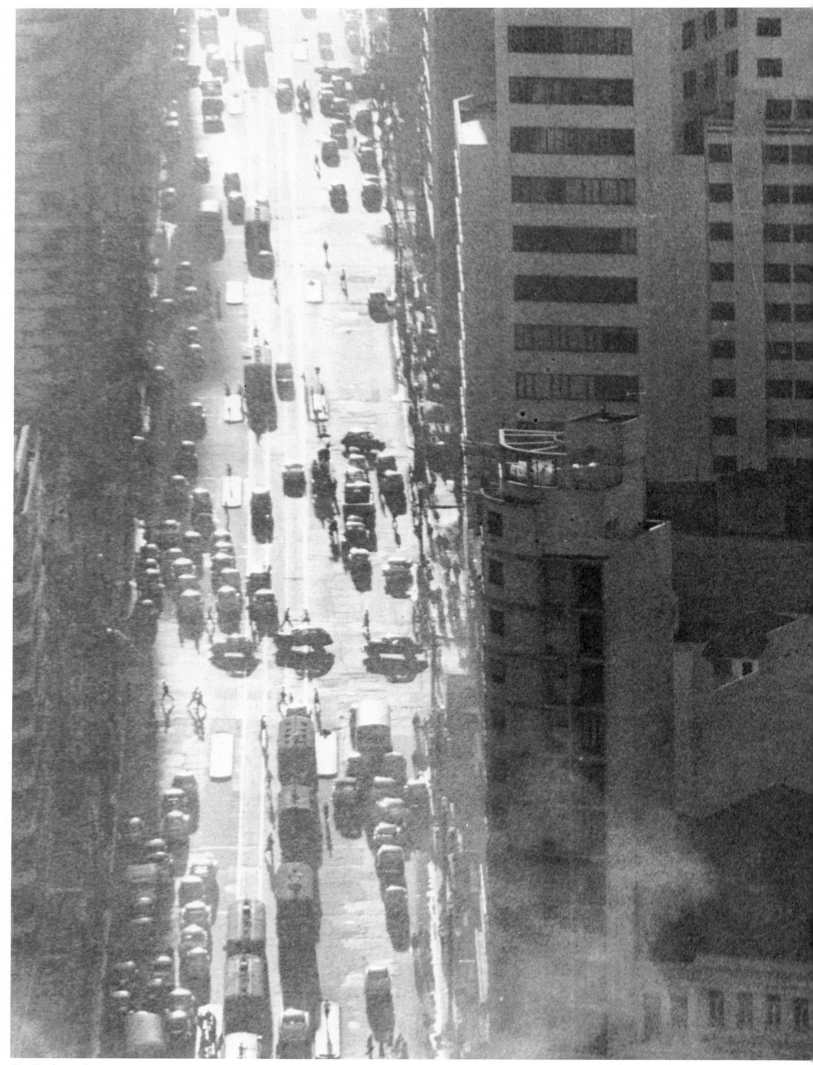

São Paulo 1958

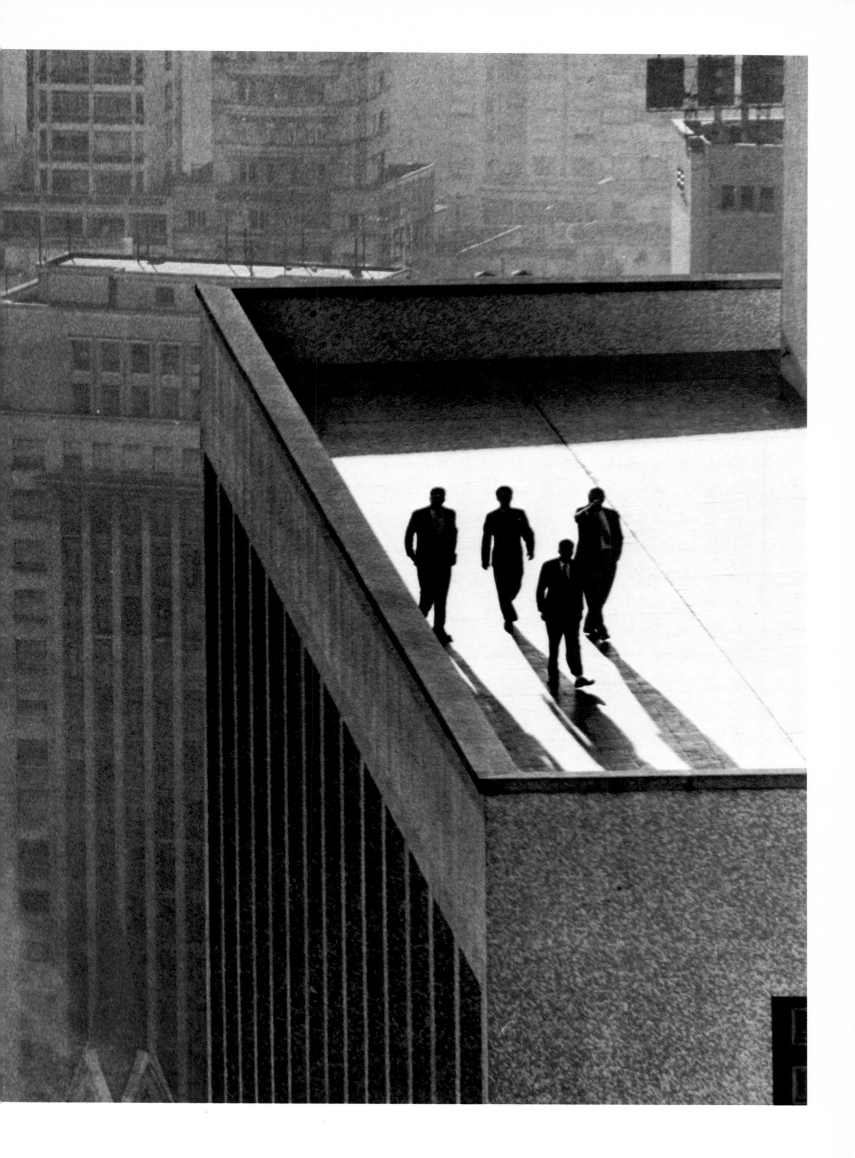

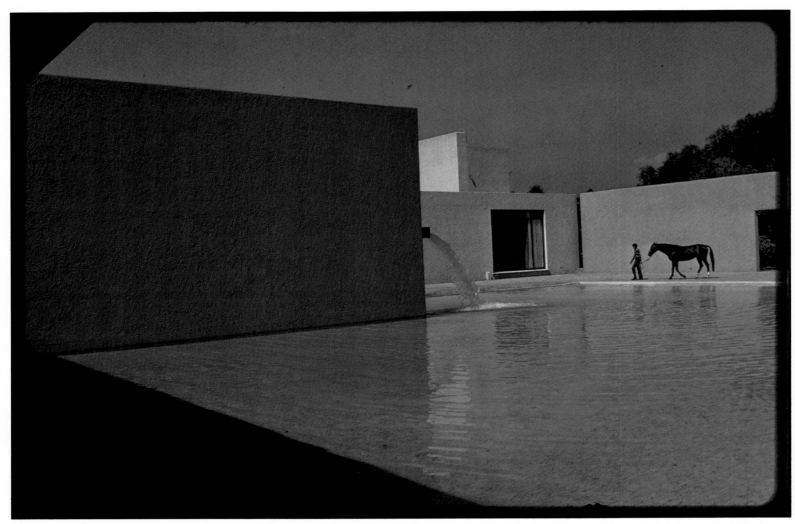

Mexico City 1972 (Architect: Louis Barragan)

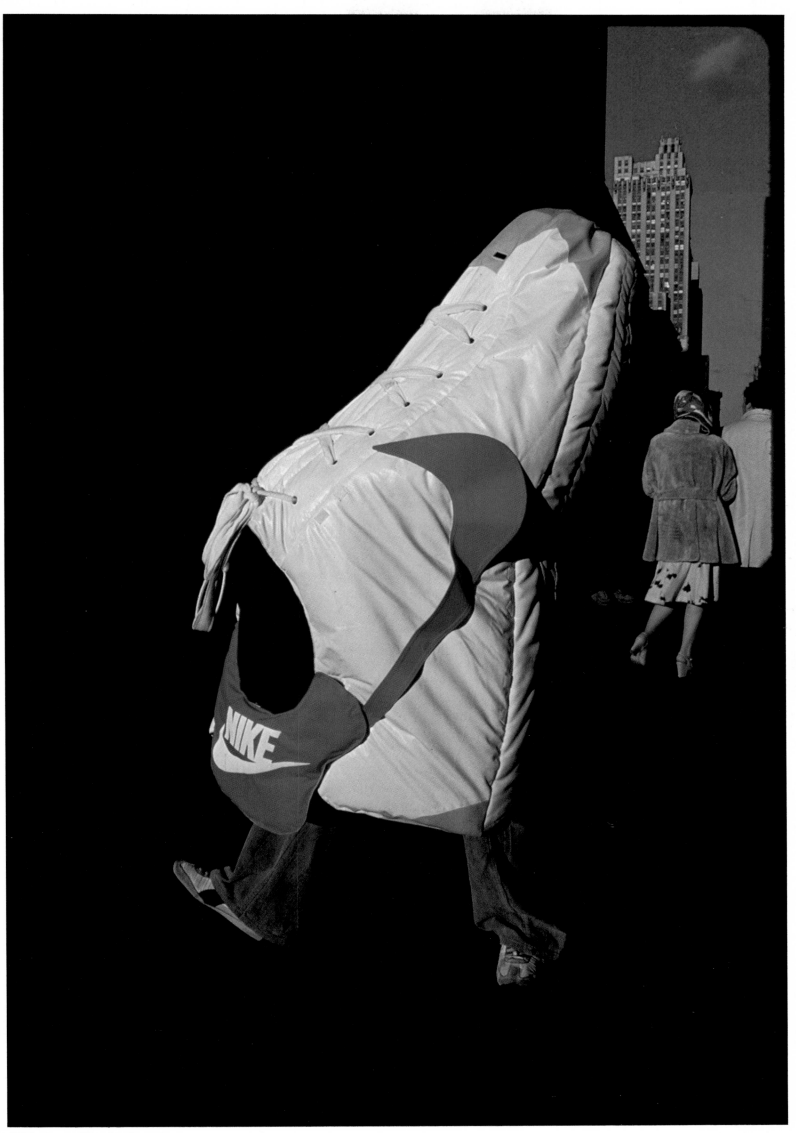

Fifth Avenue, New York 1978

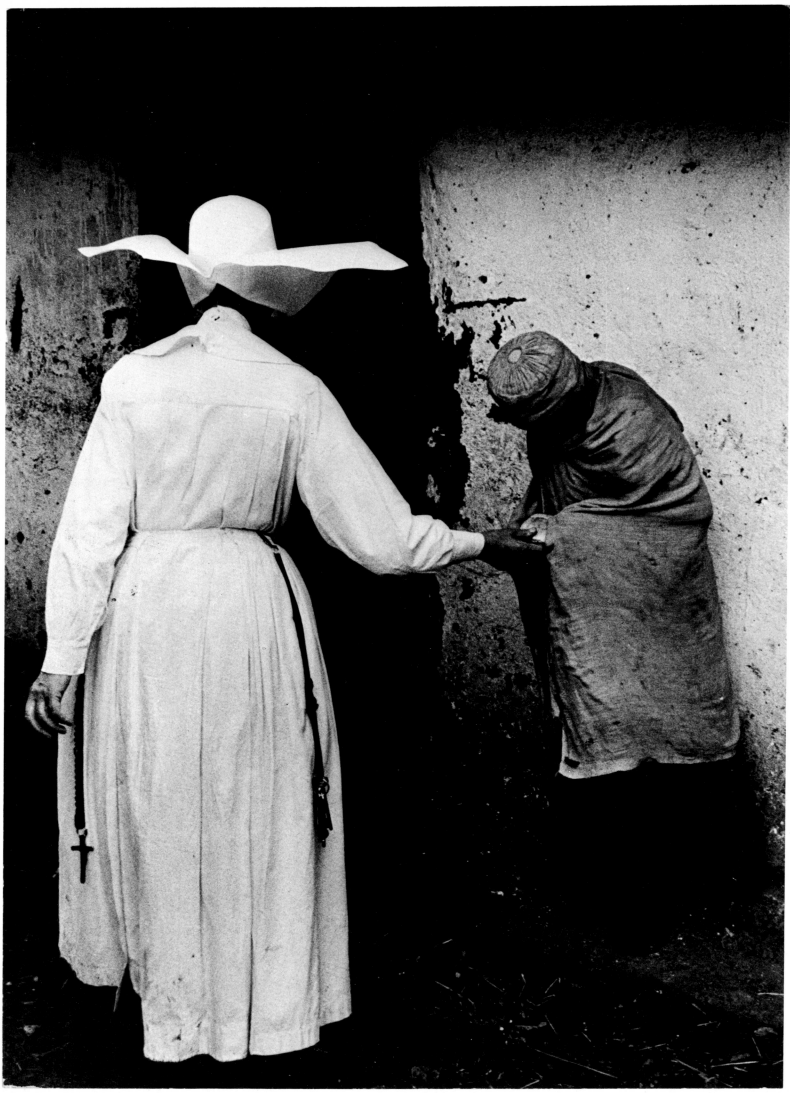

British nun working with lepers, Addis Ababa 1968

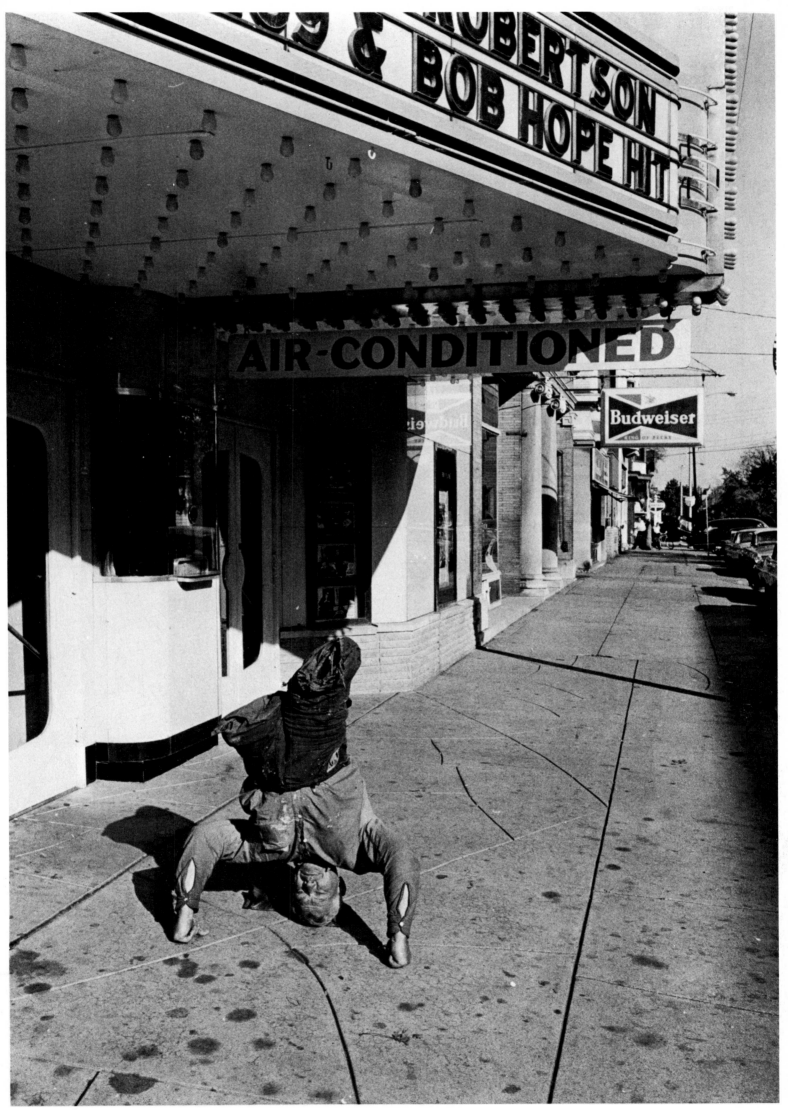

Beggar in front of movie theatre, Quincy, Illinois 1965

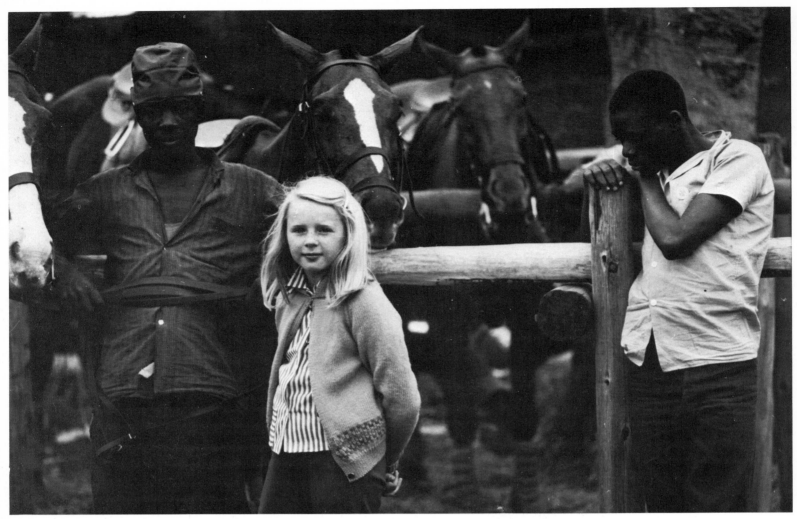

Wealthy farmer's daughter, Rhodesia 1968

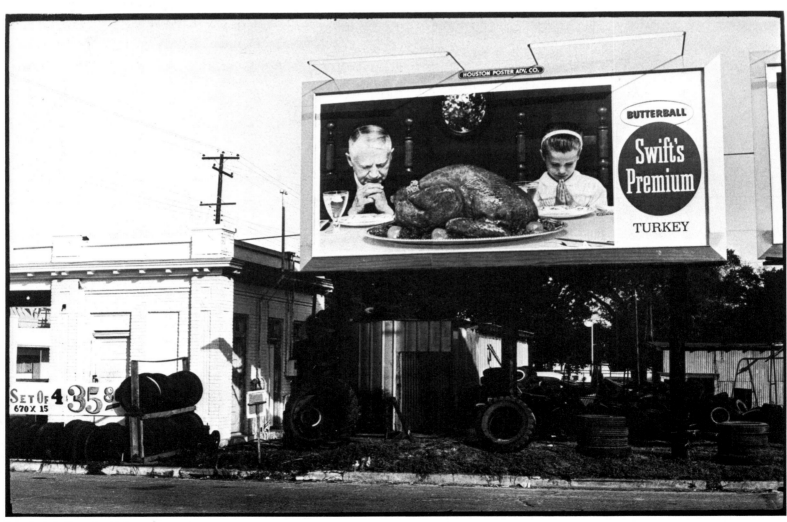

Roadside billboard, Alabama 1965

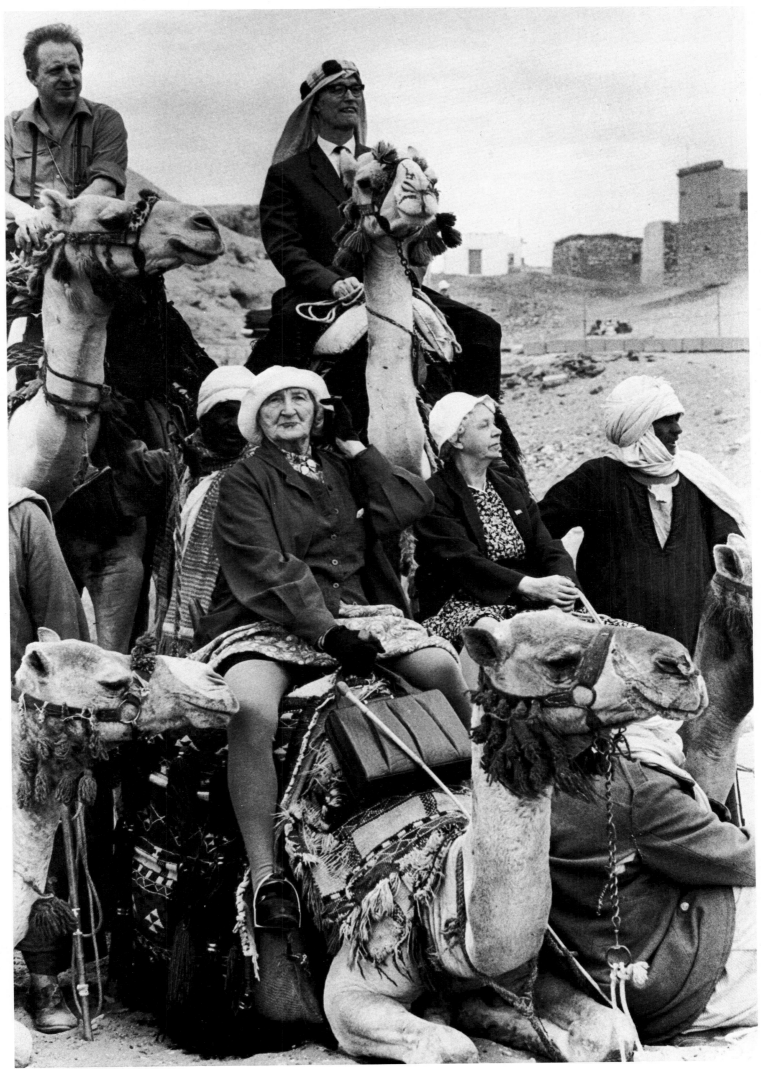

Tourists at Pyramids, near Cairo 1963

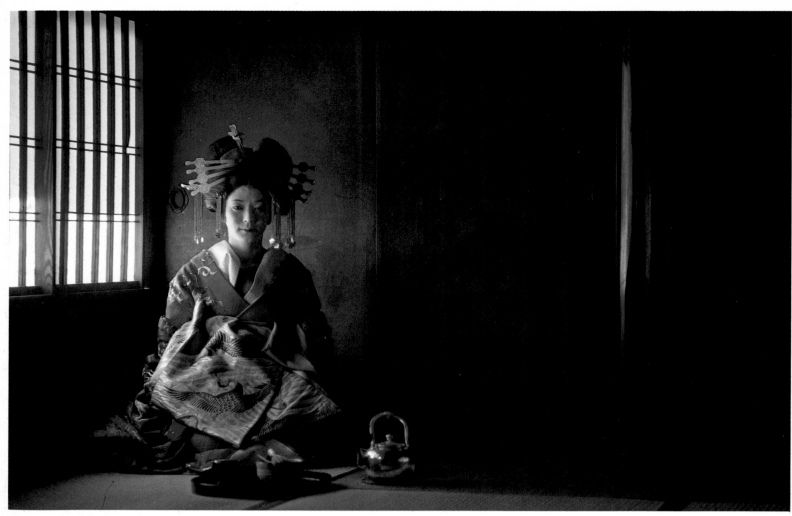

Traditional Geisha house, Kyoto 1979

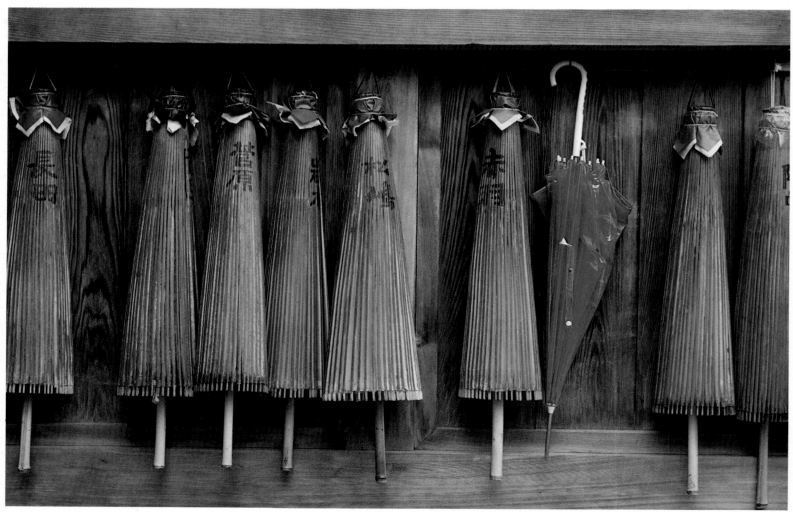

Umbrellas outside shrine, Tokyo 1979

Temple offerings, Kyoto shrine 1979

Girl in a crowd of tattooed men, Tokyo 1979

From 'Sculpture Safaris' 1978

From 'Sculpture Safaris', Sahara Desert, Algeria 1978

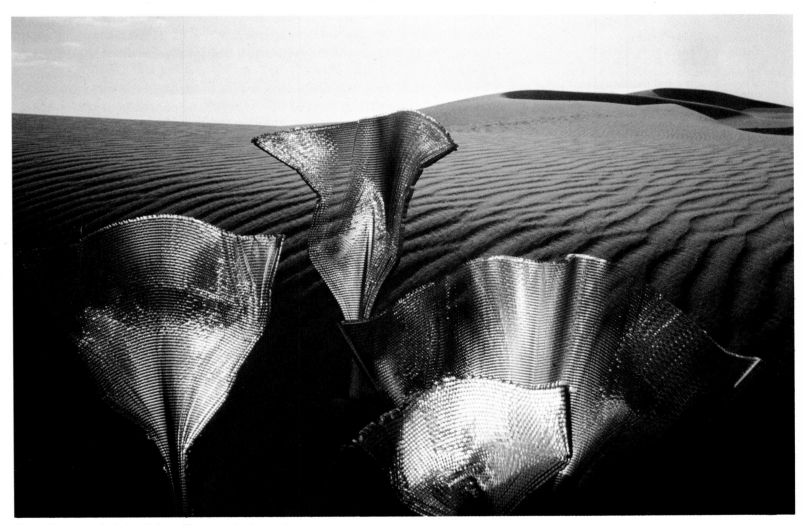

From 'Sculpture Safaris', Sahara Desert, Algeria 1978

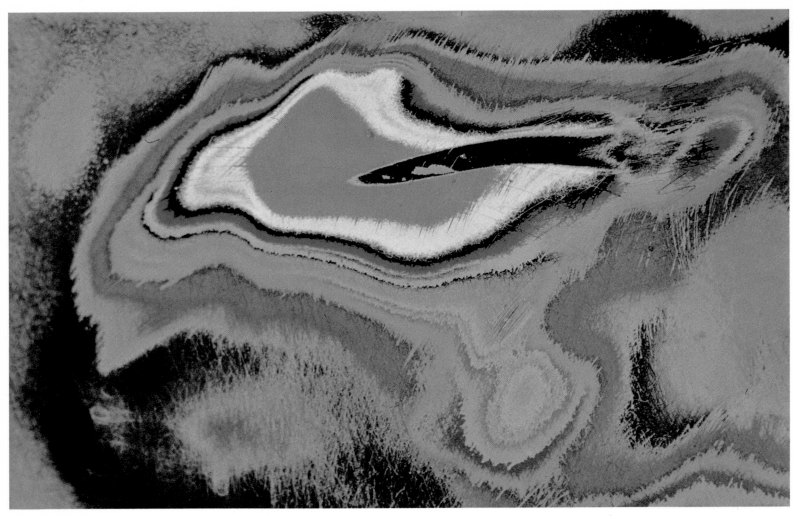

Car scratch 1978

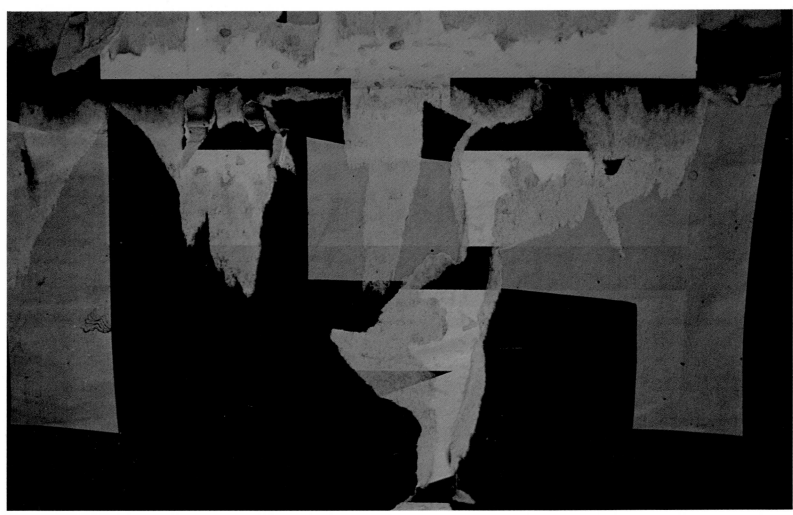

New York 1962

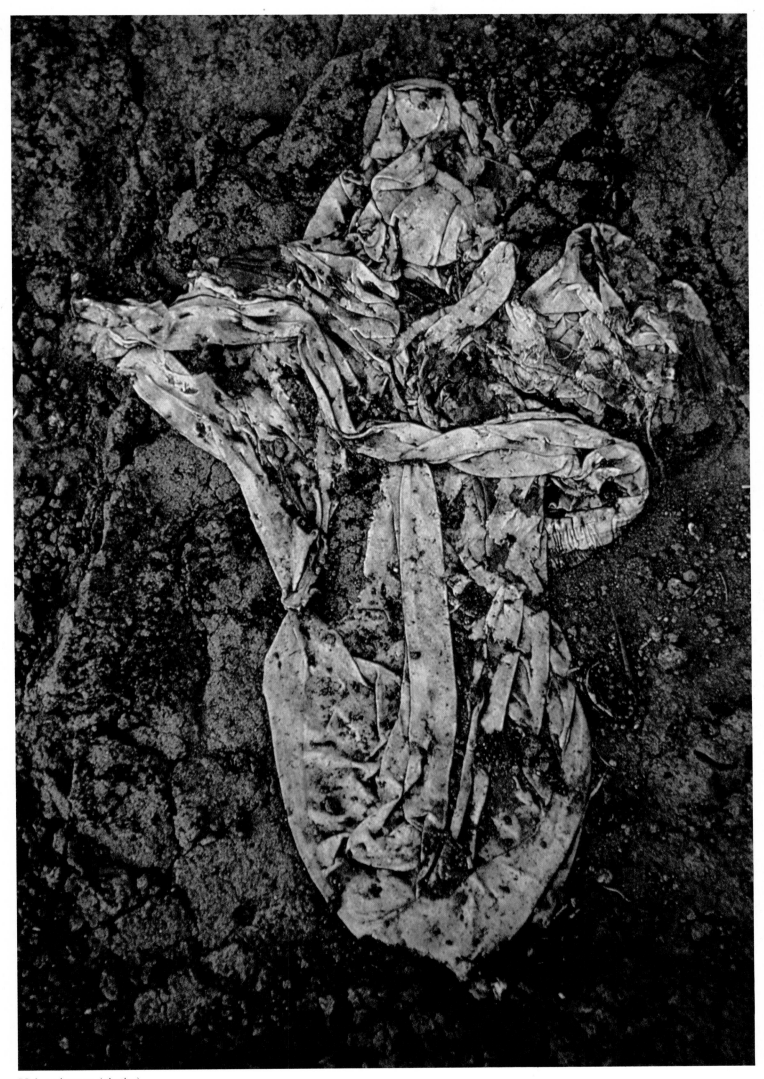

Holy underwear (sixties)

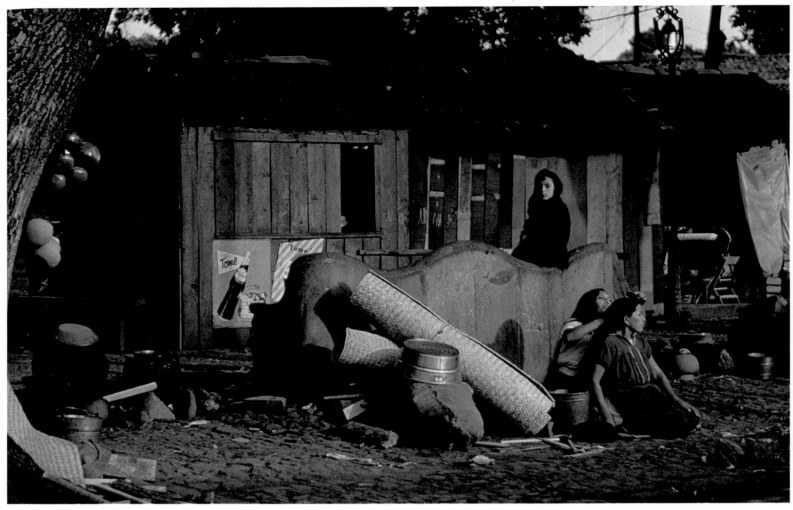

Mexico 1963

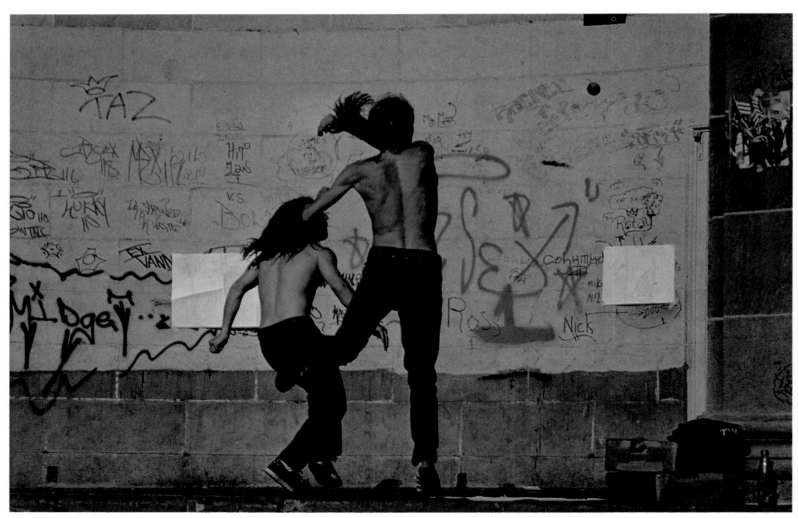

New York (seventies)

Germany 1976

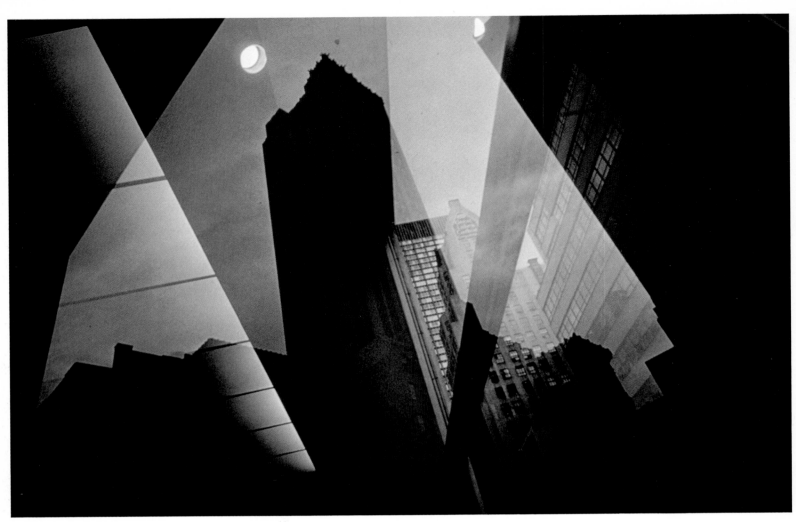

New York City (sixties)

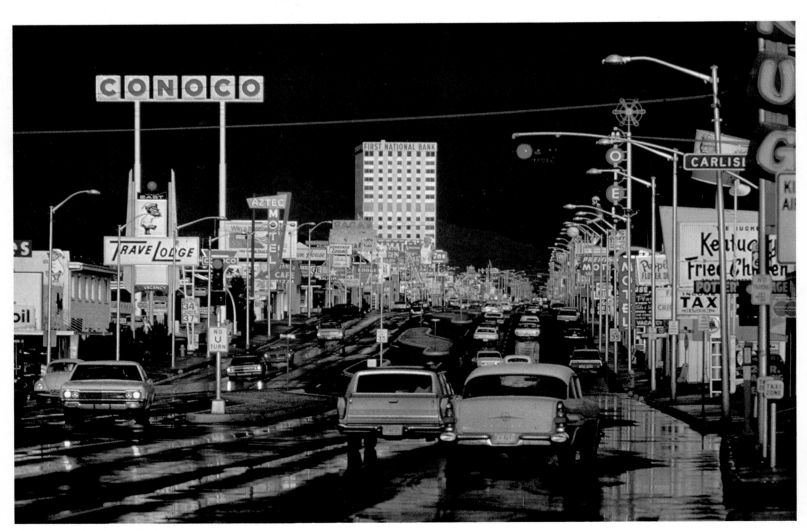

Albuquerque (early seventies)

Night Landscape (seventies)

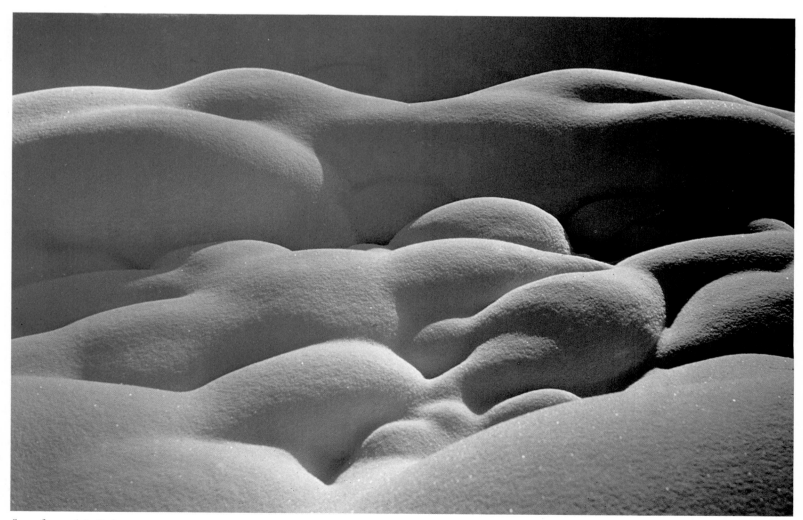

Snow figures (sixties)

Heather Angel

Born:
1941, in Fulmer, Buckinghamshire, England.

Education:
Read Zoology at Bristol University.

1966:
Began work as freelance biological/natural history photographer.

Heather Angel now lives in Farnham, Surrey, England, where she runs her own photo-library consisting of over 100,000 colour transparencies. These are used to illustrate many books other than her own (over 900 to date), as well as magazines, calendars, filmstrips, travel brochures, advertising and television stills.

She travels extensively worldwide, and is fascinated by island life. She is especially interested in close-up and macrophotography of both plants and animals.

Books:
Heather Angel has written and illustrated thirty books. The following is a selection of the most important:
1972 *Nature Photography: Its Art and Techniques.*
1975 *Photographing Nature* (5 volumes).
1977 *Life in our Rivers.*
Life in our Estuaries.
British Wild Orchids.
1981 *The Guinness Book of Seashore Life.*
Her most ambitious project to date was being commissioned to take the 350 colour plates for *The Natural History of Britain and Ireland* – in just over a year. It was published in 1981 and Kodak staged a one-woman exhibition based on this book.

There are two – often conflicting – basic requirements for good nature photography. First, the picture must be truthful; secondly, it needs to be visually interesting. A few years ago, I opened a magazine and saw a very striking picture of a little fish called a blenny, which is a common inhabitant of rock pools on British shores. This fish is so perfectly camouflaged in its natural habitat of green seaweed-filled pools that photographing it poses real problems of how to show it in its ecological context, and yet make it stand out sufficiently to give the picture impact. The photographer had deliberately chosen to transfer the fish lower down the shore to where the shallow pools were lined with attractive pink coralline seaweeds. The result had visual impact, but totally lacked truth. It showed the fish in an alien habitat and so prevented the reader from understanding the function of its colour, pattern and texture in relation to its surroundings.

All too often the division between this type of pictorial approach and the strict record photograph is clear cut. The pictorialist is inspired by light, shapes and patterns, irrespective of knowing the subject. The scientist or naturalist uses a camera as a notebook for recording some aspect of the biology of a known species for later comparison or analysis.

My aim is to produce nature photographs which are visually interesting but which also make a biological point. Striking pictures can be achieved by careful attention to lighting and background. Generally, far too little attention is paid to the background, yet a distracting one can compete so much with the subject that it leads the eye away from it. Whenever I photograph flowers I run through an automatic checklist of questions: is the flower a good specimen; is it a typical one; what camera angle shows it to best advantage; does the background complement or detract from the flower? Having focused the camera, I then stop down the lens to check the depth of field on the subject *and* on the background. I may then open up a stop or two so as to gain a more muted diffuse background by means of differential focus. Before I expose a frame I scan the field of view to check there are no red poppies or dry bracken stems lurking in the picture. Another technique which I use for simplifying backgrounds is a combination of light and shade. With luck this can be done using sun and shadows, but more often it has to be created either by using flash or by getting an assistant to cast a shadow behind a sunlit subject. When photographing plants at the coast and along river margins, I often use water as a background that is both natural and simple. For tall isolated plants, I use a low camera viewpoint to photograph them against the sky.

To achieve a good action shot the wildlife photographer needs to have a deep knowledge of, and sympathy with, his subjects. The ability to catch the moment of action depends on a combination of luck and anticipation of how an animal is likely to behave. Sympathy with the subject is essential, otherwise the photographer, in his determination to get good pictures at all costs, can cause more disturbance and damage than a multitude of ignorant tourists. Furthermore, an animal undisturbed and at ease has a totally different posture from one that is tense with

alarm and apprehension. Where man is an intruder, the photographer must either by patient waiting become part of an animal's environment, or learn to merge into the background so that his presence is no longer regarded as a disturbance. This means that hides are essential for photographing nearly all nesting birds – apart from many seabirds. Since the sense of smell is so well developed in active predatory mammals, they have to be approached from down wind, so your scent is blown away from them. Their vision is also acute, so black lenses and camera bodies are preferable to chrome equipment. I use black tape to cover any gleaming surface, and I also stalk mammals wearing a camouflage jacket and trousers.

Many small aquatic organisms – especially pond and river life – cannot be photographed adequately in their natural environment. The water is often too murky for critical photography, and even if a clear stream is found the dark stream bed reflects so little light that wide open apertures need to be used. Using a flash may solve this problem, but it can also create another by producing a reflection on the water surface in the field of view. For the time spent and the results achieved, *in situ* photographs of these animals are just not practical. So I collect water beetles, nymphs and snails, together with some weeds and stones from the same site, to set up aquaria in the studio. I feel strongly that the surroundings created in an aquarium should be as authentic as possible.

Over the last six years I have travelled to some quite remote parts of the world – in particular to many oceanic islands – to photograph a cross-section of habitats together with the endemic flora and fauna of these regions. Locations such as the Galapagos, the Seychelles, Hawaii and Madagascar may sound very glamorous, but in reality the hours worked in the field – not to mention the time spent identifying specimens after dark – means that the pace cannot be kept up for more than a few weeks at a time. Anyone who has not worked in the tropics cannot possibly envisage the discomfort of the high humidity on top of soaring temperatures. These present additional problems for the filmstock too. All exposed films are kept in an airtight double-walled cooler with silica gel. When possible freezer packs are used to keep down the temperature, but in tropical rain forests where freezers simply do not exist the films are kept as cool as possible in permanent shade.

The penalty for working as a broad-based wildlife photographer is that the range of equipment needed is inevitably much greater than is necessary for specialist work. I regard all my equipment as a tool for the job and every piece has to work *and* pay for itself. I use both 35mm (Nikon) and 6 × 6cm (Hasselblad) formats. The lenses used with Nikon F2 and MD2 motor drive bodies are 20mm, 24mm, 35mm, 35mm PC (perspective correcting), 50mm, 55mm macro, 90-180 flat field macro zoom, 105mm, 105mm macro, 135mm, 200mm, 200mm macro, 300mm, 400mm and 500mm mirror lenses. All the macro lenses are used much more than any others. The perspective correcting lens is conventionally a lens which allows the architectural photographer to correct converging verticals. I

Nature photography is clearly a specialized interest, but by no means a narrow one. The range of subjects is enormous, and those involved have to decide at some stage whether to specialize even further or else to operate on a more general level.

Heather Angel began as a specialist in marine life, but gradually widened her scope until '. . . I now tackle any living being – regardless of its size – anywhere in the world.' But even on such a broad base she can become involved in quite surprising detail. For example, there are some 600 colour shots of the common beech (*Fagus sylvatica*) in her picture library, ranging from a freshly germinated seedling to mature trees in a variety of locations, and all manner of close-ups.

Adequate and accurate captioning is essential for the naturalist, who is not merely concerned with pictorial merit. Correctly identifying an animal or plant in a strange country can be a difficult and frustrating exercise, as Heather Angel found during a recent visit to the Amazonian forest in Peru. 'The only way I could put an accurate name to the trees growing in the bewildering, luxuriant, tangled mass of vegetation was via an ex-Caiman hunter and bushman and an interpreter.'

It is important to her not only to produce truthful records but also photographs that are visually interesting. She realizes the value of a sound knowledge of techniques and equipment. 'There is enough to concentrate on without needing to switch attention to handling the equipment. The choice of lens, filter and film, how to use the lighting (be it natural or artificial), and how to compose the subject in the view-finder needs to become instinctive. This is best learnt by practice and by constantly analyzing other people's successful photography.

'It soon becomes obvious that a picture is a two-dimensional representation of three-dimensional space in a split second in a dynamic, ever-changing world. So no single picture can illustrate everything about a subject. The equipment and techniques that are used limit the amount of information in the image, but at the same time emphasize certain aspects. A wide-angle shot of a plant in its environment gives a quite different emphasis to aspects of its natural history from close-up shots of its flower, or a backlit picture showing its surface texture. By the use of a variety of techniques, the nature photographer can explore different aspects of natural history.'

Heather Angel photographs almost exclusively in colour, as the colours themselves are an essential part of the living world. 'A monochrome image does not give me the same sense of excitement as a

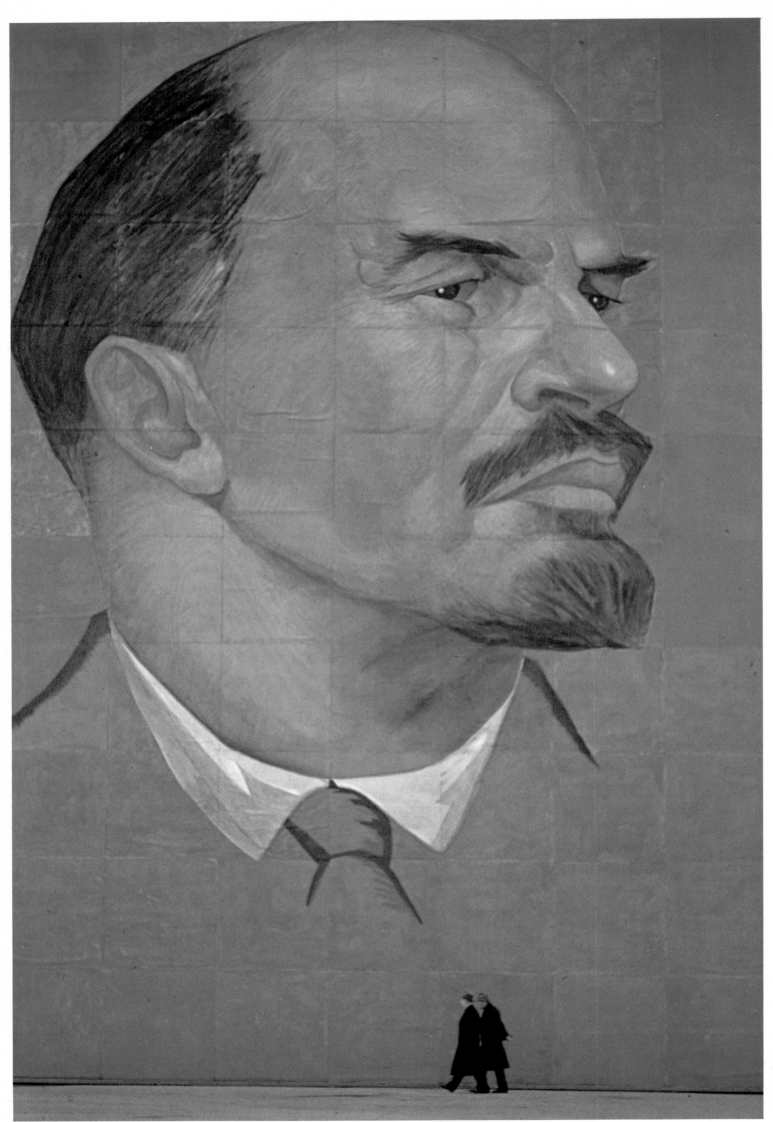

Russia 1961

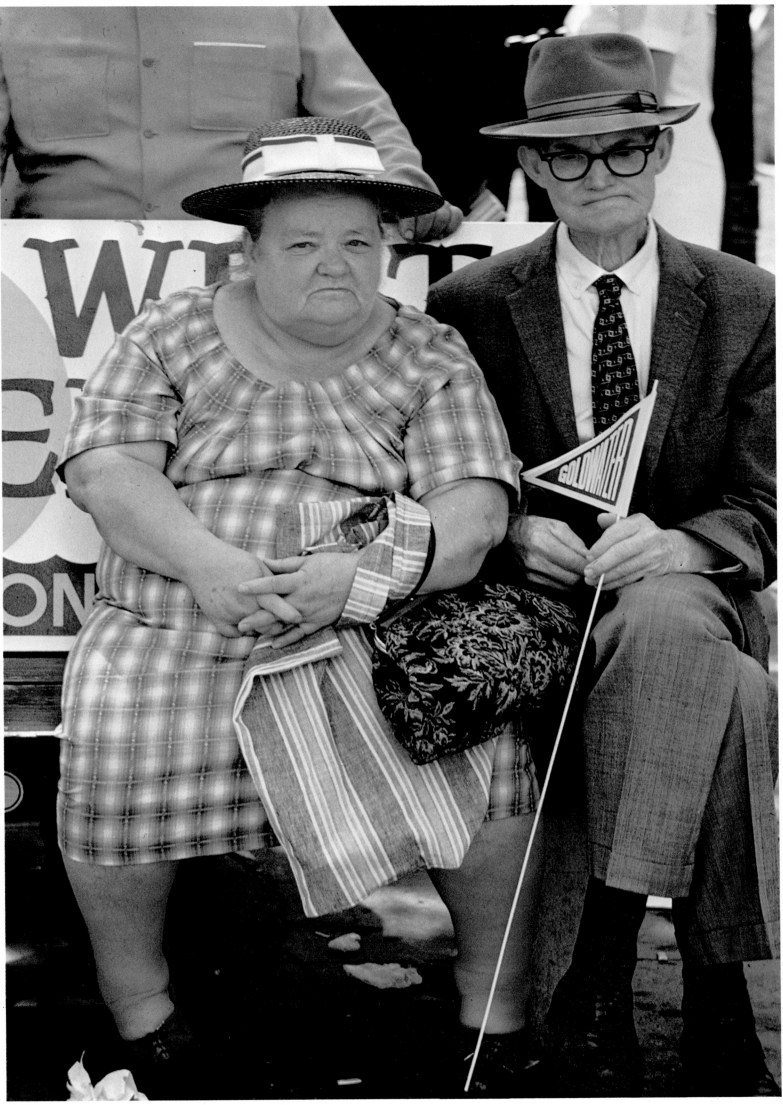

San Diego 1964

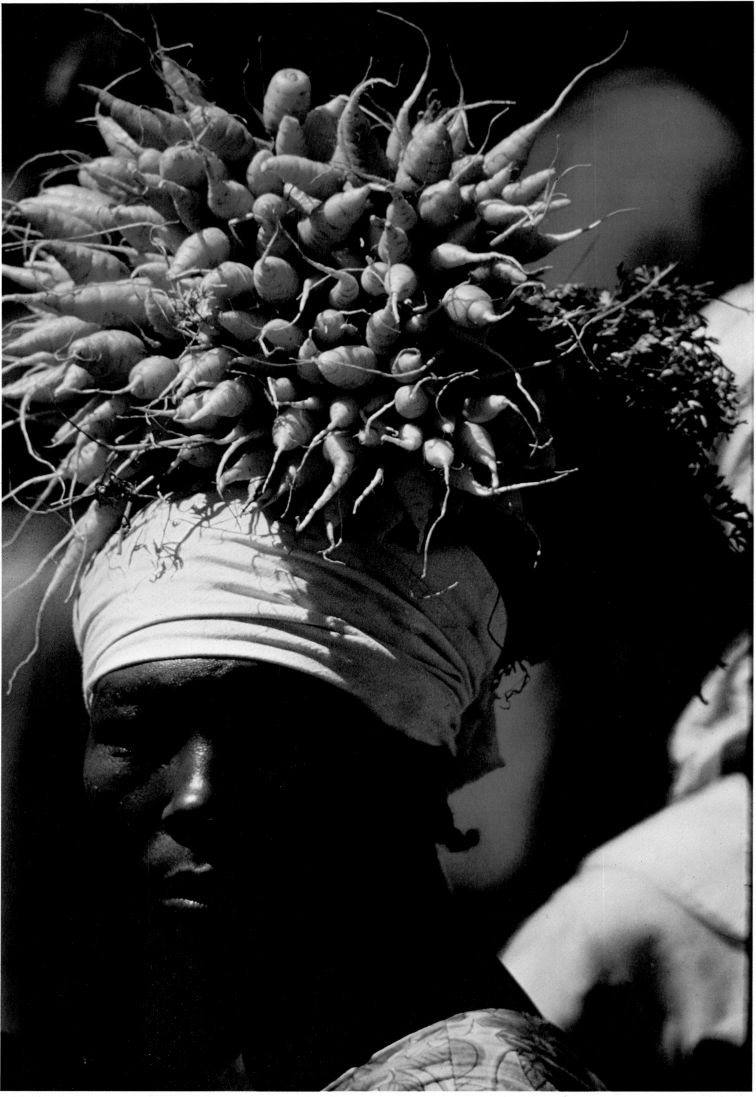

Haiti 1972

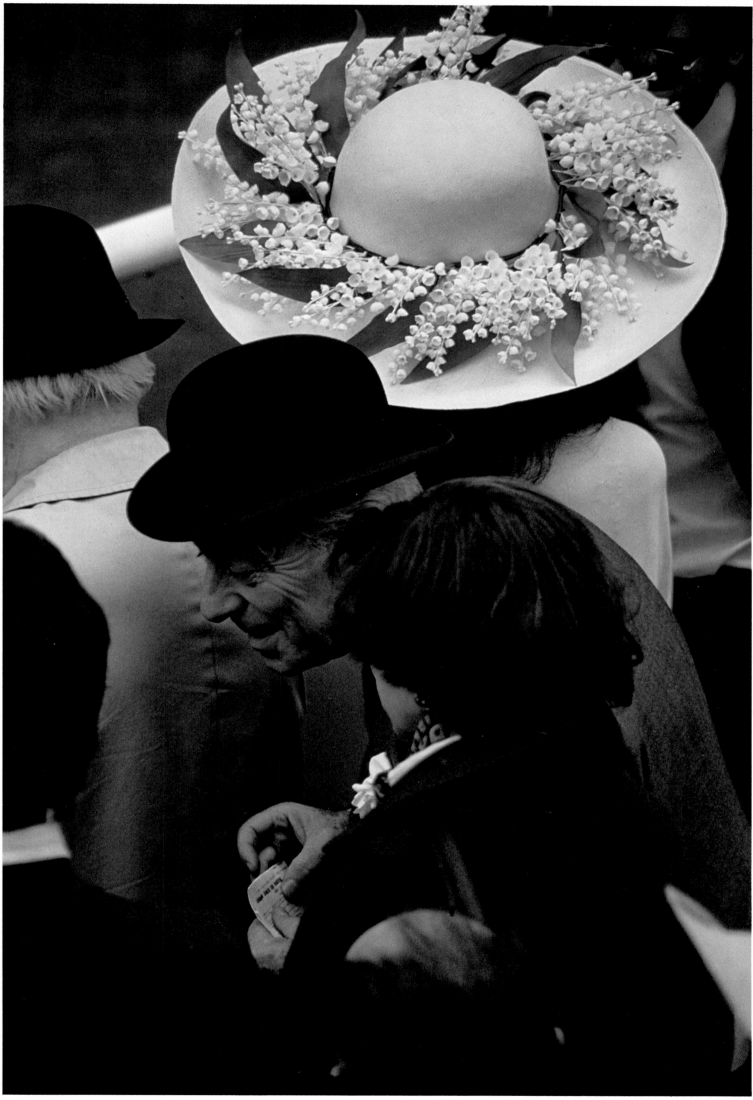

Paris 1978

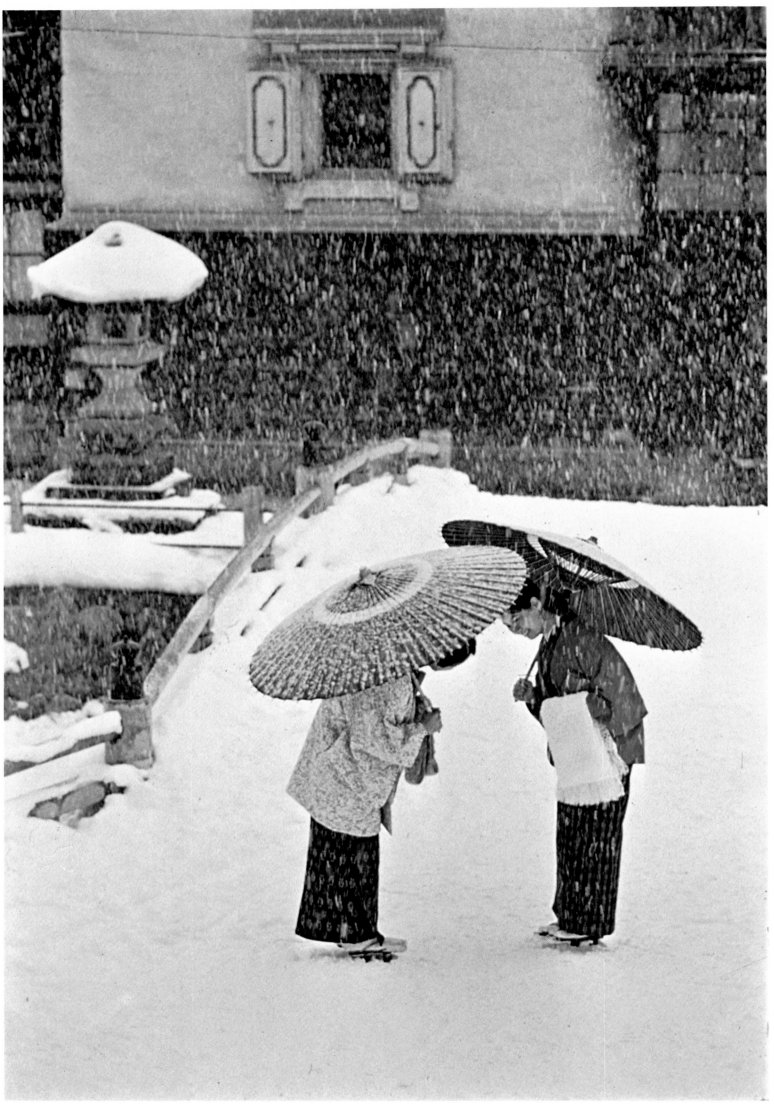

Japan 1967

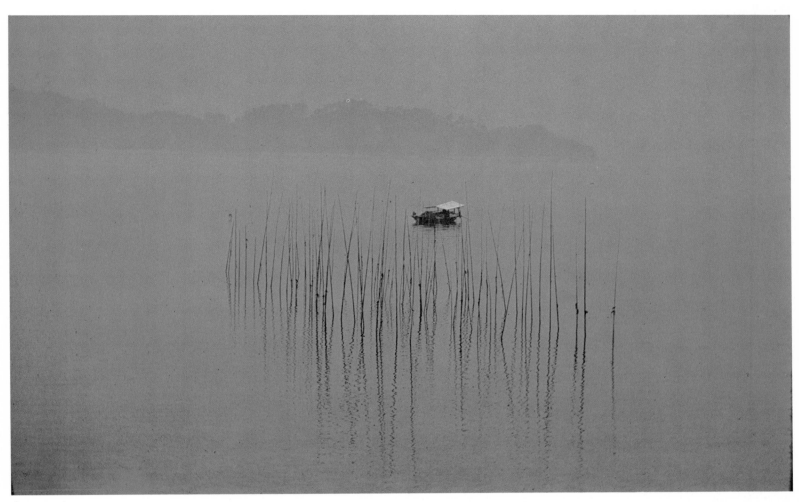

Japan 1967

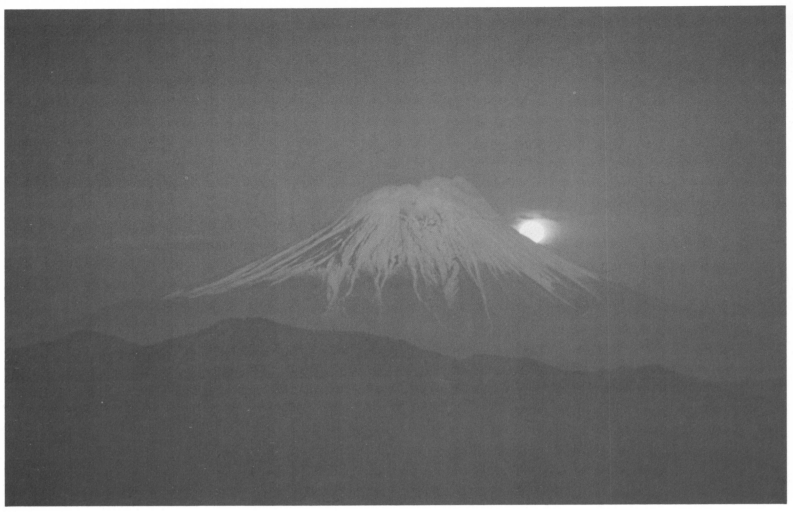

Mt Fuji 1967

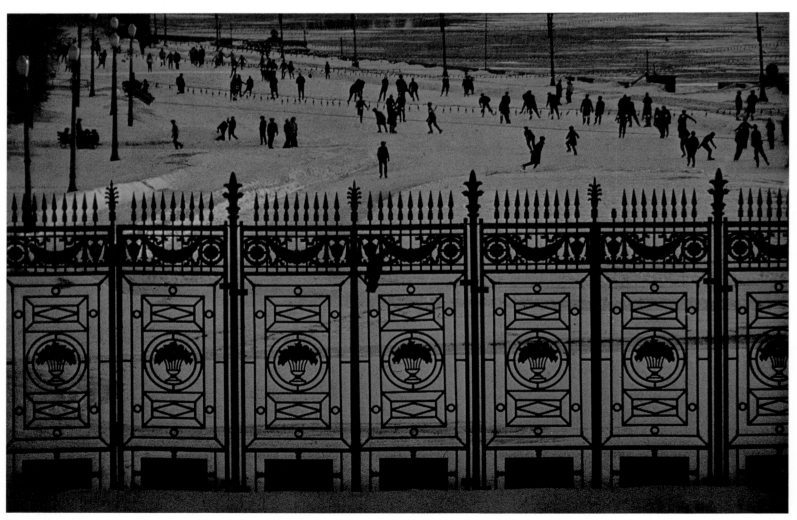

Russia 1961

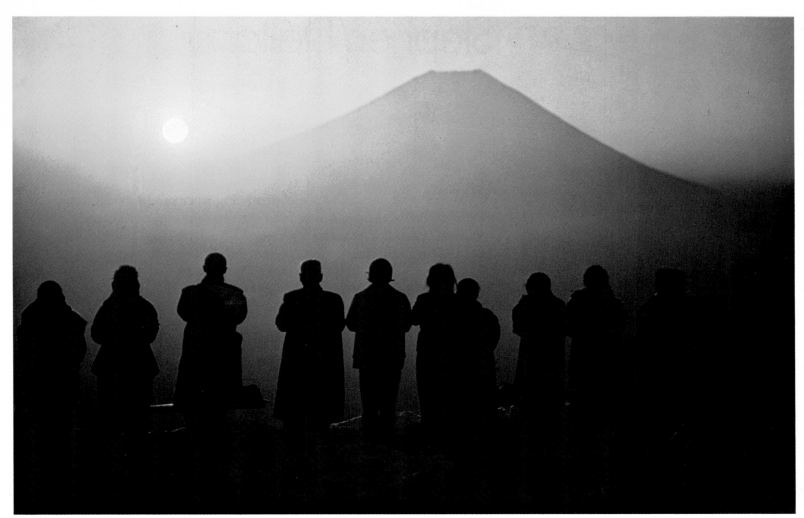

Mt Fuji 1967

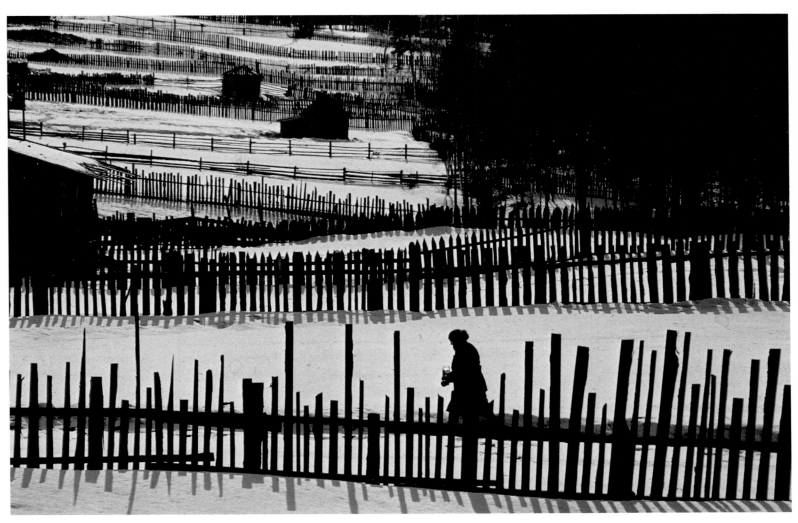

Russia 1961

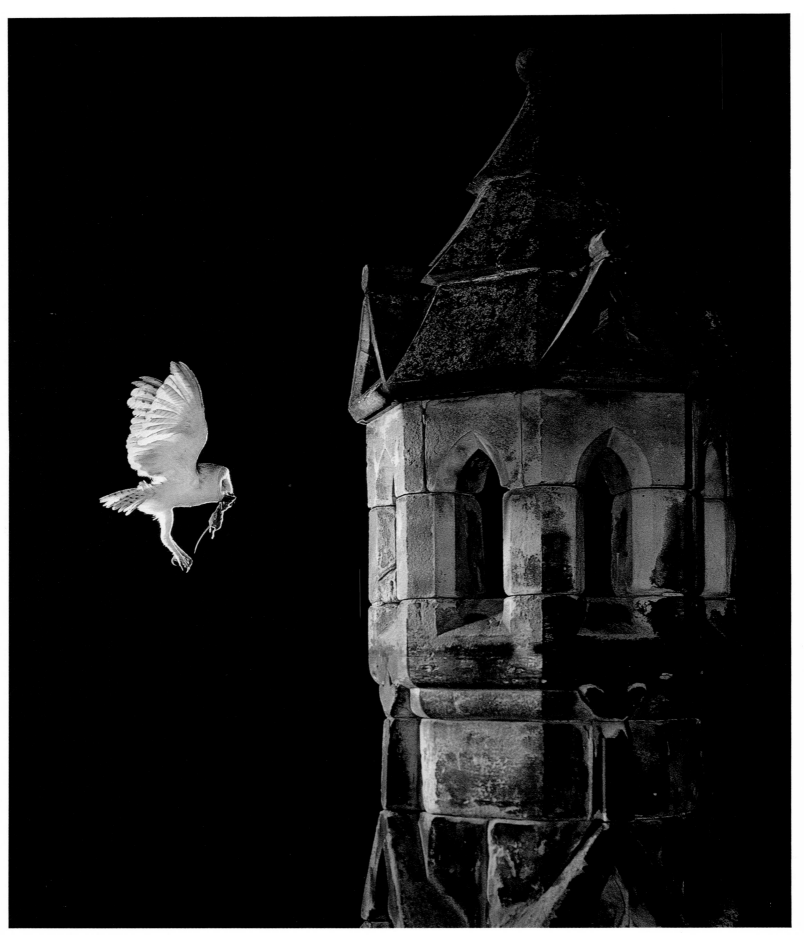

Barn owl (Tyto alba) carrying rat to nest

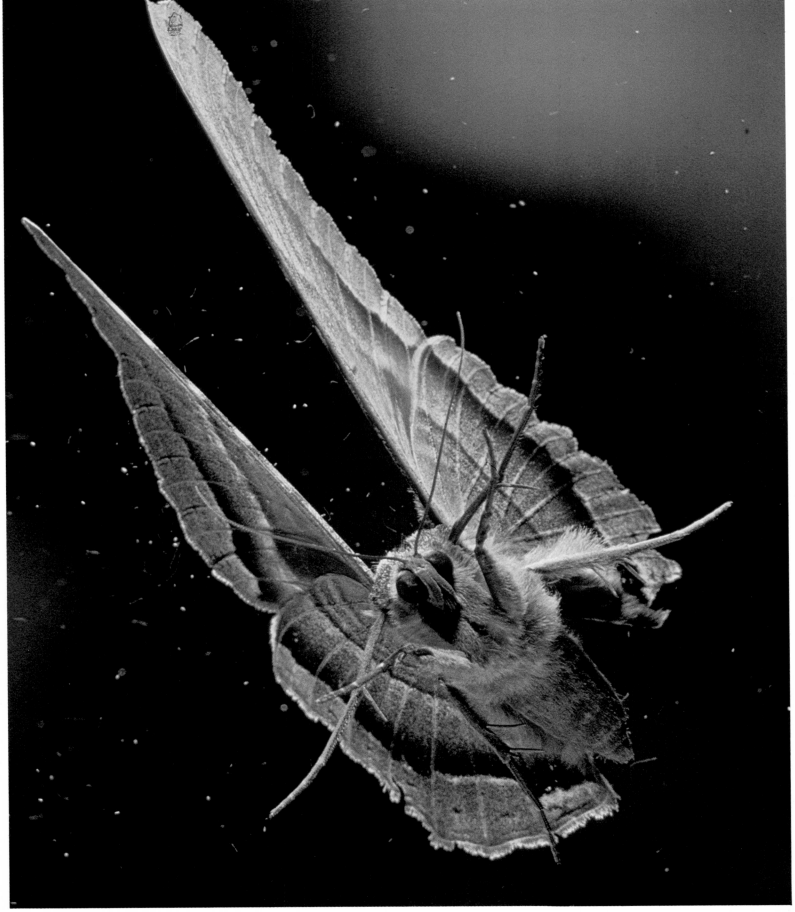

The black witch moth shedding scales shortly after take-off

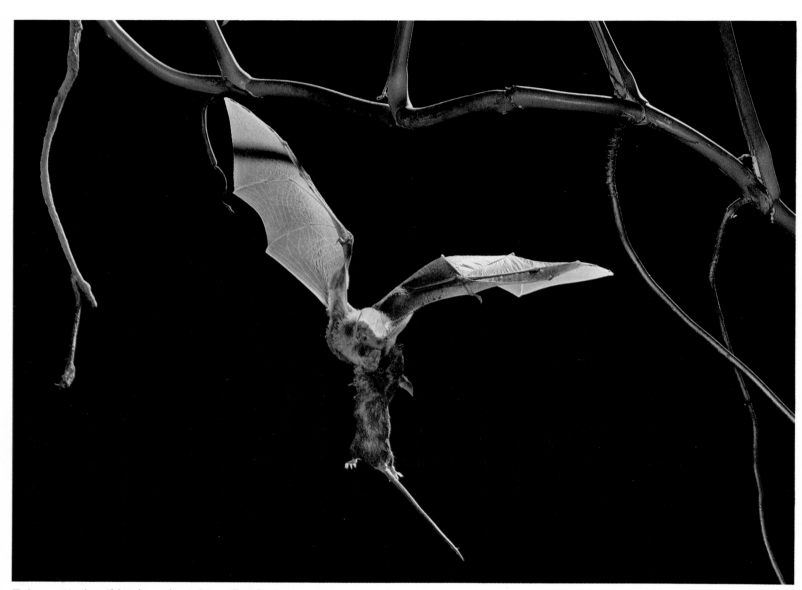

False vampire bat (Megoderma lyra) flying off with prey

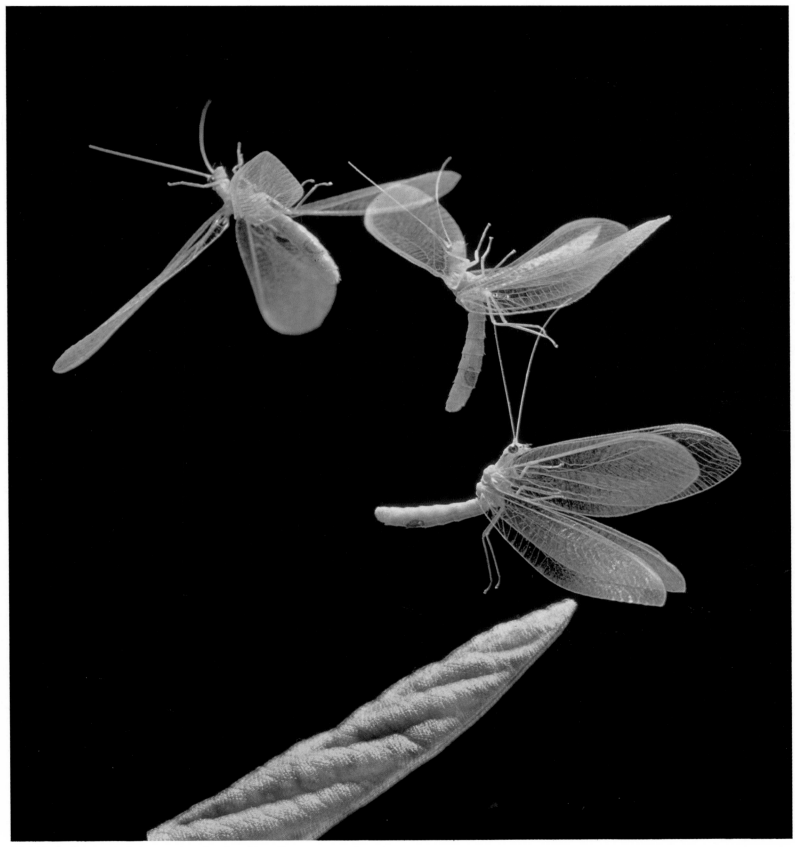

Multiflash photograph of the green lacewing-fly taking off

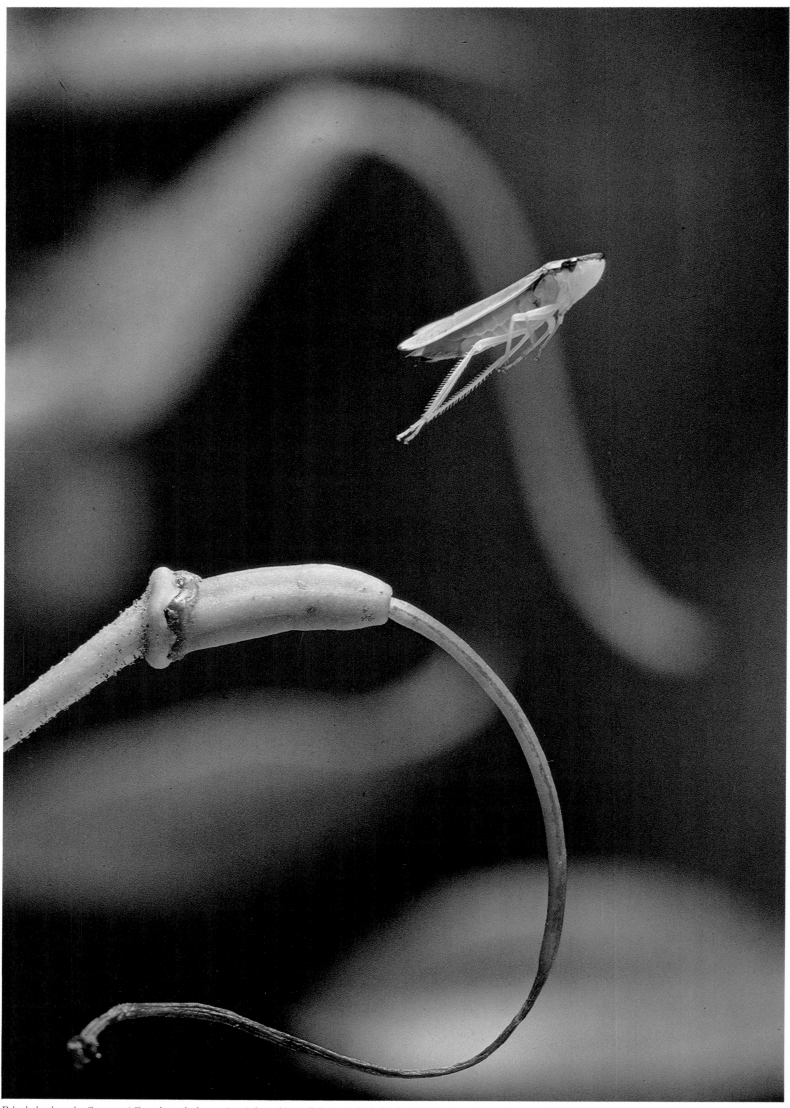

Rhododendron leafhopper (Graphocephala coccinea) launching off from a rhododendron seed

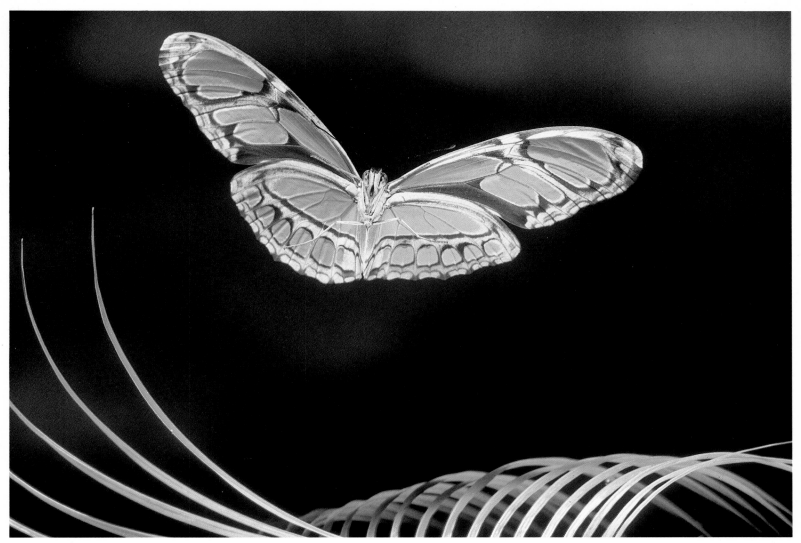

Green heliconid butterfly (Phyleathria dido) from the tropical forests of Venezuela

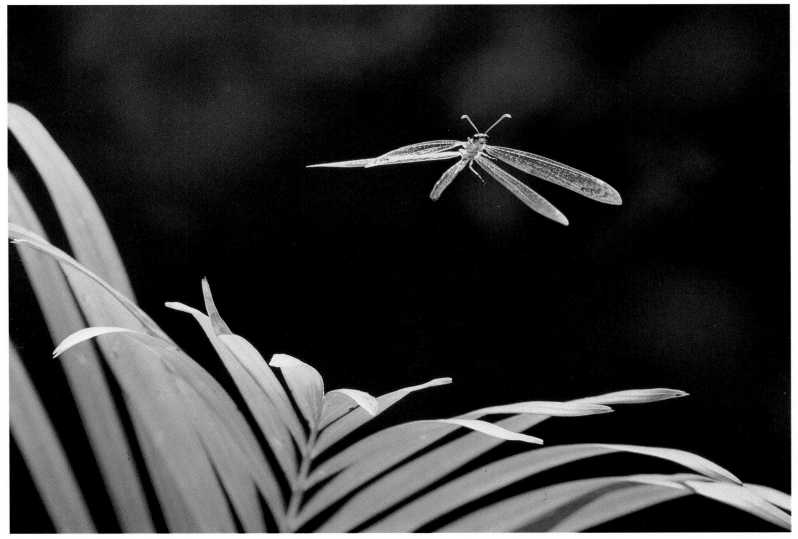

Antlion sailing over a tropical palm leaf

Joel Meyerowitz

Born:
1938, New York City.

Education:
Studied painting and medical drawing at
Ohio State University.

1959:
Returned to New York to work in adver-
tising as art director/designer.

1962:
Took up photography. Subsequently
travelled around the United States and then
Europe.

1971:
Began teaching colour photography at
Cooper Union.

1976:
Received a grant from the New York State
Council on the Arts. Bought an 8 × 10
camera and started work on Cape Cod.

1979:
Travelled to China as the first American
photographer to go up the Yangtze River.

Books:
1979 *Cape Light*.
1980 *St Louis and the Arch*.

Exhibitions:
1968 *My European Trip: Photographs from
a Moving Car*, Museum of Modern Art,
New York.
1978 Museum of Modern Art, New York.
1979 *Cape Light*, Museum of Fine Arts,
Boston.
Corcoran Gallery of Art, Washington.
1980 Stedelijk Museum, Amsterdam.

From the start I was always more interested in photographing in colour
than in black and white, and my earliest pictures were colour slides. But
when I got my bearings in photography I began to feel the need to make
prints. A print can be looked at and read in a way in which a slide can't;
I've rarely seen anyone get up and walk across a room to look closely at
a slide. And so I worked in black and white because at that time it was
the only thing I could print. My re-interest in colour came with changes
in technology: with more advanced enlargers, with the ease of printing
colour and the availability of new colour negative materials. I wanted to
make something that I could hold in my hands, and read, and learn what
colour means to me.

I'm beholden to black and white for everything it's taught me, but I
think that there's a complexity and a density to colour that reveals a
lot more about our feelings. The world is in colour: we live and respond
in colour. We're three-dimensional beings who have terrific refined colour
vision. Colour is the full spectrum, it's everything that we see and know;
we understand things in very subtle ways through our colour perception.

I'm not out to proselytize about colour photography, but for me it has
a fidelity, a range of description that's more complex and more interesting,
and in a sense has more content than black and white photography. If
we look at the same photograph in colour and black and white we will
see different things—one element will be less important, another will be
emphasized; light and dark will be of value in one, and the complete
bite and etch of everything in the frame will be important in the other.

I don't think about colour photography as being about colours, but
about description, describing everything—the envelope of light, the
colour, the textures, the space, the buildings—all of it.

If you want to have that description you have to sacrifice something,
and what I gave up was the speed that I worked with. When I was
shooting black and white on the streets, on a sunny day I could work at
1/1000th of a second at f/8 or f/11 and it drank in everything. There was
nothing out of focus from 4 feet to infinity. You couldn't miss. But with
colour, working at 25 ASA, you have to be very delicate with the balance
and proportion of things: you have to slow down. In a sense I had to give
up those 'decisive moment' gestures and incidents that 35mm photo-
graphy has been based on. Ever since Cartier-Bresson we've been
celebrating the incident, and although that reveals a lot about the world,
it also limits you to becoming a visual athlete making better and better
catches. I found that I began to step back so that I could make an image
that was sharp and refined and had the deep space in it, and as I stepped
back I began to see a new kind of image.

The streets are like a comedy: you never know what's going to happen.
Things are always plunging in from the wings. As you step back you see
the whole procedure; you see the wings, you get a chance to see the deep
space of the theatre. You begin to see down the street rather than just
the plane of an image 10 feet in front of you into which some action
erupts for a moment.

I've begun to think of mine as field photographs in that they are about the entire frame rather than about a subject within it. The subject is the frame and everything in it; the energy is spread out over the entire frame, and this relieves it of the burden of a single incident. It is more purely photographic: the photograph describes *everything* in it, not just an event that hooks you, the viewer, into seeing it.

For working in the kind of dense urban environment that I like to shoot in, I carry a Leica with a 35mm lens. I know Cartier-Bresson has used a 50mm lens for years in Paris, but there the space and scale of the boulevards and the quality of the street lighting is so different that you can get away with that kind of plastic space in the photograph. In New York City you have to work with something that embraces the whole street, something that allows the richness and the energy of the street to pervade the frame. You need that space-gathering quality of the 35 or 28mm lens, especially for colour. In order to engage the high description of colour you have to lay back a little bit; you have got to use a piece of glass that gives you a lot of description. Besides, the 35mm relates very much to our own vision. We don't walk around with a narrow 50mm field, we have a scanning character to our eyes, and I find that the 35mm lens approaches that in a beautiful way.

A 35mm camera is appropriate to use on the street. It's gestural and instantaneous: you could fling the camera around, but at 1/1000th of a second it's going to freeze whatever comes across the lens. But other situations provoke a more steadied, contemplative mode. And so after I had worked with colour for a few years, I decided to go backwards and deal with a tool from the past, with the original voice of the medium. I purchased an old Deardorff 8 × 10 view camera and a good lens (called a 10-inch wide field lens, equivalent to the 35mm on a Leica) and I took myself and my family to Cape Cod. The light there is beautiful and eloquent, and I decided to spend the summer photographing there just to see what colour looked like in that condition and in that place. I found that it opened up doors of perception; it suggested new material to work with.

At the same time it seemed to be the other side of my personality. It's almost as if I've denied myself that contemplative side: I love to study things, to have sensations – sensations of textures, of the smells of a place, those subtle characters. It's a sensual experience to walk through the world, and I'm constantly being touched, embraced, overwhelmed by the colour of things or the presence of things. And yet I've been out there on the street pushing street humour, street vitality, all of that craziness. But this other aspect of the medium allows me to experience the other side of my sensibility, and I find that very rewarding.

The way you actually view through a large-format camera affects the way you see pictures. Day after day you go out with the camera and you have to study the image upside-down. One of the most revealing things about photography itself is to take the work of Atget, Adams or Weston, or any of the view camera photographers, and to look at it upside-down

Joel Meyerowitz started in photography by taking colour photographs but soon switched to black and white because he felt the need to print his own pictures. It was another 10 years before he began printing in colour. By then it was a much more practicable proposition, with improved technology and materials. His interest in colour had been reawakened and he wanted to produce images that could be read more conveniently and more naturally than a projected slide.

He was still mostly photographing life in the streets of New York, whether in black and white or in colour, using a Leica and a wide-angle lens. With a fast black and white film he could work on a sunny day at an exposure of 1/1000th second at f/8 or f/11. The depth of field stretched from about 4ft to infinity, it drank in everything. The shutter speed stopped every action. But once he turned to colour he was forced to change his technique. The film was so slow that in order to retain the depth of field he wanted, he had to sacrifice fast shutter speeds; he had to give up trying to snatch gestures and incidents. As a result he began to see things differently. He began to see down the street, to take a calmer look into deeper space, rather than nervously anticipating some action that might erupt for a fraction of a second in a zone about 10ft away from the camera.

The decision to take a photograph became more complex. Once the picture no longer revolved around a single event, it more obviously described everything in it, the whole field of view became the subject. Sometimes a picture might hinge on a particular element, it might provide the stimulus to take a photograph now rather than later, but it would not assume an overriding importance in the image.

Colour acquired a new significance as the priority of the photograph became description. Meyerowitz said, 'Colour photography has a fidelity, a range of description that is more complex and more interesting for me than black and white. In a sense it has more content. There is more to know and more to see in a colour photograph.'

Almost inevitably, he moved on to large-format work. He bought an old Deardorff 10 × 8 camera with a wide-field 250mm Ektar lens, and shot Vericolor 2 colour negative film. With experience he was able to increase his control over the medium, and the image quality of his large prints is indescribably rich, '. . . there's no grain, everything is told in this airy, seamless space.'

He photographed at Cape Cod throughout the summers of 1976 and 1977, getting accustomed to the formality of the view

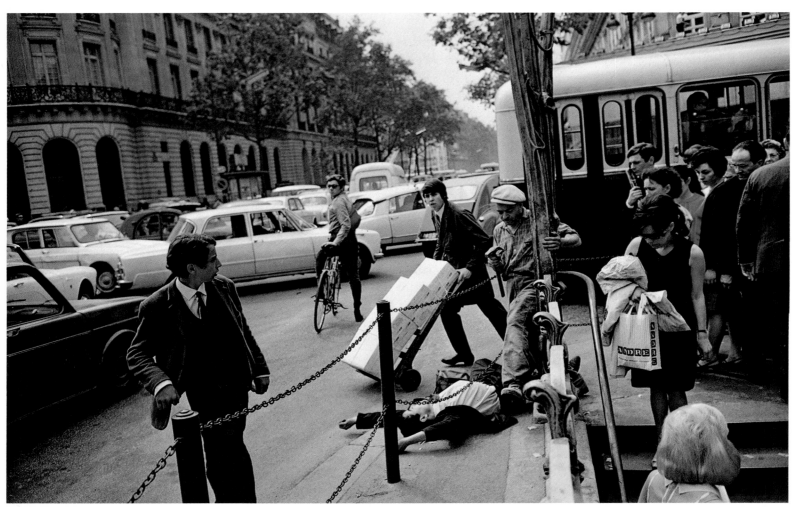

Paris 1967

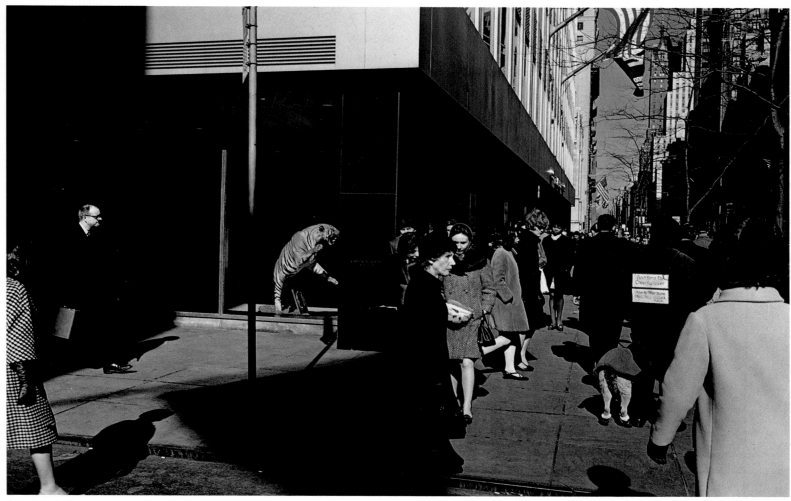

New York City 1976

New York City 1976

St Louis 1977

St Louis 1978

St Louis 1977

Cape Cod 1976

Cape Cod 1977

St Louis 1977

St Louis 1977

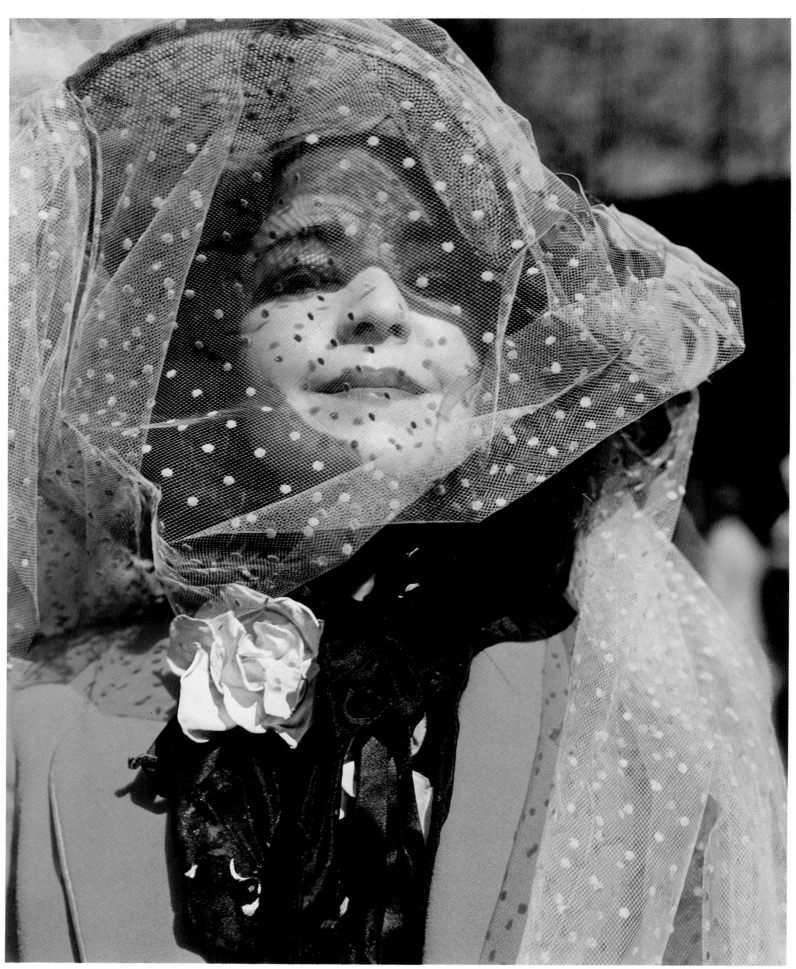

New York City 1980

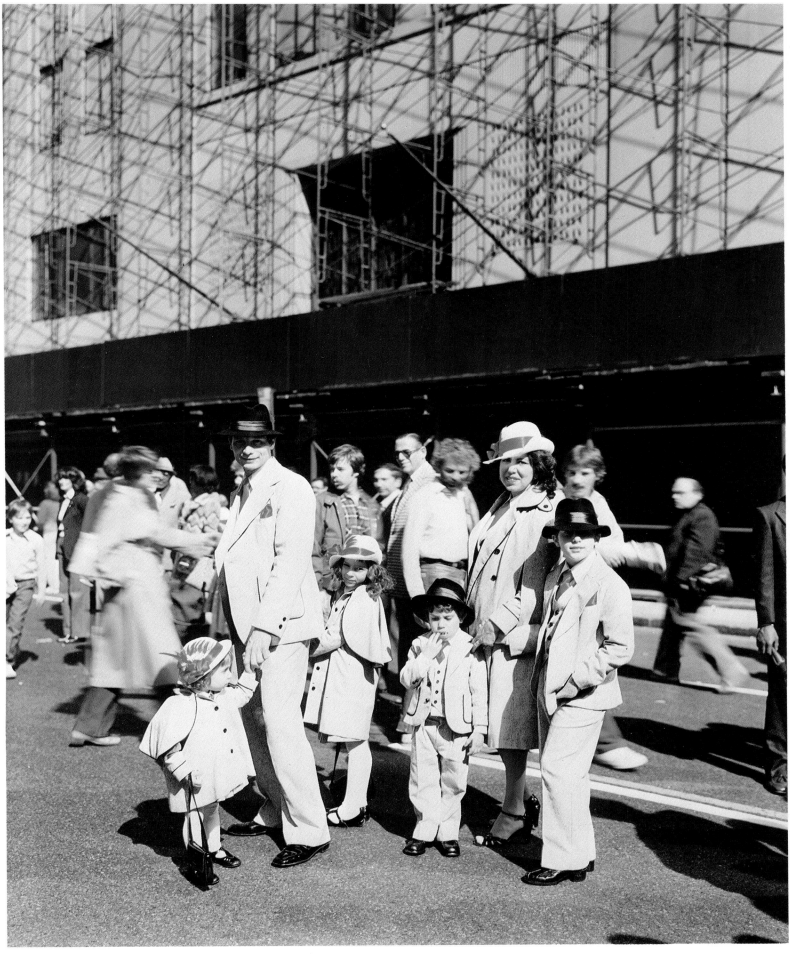

New York City 1980

Don McCullin

Born:
1935, in St Pancras, London.

Education:
1944-49 Primary and Secondary Modern Schools in London.
1949 Won Trade Art Scholarship (for drawing ability) to Hammersmith School of Arts and Crafts.

1958:
Bought his first camera (Rolleicord).

1959:
First picture story, *Guv'nors of the Seven Sisters Road*, published by *The Observer*. Went freelance.

1961:
Pictures of the Berlin Wall published by *The Observer*. Received press photography award.

1962 on:
Worked regularly for various magazines including *The Observer, Town, The Daily Telegraph* and *Sunday Times*.

Publications:
1971 *The Destruction Business*.
1979 *The Homecoming*.
The Palestinians.
1980 *Hearts of Darkness*.

Exhibitions:
1971 *The Uncertain Day*, Kodak Gallery, London.
1980 Victoria and Albert Museum, London.

My approach to photography has always been a very physical one. My work has demanded a certain toughness and fitness, and I have always thrown all my energy into it. But even more than that, my pictures have a quality of almost physical contact.

Over the last twenty years I have covered many wars and other human tragedies. And I have always done so in a very direct, rugged way. I never move into such situations with a stock of preconceived ideas. I am very aware of the work of other photographers and how some of them pride themselves on the intellectual content of their pictures. But I deliberately operate quite differently. I go in with an open mind, ready to take what I can get. I go straight in there – and do it.

I can appreciate the other possibilities; for instance, how in the Vietnam War one could relate the American war machine to the basic life of the peasantry, and so on. But I do not want to be too heavily involved with the intellectual and the artistic pretensions of photography. That is a burden I do not need to carry. The essence of my work I hope is simplicity.

The first time I became aware of this physical quality in photography was in the pictures of the American, William Klein. His photographs were always taken as though the camera were almost rammed up the very nose of the subject. It set me thinking, and I began to explore this very direct approach myself. His printing attracted me too, the strong blacks and the dramatic use of contrast. Bill Brandt's pictures appealed to me in the same way.

When I was young and went to war for the first time, I thought it was a terrific adventure. The sound of gunfire, that crackling in the air, used to make my hair stand up. I wasn't really sure why I was there – to take photographs or just to prove how exciting it was.

At first I had a total disregard for what was flying around. There was nothing I was afraid of, I used to take enormous risks. I wanted to become known in photography. I wanted to open doors that would normally be closed for me. Half the problem in life is getting people to believe in you and give you the chance actually to show what you can do. I thought war photography would give me the opportunity to prove myself. I didn't know much about war, but it seemed to me that photographing it successfully was just a physical problem. It was a matter of being strong enough and perhaps stupid enough to get really close to it. I knew I could take good pictures. If I hadn't believed in myself, I wouldn't have continued.

It took two or three years for that excitement to diminish, for those feelings to change. People started to talk about my pictures. They kept saying that I did not realize what effect my photographs were having, how upsetting they were. So I realized that my photography was finally succeeding. I could see the reactions, and I began to work even more precisely, searching out the really bad scenes to make people aware of them.

Of course I came in for a lot of criticism, some of it very hurtful. There *is* a certain mercenary element in what I've done and that does disturb me,

but the rights and wrongs of the situation are not as simple as some people make out.

I've recorded what some human beings have done to others. Is it better that we let these things happen and there is no witness, nothing to show us what is actually going on? If I am going to stand there in front of those families of dying Biafran kids hoping for food, or some soldier shot in the throat and dying, or a man lying next to me in a truck in Cambodia with all his stomach blown out, if I am going to do that, then I am going to show it exactly how it is and not just dress it up a little so that it is acceptable. To me, that would be self-indulgent, just being a voyeur.

In a war I'm up with the front-line soldiers. I take what they get, I sleep where they do, I help them when they're in trouble. When they see the stuff coming in and they're all terrified, lying down clawing the ground and wondering if they're going to get through the day, and they see me doing the same thing, I become one of their comrades. I'm taking photographs, but I always behave like a person first and a photographer second. There is never any occasion when I behave as *the* photographer. You have to behave as a human being.

Once I was in a battle in Vietnam and a marine had just been hit in the jaw by two bullets. It was really a severe wound, the jaw was shattered. I was crawling down the road under fire and I saw him sitting there with a medic. I raised my camera but he tried to move his head and eyes, which meant, *No!* And I didn't do it. I went away. If ever someone says 'No!' in those circumstances, there is no way in the world that I am going to override that request and take a picture.

I've always tried to work with a reasonable amount of consent. It's a very thin line. I've walked that line, I've been on both sides of it and I'm in a better position to know what is involved than people who just sit in the comfort of their homes in England. Sometimes I am asked whether taking photographs of people in such distress doesn't add to their misery. When I was injured in Cambodia, I was in deep shock. I was rolling around in agony and I had no idea what was going on. A whole film crew could have been there and it wouldn't have made the slightest difference to me. I think when people are in such shock, they are so dazed that you can't hurt them any more.

People sometimes fail to understand how much the photographer himself is emotionally disturbed by what he photographs. They think that all war photographers are just ruthless and relentless. But some picture of mine that they saw a couple of years ago has probably stopped hurting them – it is still hurting me.

The first war I covered was in Cyprus. I was in a room with these dead bodies, their relatives and friends. I tried to wedge myself tightly against a door because I was so emotionally upset by what was happening that I could barely keep the camera still. But outside in the street battles, the dangers meant nothing to me.

Even now my greatest fear is being closely confined in such grief-stricken situations. I remember in Beirut a couple of years ago, all the

Don McCullin was a fine photographer before he ever tackled a war story. His early work in London and in the industrial areas of north-east England, together with a handful of landscapes and a few news pictures, had a quality that was more than just promising. But these images were imbued with a mood of latent violence and melancholy that presaged his later achievement.

More than any other photographer, he has confronted us with the foulest horrors of battle and of natural disasters. He has rubbed our noses in the evidence. Others have aroused our compassion, our interest, our dismay, our cynicism, and even our sense of wonder or pride at people's will to survive. But our instinctive response to so many of McCullin's pictures is disgust at what he forces us to witness. His skill sharpens rather than softens the visual outrage.

He is obviously uncomfortable at being so remorselessly typecast in his combat role and he would dearly like to establish his reputation on a much broader base. The very strength of his popular image may work against him in the short term but he feels that he is at a turning-point in his development and he is restless to widen his scope.

The intensity of his photographs has largely depended not only on the subject matter but also on the style and quality of his printing. A long-time admirer of Bill Brandt, he too makes dramatic, though more moderate, use of tonal contrast. He is a superb printer and has often emphasized how much he puts into his darkroom work: '. . . I talk inside me with my emotions, and I will that print to come the way I want it to. It's energy. It's all there in me. That's my hallmark, my print.'

He is meticulous too about producing good negatives, taking frequent exposure readings even under heavy fire. As he says, it is futile risking so much only to end up with unprintable pictures.

For professional reasons he has occasionally to shoot colour but he much prefers working in black and white, standardizing on Tri-X film. Colour, he feels, is an extravagance he does not need. Black and white has a much more forceful presence and is simpler to control.

His choice of equipment is careful and conservative. He carries only what his experience has taught him is essential and reliable. He actively distrusts automatic exposure systems, putting his faith firmly in manual operation and a hand-held exposure meter. McCullin is not so narrowly practical that he does not marvel sometimes at the technology of photography, but he is too sensible to be awed by its mystique.

women were sent out of a house and these two prisoners were pushed into a little stairwell. I saw them shot down at absolutely point-blank range. I was literally shaking with emotion as I walked away. I went into another empty apartment just to stand on my own and recover from the shock. And yet people take so much for granted your experience in being able to cope with such tragedies.

Whatever their short-term effects I don't think my photographs have done an enormous amount of good. The trouble is that people see a photograph and they are terribly disturbed by it, then they have to worry about their mortgages, their new cars and their foreign holidays. My pictures need to be shown and then shown over and over again, so that we don't forget. People have probably forgotten already what happened at My Lai.

I don't mind taking risks. If I am prepared to photograph someone else having a hard time, I have to accept sharing those dangers myself. I'm not afraid even to this day, but I do have a more rational sense of self preservation. But professionally, the situation now is very different from when I started. Then there were hardly any trained war photographers, apart from Larry Burrows and a small handful of others. The field was wide open. Many battles I covered on my own. But by the time of the Yom Kippur war I saw 500 correspondents clambering to get into some Press conference. It was one of the turning points for me, apart from the fact that I had just seen one of my colleagues killed. I did not want to be part of that kind of gang, pushing and shoving to get pictures. I want to retain some kind of individuality. Now, as far as war is concerned, I feel as though someone has forced down my throat another can of beer that I just can't take. I'm still interested in photographing people, but I would like to show their way of life without them being on the floor in front of me bleeding.

I don't want to be labelled as just a war photographer. In many ways war is all too easy to photograph. You just have to grit your teeth and hope you can keep your eyes open. When I was younger I did what I was assigned to do. As I said, I wanted to prove myself and I had to support my family. But now when perhaps I'm a little more privileged, it is easier to pick and choose what I want to do. I can look for more creative ideas, for different opportunities.

A good example is my new book about the British. After all those months and years spent abroad, covering one tragedy after another, I wanted to rediscover my own country, to photograph the people I know best. It took me about two and a half years in between assignments, and I know that the result is as much about me as about the British themselves. It's my mind and my thinking, and that's my photography.

I like working in half-light and in areas that are a bit seedy, because for me photography has to have a fair amount of drama. If it doesn't have that kind of impact, some sense of mood, then I think the photograph is too weak. My photographs have to be strong, they have to stand out – more so now than ever, since so many photographers are involved with

similar social subjects. I do not want my technique to override the subject itself, to take away from the content, but it must stand out, it must have my hallmark on it.

I don't consider myself an artist, but I am very sensuous about my photography. And my prints are a way of expressing my energy and my feelings for light and shade. My kind of photography can only be represented by my fist-like black and white prints, by my really upfront presentation.

I find colour very weak. I can do it of course. I can photograph pretty landscapes, pretty foreign country assignments, but I'm not really interested in it. I remember meeting Edward Steichen at the Museum of Modern Art in New York, just before he died. He asked me what I did and I said I just worked in black and white. He said, 'Black and white is dead.' And I said, 'I'm sorry to disagree with you, but I think black and white photography is going from strength to strength.' I suppose we agreed to differ.

Some photographers boast that they never get an exposure wrong. I just don't believe them. Even in the middle of a war, I use my exposure meter continually. I don't want to risk getting killed and then get the exposures all wrong. I always use the same film – Tri-X – and in general I like to be very basic about my photography. I'm not a very technical person and to me cameras are just tools to do a job. The real camera is me. Without that little black box I couldn't transfer my feelings into images, but for all that it is still a tool.

I simply do not trust automatic cameras. If I use them it is always on manual. I don't want photography taken away from me by some silicon chip. I want photography to be a manual, human thing that I deal with through my own body and my own hands. The camera they *can't* make is the one I've already got in my head – it's my eyes and my mind and my heart.

On assignment I carry two working bodies and two in reserve, wrapped up carefully in foam rubber. Again it's simply being professional, taking logical precautions. I like using the motor winders – not the motor drives, just the winders. The only lenses I use are the 35mm, 28mm and the 135mm.

Sometimes I think I would like to buy an old plate camera and photograph landscapes. There is a romantic side to me that enjoys being close to Nature and being able to capture it in a thoughtful, considered way. I want to explore all these dimensions of my photography, to rekindle old ideas I didn't have time to finish and to experiment with new ones.

Nothing excites me more than photographing the landscape. Only the other night I went across the fields and quietly took pictures of a pond over there that was half dried up. It was nine o'clock and there was hardly any light at all. I can't remember feeling happier in a long time. It was like a cleansing of my soul.

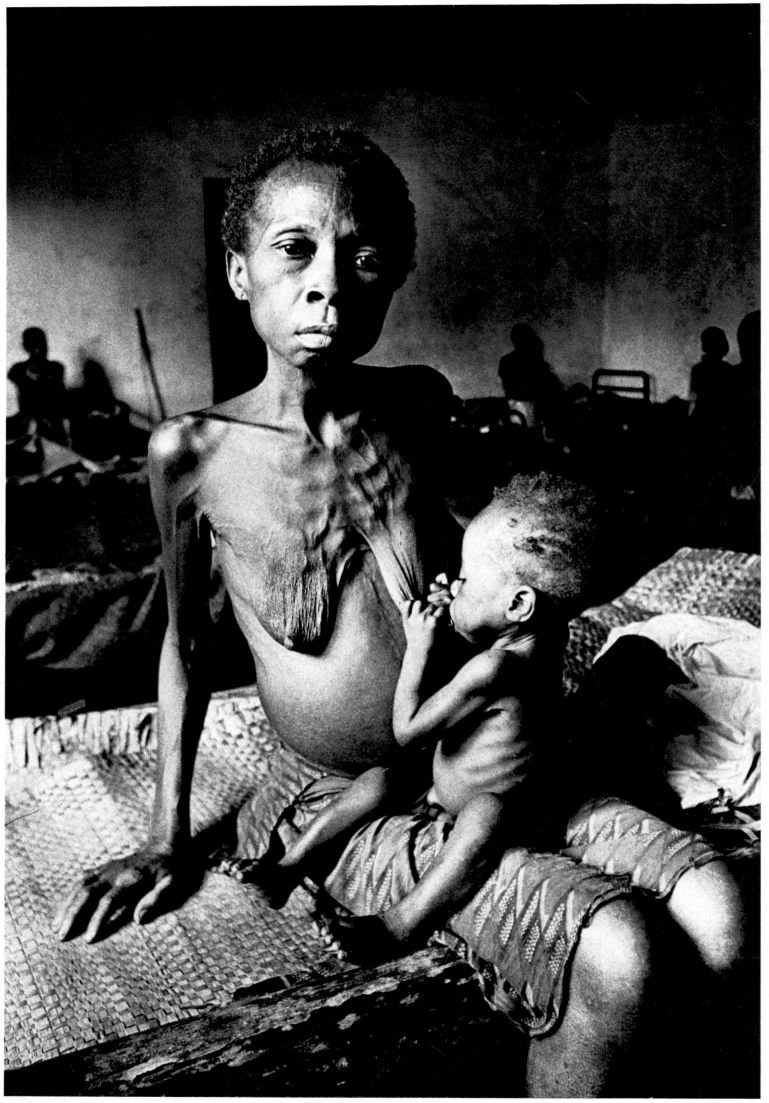

Biafra 1969

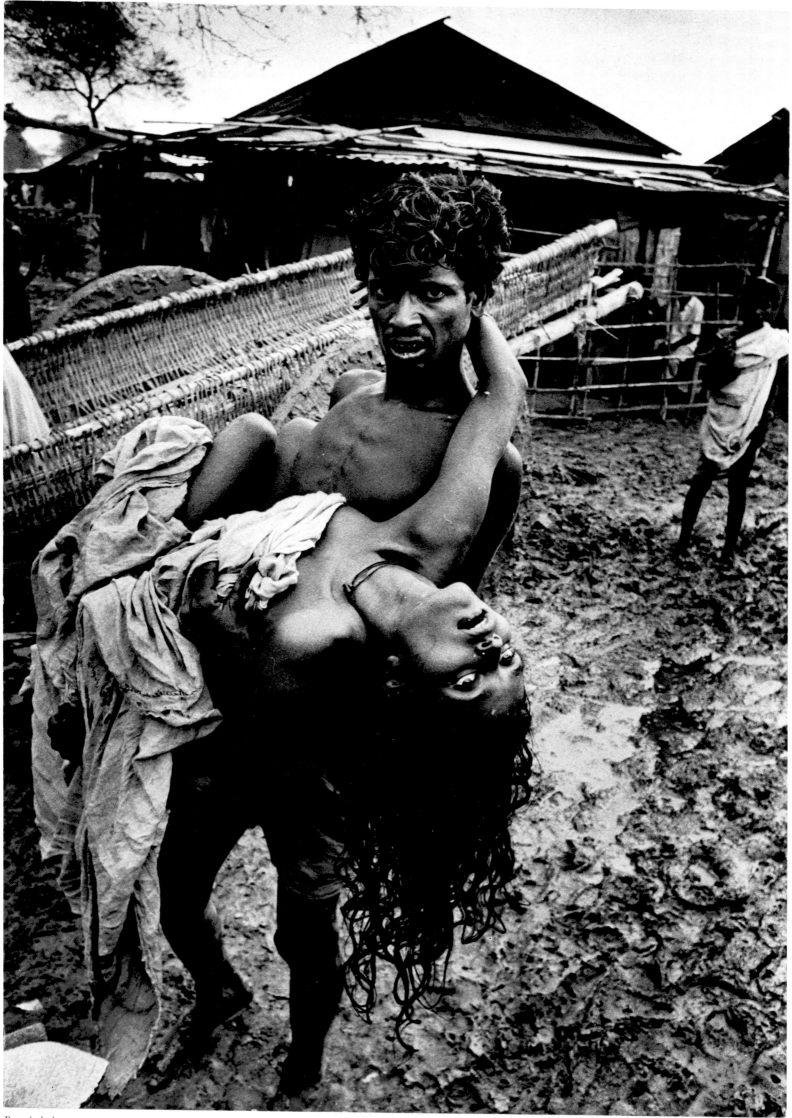

Bangladesh 1971

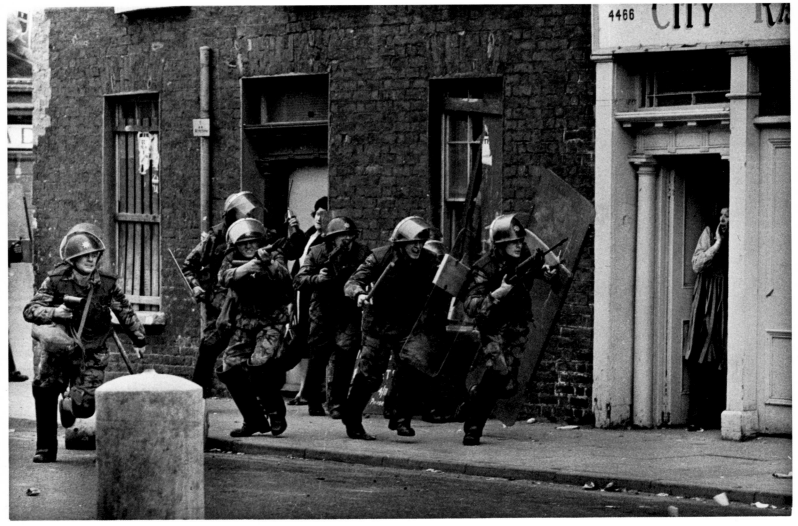

Londonderry 1970

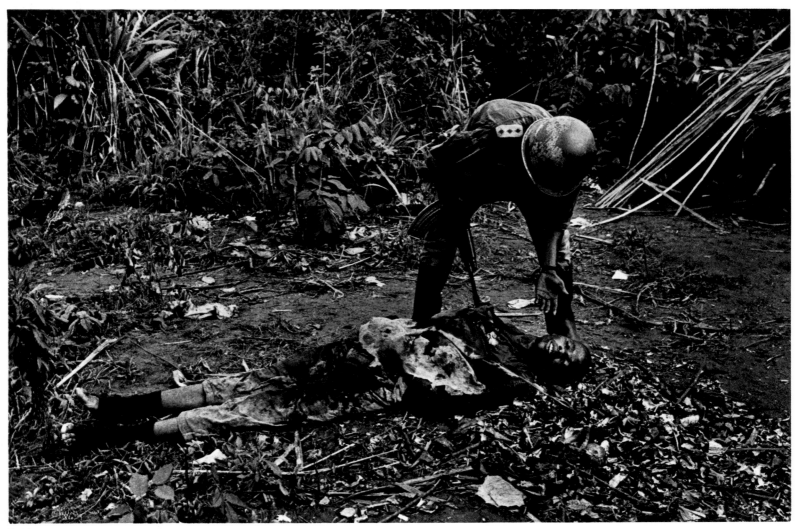

Biafra 1969

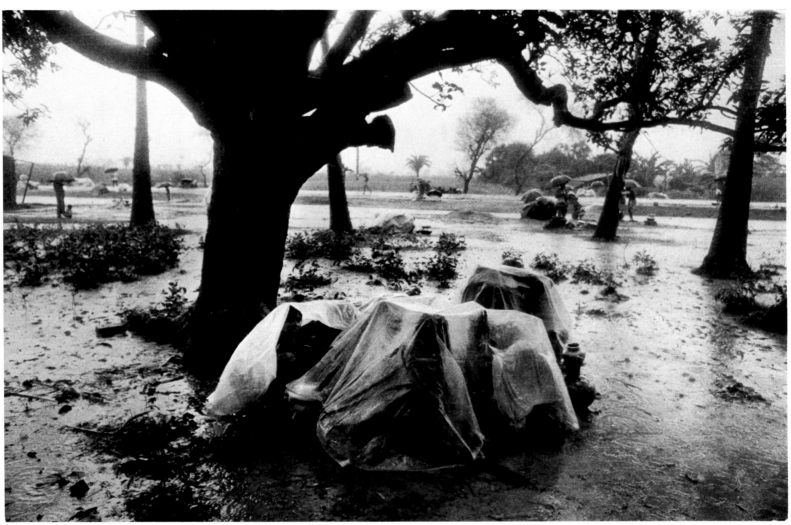

Bangladesh 1972

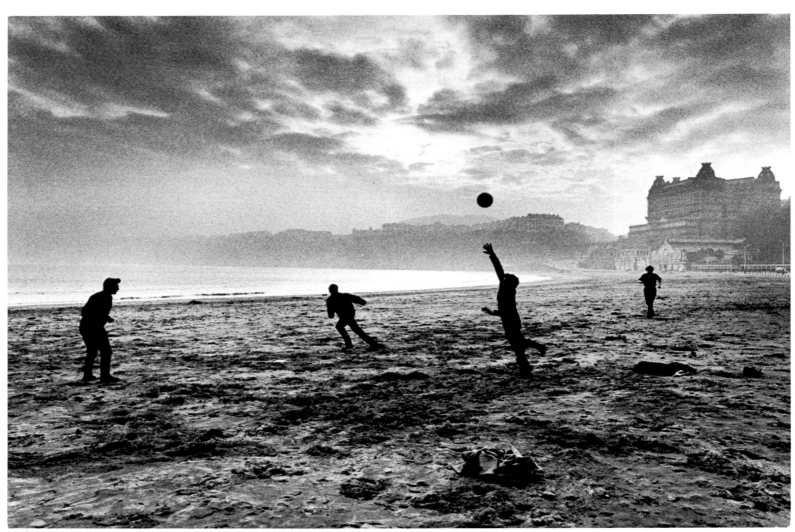

Scarborough 1967

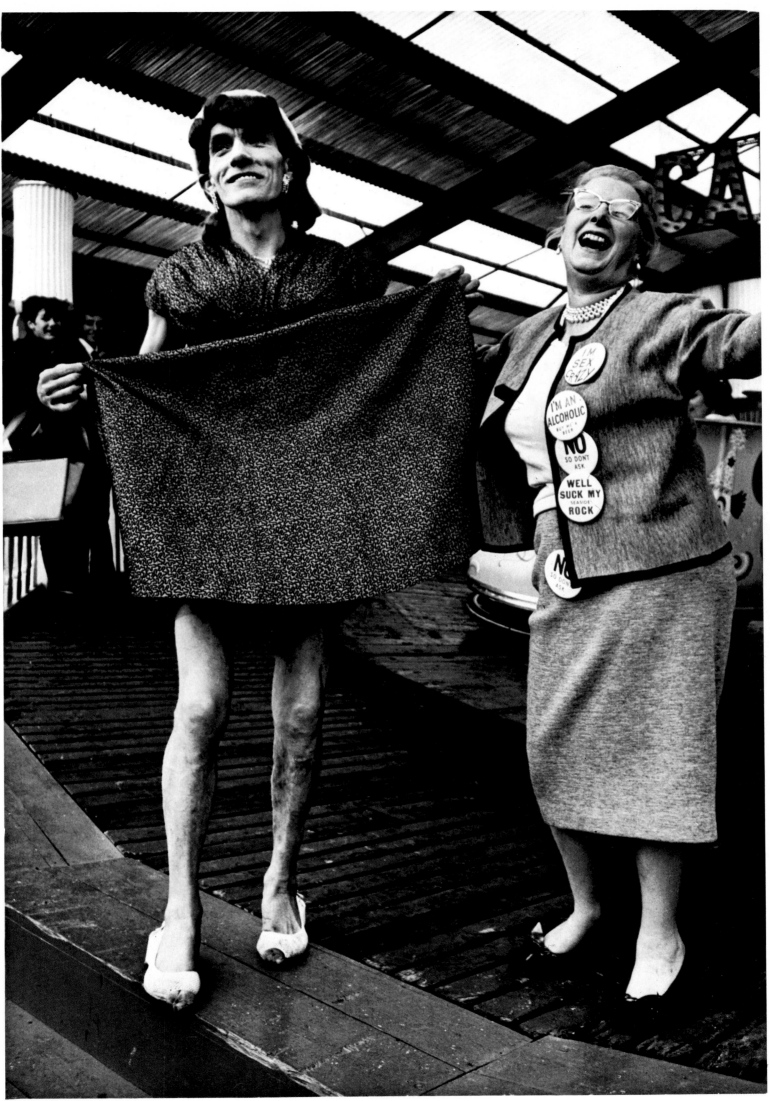

Southend 1969

Brassaï

Born:
9 September 1899, in Brasso, Transylvania
(Hungary, now Rumania).

Education:
Studied at the School of Fine Arts in
Budapest and in Berlin.

1924:
Moved to Paris, where he has lived ever
since, undertaking occasional trips abroad.
During this time he has met such famous
figures as Henry Miller, Picasso, André
Breton, Paul Eluard, Salvador Dali and
Giacometti; he also contributed to
periodicals such as *Minotaure, Harper's
Bazaar, Verve* and *Labyrinthe*.

1956:
Received a prize for his film *Tant qu'il y
aura des bêtes* at the ninth annual Cannes
Film Festival.

1958:
Executed the 9-metre photographic mural
Les Roseaux for the Unesco building in
Paris.

Books:
1932 *Paris de Nuit.*
1934 *Voluptés de Paris.*
1948 *Les Sculptures de Picasso.*
1949 *Brassaï: Camera in Paris.*
1951 *Formes.*
1952 *Brassaï 'Oeil de Paris'.*
1954 *Seville en fête.*
1960 *Graffiti.*
1968 *Brassaï* (Text by John Szarkowski and
Lawrence Durrell).
1973 *Portfolio Brassaï.*
1976 *Le Paris Secret des Années 30.*

Exhibitions:
Brassaï has exhibited drawings, sculptures
and tapestries on many occasions as well as
photographs. The following are among the
most important of his many photographic
exhibitions.
1933 Batsford Gallery, London.
1946 Palais des Beaux-Arts, Brussels.
1954 Art Institute of Chicago.
1956-64 *Graffiti* shown at The Museum of
Modern Art, New York, and at the
Institute of Contemporary Art, London, as
well as in galleries in Milan, Paris, Rome
and Baden Baden.
1959 Limelight Gallery, New York.
1963 Bibliothèque Nationale, Paris.
1966 Kölnischer Kunstverein, Cologne.
1968 Museum of Modern Art, New York.
1971-74 Under the sponsorship of The
Museum of Modern Art, a travelling
exhibition of 75 prints shown in Australia,
New Zealand, Venezuela, Columbia, Peru,
Brazil and Mexico.
1976 Marlborough Gallery, New York.
1980 The Photographers' Gallery, London.

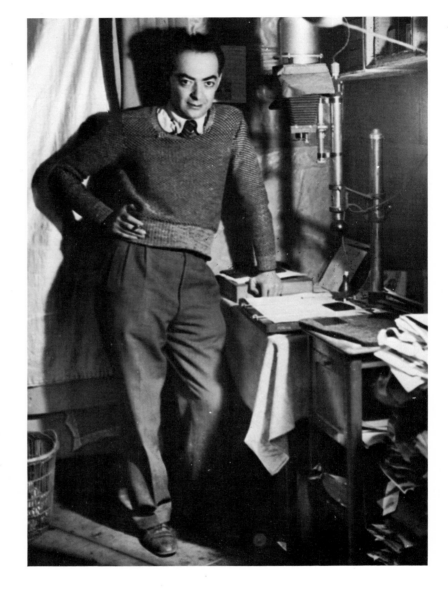

One of the trials of old age—its curse even—is having to reiterate the same things over and over again: the same date and place of birth, the same old biographical details. How I admire and envy those Japanese artists who, like Hokusaï, seem to have changed names several times during their lifetime, in order to escape the monotony of having to drag an official identity behind them as a convict drags his ball and chain. This enables them instead to start again at the beginning. I hope I will be forgiven then, if I do not dwell on the umpteenth repetition of the fact that I was born in the last year of the 19th century, on the 9th day of the 9th month, 1899 (and indeed the number 9 has been significant throughout my life) in Transylvania—a beautiful, mountainous land in the Carpathian region covered with forests of fir-trees and inhabited by brown bears, and now notorious for the horrible crimes of Dracula which have been attributed to the area in numerous horror films. Strangely enough, when I was living

in Brasso, the town where I was born and the one from which I borrowed my name (Brassaï meaning 'from Brasso' in Hungarian) I had never heard the name of Dracula, and it was with surprise that I learned that this aristocratic sadist was supposed to have had the citizens of the town tortured and impaled on stakes.

Every creative person has a second date of birth, and one which is more important than the first: that on which he discovers what his true vocation is. Mine came quite late in life, and I can pinpoint it with reasonable accuracy. In a letter sent from Paris to my parents I wrote: 'I have managed to get hold of a camera and for some weeks now I have been busy taking photographs. The results are quite encouraging, as you can tell from the photographs I am sending. I am thinking of getting some really good photographic equipment before long.' This letter, dated 11th March 1930, shows that I was beginning to take photographs in February 1930, over fifty years – *half a century* – ago.

Why did I not get interested in photography until so late in life? I originally intended to devote myself to painting and sculpture; I regarded photography with the same prejudice, the same contempt as was then prevalent, for at this period it was not recognized as being a means of expression worthy of serious consideration. So, until my thirtieth year, I had never held a camera in my hand. But during my stay in France my ideas underwent a slow change of direction.

I had arrived in Paris in 1924, and was leading the life of a nocturnal wanderer, retiring at sunrise, rising again at sunset. During these thousand and one nights – or rather, two thousand and one nights, for this period of Bohemian life lasted nearly six years – during my night-time walks through the capital, I covered the ground from Montparnasse to Montmartre, crossing the bridges over the Seine, walking through the garden of the Tuileries and the 'Belly of Paris' as Les Halles were known, and along the 'Grands Boulevards'; I walked through the peripheral districts under the pink Parisian sky, in the spring – that time of emotive awakening – in the mists of autumn and the snows of winter; I was struck, overwhelmed even, by the images which this nocturnal town never ceased to reveal to my eyes, and also by the extraordinary fauna that consisted of the colonies of people who lived by night. By what means could these images be recorded? It was thus that, using an amateur's camera that a woman had lent me, I began to capture the nocturnal images which had been haunting me for so long.

There is no doubt that the example of my friend André Kertész had something to do with this change of direction. Having set aside my vocation as painter and sculptor for the first six years of my Parisian life (so much more interesting did I find life itself) I made a living by journalism, principally by working on illustrated German magazines. For the illustrations for my articles I turned to various photographers, including André Kertész. At my instigation he carried out half a dozen or more news stories. For example, I had him photograph Eiffel's apartment at the top of his celebrated tower; the great evening performance given

Brassaï was inspired to take up photography after meeting André Kertész in Paris in about 1926. 'This was a happy event if ever there was one, since thanks to seeing his pictures and listening to what he said about them, I discovered how much this "spiritless and soulless mechanism", this "technical process", had enriched man's means of expression. This eliminated my prejudices, I was trapped by photography. But the bird catcher was exceptionally good.'

Initially Brassaï followed Kertész's example and advice, but he soon proved his own individual talent, often working in conditions that were not only technically difficult but also personally dangerous. An avowed 'noctambulist', he determined to photograph Paris night-life, and bought a good camera – a Voigtländer Bergheil with f/4.5 Heliar lens. He was keen to do his own developing and enlarging, and turned his hotel room into a darkroom. (Even today, he still makes his own prints. He said once, 'Of all printing papers I love the glossy – it's the only type that tells you straight away that you have to do with photography and nothing else.')

Some members of the Parisian underworld were less than sympathetic to being photographed by Brassaï and several times he was seriously threatened with violence. But he persisted and his pictures are remarkable for their close-up portrayal of very sensitive situations and for their technical quality despite so many problems.

However, he certainly never indulged any fetish for equipment. In the introduction to the Museum of Modern Art monograph on Brassaï, Lawrence Durrell tells a revealing story about being photographed by him. Owing to a muddle over dates, Brassaï turned up to find Durrell already in the middle of a photo session with two young American press photographers, elaborately equipped and frantically industrious; '. . . their idea seemed to be to shoot a million pictures before selecting one for printing.'

In complete contrast, Brassaï '. . . had hardly any equipment at all, one very old camera with a cracked lens hood, a tripod which kept kneeling down like a camel – really amazing equipment, but as cherished as it was venerable. "After twenty years you can begin to be sure of what a camera will do." '

Durrell noted some of Brassaï's comments to the young photographers – very respectful, once they learned his name. 'Yes, I only take one or two or three pictures of a subject, unless I get carried away; I find it concentrates one more to shoot less. Of course it's chancy; when you shoot a lot you stand a better chance, but then you are subjecting yourself to the law of accident –

if accident has a law. I prefer to try and if necessary fail. When I succeed, however, I am much happier than I would be if I shot a million pictures on the off-chance. I feel that I have really made it myself, that picture, not won it in a lottery.'

And later, 'Another thing today is to try and trap your subject off his guard, in the erroneous belief that you will reveal something special about him if you do so. This leads to tricks in the end. I don't do things that way, I can't.'

Durrell also quotes from an interview with Brassaï on Paris radio: 'When I do a picture of someone, I like to render the immobility of the face – of the person thrown back on his own inner solitude. The mobility of the face is always an accident . . . but I hunt for what is permanent.'

Brassaï's photographs never seem accidental and are rarely oblique. They have a robust directness, a single and sturdy dignity, and a warm, even mischievous humanity.

annually by the Molier Circus – that extraordinary worldly circus in the Rue de la Faisanderie in which all the routines were performed by ordinary men and women – and Robinson's restaurants, where the meals are served in the tops of old trees, at tables perched high up on the branches in the midst of all the foliage.

When in 1957 I saw Kertész again in New York, twenty years after his departure for the United States, he was waiting for me at the quayside where the steamers from Europe used to dock. The first thing he said was: 'I am dead and buried . . . this is a corpse you are looking at. . . .' And he explained to me how, although he was making plenty of money photographing luxurious interiors for Condé Nast's *House and Garden*, his real photographic work and his name were completely unknown, and he was unable to find anyone to promote them. One day I spoke about Kertész's moral predicament to Romeo Martinez, who was then editor of the Swiss periodical *Camera*. 'Brassaï,' he said to me, 'if you would like to write an article about Kertész, I am prepared to devote an entire issue to him.' I accepted his proposal with delight. The piece I wrote, entitled *My Friend André Kertész*, appeared in April 1963 in English, German and French. Kertész was subsequently invited to exhibit in Venice, then at the Bibliothèque Nationale in Paris; he was also 'discovered' in the United States, where the Museum of Modern Art gave him an exhibition and published his monograph. Kertész wrote to me several times to express his thanks.

I admired Kertész's photographs and have always said that I found his example stimulating. But he never lent me a camera, as has sometimes been written; I never worked in his laboratory and I was not 'his pupil'. Otherwise Bach might be called the 'pupil' of Buxtehude because, when listening to the latter giving his evening recital at Lübeck, he felt as if he was hearing his own music revealed to him for the first time; and Mozart might be called the 'pupil' of Haydn because Haydn's music was a source of inspiration to him. My photographs and those of Kertész are a world apart; and indeed this is confirmed by John Szarkowski, Director of Photography at the Museum of Modern Art, New York.

In contrast to the poetic and almost feminine indirection of Kertész's imagination, that of Brassaï is blunt, unornamented and muscular.

He goes on to say:

Brassaï, like Atget, came to photography as a man of broad experience and mature intellect. The adult Brassaï adopted the camera not as a magic toy to be explored in a spirit of play, but as a tool, the use of which though demanding, was simple in principle. Photography could describe clearly and objectively those facts that interested him.

(John Szarkowski: *Brassaï: Photographs*, October 29, 1968.

Wall label, Museum of Modern Art, New York.)

The 'facts' which obsessed me between 1930 and 1934 consisted above all of the night-life of Paris, from which I compiled a large fresco of urban landscapes, published in Paris and London in my first book *Paris by Night* (November 1932) and in a sort of photographic study of manners and

customs in the Paris underworld, which did not see the light of day until forty-five years later, in my *Secret Paris of the 30s*.

It was at this time that I also began to collect the graffiti of the walls of Paris. The first series of these was published in 1934 in issues 3 and 4 of the semi-surrealist review *Minotaure*. These graffiti were shown in a dozen exhibitions, notably at the Museum of Modern Art in New York in 1956 and at the Institute of Contemporary Art in London in 1958. They appeared in book form with my own text in 1960. There were many other subjects that obsessed me. Indeed it is my opinion that in the absence of a subject with which you are passionately involved, and without the excitement that drives you to grasp it and exhaust it, you may take some beautiful pictures, but not a photographic *oeuvre*. It was therefore with pleasure that I read the following words written by a critic as early as 1953:

> Brassaï is one of those very rare photographers, the expression of whose thought has crystallized into an integrated *oeuvre*, and who is now becoming known to the public on the same plane and by the same means as some writers are known. Indeed, Brassaï's prints engrave themselves on the memory with an emotional impact similar to that experienced during the reading of a literary work, and the emotions themselves are comparable. In other words, these emotions have a source, a development and a conclusion, following a certain necessary progression. From the beginning Brassaï has conceived his creations as works belonging to a greater whole.
>
> (Jean Gallian, *Photo-Monde*, October 1953.)

Recently an interviewer asked me if it was not an act of courage on my part to abandon my other talents in order to take up photography, which was not then considered to be a major form of art. In reply I agreed it was true that in the thirties photography was still the poor relation among the arts, and that photographers themselves were treated with shocking indifference or contempt. Thus, when I published my *Paris by Night*, it was actually presented as being a book by Paul Morand, a diplomat and an author who was fashionable at the time. In fact, he had contributed nothing to it except an introduction. There was nothing abnormal about this in France and it took an American journalist, one who was ahead of his time, to express outrage at this injustice.

> There is nothing like having a reputation. On the upper left-hand corner of *Paris de Nuit* appears in large letters the name of Paul Morand, who contributes to this book eight pages of more or less routine text. Somewhere down in the lower right-hand corner, in smaller type, hidden away with the name of the publisher, one finds the name of Brassaï, whose 60 photographs are the *raison d'être* of the book. The only consolation to be derived from this obvious injustice is the reflection that, judging from a comparison of the results achieved by the two, Brassaï's name will still be known when Paul Morand's has been forgotten.
>
> (Waverley Lewis Root: 'Brassaï Makes Photo Record of Nocturnal Paris.' *Chicago Daily Tribune*, 13th March 1933.)

I could also cite the example of Picasso. He came to visit me once, and having seen my drawings he cried out, quite shocked: 'But Brassaï, how can you go on working a salt mine when you are the owner of a gold mine?' For Picasso, the 'salt mine' was naturally photography and the 'gold mine' drawing or painting. But as I have already said, my ideas had been undergoing a slow change of direction – the same reversal, as it happens, that twentieth century thought underwent forty years or so later when it discovered its *specific and irreplaceable* means of expression in photography. In fact, it was only towards 1970 that art galleries, museums and private collections opened their doors to photography on any scale. Nevertheless I have never considered photography to be an art.

When in 1950 I stated in an interview that photography was not an art it provoked a storm of indignation and protest from photographers, and unleashed in one magazine a controversy which lasted for several months.

However, to wish at all costs to place photography among the Fine Arts, somewhere in between painting and engraving, is to deprive it of its striking *innovative* quality. (This is what the English photographer P. H. Emerson insisted on doing; he awarded me the last of his medals, for *Paris by Night*.) Photography is an intruder among the arts, a discordant note spoiling their harmony. All the faults of which it has been accused – too great precision, dependence on reality, lack of scope for imagination, invention and spiritual quality – all these 'faults' are in fact its positive qualities, qualities of *non-art*, even of *anti-art*. It is just these 'faults' which should have been cultivated and explored, rather than photography being used to mimic the Fine Arts, as all the exponents of the 'pictorialist' movements in photography were striving to do. This is my deep conviction as I expressed it the very first time I wrote about photography, in an article entitled *Latent Images*, published in *L'Intransigeant* in November 1932. As my conviction has not altered over half a century, I can do no better than quote the following passages from the article.

> What did photography bring us? A breath of fresh air, a strong smell of reality; it gave things an almost tangible presence, an indefinable note of authenticity and truth. It completely renewed our relationship with the universe.
>
> Before the invention of photography, nothing could come to us without the eternal artist acting as interpreter; everything was transfigured, if not by the creative imagination of genius, then imitated for better or for worse by draughtsmen or engravers, or dressed up with trashy beauty by mediocre artists. We could never look at a landscape, a face, a town, a street-scene that had not been interpreted, loaded with sentiments by some intermediary. So accustomed were we to seeing reality coloured by the temperament of another that the world captured unexpectedly by the camera lens was a revelation to us. It took the arrival of the darkroom and the miracle of the latent image to make us aware that the artist was not an indispensable intermediary between our eyes and the world. By means of the photograph, and for the first time, *things were allowed to speak for themselves.*

The black cloth that for a long time enveloped the photographer is a symbol. It signifies that the man of images is entering into an order: the strict order of silver bromide. He has renounced his individual identity, his ego. Henceforth he will live under the authority of reality and devote his existence to the cult of images. An insurmountable barrier will separate him from the object—a barrier of optical and chemical laws: rays of light, crystals, elementary particles. He will never be able to intervene in person: he is nothing but the *deus ex machina* in a process set in motion by the release of the shutter. The entire domain of the real world is his, yet everywhere he looks the warning is there: 'Touching these objects is strictly prohibited'. The photographer's optical equipment permits everything which comes from the object to enter the image, but intercepts all the disruptive influences by which man has never, until now, ceased to embellish things or give them a moral significance. But—and this is the most far-reaching innovation of all—the human hand is excluded from every stage of the photographic process.

Nothing has ever given me more satisfaction than this statement by John Szarkowski:

Looking at his pictures, one is not aware of the act of photographing; it is rather as though the subject, through some agency of its own, reproduced itself.

(John Szarkowski: *Brassaï*, edited by the Museum of Modern Art, New York.)

Certainly this objectivity can never be total. The mere presence of an observer, his personality, is enough to disrupt it, even in the realm of scientific investigation. Absolute objectivity will never be within the reach of man; nevertheless it is in photography that he comes closest to it. The fact that it is so closely bound to reality constitutes its guarantee of authenticity. Thus a photographer is never an 'artist' as long as he wishes to establish himself as one. He can only be an artist *in spite of himself*, not by a deliberate effort of will. It is one of the many paradoxes of photography that the personality survives the passage through the chemical and mechanical cogs of this optical instrument, and that prints by certain photographers bear their stamp. This paradox has never been better expressed than by Henry Miller:

The desire which Brassaï so strongly evinces, a desire *not* to tamper with the object but regard it as it is, was this not provoked by a profound humility, a respect and reverence for the object itself? The more the man detached from his view of life, from the objects and identities that make life, all intrusion of individual will and ego, the more readily and easily he entered into the multitudinous identities which ordinarily remain alien and closed to us. By depersonalizing himself, as it were, he was enabled to discover his personality everywhere in everything.

(Henry Miller: *The Eye of Paris*, from *Max and the white phagocytes*, The Obelisk Press, Paris, September 1938.)

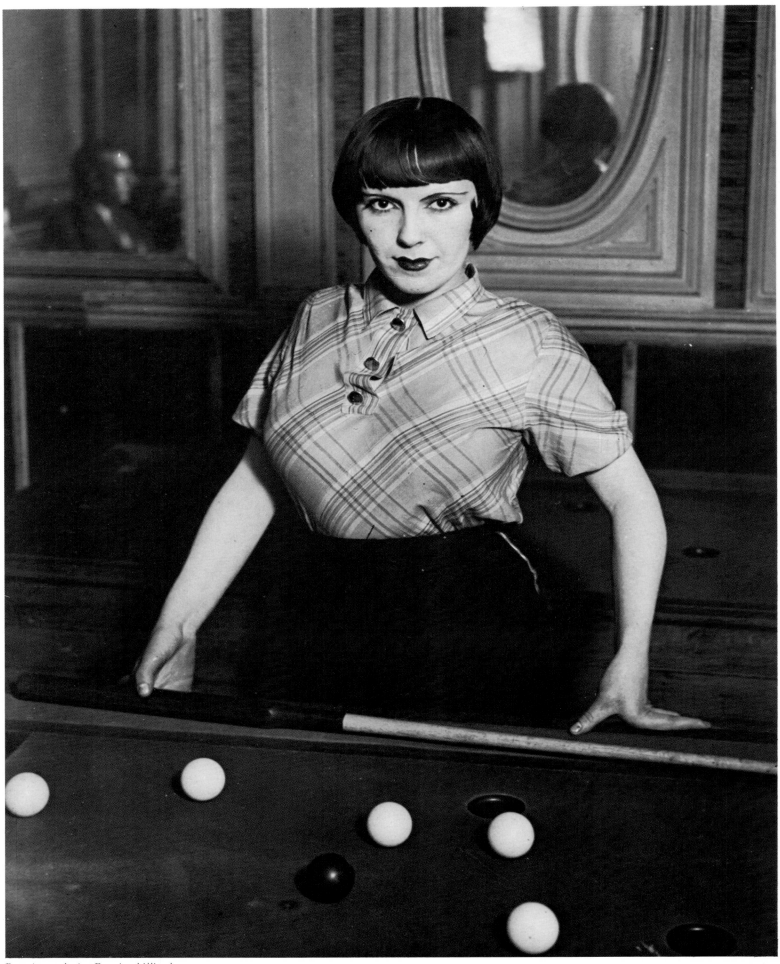

Prostitute playing Russian billiards, 1932

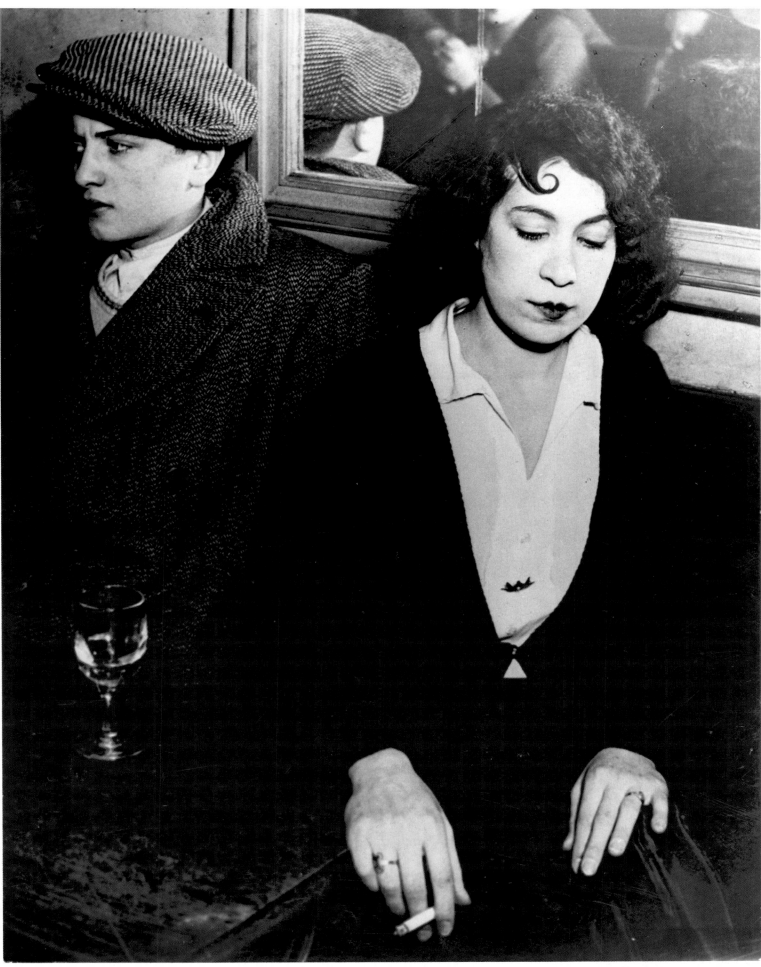

Lovers' quarrel, Bal Musette 1932

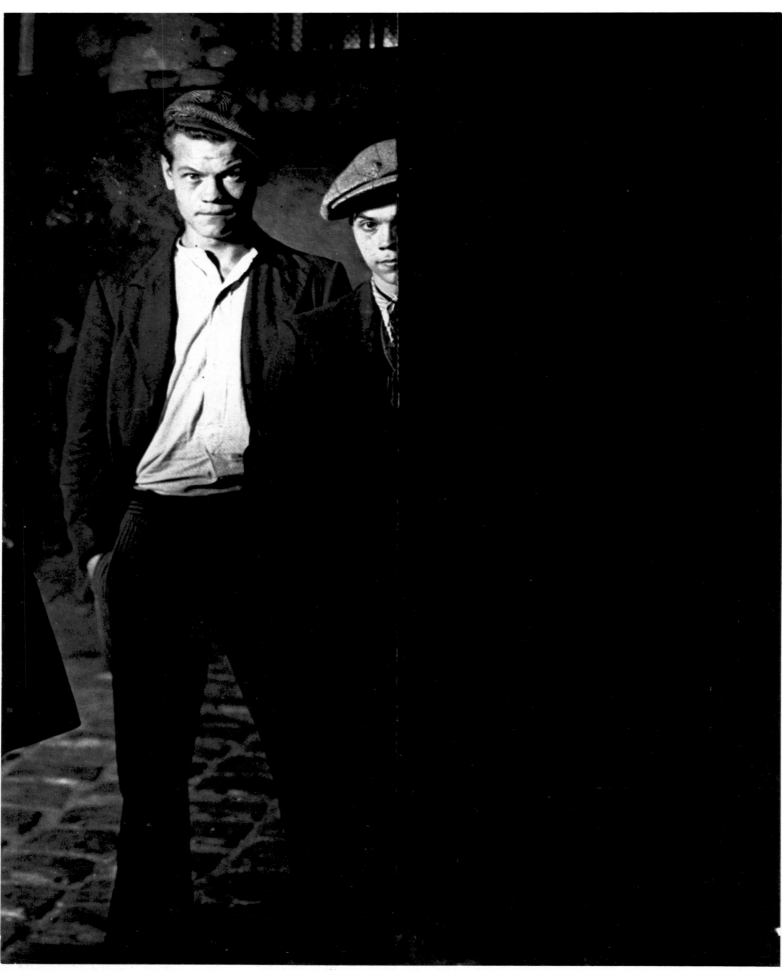

Two members of Big Albert's gang, 1932

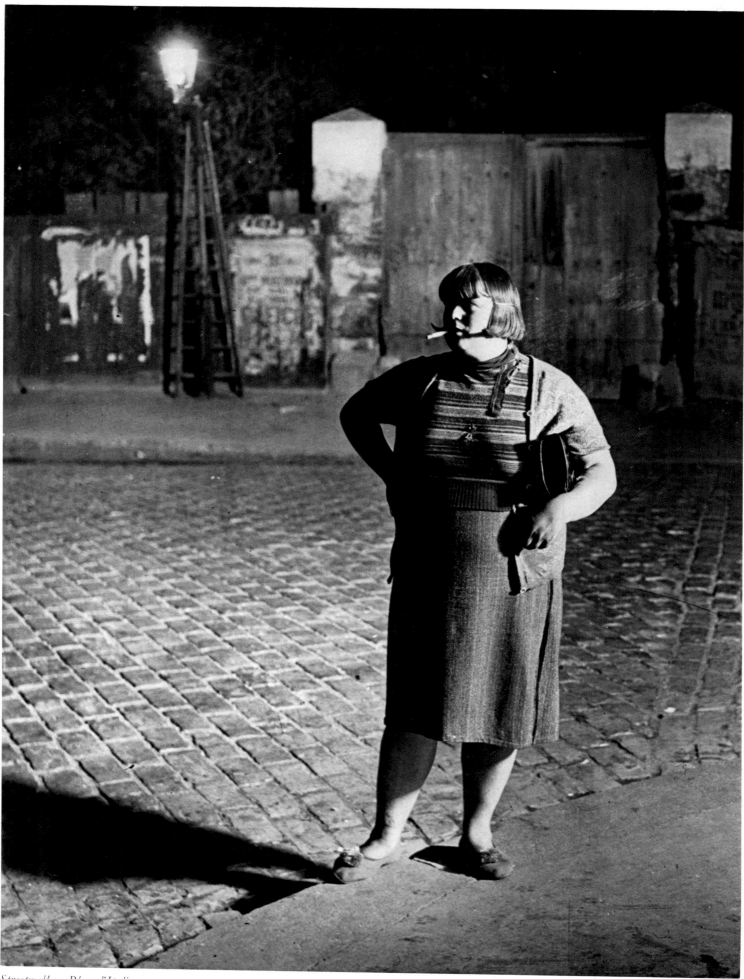

Streetwalker, Place d'Italie 1932

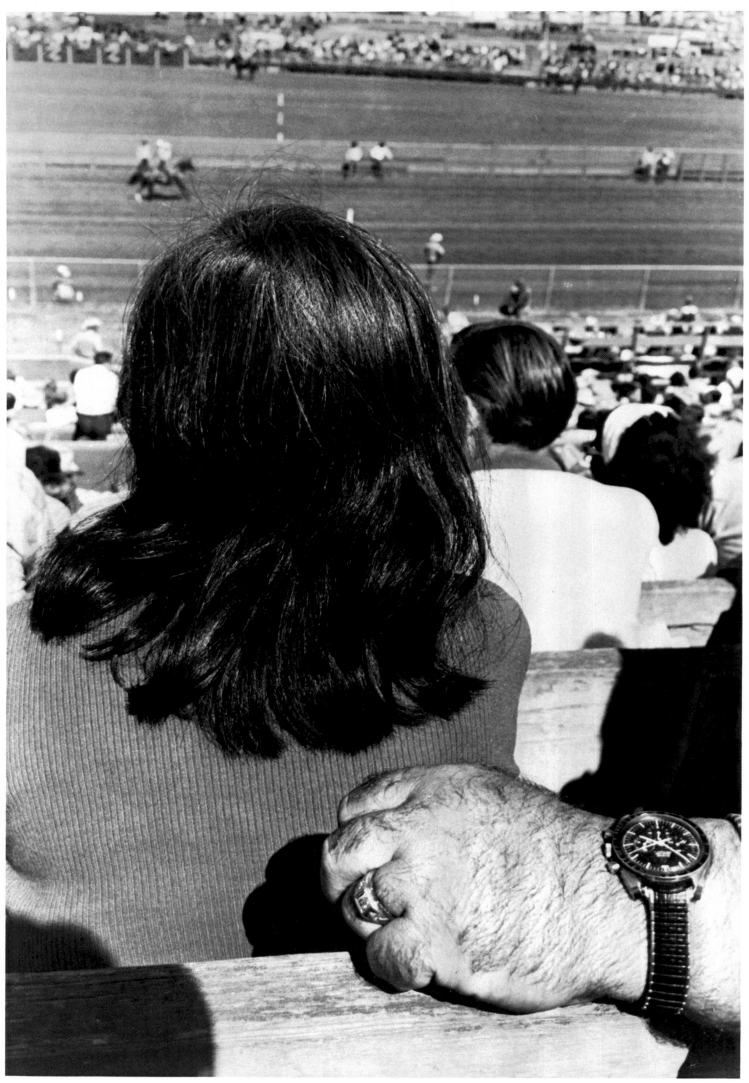

Salinas, California 1972 © *Lee Friedlander 1978*

Idaho 1972 © *Lee Friedlander 1978*

Mt Rushmore 1969 © *Lee Friedlander 1976*

Wichita, Kansas 1975 © *Lee Friedlander 1978*

Washington DC 1973 © *Lee Friedlander 1978*

Albuquerque 1972 © *Lee Friedlander 1978*

Knoxville, Tennessee 1971 © *Lee Friedlander 1973*

Washington DC 1976 © *Lee Friedlander 1976*

South Salem, New York 1975 © *Lee Friedlander 1978*

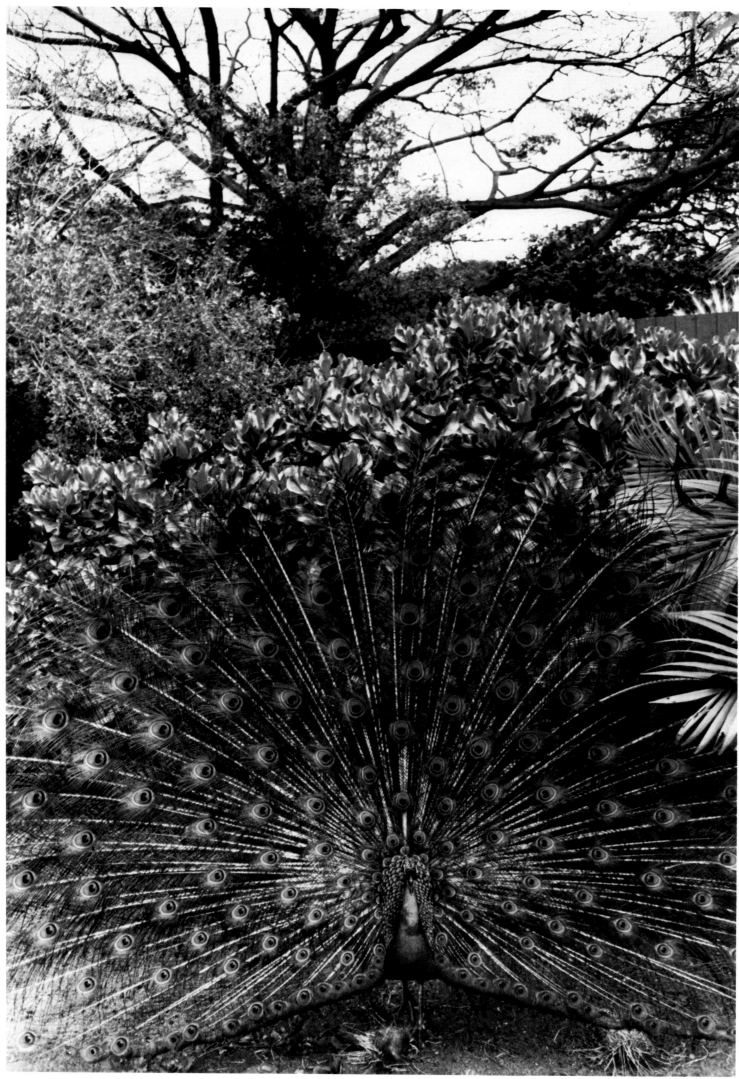

Honolulu 1977 © *Lee Friedlander 1978*

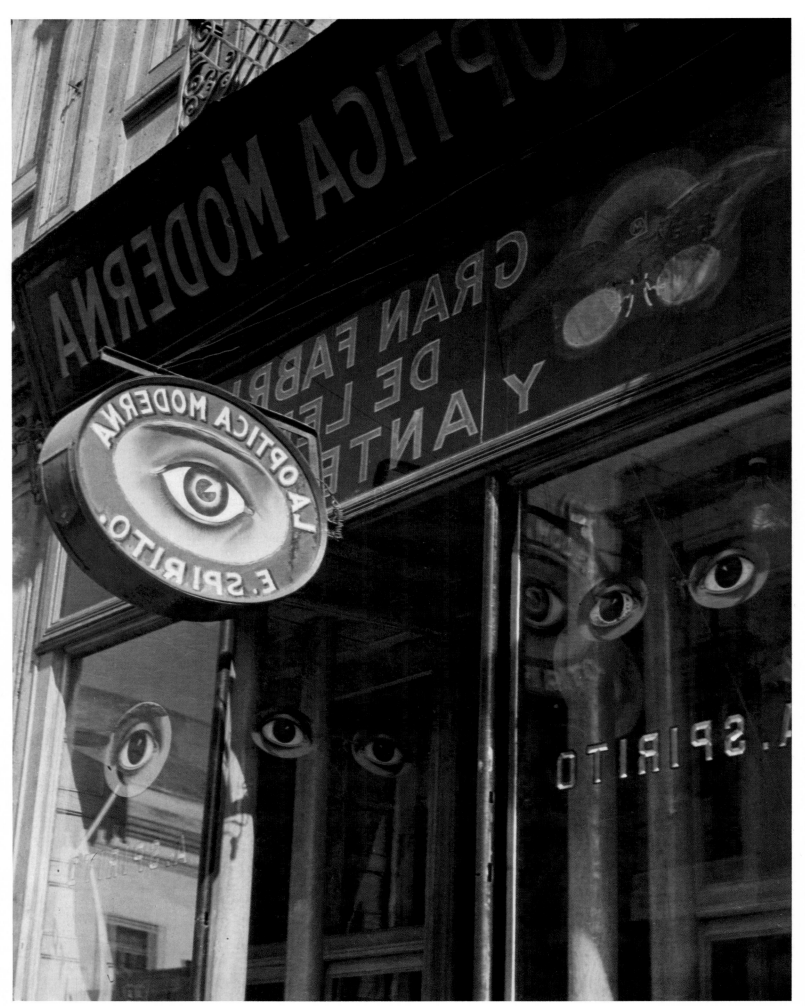

Parábola óptica (Optic parable) 1931

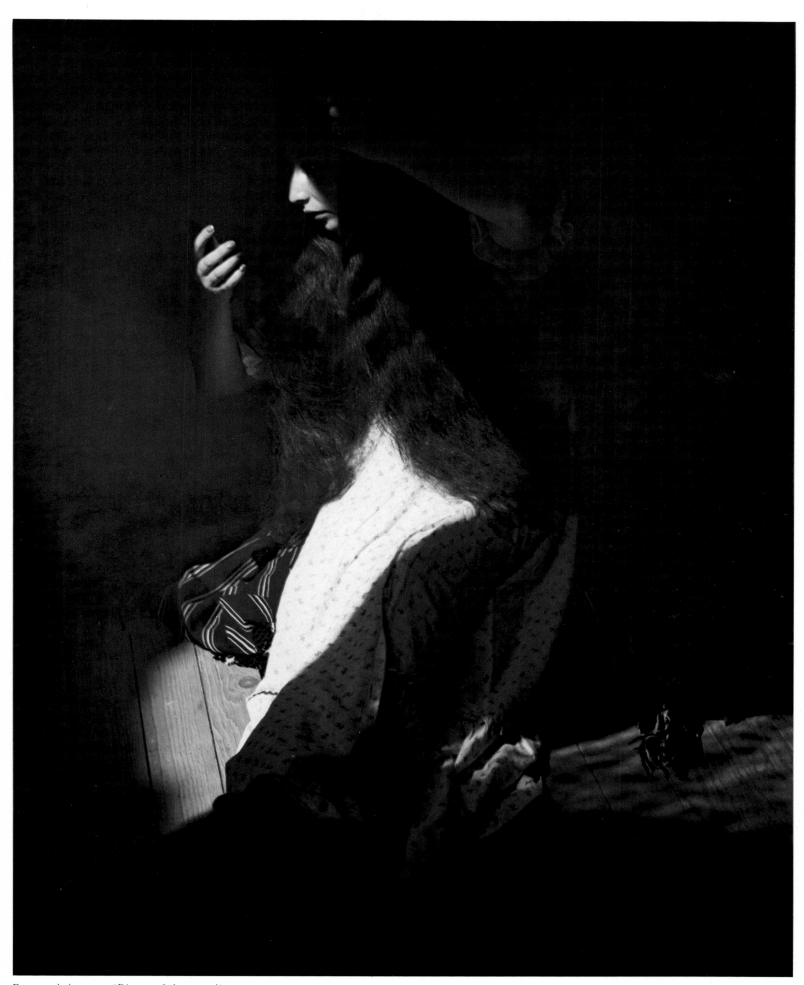

Retrato de lo eterno (Picture of the eternal)

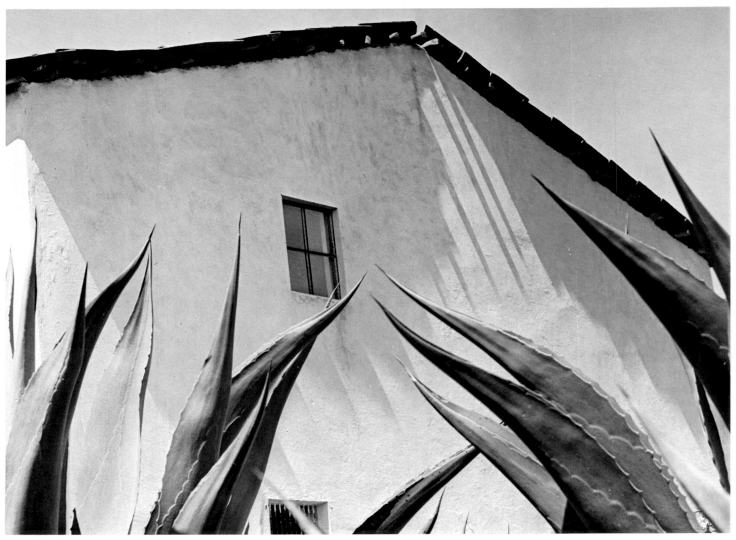

Ventana a los magueyes (Window on the agaves) 1976

Paisaje y galope (Landscape and gallop) 1932

Los obstáculos (The obstacles) 1929

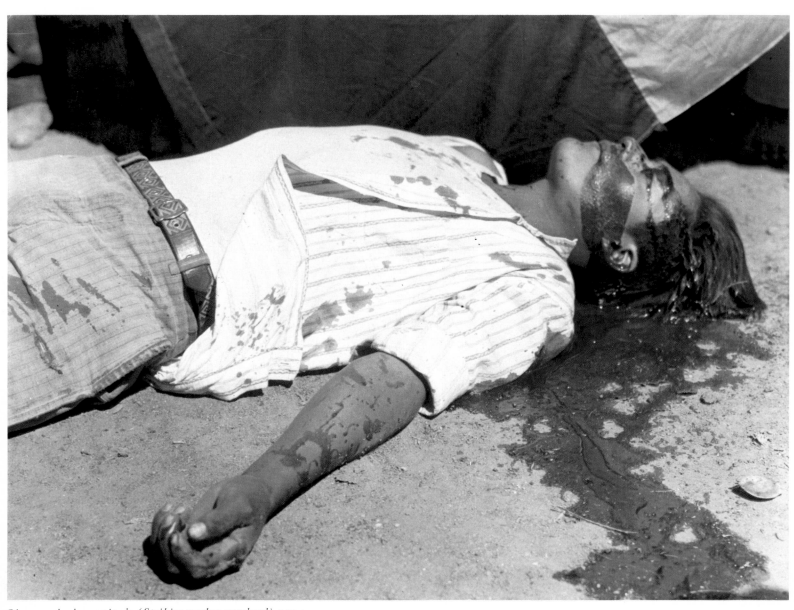

Obrero en huelga asesinado (Striking worker murdered) 1934

Escala de escalas (Ladder of ladders) 1931

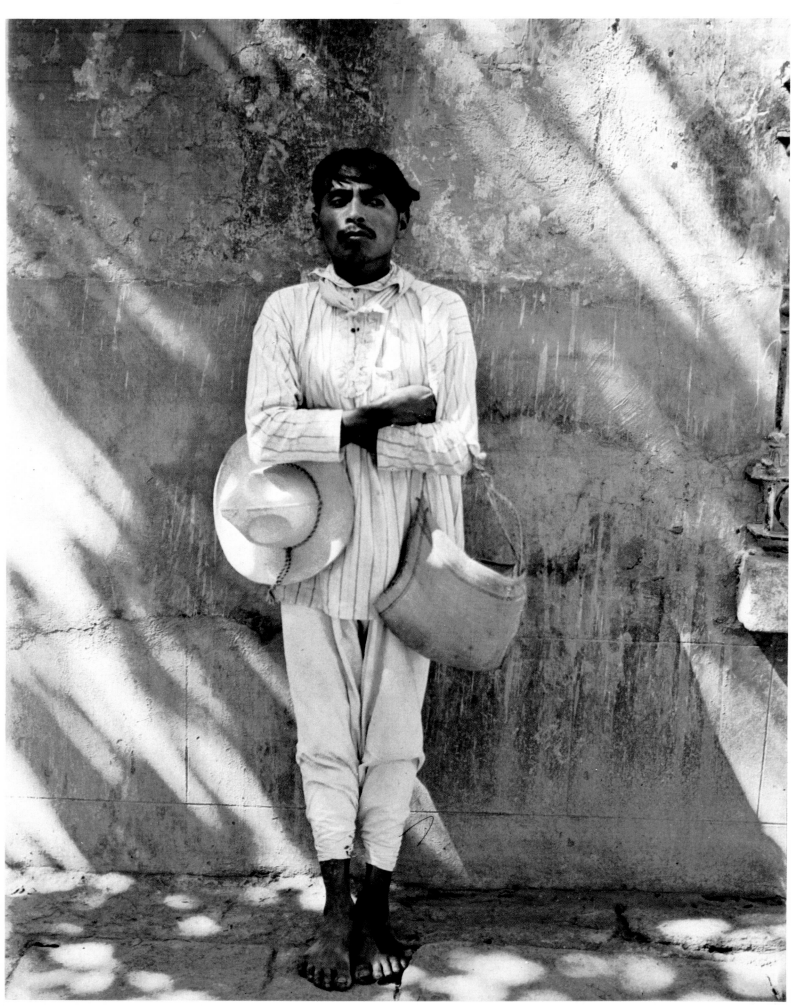

Señor de Papantla (Man from Papantla) 1934/35

Un poco alegre y graciosa (Somewhat gay and graceful) 1942

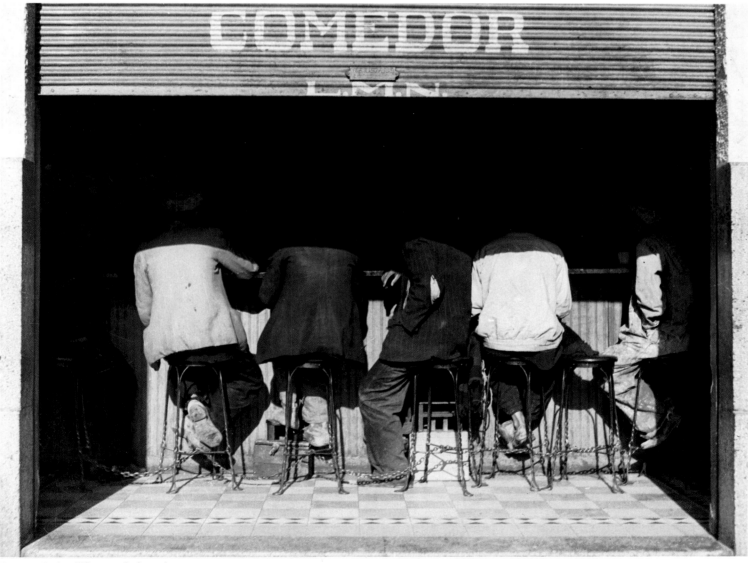

Los agachados (The crouched ones) 1934

Ralph Gibson

Born:
16 January 1939, Los Angeles.

Education:
1956-60 Studied photography in the US Navy.
1960-61 San Francisco Art Institute.

1970:
Founded his own publishing company, Lustrum Press. Its first publication was his own collection *The Somnambulist*, 'a dream sequence in which all things were real'. This was followed by more books of photography, by other contemporary photographers as well as himself.

Publications:
1966 *The Strip*.
1968 *The Hawk*.
1970 *The Somnambulist*.
1973 *Déjà-vu*.
1975 *Days at Sea*.

Exhibitions:
1975-80 Gibson has had over forty one-man exhibitions in various countries and been featured in almost as many group exhibitions. He is also represented in twenty-eight public collections.

Writing about photography is like talking about music – i.e. it can be done but one doesn't really *advise* it. But I want very much to know what I am doing with my work and so I find myself writing, tape-recording and talking a great deal about photography. I prefer to speak or write about my own photographs, but I will occasionally discuss student works in seminars etc. The basis of my reticence regarding the work of others is simply that I consider the artist to be the only one qualified to pass judgement on his or her work.

I want to discuss some of my photographs and attempt to trace certain vectors of growth leading to a visual signature.

The image from San Francisco (plate 1) dates back to a period when I was concerned with shooting on the street in a documentary way . . . at the time I believed this approach was the most truthful . . . ho-hum. As I look at this photograph now, I compare my original intentions with my current response. I remember wanting to use the edge of the frame in such a way as to imply activity transpiring outside the frame. I suppose this must be the case with every photograph ever taken, but I wanted to state this very emphatically. Secondary to all this was the tension created by the diagonal white line. I didn't pay as much attention to the line then as I do now. In fact, the white line is the entire point of discussion of the first four photographs dealt with here.

My eye formed a proclivity for diagonal composition very early in my learning years. I made this photograph while still a student at the San Francisco Art Institute. From the very start I was using graphic structure to support various modes of composition. And doing so in a very intuitive way. I believe that every serious photographer has similar natural tendencies. Analysis such as this comes after the fact. I must also say that in 1961 I strongly rejected this photograph because I thought it was too contrasty. And yet contrast has become another of my leitmotivs for the past 15 years.

It was 10 years later that I made *The Perfect Future* on 23rd Street in New York (plate 3). I neither saw nor recalled the connection between the two photographs until much later. When I made the photograph of the man with the stick I was primarily interested in the dialogue between the two white forms. I see recurring forms everywhere and first heard about this idea via Jean Cocteau, with his thematic involvement with what he called 'the eternal return'.

Shape, volume, colour and light are all of great importance in that they define and resolve interests I have in photography. This remains true even though the interests have changed through the years.

The image of the priest (plate 4) was made for a series entitled *Quadrants*. All of the images during this period were made with a 50mm lens at three feet distance to the subject. The idea being that if I made a 16 × 20 inch print of the subject, there would be no reduction in scale between the print and the subject photographed. I also wanted the print to be viewed at a distance of three feet, thereby producing the same viewing/taking sensation. All this worked to some degree. The concept

continues to influence subsequent work, and I continue to look at the image of the priest and find additional information there to be extracted. I consider this photograph to be balanced precisely between my formal concerns and a perception of reality. The framing seems to compress the subject into a set of concise proportions, and the diagonal continues to inform the composition with the same structure that has run through the previous images. As mentioned earlier, my eye sees in a geometrical way, and I attribute this to an idea I once heard explaining that the eye is self-monitoring. I imagine this would be difficult to prove.

Plates 4 and 5 seem to share the same proportion but differ in scale. I find this aspect interesting. I want to use photography to learn about things rather than making an open and closed statement. I believe that as long as an image resonates I will learn something from it about the nature of photography, perception, reality and time. This is why I am a photographer rather than a painter. Although I never get concrete answers to the questions posed, I do get very satisfactory definitions of these questions.

The content of many photographs is often centred around an event. To make 'event' photographs the photographer must align himself in place and time with the event. One minute late for the execution and his shot is missed, as it were. I'm not interested in recording great moments in history. For me, the great event is when my awareness has risen to the point of perception, a brief but intense moment. At such times one could photograph almost anything . . . a corner or a chair, a detail of something normally insignificant, etc. I crave this feeling because of its greater clarity.

One day it occurred to me that it was no longer a question of *how* to photograph but rather of *what* to photograph. After this most important question was answered, the next step was where to put the camera. After that, the rest is relatively simple. The real question remains 'What'.

The pairing of photographs has always been of interest to me. I believe there is a syntax to the way images speak, and I am interested in understanding it better. In the spread of the woman at the beach(es) (plates 7 and 8) I photographed the same woman first in Corsica and then 9 months later in Anguilla, BWI.

The sizing of the prints and the spacing between them are both important factors and determine how the spread works. I like working on books because one of the things that remains constant is the viewing distance to the page. I realize that if one is near-sighted the book is brought just a little bit closer, and if far-sighted the reverse, etc. But overall, the viewing distance remains under the photographer's control.

For the past few years I have been using longer focal length lenses. The 90mm is my normal lens now and on occasion I will work with the 180mm. I like the way the long glass flattens out space, and I have noticed with the 180mm lens that the image becomes normal-looking when I step away from the print. A 16 × 20 inch print pops into normal proportion at about five yards viewing distance. These are the kind of phenomena that interest me, because such things are less understood and

An aura of overnight stardom hovers around the reputation of **Ralph Gibson**. One sometimes feels that he burst into the world of photography as a fully-fledged prophet. It is an illusion, but it does suggest how quickly he became a major influence once he had found his own direction and become recognized.

His book *The Somnambulist* smouldered like a slow fuse and then brought on the explosion. But that was the climax of more than fourteen years of training and experience. He had published two earlier books of reportage, both hardly known.

The Somnambulist was a totally different product, the first volume of a trilogy which eventually included *Déjà-vu* and *Days at Sea*. They combine a severe precision of graphic design and a romantic awareness of photography's potential for surrealism. It is not surprising that Gibson has such respect for the work of Bill Brandt, but his own vision too is strongly personal and distinctive.

His pictures are not concerned with information and incident but with evocation and intuition. They make us consider the nature of perception, the power of suggestion of the visual image and the unique qualities of photographic description. They are so interesting that it is easy for the critic to forget that they are also enjoyable. There is a sensuous richness about the work, a wealth of surprise and more than a touch of eroticism.

In order to produce *The Somnambulist*, Ralph Gibson founded his own publishing company, Lustrum Press, by selling shares in it. Apart from his own work, he has since published important books by other contemporary photographers, such as Robert Frank, Neal Slavin, Larry Clark and Mary Ellen Mark.

In the mid-seventies, Gibson turned his attention to exhibitions and to the variables that affect our perception of images. The result was a show entitled *Quadrants*, a set of 20 × 16 inch prints of details of people and architecture, all shot from a distance of three feet.

He also began to work in colour, again concentrating on detail, such as painted brick walls. His approach at this time, both in black and white and in colour, was decidedly minimal in concept. For his latest exhibition he reverted once more to black and white. He works almost exclusively in bright sunlight to take advantage of its high contrast.

He uses both Leica and Leicaflex cameras with a choice of 50mm, 90mm and 180mm lenses. He prefers the complete clarity of the Leica M-series viewfinders but he needs the convenience of reflex viewing with the 180mm objective. His favourite lens at the moment is the 90mm Tele-Elmarit but he

still turns occasionally to the 50mm dual-range Summicron with its close-up attachment–'an extremely fluid lens', he calls it. But in general now he finds the longer focal length objectives more of a challenge.

He says, 'I spend a lot of time looking at my photographs and have found that this leads to a deeper understanding of them. I try to view new works through every aspect of my personality, and for this reason I have prints up on the wall of my studio, where I also live, for months at a time. There is no better way for me to function, and for this reason I say that the artist is the one most qualified to judge his or her work. Certainly no critic is ever going to spend as much time looking at my work as I do . . . and hopefully never with such a ruthless eye. I am more demanding of my work than any professional critic.'

more abstract. Although I am not interested in making abstract photographs, I am very interested in photographing the abstract element in things. This is another reason for the apparent simplicity of my photographs. I can locate those areas of abstraction that are most related to my attitudes about life and the medium of photography through simplicity. There is a relationship between reductivist attitudes and the longer focal length lenses. I still find the 50mm dual-range Summicron with its close-up attachment to be an extremely fluid lens and occasionally use it. But I know the 50mm very well after all these years, and find the longer lenses more of a challenge. When I use the 180mm I have to use the Leicaflex rather than the M3 or M2, and I'm not very happy with reflex viewing. I definitely prefer the rangefinder-viewfinder system for its total clarity. Also the image blackout with the reflex at the exact moment of exposure is rather like visual coitus-interruptus.

Since 1974 I have photographed, both in black and white and in colour, almost exclusively in bright sunlight. This becomes another means of eliminating unwanted information from the picture. I let the shadows fall into deep black, and am more interested in the shape of the shadow than the detail within it. Shooting in bright sun alerts my eye in a tropistic way, and on cloudy days I rarely carry my Leica. Perhaps one day I'll change this approach, maybe reverse it entirely. But I know it is necessary for me to set a series of parameters in order for me to be able to work creatively as a photographer.

In his book of collected interviews *Bergman on Bergman*, Ingmar Bergman states that it was only while working on *Persona*, his 26th film, that he realized for the first time the creative potential of his own ambivalence! The brilliance of that thought has stayed with me since the moment I read it. Ambivalence is generally considered to be a negative factor in one's life and people tend to recoil from it. To recognize the creative potential in ambivalence delineates the difference between a growing pain and a neurosis. For an artist, ambivalence is his stock-in-trade. I know so well the feeling that comes when I put up a new print on the wall and am not sure of its merits. But the work itself determines and dictates its quality and direction. I have great faith in the integrity of the work and listen carefully to it. For reasons such as these I cannot accept commercial assignments. I don't want anyone to tell me what to photograph, and then furthermore determine whether or not it is a good picture.

Whenever I have the opportunity to speak or write about my work I relate the anecdote that has played a large role in my development as a photographer. Years ago I was assistant to Dorothea Lange. I had just dropped out of Art School and was given the job because I was a good printer, which was what she needed. I printed many of her great classics, and the two of us spent many hours in her darkroom. One day she suggested that I bring some of my photographs the next time, she would like to see them. I was in my street period (plate 1) at the time and brought her a box of about 15 prints. She looked at them, then turned to me and said, 'I can see that you have no point of departure, Raphael . . .' I replied

that was probably true, but what actually *is* a point of departure? She said that shooting with a point of departure means that one never stands on the street corner waiting for something to happen. She said that if I was going down to the drugstore to buy toothpaste, my life would be at that moment directed and at such times the possibility of taking a strong photograph was much greater. I promptly returned to the street corner for the next six or seven years, and it was only later while working on my first book *The Somnambulist* that I realized how important her advice was. Since 1967 I have always worked on specific projects or themes, with a point of departure, and will continue to do so. I never know in advance what my next photograph will be, but I always have a direction, a set of concerns. This is in no way inhibiting. It helps because it lends additional meaning to the act of photographing.

In 1974 I was in Jamaica on vacation. I had noticed a young woman at the hotel where we were staying and asked her if I could do her photograph. She agreed, and then I procrastinated for a few days. Finally I decided to try to photograph her with a close-up attachment on the Summicron 50mm lens. I should mention that the urge to move closer to the subject had been increasing for about five years. So I made her photograph (plate 2), and this led to ideas that have been included in several photographs, e.g. the priest (plate 4) and the man in the pea coat (plate 5). I continue to use this leitmotiv of truncation in various ways. I like the proportions that are revealed by working up close.

I made the *Black Series* in 1979-80. I called the series black because for a long time black has been a prominent aspect of my work. In this series I was able to bring in some of the things I learned while working with minimal colour (1976-78). All of these photographs were made with a 90mm Tele-Elmarit lens. I discovered that working with the 90 had distinct characteristics. For example, in plate 6 we know that the left side of the frame is farther from the camera than the right side. This is also true of that on plate 9. But visually, the tendency is to experience the left side of the frame as being closer. This is because of the pulling power of the longer focal length lens. This only works at a precise angle to objects of certain sizes. Altering spatial effects intrigues me and I continue to examine other possibilities. Printing will also influence how an image is seen and I have been striving towards a simpler approach to printing. I decided that rather than do a great deal of burning-in to get a strong black, I would simply shoot something that *is* black . . . the *Black Series* is very monochromatic in the details chosen.

As I mentioned before, it is the work itself that dictates the direction taken from project to project. The detail from Arles (plate 10) clearly inspired the *Black Series*. Primarily because the negative shape (the black on the left) became equally if not more prominent than the limestone detail on the right.

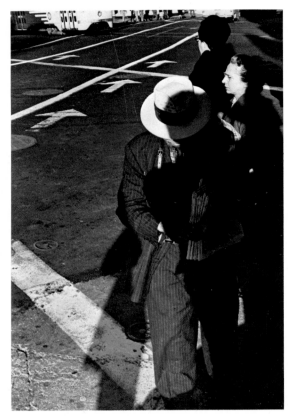

Plate 1 San Francisco 1961

Plate 2 From 'Days at Sea', 1974 (Jamaica)

Plate 3 From 'Déjà-vu', 1972 (New York)

Plate 4 From 'Quadrants', 1975 (New York)

Plate 5 New York 1980

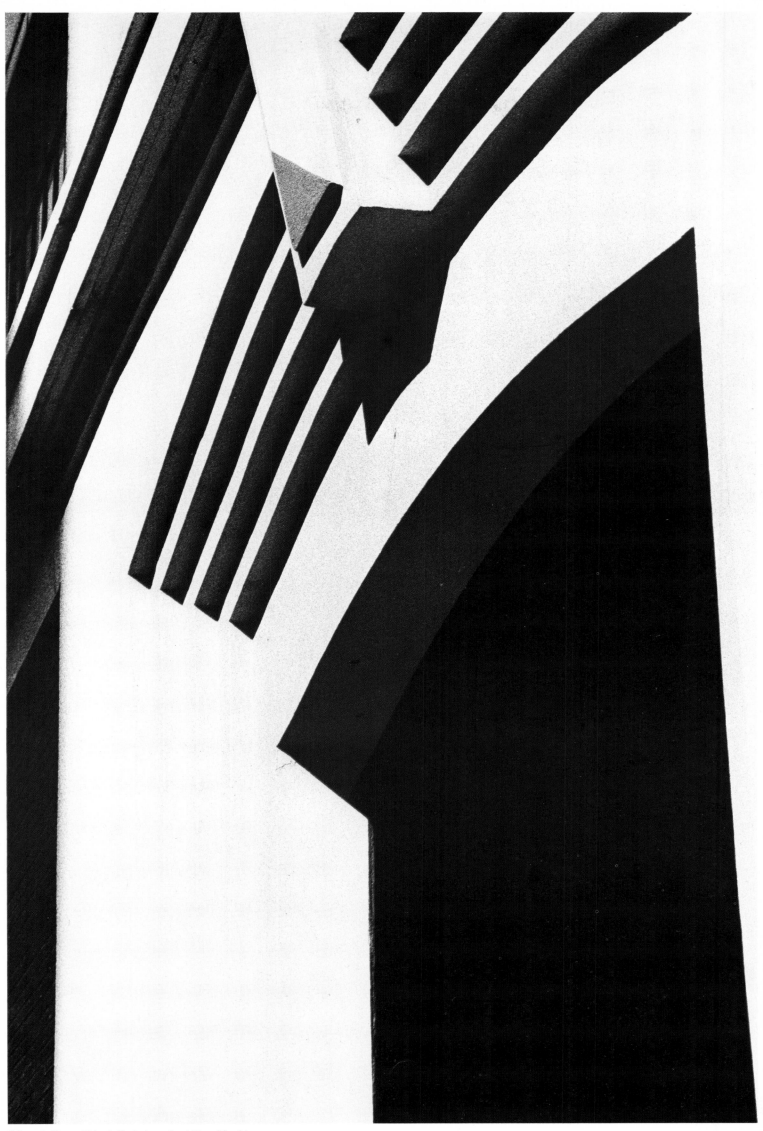

Plate 6 From 'Black Series', 1980 (New York)

Plate 7 Mary-Jane, 1979 (Anguilla, BWI)

Plate 8 Mary-Jane, 1979 (Corsica)

Plate 9 From 'Black Series', 1980 (New York)

Plate 10 From 'Quadrants', 1975 (Arles)

Henri Cartier-Bresson

Born:
22 August 1908, Chanteloup, France.

Education:
1927-28 Studied painting with André Lhote.

1931:
Took up photography seriously. He later went into film-making which he continued when he joined the army. During the war he was captured by the Germans but escaped after three years in captivity, then worked for the Paris underground.

1947:
With others, founded Magnum Photos. Since then Cartier-Bresson has travelled all over the world on photographic assignments.

1973:
Returned to drawing, although not to the complete exclusion of photography.

Books:
1952 *The Decisive Moment.*
1955 *The People of Moscow.*
1956 *China in Transition.*
1968 *The World of Henri Cartier-Bresson. Man and Machine.*
1970 *Cartier-Bresson's France.*
1972 *The Face of Asia.*

Exhibitions:
1934 Madrid.
1946 Museum of Modern Art, New York.
1957 Pavillon de Marsan, Musée du Louvre, Paris.
1968 Museum of Modern Art, New York.
1980 Musée de l'Art Moderne, Paris.

Photography has not changed since its origin except in its technical aspects, which for me are not a major concern.

Photography appears to be an easy activity; in fact, it is a varied and ambiguous process in which the only common denominator among its practitioners is their instrument. What emerges from this recording machine does not escape the economic restraints of a world of waste, of tensions that become increasingly intense and of insane ecological consequences.

'Manufactured' or staged photography does not concern me. And if I make a judgement, it can only be on a psychological or sociological level. There are those who take photographs arranged beforehand and those who go out to discover the image and seize it. For me, the camera is a sketch book, an instrument of intuition and spontaneity, the master of the instant which—in visual terms—questions and decides simultaneously. In order to 'give a meaning' to the world, one has to feel oneself involved in what he frames through the viewfinder. This attitude requires concentration, a discipline of mind, sensitivity, and a sense of geometry. It is by great economy of means that one arrives at simplicity of expression. One must always take photos with the greatest respect for the subject and for oneself.

To take photographs is to hold one's breath when all faculties converge in the face of fleeing reality. It is at that moment that mastering an image becomes a great physical and intellectual joy.

To take photographs means to recognize—simultaneously and within a fraction of a second—both the fact itself and the rigorous organization of visually perceived forms that give it meaning. It is putting one's head, one's eye and one's heart on the same axis.

As far as I am concerned, taking photographs is a means of understanding which cannot be separated from other means of visual expression. It is a way of shouting, of freeing oneself, not of proving or asserting one's own originality. It is a way of life.

© Henri Cartier-Bresson 1976 (Reprinted from the monograph published by Gordon Fraser, London 1976, co-published by Aperture, Inc., and Robert Delpire, Editeur.)

The following is condensed from a hitherto unpublished article by Ernst Haas.

Every situation has a moment best suited to its form as well as a moment best suited to its content. To bring these two moments so close together that they almost become one single moment is the direction of Henri Cartier-Bresson's aim in finding what he calls 'the decisive moment'. Compositions created that way will be neither overcomposed nor too graphic. They might almost be called 'imperfect perfections'. You will not learn by watching him photograph, for what really goes on remains between his eye and the camera. You don't have the feeling that here is somebody who is thinking in terms of pages and layouts. He just seems to melt into the situation he photographs. There he stands in what in ballet is called the 'sixth position', observing and photographing—never bending

over too deeply, never on top of a table or underneath, certainly never lying on his stomach. His view is that of a gentleman who would never take distorting poses while working in order to improve a photographic angle. The eyesight of a normal man standing and walking is enough.

One of the main lessons we learned from him is the importance of the contact sheet. It always was and still is fascinating for me to look at his contacts after one of his trips. His editing is immediate and fast. He rates his own pictures by framing them with one, two, three or four lines. One line means 'maybe', two or three mean 'quite good', a totally framed picture means 'perfect'—it can be printed. His rhythm in developing a scene through four or five pictures shows his genius. He first notices the possibility, then realizes its potentials, then prepares for the moment in construction and finally finds this moment by reacting to those invisible actions which create his strange 'off compositions', so perfect in their imperfection.

It is good to have a master who is not dependent on too much equipment. What a difference between a professional photographer who goes away on location with an assistant and many pieces of luggage, and Henri with his one camera and two lenses one of which he seldom uses. No strobes, no fish-eye, no motor. How good to have someone in our time who can photograph a whole book with one normal lens. The normal 50mm lens is very underrated today. In HCB pictures it fulfills a way of thinking. A man is in a normal proportion to his environment—not too big, not too small. Man is part of his surroundings, but in control of them.

His cameras are light and almost invisible, all black. A few films for emergencies; never extremely long or short lenses. The surprises of life are valued much higher than the surprises of a distorting lens.

HCB loves simplicity and simple people. Nobody seems poor, only simple, and the dignity of man is never lost in the eyes of this lyrical sociologist. He introduces people so that you want to know more about them. They live on within you. The little human weaknesses he points out remind you often of yourself, providing you are candid enough to admit it. Because they are so human they are never destructive. He smiles with his camera more than he criticizes. And even if he does criticize he never seems to hurt his people.

Ours is a time of cultured pearls: a calculated way to force nature to copy itself, to imitate wealth through phony 'accidents' in order to create fakes for the millions. Through mass-production we destroy the value of a rarity. This seems typical of the self-deceiving attitude of our time, where greed and a profit-orientated philosophy have cut much too deeply into our sense of values, ethics and aesthetics.

A real pearl is the creation of an accidental irritation and the pain thus initiated culminates in a poetic symbol of beauty. There are many cultured pearls on the photographic market. They can be predicted, repeated, are cheaper and almost identical.

There are less and less real ones. But they do exist—true, hidden, beautiful and rare. HCB has created many strings of them.

Henri Cartier-Bresson occupies a special place in the photographic pantheon, both because of the quality of his work and the weight of his influence.

He has written relatively little about photography but he has the gift of lucid, succinct and elegant expression. His first major statement was published in 1952 as the preface to his album of pictures *The Decisive Moment*. The ambitions of the post-war generation of photographers were mostly centred on the burgeoning magazine market. Cartier-Bresson's description of his intentions and technique brought a new discipline and dignity to the craft of photo-reporting. It was a rigorous doctrine but as his accompanying pictures proved, a practical and noble one. Worldwide, thousands of young photographers took this philosophy as their own.

In time, the more pragmatic of them adjusted their position according to circumstances, the more talented according to their instincts, and the more radical according to their vision. But for a long period, it was Cartier-Bresson's work that provided the prime standard against which other aims and achievements were measured. The climate of opinion was so strong that several of his contemporaries, pursuing totally different courses, found it very difficult to gain adequate support from readers and publishers.

It is remarkable how well Cartier-Bresson himself has managed to live up to his own strict precepts, as can be seen from the consistent quality of his photography for almost 50 years. His range is wider than is often recognized, including many fine portraits and even a few interesting land-scapes. But it is for his candid pictures of everyday life that he is best known.

He likes to work as inconspicuously as possible and carries a minimum of equipment—'an economy of means forces me to be more rigorous.' Generally he uses a Leica with its standard lens but occasionally he does turn to a 35mm wide-angle or a 90mm telephoto. Most of his photographs are in black and white, though he has shot a little colour.

He searches for harmony in the rhythm of a line, in the balance of shapes, and in the interrelationship of form and content. For him, the image must be perfectly and precisely realized at the moment of exposure. Cropping will never salvage anything worthwhile from a bad picture and can only spoil a good one. This instant when the harmony is both revealed and recorded takes place in a fraction of a second, a coup of almost mystical timing. It is the result not of simple intuition but of 'a developed instinct'.

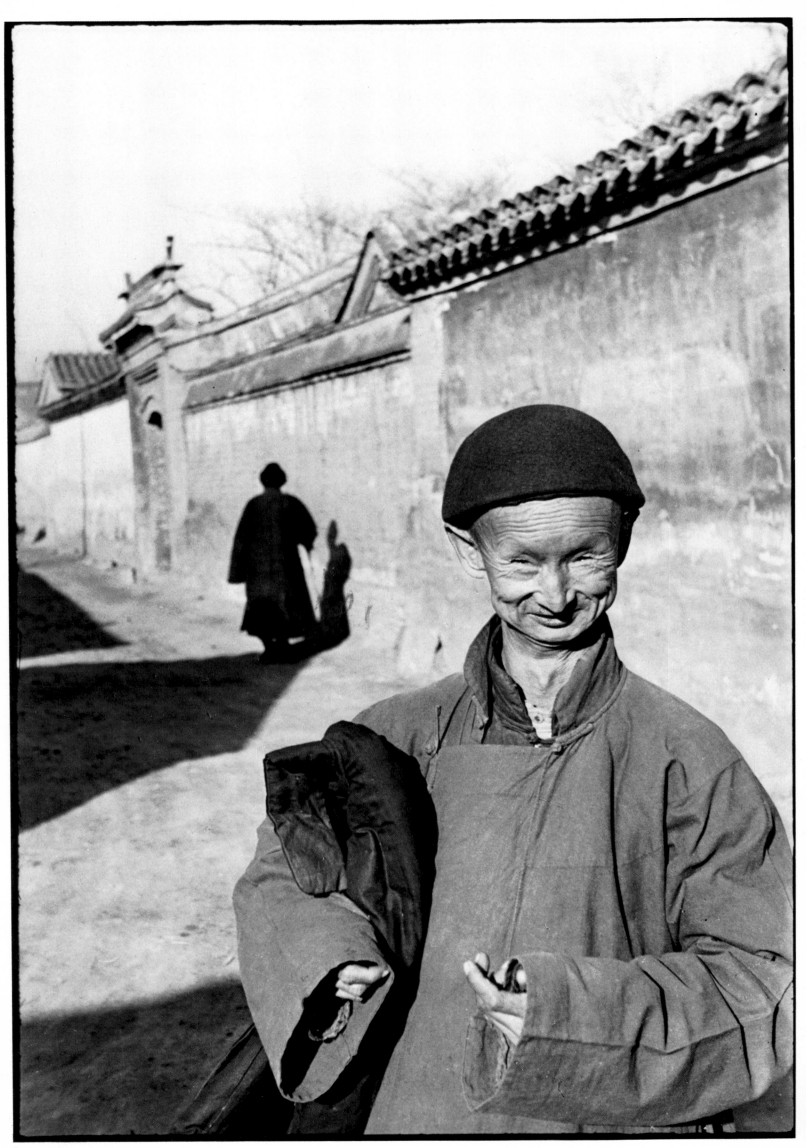

Peking 1949

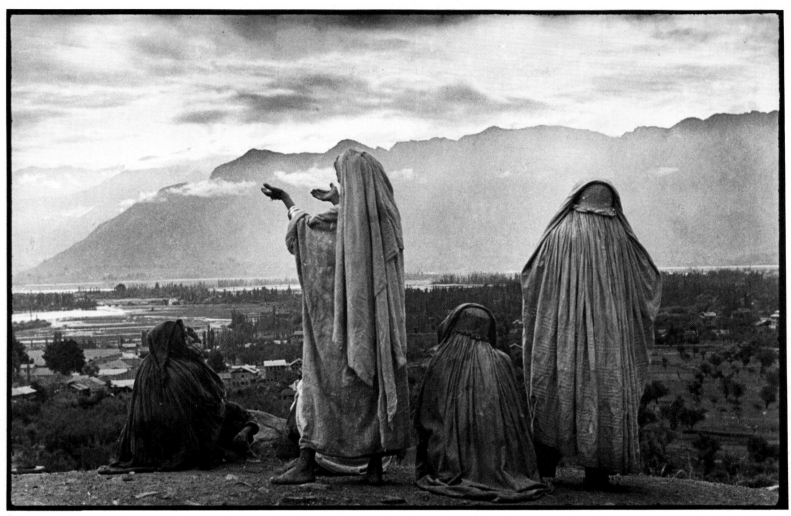

Srinagar, Kashmir 1948

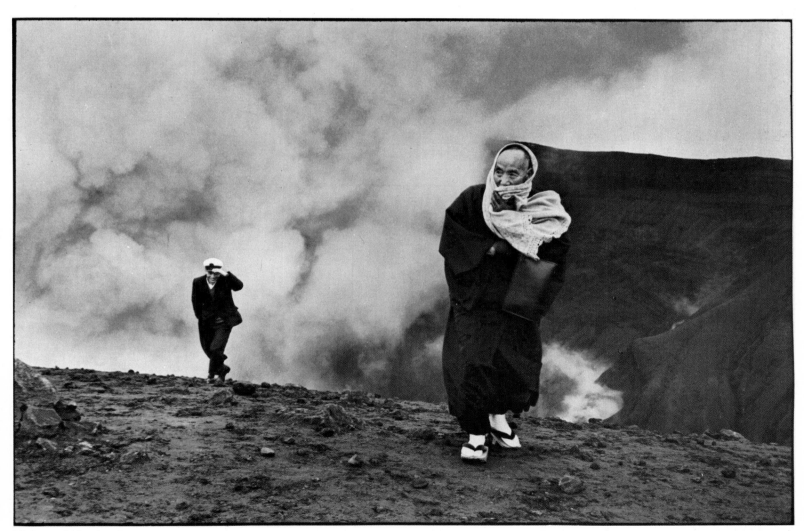

Volcano of Mt Aso, Japan 1966

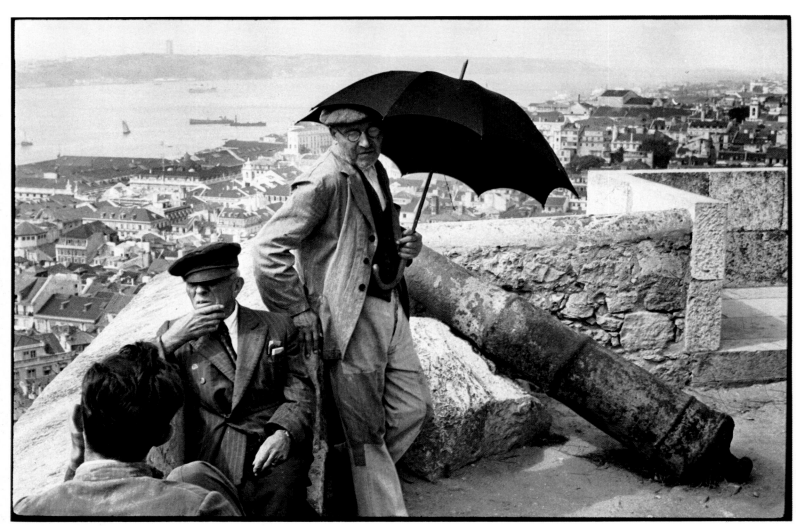

Lisbon 1955

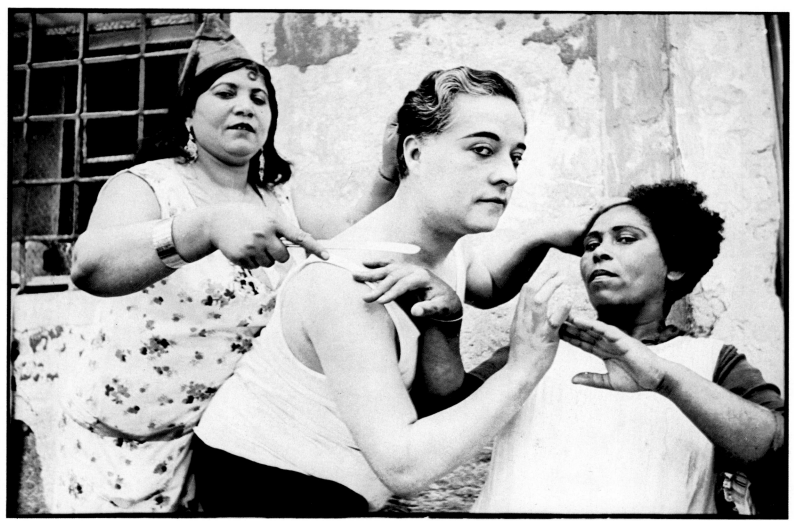

Alicante, Spain 1932

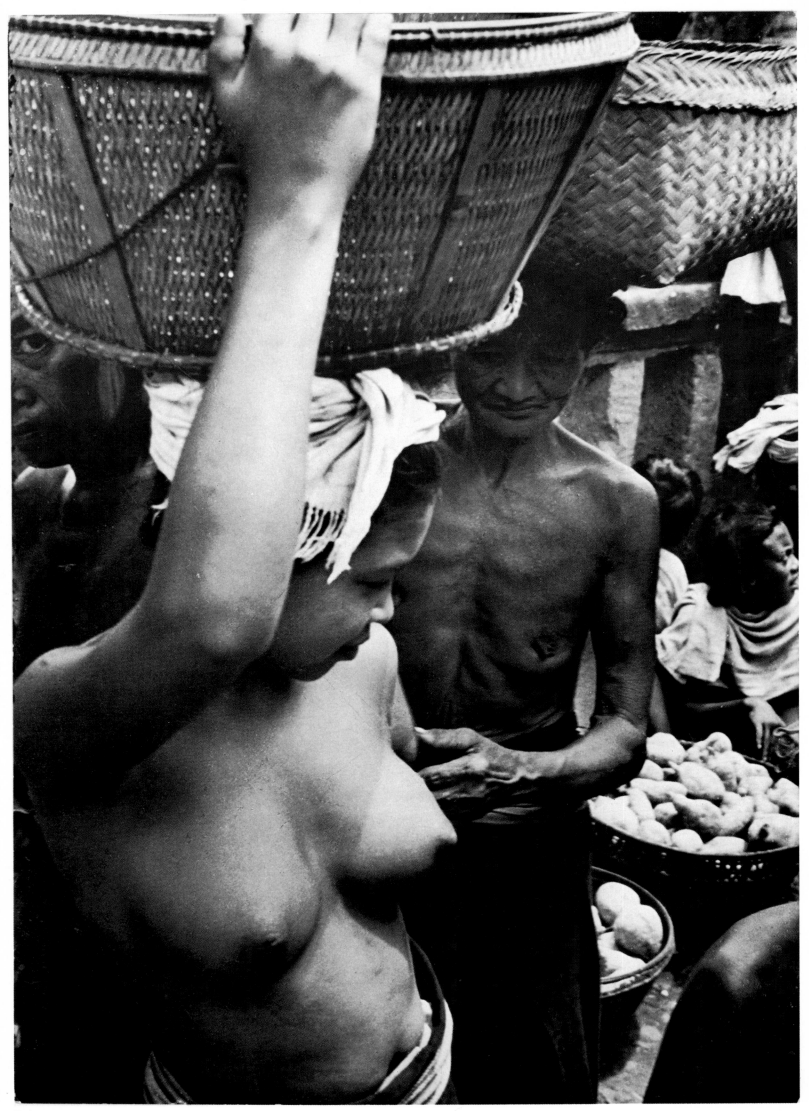

Bali 1950

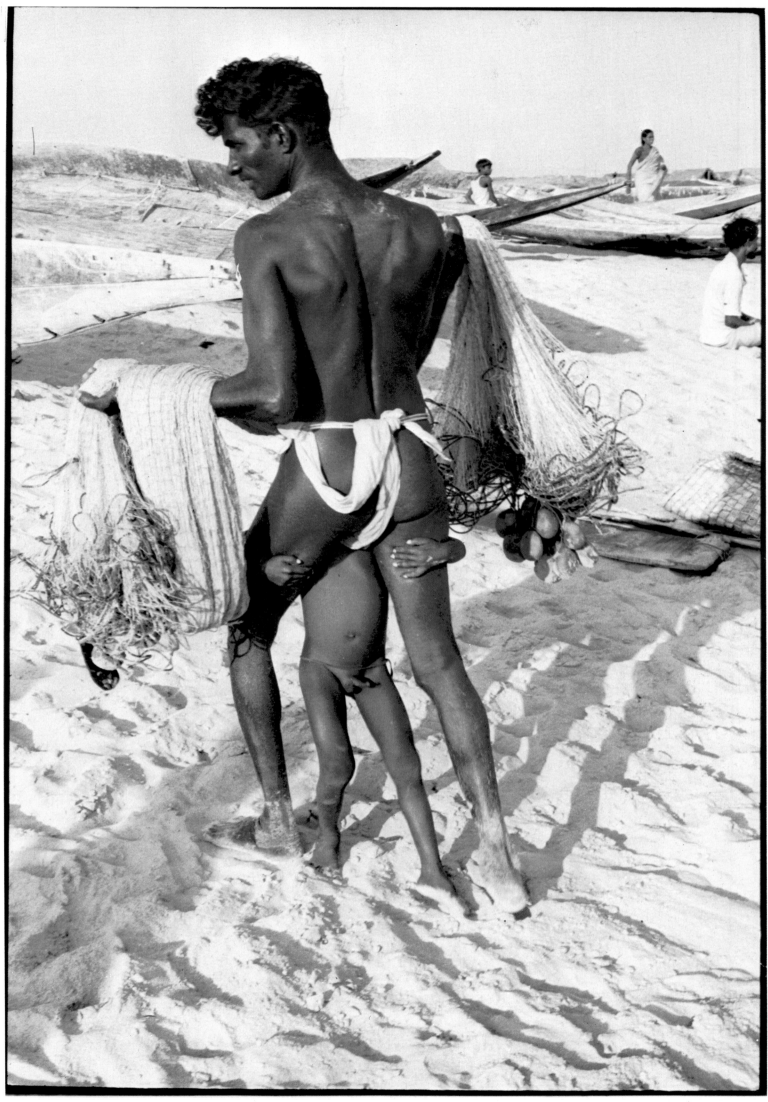

Orissa, India 1979

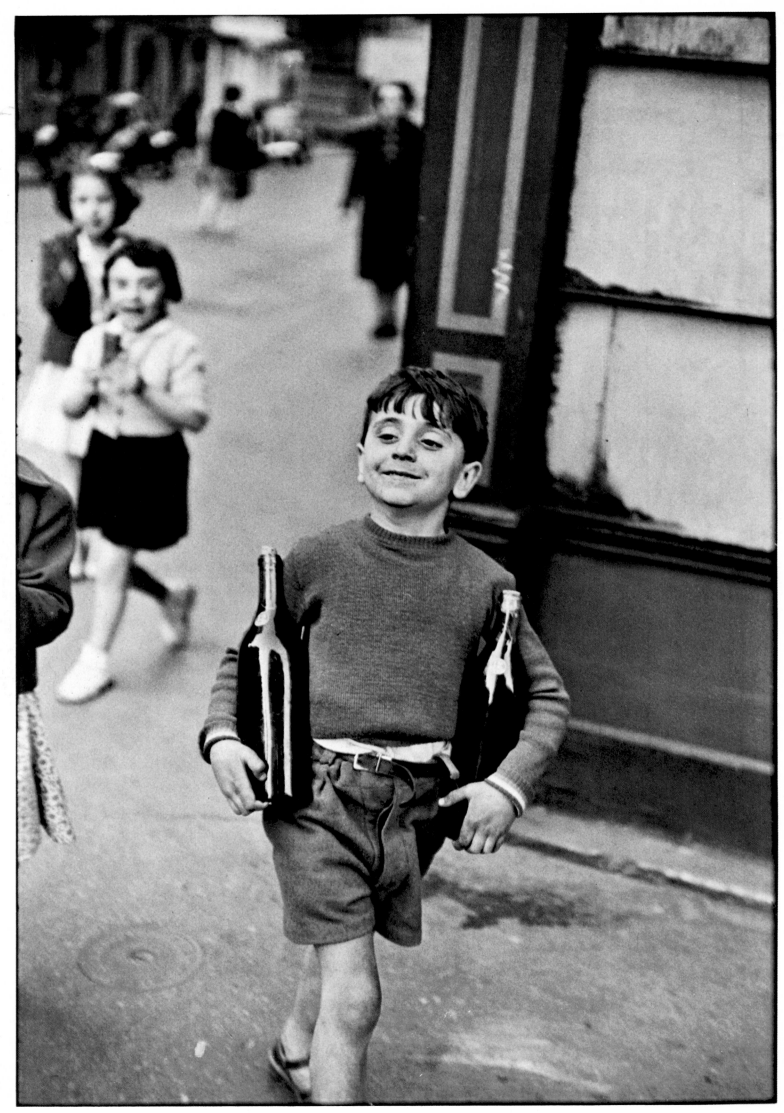

Rue Mouffetard, Paris 1954

never consciously shoot for a particular kind of market. Basically I shoot for myself.

Whoever I am working for, I am going to watch people reacting to each other in the same way. It is still the same eye behind the camera, it is still the same emotion. And I am going to take the same type of picture.

As I work through Magnum, rather than for any individual magazine, if the publication that assigns me does not use a story properly there is always a chance that another one will.

The professional discipline necessary in covering a story thoroughly – going into art galleries, museums, saunas, hospitals and so on – opens up new picture-taking situations for me. If I were just taking photographs for myself, I might not go to the trouble of getting permission to visit some of these places, and so perhaps miss some great opportunities.

Most of my work is in colour but I find black and white photography far more meaningful. It is far easier to catch the feeling of a situation in black and white than in colour, which is much more artificial in its effect.

The purely graphic possibilities of colour have never enormously appealed to me. Colour has never made me look at things in a different way. It has been a limiting influence on my work, firstly because there is an added risk of the eye being distracted from the main subject by a random splash of colour, and secondly because of the extra technical problems involved in shooting it.

In black and white you virtually never miss a picture for technical reasons. It is a far more tolerant medium in terms of exposure, and since you always have the same type of film in your camera you are always ready to grab a picture if one offers itself.

But with colour, you have to switch from daylight-type film to artificial and back again. If sometime you decide not to bother, you might miss a picture.

A few years ago I was able to take a break from my usual professional work and to produce a black and white book about the English. For many reasons this was an especially important project for me.

I was born and grew up in England but I left the country as soon as I finished school. When I returned in the early seventies, I felt that there had been enormous social changes while I was away. So eventually I set out to rediscover England and the English.

Once I got out of London, I found that the changes were less dramatic than I had imagined. I was fascinated by the contrast that still exists between north and south. The cliché situations of twenty years ago are still obvious, cobbled streets and all.

I found that it was not possible to produce as balanced a picture as one would like, simply because one does not have access to large sections of life in this country. For instance, it is very difficult to photograph the so-called upper and upper-middle classes, except at special events, and this does distort the overall coverage.

It was soon clear that a project of this kind needed much more than a year. If nothing else, it gave me an awareness of my own limitations. But

Ian Berry first attracted international attention with his photographs of the Sharpeville massacre in 1960. Later he covered other violent news-stories, such as in the Congo, with the same remarkable *sang froid*. It was assignments of this kind that established his public reputation, but he began to win further respect among other photographers for his quieter pictures of everyday life.

A member of Magnum, his roots, interests and ambitions are firmly in photo-journalism, though he does enjoy working on occasional industrial commissions. The importance of photography to him is in its unique ability to communicate quickly and powerfully with a world-wide audience, regardless of language differences. He says plainly, 'For me, unless a photograph tells someone something, no matter how beautiful it is, it has no real value.'

And yet he expects more of a photograph than to be just a simple record of a situation. He wants it to have a good shape, a balance between what it says as a document and how it is formed as an image. 'I think one without the other doesn't really work.'

There is a consistent quality of visual refinement about his photography. It is precise, elegant, restrained but vital. Its virtues spring from a solid tradition, from considered experience and from an intelligent eye. For all its understatement, it is rich with keen observation and visual surprise.

Most of his professional work is in colour but he prefers to shoot in black and white. The creative possibilities of colour have never much appealed to him and he also feels limited by its technical constraints and by its power to distract. He finds black and white altogether more satisfying.

He uses 35mm exclusively, with a basic choice of Leica rangefinder cameras or Olympus SLRs. On commercial assignments or major colour stories, his approach is quite pragmatic and he will carry a wide selection of lenses from 18mm to 500mm, and also electronic flash. His principal cameras will be Olympus OM-2s but he will also take a Leica M3 with 50mm Summicron. Its viewfinder, he says, is unbeatable and the 50mm has always been his favourite lens. By now he knows exactly what it covers at any distance and it lets him operate quickly and discreetly.

With black and white he prefers a pair of Leicas, an M3 and an M2 because of its built-in 35mm viewfinder, together with 28mm, 35mm and 50mm lenses. Probably he will also pack an OM-2 with a 180mm telephoto. He likes the wide-angle lens because '. . . you can get in amongst people and photograph without them being aware of you, and the perspective is interesting.'

in fact it was altogether a very valuable experience for me, both privately and professionally.

Before long I hope to tackle another personal project that I have been considering for some time.

Since my style of working is essentially unobtrusive, I try to keep equipment to a minimum. I use 35mm cameras exclusively, with a mixture of Olympus SLRs and Leicas.

The automatic exposure control on the Olympus OM-2 is a great help if used intelligently. You can snap away and be fairly sure of producing properly exposed pictures. And if you are aware of the limitations of the automatic mode, you can control it even better.

What is particularly important to me, is that the OM-2 has its over/under exposure correction dial in the same place as the Leica has its shutter speed dial. So I can make corrections instinctively on the OM-2 in the same way as I would correct speeds on my Leicas.

Unfortunately, I cannot focus the OM-2 as accurately as a Leica, which is critical when one is working at wide apertures, as I often must. And so whenever I go away, I take a mixed bag of OM-2s and Leicas, and depending on my mood and the situation, I select the camera to suit.

If I am shooting black and white, I use a couple of Leicas and one or two OM-2s. If I am shooting colour, I use a couple of OM-2s and one Leica or two.

My primary tool with black and white is the Leica, and my primary tool with colour is the Olympus.

For me, the Leica M3 viewfinder is unbeatable and I use this camera with the 50mm lens. It is ideal for sixty percent of my work. I have used it for years, and I know exactly what I am going to get at any range.

The other Leica I carry is an M2, to take advantage of the built-in viewfinder for the 35mm lens. Usually I prefer the 28mm wide-angle, but since it has a maximum aperture of f/2.8 I have to switch occasionally to the f/1.4 35mm lens.

I compose and shoot very rapidly with the 35mm. It is essentially a snapshooting lens for me. The 50mm is a more considered lens. I use it in situations where I stand off and wait for the event to develop before I shoot. It is not a grab lens. And so when I walk around the streets, I am looking for two things—I am watching for situations that may develop, and I am staying alert for situations that develop before I can think about them.

In a crowded place, or when people are aware of me, it is easier to work with the relatively wide-angle 28mm. It is also a way of artificially emphasizing the foreground.

I also regularly use a 180mm lens on an OM-2, with both black and white and colour.

I rather dislike very long lenses, partly because of the flattened perspective that usually results, and partly because they suggest a Peeping Tom element. I do not like being caught pointing a long lens at somebody.

When I travel on a major story where I shall be shooting mostly colour,

I take three or four OM-2s, a Leica M2 and an M3. For the Olympus, I take 18mm, 28mm, 50mm, 180mm, 300mm and 500mm lenses. For the Leica, 28mm, 35mm and 50mm.

Over ninety percent of the time I use available light, but on certain assignments I take along a few flashguns. Probably only one of them will be needed, but if the only way to produce a picture is to rig up three or four flashguns, I'll do it. I think that I owe that much to the people who are paying me to be there. In reality, it hardly ever happens. Usually when the light is so abysmal that I cannot shoot with 400 ASA Ektachrome, then I use a tiny flashgun to open up the foreground.

I very, very rarely crop my pictures in printing. Possibly it is an unnecessary self-discipline, but I find it better to get the picture right first time in the camera, rather than trying to make it work afterwards.

Mostly, my pictures are printed by a commercial darkroom. I would like to spend more time doing it myself but it is just not practicable when I am so often abroad on assignment. Therefore I have to expect most of my photographs to work whoever prints them.

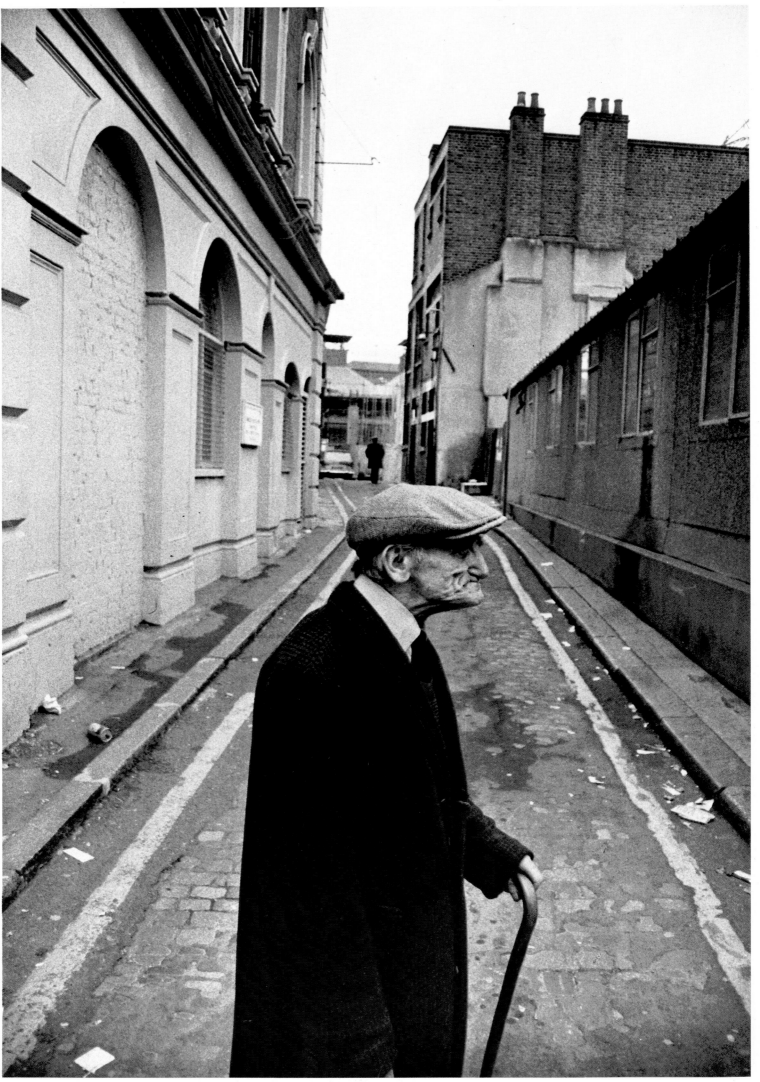

Whitechapel, London 1975

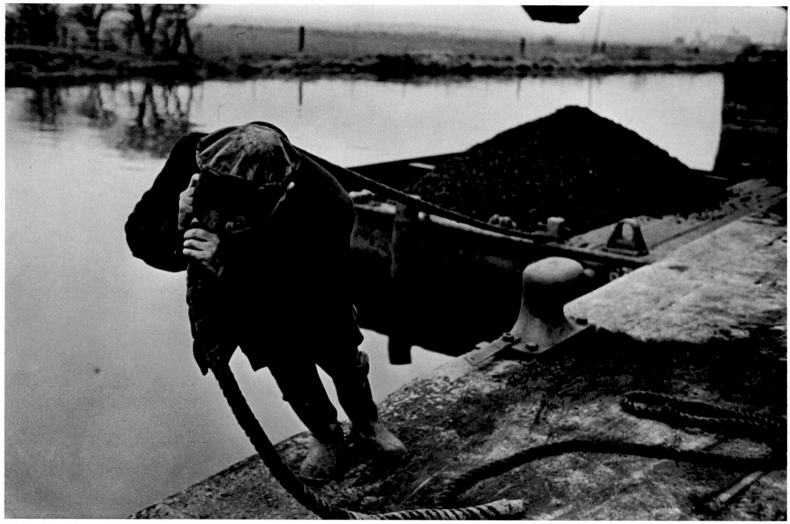

Hellingley coal mine, Pontefract, Yorkshire 1975

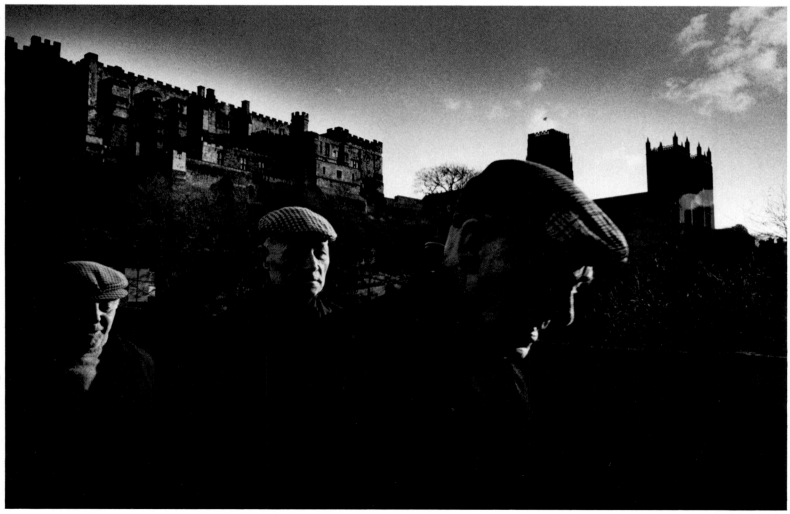

Durham Castle 1975

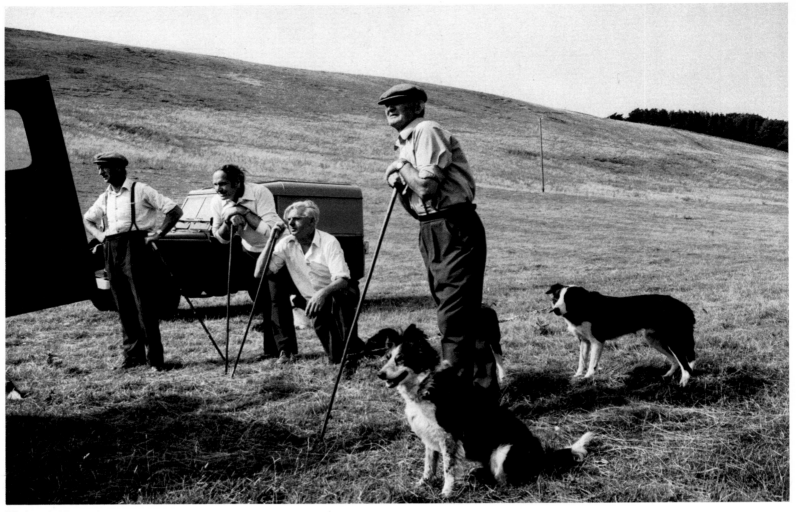

Hethpool, Northumberland 1975

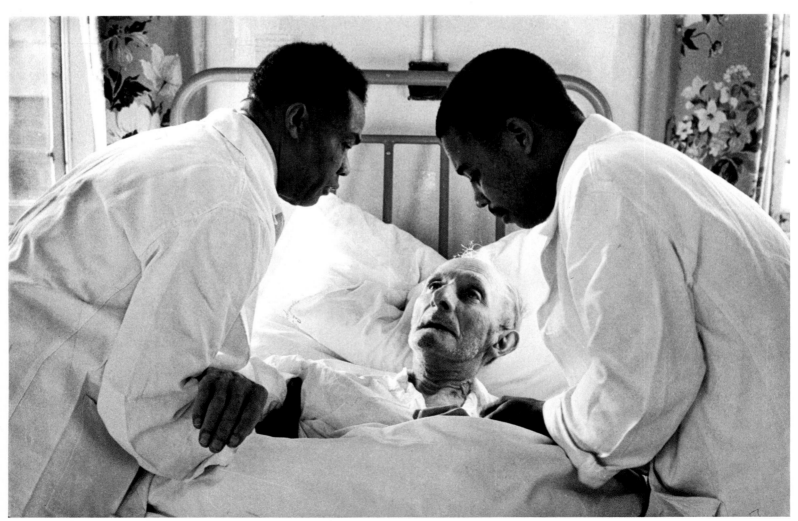

Midlands geriatric ward, 1975

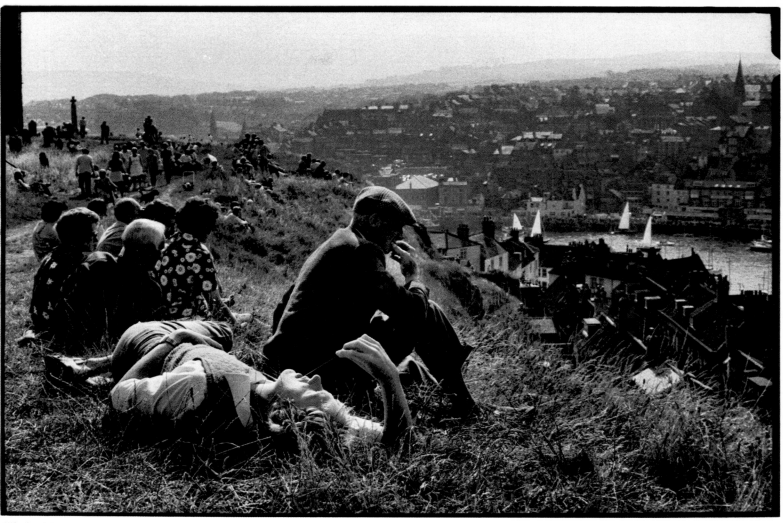

Whitby, Yorkshire 1975

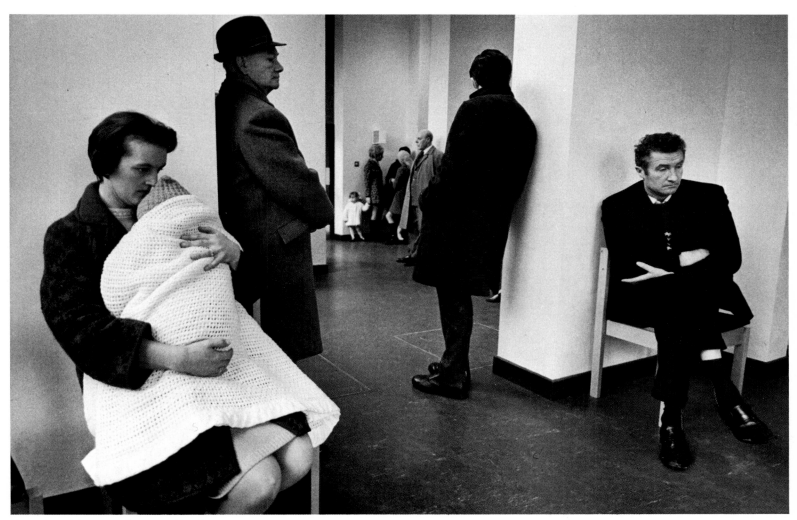

Doctor's waiting room, Battersea, London 1975

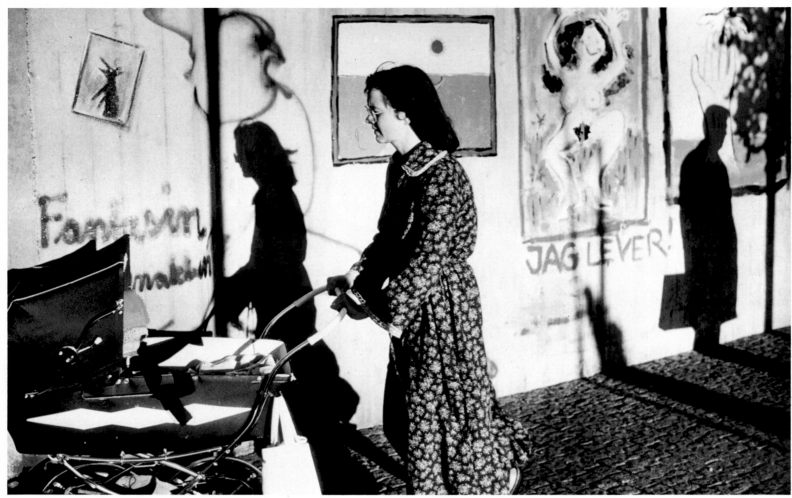

Stockholm 1980

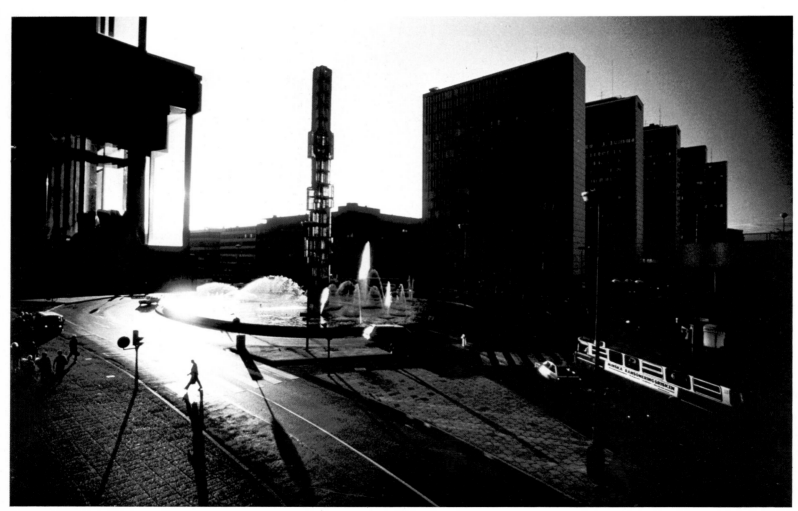

Stockholm 1980

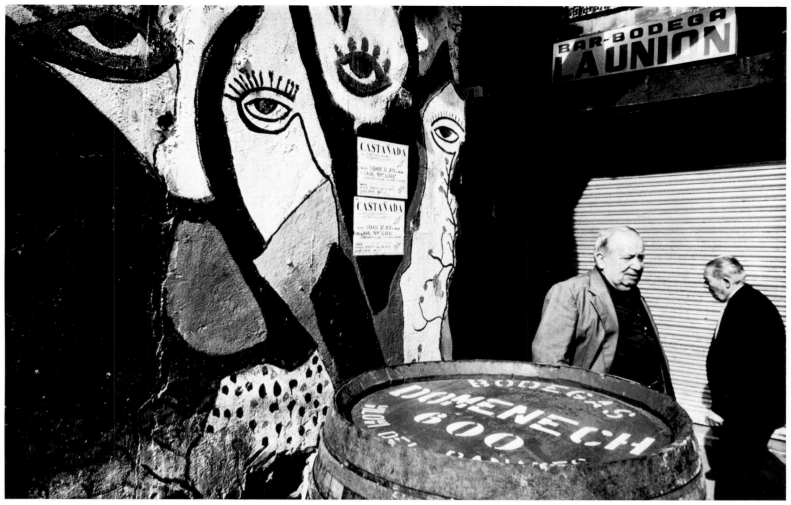

Barcelona 1979

Capetown 1980

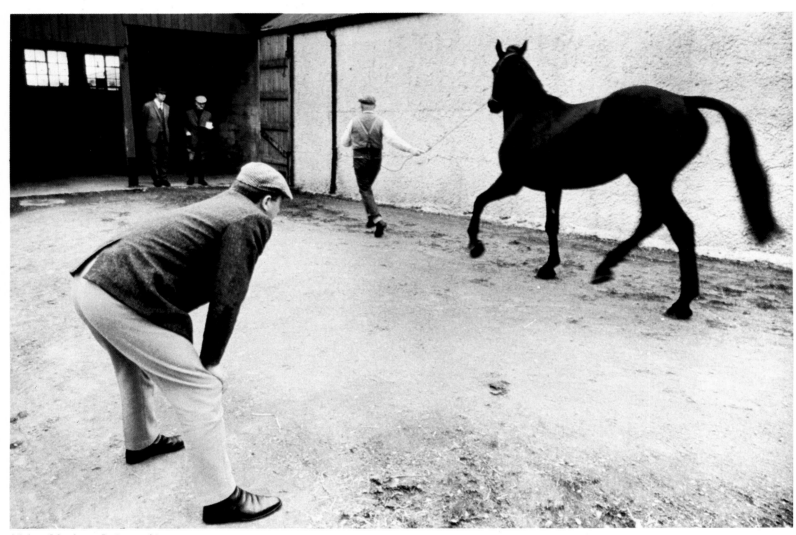

Melton Mowbray, Leicestershire 1975

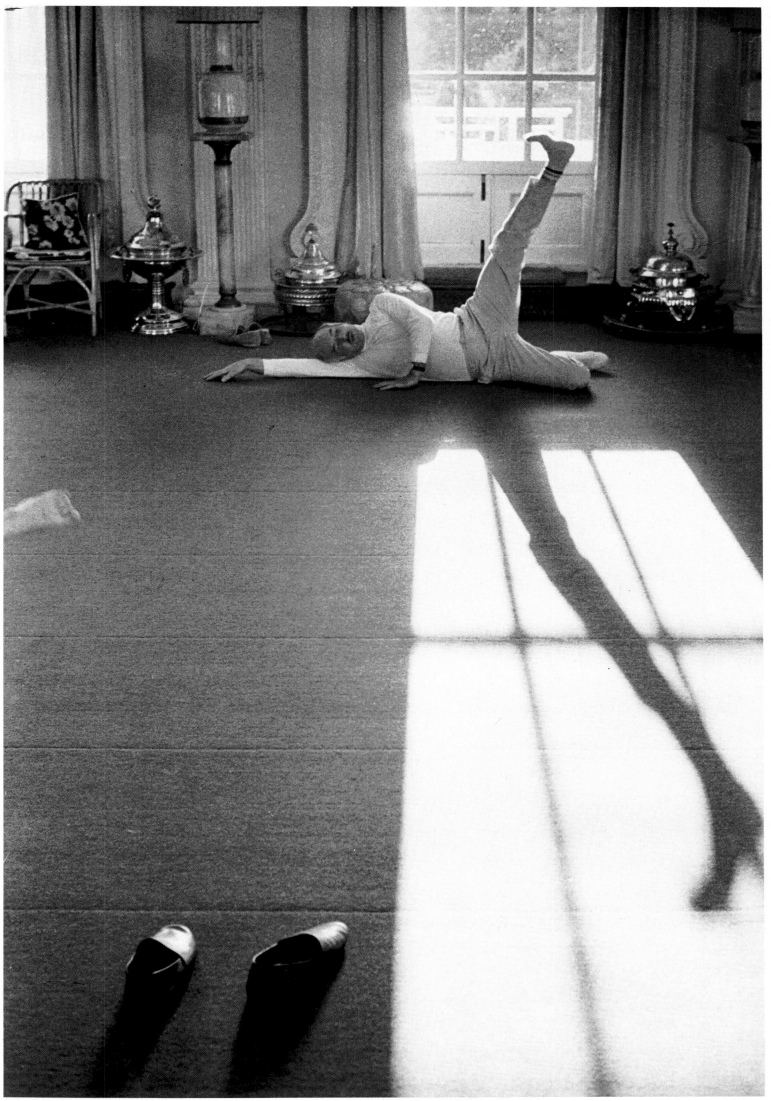

Health farm, Haywards Heath, Sussex 1975

André Kertész

Born:
1894, Budapest.

Education:
Academy of Commerce.

1912:
Began work at the Budapest Stock
Exchange.

1915:
Called up into the army. Took his camera
with him when he went to war in Central
Europe and the Balkans. After the war he
took up clerical work again.

1925:
Went to live in Paris, working as a free-
lance photographer.

1936:
Went to live in New York, initially on a
one-year contract; stayed on, working in
fashion magazines.

1949-62:
Under contract to Condé Nast
Publications.

Books:
1933 *Enfants.*
1936 *Paris vu par André Kertész.*
Nos amis les bêtes.
1937 *Les Cathédrales du vin.*
1972 *André Kertész: Sixty Years of
Photography 1912-1972.*

Exhibitions:
1927 Sacre du Printemps Gallery, Paris.
1937 Julien Levy Gallery, New York.
1946 Chicago Art Institute.
1963 Bibliothèque Nationale, Paris.
1964 Museum of Modern Art, New York.
1972 Photographers' Gallery, London.

As a boy, I felt very close to the country, though I was actually born in
the city of Budapest. At the age of six or seven I used to visit my uncle in
the country, and play with his children, who were about the same age as
me. In his attic we found some old household magazines, with very nice
illustrations. Even then, I dreamed that I might do something artistic
myself one day.

The older members of my family had cameras, and took snapshots. I
took my own first photograph in 1912–a very long time ago! But for
four or five years before that I had been taking, as it were, photographs
without a camera, visualizing exactly what I wanted to do. I made up my
mind to get a camera.

With childish pride, I did not ask my father for the money to buy one,
but waited until I had my first wages from a job. Then I bought a cheap
box camera–I don't remember the make–and took pictures of the
things and people I saw around me. They were exactly the kind of things
I photograph today . . . little happenings.

Dissatisfied with that first camera, I bought an Ernemann pocket
camera, and then an ICA 'Baby'. All used 4.5 × 6cm glass plates, and my
first camera to take larger pictures was a present from my elder brother,

Imry. A Voigtlander 'Alpin', it took 9 × 12cm plates, still less than half-plate in size.

When the First World War began I was twenty years old. I was called up in 1915 and I took a camera – this time a Goerz-Tenax – with me into the front line. Imry worked out that it would be lighter if I were to take large plates with me, to be cut down to 4.5 × 6cm with a glass cutter, but the plates and the metal holders still made my infantryman's pack very heavy!

One day, at a place called Gologory, a Russian soldier shot me; I don't know why he wanted to kill me. The bullet just missed my heart and entered my arm, where it injured a nerve. My left hand was paralyzed but I was given the chance to have an operation, though the specialist told me that he could not guarantee success. I was lucky, and while convalescing I even managed to find a way to hold my camera. I took photographs of other wounded soldiers, friends, children from the nearby gypsy camp, incidents in the countryside, and so on. In 1917, I took *Underwater Swimmer*. We were sitting around this beautiful blue pool before lunch, talking and swimming. Sitting on the steps, I did several shots of the play of the water and reflections in it, but this is the only one I've still got.

It's all changed now. Ten years ago the Hungarian government made an exhibition for me in Budapest, and I went to see some of the places I photographed so long ago. I found the blue pool surrounded by tourists, coaches and souvenir shops.

After the war I became a clerk again, first with some stock exchange accountants, then in the head office of Hungary's biggest agricultural products company. But I went on taking photographs. *The Circus* (1920) was a small travelling show: you can see the canvas of its tent at the top of the picture. I wanted to photograph them putting the tent up but failed, so I took this shot of two people who couldn't – or wouldn't – pay the few cents' admission. It's an example of how I 'take notes' with my camera, which is for me the same as a pen for a writer. In a way, all my work adds up to a sort of diary with pictures.

In 1925 I left Budapest to live and work in Paris. I took many photographs around Montmartre and along the banks of the Seine. I was lucky enough to get to know, and to photograph, many important artists, among them Chagall, Brancusi, Calder and Mondrian. My picture of *Mondrian's Studio* (1927) shows a view no-one else saw. I placed myself behind the settee in order to get the exact composition I wanted. In those days I couldn't make enlargements and, though I knew in my imagination exactly what I wanted, I couldn't always crop my tiny contact prints. I actually designed my first enlarger myself, and then found a carpenter to make it for me. At first I didn't have an enlarging lens, so I used a lens from an ordinary bicycle lamp. I still have some of the prints made this way. Of course, they're not sharp, but they are very effective flukes. After all, in real life things aren't always sharp: aesthetically, it's nice to have a little softness.

'We all owe something to Kertész,' said Henri Cartier-Bresson, and indeed it has become a cliché to call **André Kertész** 'the father of modern photography'. The debt is real and the tribute deserved. But one not only respects him for his early pioneering work, one also marvels at his creative stamina and constant freshness of vision – over fifty years passed, for instance, between *Underwater Swimmer* and *Martinique*.

Another great pioneer, Brassaï, was actually inspired to take up photography through meeting Kertész in Paris in about 1926, looking at his pictures and listening to him talk about them. He said later, 'André Kertész had the two qualities which were essential to a great photographer: an insatiable curiosity of the world, of life and of people and a precise sense of form. Now, in most cases, these two faculties do not go together. One can often be a good photojournalist and yet lack a sense of form (the effect of the significance always being one step ahead of the composition of the image), just as one can be a remarkable photographer only on the deliberately aesthetic plane. But rarely are these two qualities found in the same person. And yet Kertész was able to give to his most fleeting images of life all the formal qualities and tonal values which are generally attributed to premeditated pictures. In this respect, he may be considered a real *creative photographer*.'

Kertész explains that his sense of composition is quite instinctive. 'This is a big gift; I was born this way. I feel it, I do it. Today after all these years I know I do the right thing.'

From the beginning it was movement he wanted to capture, the very flow of life. He was not interested in fine detail but in moments of action, in spontaneous behaviour. The advantages of a small, light, inconspicuous camera for work of this kind were obvious to him and so he followed his instinct, even when fellow professionals scoffed at his 'toy' (a Goerz-Tenax, using 4.5 × 6cm plates). In 1928 he bought one of the first Leicas sent to Paris and became an instant devotee. As he said, 'I took Leica pictures before the Leica was invented.'

Another piece of equipment that immediately appealed to Kertész was the zoom lens. He tried out a very early model and was duly impressed. Much later, when they became commonplace, he bought one and gradually changed his allegiance from the Leica to the 35mm single lens reflex, trying out a Nikkormat, a Canon and then an Olympus.

Although Kertész has concentrated for most of his life on black and white photography he has not ignored colour altogether. His first tests in 1938 were disappointing,

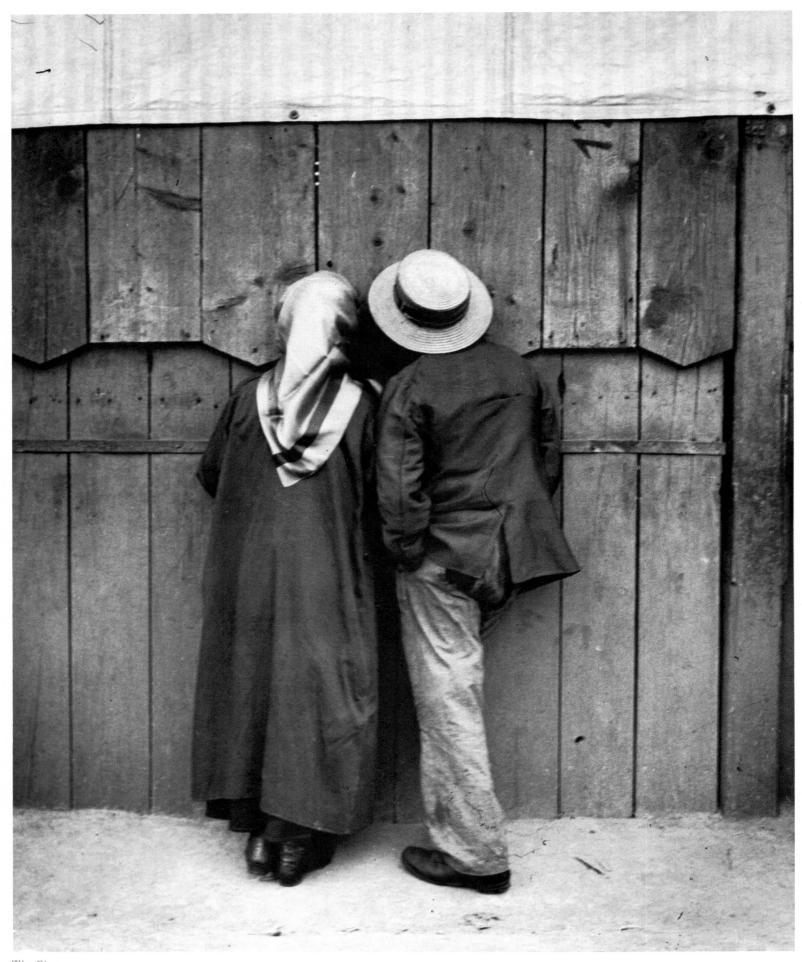

The Circus, 1920

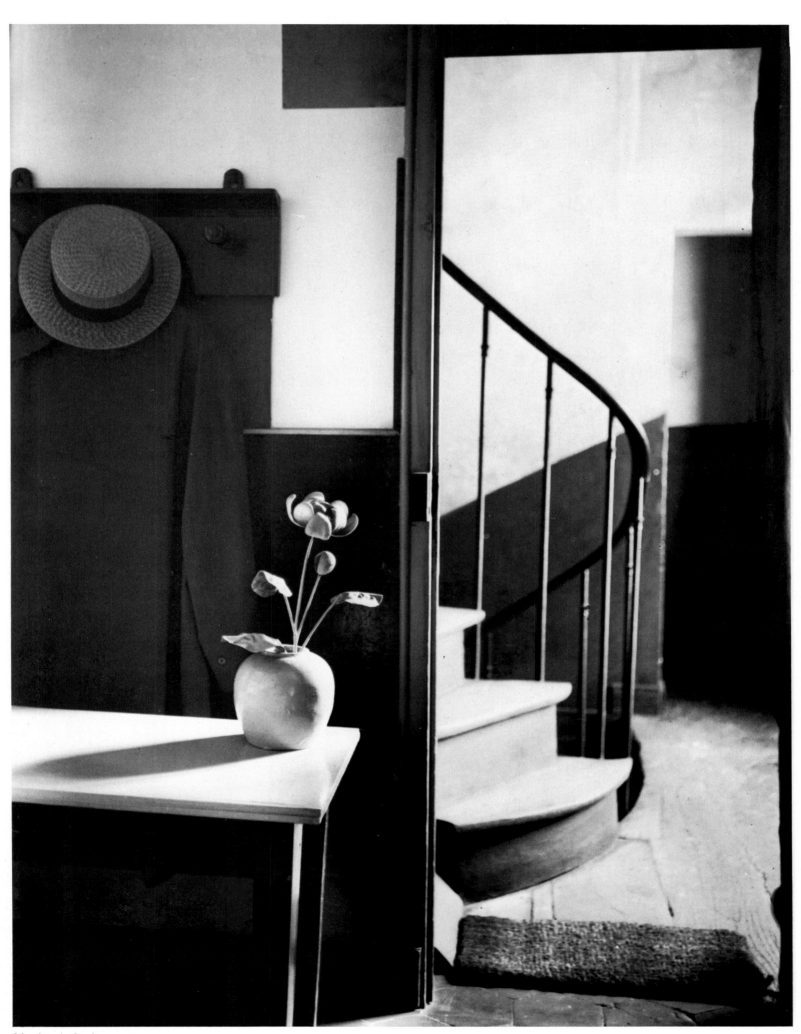

Mondrian's Studio, 1926

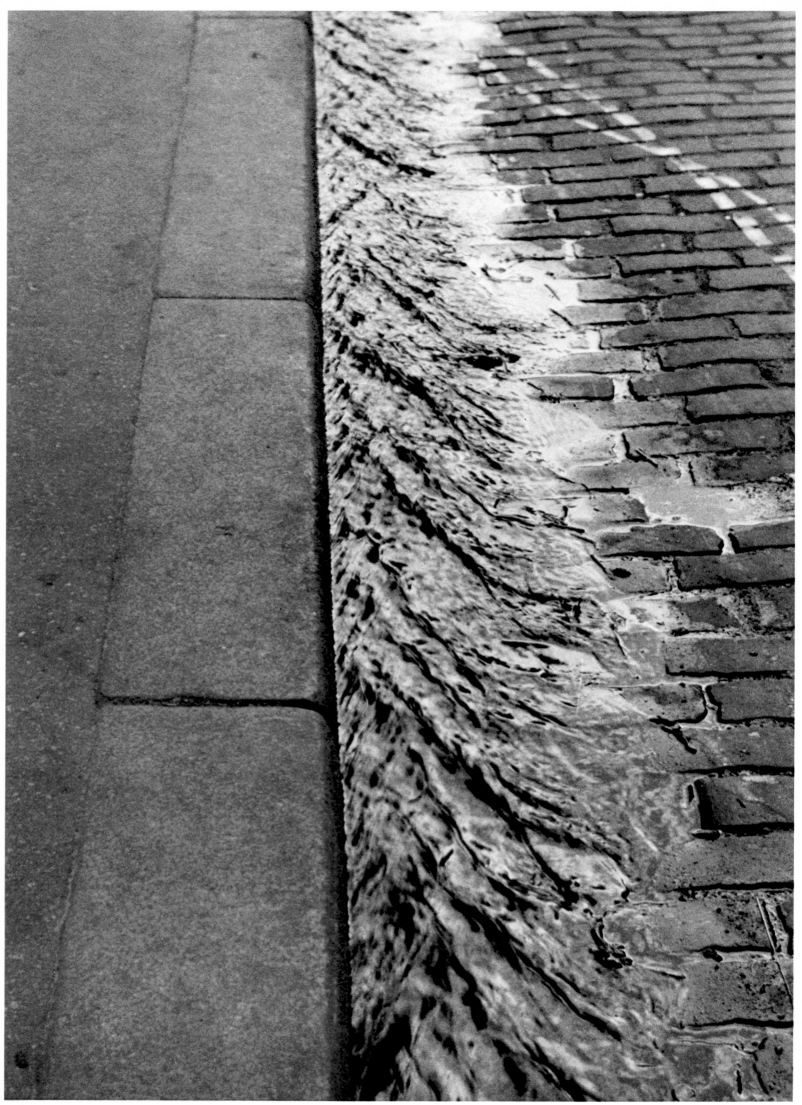

Paris 1929

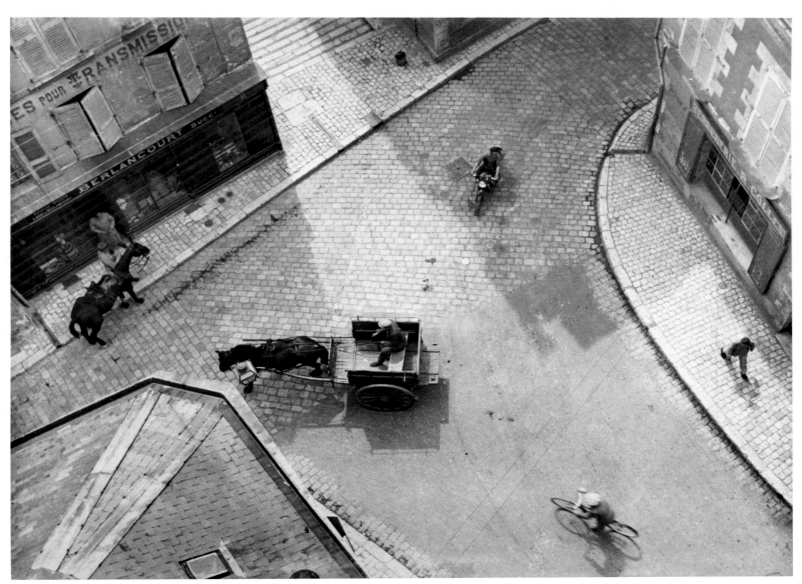

The Crossroads, 1930

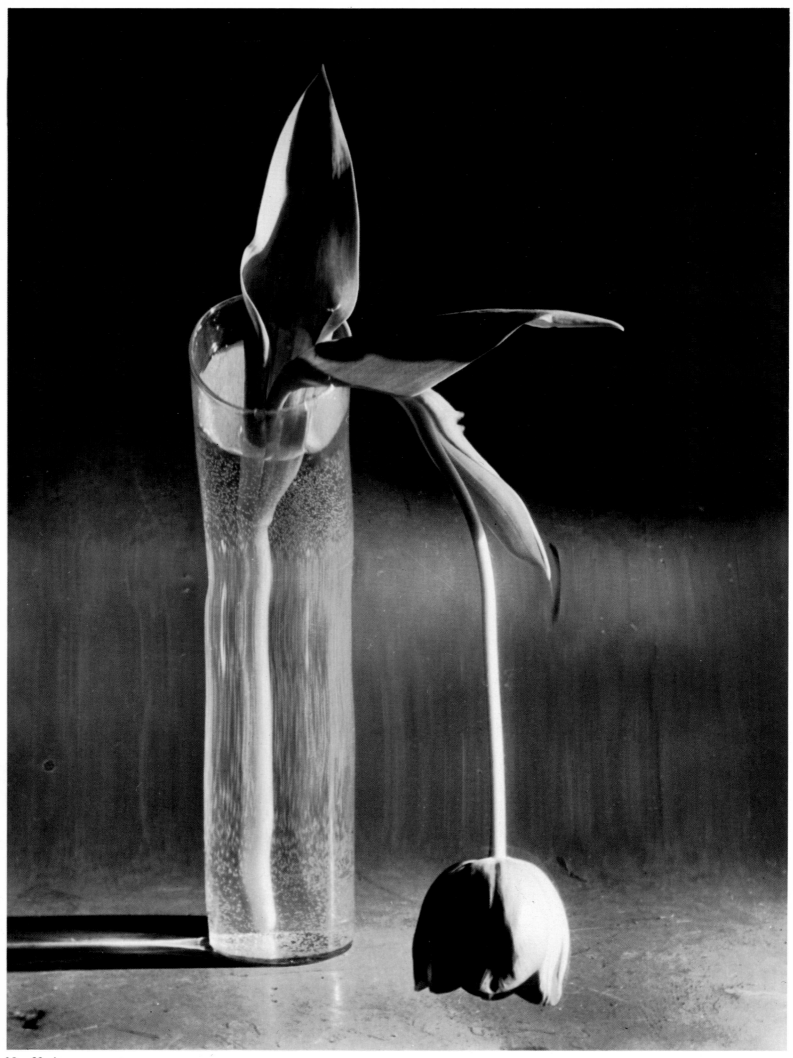

New York 1939

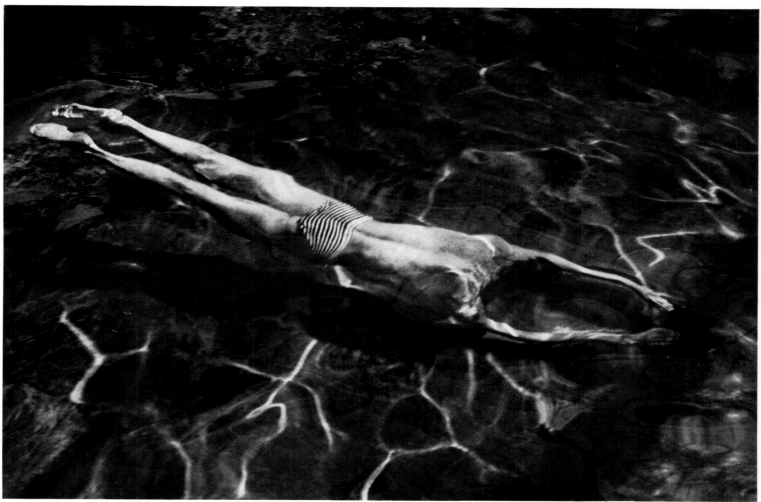

Underwater Swimmer, 1917

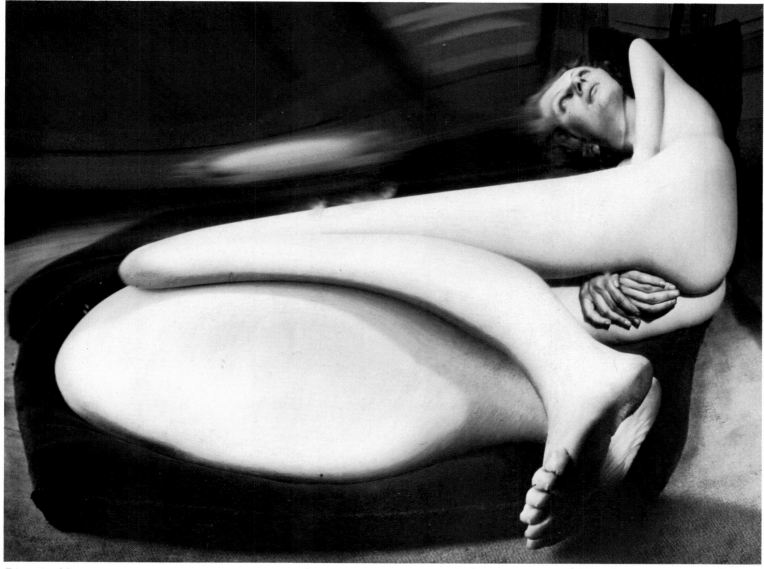

Distortion No. 40, 1933

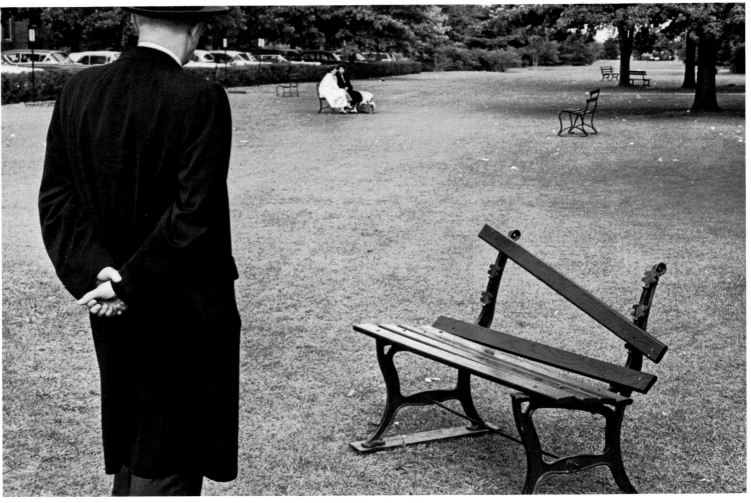

Broken Bench, 1962

Martinique, January 1 1972

Lost Cloud, 1937

William Klein

Born:
1928, New York.

As a painter, William Klein worked with Fernand Leger on arriving in Paris. His paintings were exhibited throughout Europe and he executed numerous abstract murals for French and Italian architects.

1954:
Having become interested in photography, he made a photographic record of New York while revisiting the city.

1955 on:
Under contract to American *Vogue*.

1965:
Gave up photography to concentrate on making movies. Klein has been involved in films made for both television and the cinema.

1978-79:
'A sort of return to photography' with new books and shows.

Books:
1954-55 *New York.*
1956 *Rome.*
1960 *Moscow.*
1961 *Tokyo.*

Exhibitions:
1978 Photographers' Gallery, London.
Gallery Fiolet, Amsterdam.
Apeldorn Museum, Holland.
M.I.T. Boston—10 photographers from Atget to Klein.
1979 Fondation Nationale de la Photographie, Lyon.
Canon Gallery, Geneva.
1980 Museum of Modern Art, New York.

Lately, I find myself being asked, about once a week, to explain what photography is, or was, for me. When I was taking pictures, actively and professionally, nobody ever bothered to ask me. And I hardly thought I would have needed to spell it out. But I did try once, in three words, and I thought that did it. It was in the title for my book of first photos: New York Is Good For You William Klein Trance Witness Revels. So Trance + Chance, Witness + Witness, Revels + Reveals. What else could I say?

I left photography 15 years ago to make movies. I didn't stop taking pictures—nobody does!—but I certainly stopped getting high on photography or *worrying* about it. I became more or less a Sunday photographer, or re-became an amateur. I'd take pictures on vacation like everybody else or photograph locations or actors. Or some event would prompt me to snap away, but nothing sustained.

Very much out of it, I hardly noticed the photographic boom of the last few years. I missed much of recent developments—technical, aesthetic as well as economic.

Up until two years ago. Since then, I was asked to exhibit, publish, even take pictures again. It was flattering to know that photos taken 20-25 years ago still held up and were even considered at the origin of a lot that's happened since.

One of the reasons I was frustrated by the photographic scene in the past was the lack of dialogue with either colleagues or media, or public. The pictures I took seriously were apparently not that publishable. Outside of fashion or advertising, in 10 years I had no more than 10 assignments. My books, some people dug them, most people didn't, and that was that. The photographic establishment was a joke, photographers were in a ghetto.

When I felt I'd done all I could do in photography I went on to other things. Which is another story.

What might be interesting to describe here is that in trying to deal with photography again I was obliged to retrace my steps and take another look at what I'd done. On one hand, I had to reorganize my archives, hunt down waylaid negatives, etc., and on another, find out what work still meant something. Both to me and as photography.

Another thing: at each free moment during almost a year I went over every sheet of contacts, every picture I'd ever taken. Pursued by echoes of the What Is Photography? debate, I couldn't avoid asking myself what had prompted each of more than a hundred thousand clicks I could still hear somewhere in my head.

And that's the first thing I discovered. I could still almost hear the shutter clicking off. Incredibly, each tiny rectangle 24 × 36 millimetres square rang a bell. A hundred thousand Proustian Madeleines. I could remember the smells, the air, the time of day or night, what and how I felt, high or low, sure or hesitant.

I couldn't believe you could remember that much – but it was all there, stored, the contact unlocking the circuits.

It would all come back: the realization, on reading the sheet, of what I'd seen or thought I'd seen or, even more, had not seen but felt – and saw for the first time on the contact.

Peering through a magnifying glass for hours at a time I was observing someone I hadn't seen for a long time but immediately recognized. Theory on the nature of photography aside, this was my diary. One might see social comment, violence, caricature in my pictures – there, of course – but they were, first of all, pages in my family album. The original stream of consciousness.

Flashback: How I came to take pictures in the first place. An accident, like everything else. I was about 24. For four years I'd been painting more and more abstract, geometric canvases with less and less reference to reality. I'd just finished a commission to paint some pivoting panels on rails separating a room and photographed the panels as they turned. The blurred forms that came out gave me the idea that if I could recreate and control this blur – this graphic trace – I could get out of the formal, geometric rut we were all in at the time.

When **William Klein** joined the photographic circus he was a natural high-flier. Whatever the ground-level glamour of the other acts, from the trapeze they looked earth-bound and confined. He wanted to take new risks in a freer space.

His first book *New York* was like singing scat in the church choir. The pictures were brash, aggressive, grainy, blurred, contrasty, totally irreverent of all photographic conventions and doctrines, electrically urgent and alive. The layout was as slick and sharp as a tap-dance. He quickly jabbed in three more books, *Rome*, *Moscow* and *Tokyo*, and photography, as it was, never recovered from the attack.

Until the mid-fifties, photography in general aspired to elegance. However finely one sliced time, however one snatched at a moment of passing life, it was a point of pride to organize the image harmoniously.

In comparison, Klein's pictures have the dissonance and changing rhythms of city streets. The eye may pause but rarely rest. Some images assault your attention. Others, you wander through warily. The inhabitants of this world are too ordinary, too vulgar, too recognizable, too obviously caught on the hop to count as humanity or mankind – they are just people. Passing people. They stare, the camera blinks. The photographs are fragments of flow. We are aware of continuing life, of surrounding movement and space, of the anonymous intimacy of crowds, of the ubiquity of signs, of half-seen curiosities and the chance traffic of revelations. The pictures have the rough immediacy of present experience.

Klein describes his early work as 'a crash course in what was not to be done in photography'. What he lacked in basic technique he made up for in purpose, energy and confidence. With the Leica he hardly knew how to use, he scribbled the city on film and re-wrote his impressions in the darkroom. Coming from the world of art, or even anti-art, he was completely uninhibited about working his material into the images he wanted.

Later the pictures often have a more formal structure, but the techniques are still unconventional and flexible. For example, he frequently photographs people in the street head-on. Sometimes a huge, out-of-focus face will half fill the frame, balanced by some activity in the middle distance. Sometimes the picture will be sharp from front to back, with strong interest in the foreground, middle and far distance. Sometimes the composition will be like a cross-section of a club sandwich, with strong vertical bands of support and filling, some foreground and some middle distance. The rather high tonal contrast gives the image an extra graphic vitality.

I improvised a small darkroom and experimented with projecting light through cutouts in black cardboard onto the paper – literally drawing with light. It worked and I used the results in other murals.

But now I had a darkroom and could fool around enlarging the odd vacation snap. I found they weren't as bad as they looked coming back from the corner drugstore. So photography to the rescue – first of formal research then of the nostalgia for everyday reality I was no longer able to deal with in my paintings.

As an apprentice painter I had spent some time with Leger. One of the things I picked up from him was a taste for the mechanical process as well as the idea that anything goes. Painting, film, design, photography – same difference, *le même combat*.

About that time, I had the opportunity to go to New York, where I was brought up. I'd been living in Paris for 6 years and it was my first trip back. Somehow it seemed obvious that I should make a photographic record of my return.

I knew that for several weeks I would see everything with a particular double vision – European frames of reference and native New Yorker instinct.

And my second-hand, beat-up-but-trusty Leica would manage to record all this.

For the first time, I was to take photos for a purpose. I was painting, but mainly I was trying to find out who I was. Oddly enough, although I'd lived in Paris for 6 years I never considered myself an expatriate. I was homesick, curious, and I had a lot of old scores to settle with the city, with my past.

As a child growing up in a semi-slum I felt excluded from the dazzling metropolis you presumed existed somewhere but which you saw only in movies.

Coming back I was to set things straight. I felt I had the key to the city if not to myself – the ultimate secret weapon – my Leica.

I had a camera but barely knew how to use it. The right film, the right lens, the right filter – who cared. What interested me was getting something on film. And then getting it into an enlarger.

My plan was to make my own personal newspaper. My model was the *New York Daily News*, that monster big city tabloid with its scoops and scandals and Cro-Magnon politics that you'd find blowing on the streets at three in the morning. I wanted to use newsprint, make my book look like the News, have its general noise, energy and vulgarity. Plus a touch of my own brand of Dada.

So obviously, I was less than preoccupied with the niceties of photographic technique.

With friends in Paris I had been gravitating towards anti-art; why not take anti-photos? Or at least anti-'good' photos.

I played the *paparazzo*, treating the most banal event as if it were a scoop. At that time, in 1954, the photographic model was Cartier-Bresson and the word was objectivity. Elegance, measure, distance, and discretion.

My diary-tabloid project was of another nature; I went in the opposite direction, dropped the myth of objectivity and provoked a kind of street photomaton-ography.

Photomaton, *paparazzo*, tabloid, parody, *art brut*, anti-photos, just to start with. Unencumbered by photographic training or taboos I tried anything. Grain, blur, deframing, deformations, accidents. I would shoot without aiming, frame as catch can, push the grain, the contrast, torture enlargements and generally put the process through a wringer. A crash course in what was not to be done in photography. Mainly I kept and used somehow what almost all photographers at that time would have thrown out. I felt painters had freed themselves from rules—why not photographers? Perhaps as an outsider and a heretic it was easier for me.

I can remember what it was like taking those first pictures. Going over the contacts it comes back.

And strangely, today—taking pictures again—I find myself in a similar situation. Stop taking pictures for a while and you're out of shape. It's like breaking training or no longer speaking a language—your body or your tongue forgets. My reflexes had become rusty, I was tentative, I fumbled with movements that used to be automatic.

I worked to become fluent again. I was bored with exhibiting old pictures and I wanted to see how I could photograph today, considering what had taken place since I stopped.

OK. Looking backwards and inwards I checked what I was doing and had done. Since we're talking about taking photos and not assembling a machine gun perhaps I'm justified in noting *pêle-mêle* how it feels.

Ready, aim click. On purpose. By accident. Click. The risk. It's not painting: composing, adding, subtracting, changing. But one shot. All or nothing. Bang, you're dead. Or alive. You never stop ruminating. Apparently rare one who can go 15 seconds without thinking of self. Constant. Normal. Taking pictures—your reflection in a crowd. In a silver eye. Reflex. Reflection. Click. Off the top of your head. The sum of what you see, think you see, remember, project. Slicing life. All the rosebuds pop up, triggered. Clues. Hieroglyphs. Keys. Pocket calculators, each button with its own beep and circuit. Instant square root, memory. *Déjà vu. Jamais vu. Revu.* Aftervision. Prevision. Busloads of Japanese snap the palace. Proof. Celebration. They've been there. They're alive. They photograph, they exist. They are photographed, they exist: I came, I saw, I conquered. *Veni vidi vici* = to photograph. Instinct of reproduction. Reproduce a world. Your world. Its mark on you. Leave your mark. Hold it. Don't move. Move. Be natural. A look, a gesture is an ikon. A microcosm. Each photo a cell. Shoot. Shot. Hunt. Hunted. Hunting. Cruising. Happening. Flashback. Shot in French = *coup*. Lightning = *foudre*. *Coup de foudre* = love at first sight. You know. Everything at once. A drowning man sees whole life. Image. Imagine. Taking photos = looking for *coup de foudre*. How many times can lightning strike? Trance witness revels.

Moscow 1959

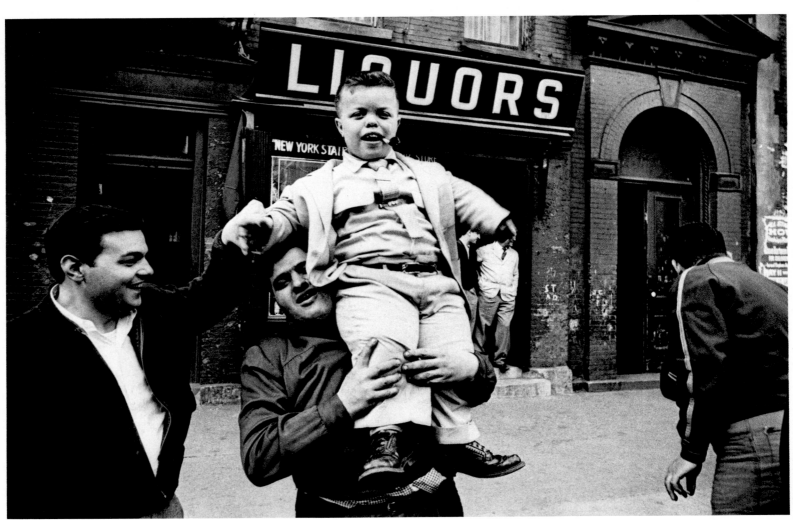

New York 1954

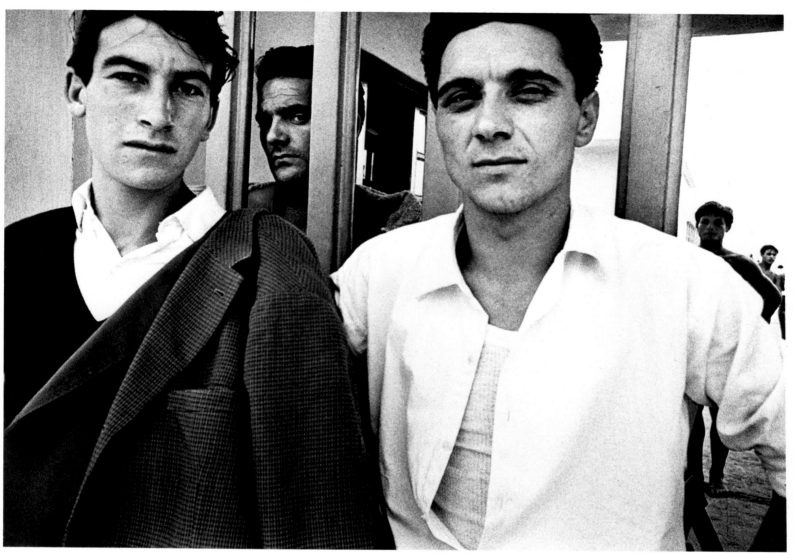

Rome 1956

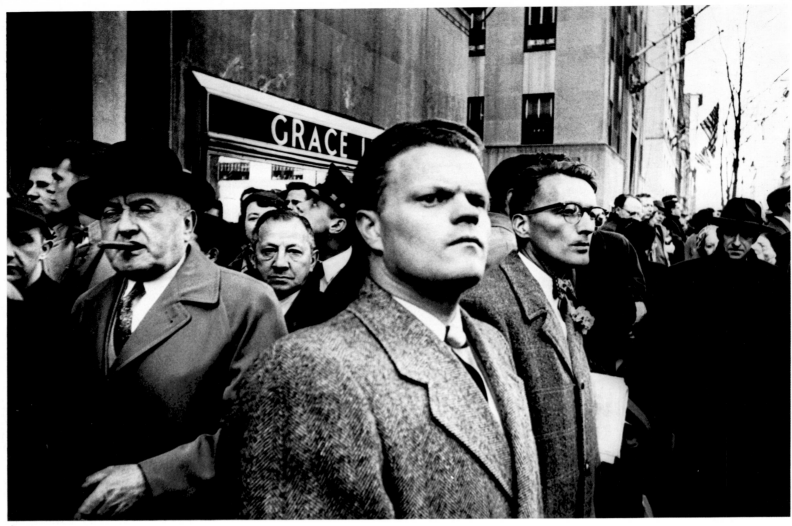

New York 1955

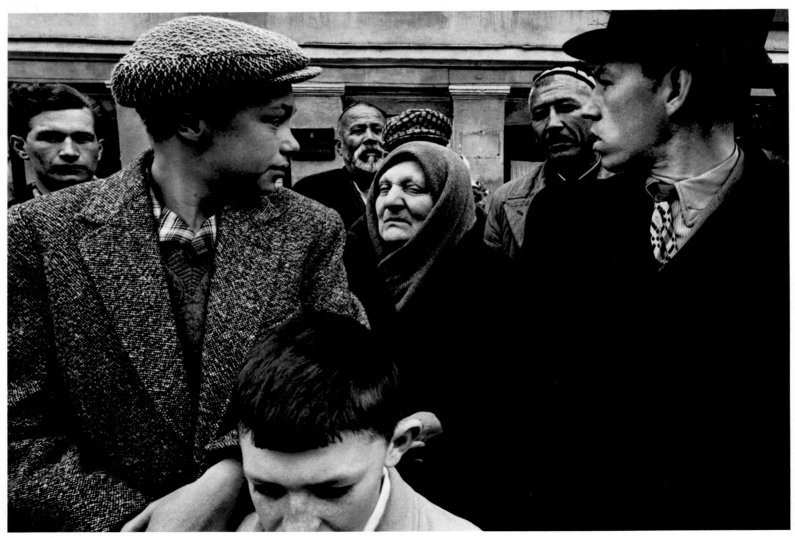

Moscow 1960

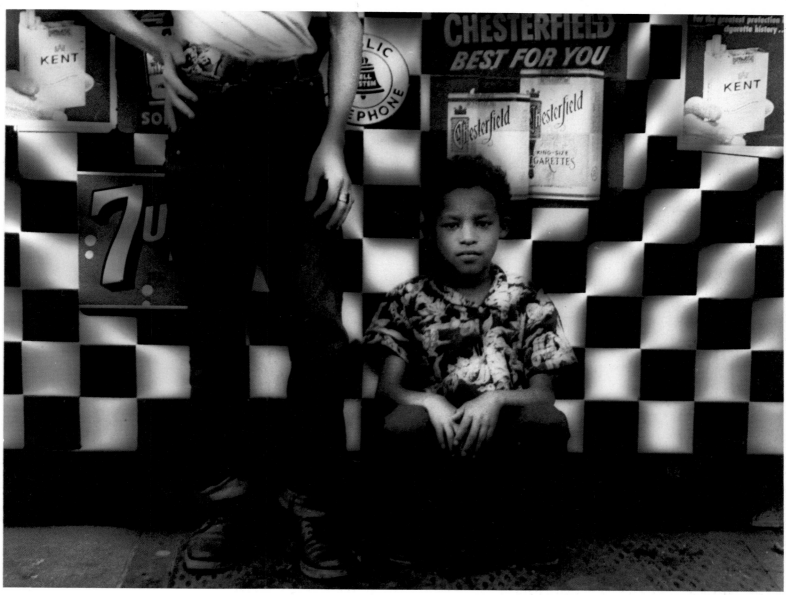

New York 1954

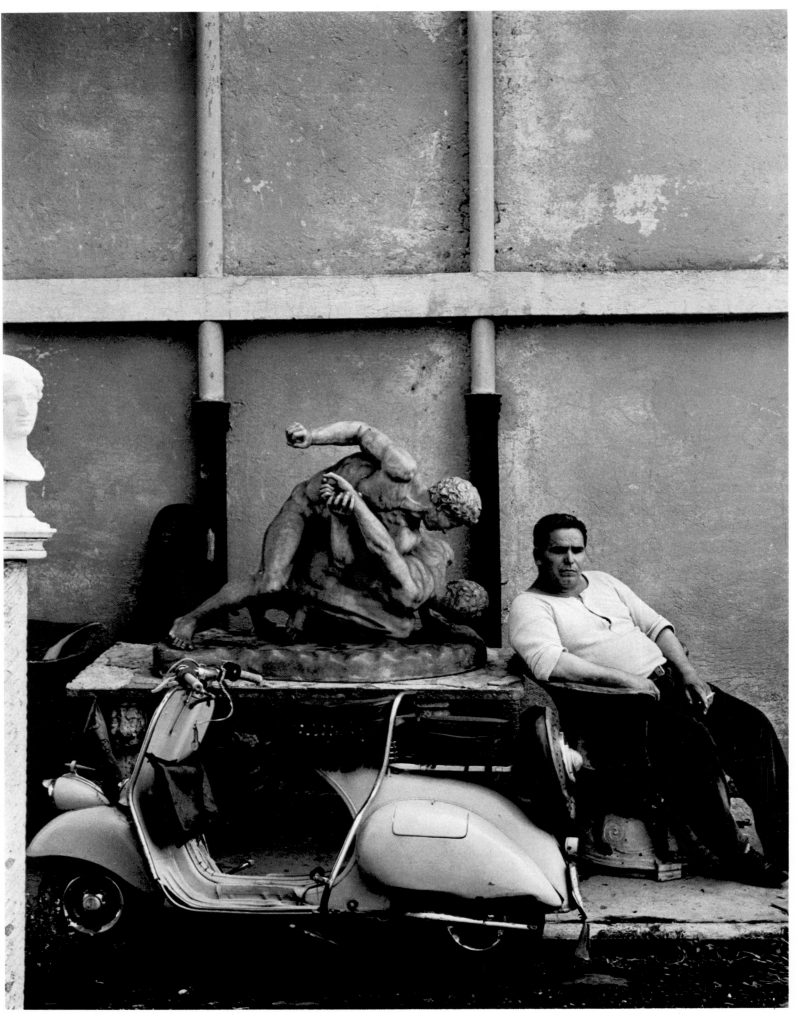

Rome 1956

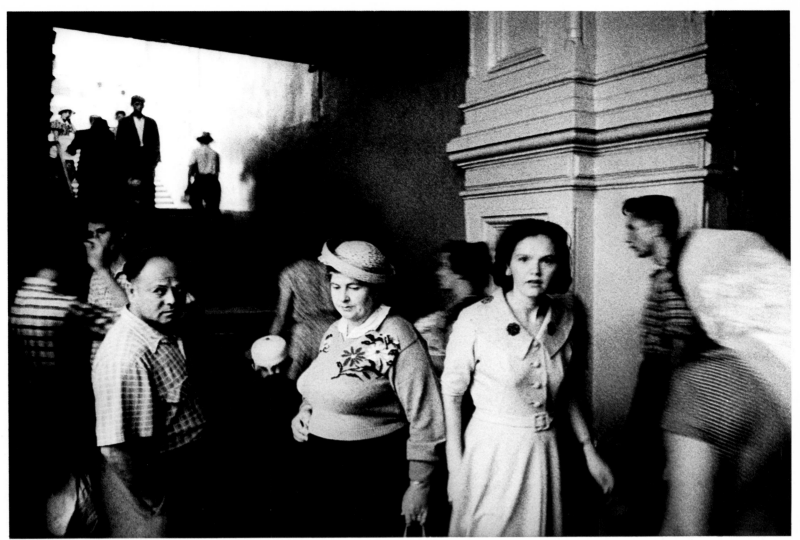

Moscow 1959

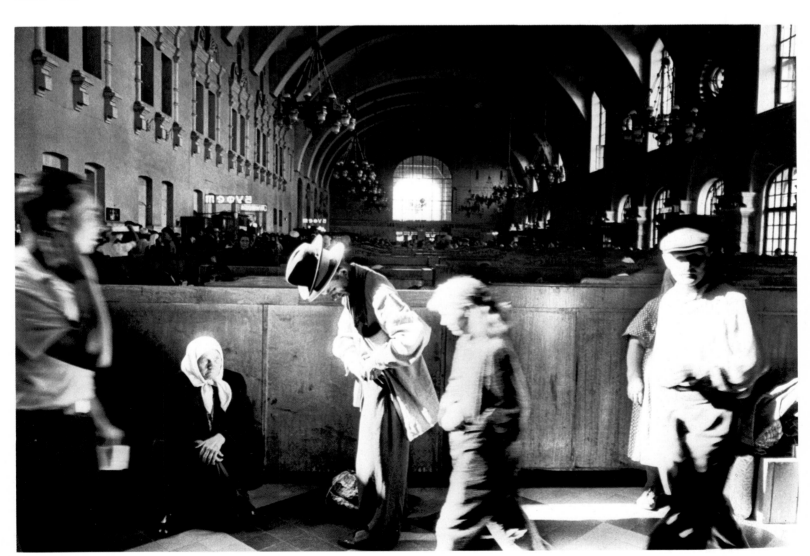

Moscow 1959

Tokyo 1961

Tokyo 1961

Jean Dubuffet

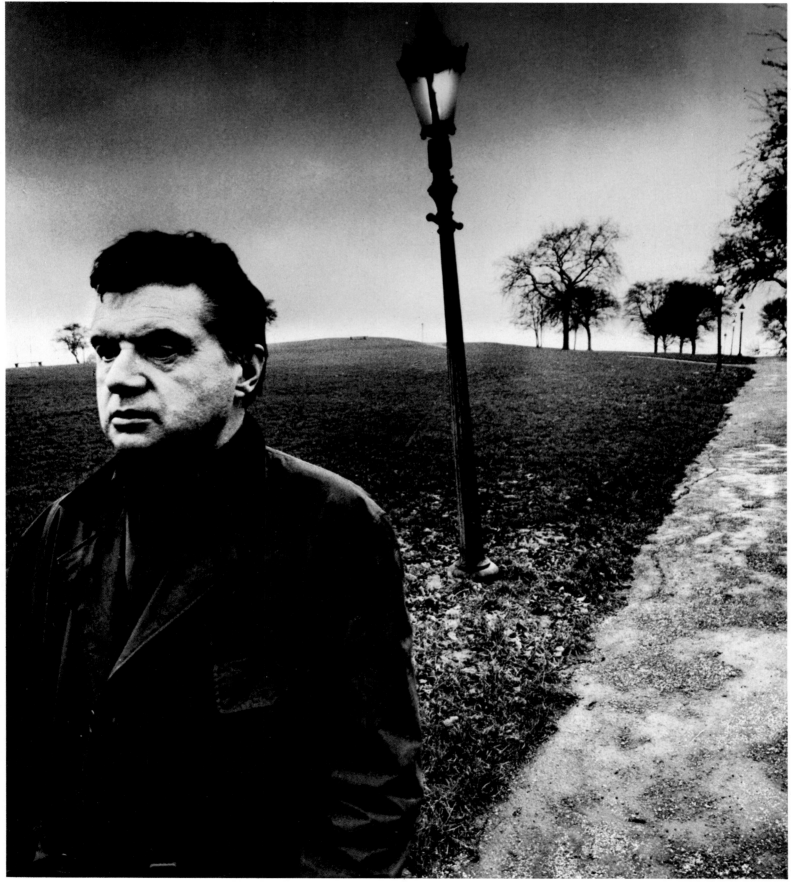

Francis Bacon

Evening in Kew Gardens

Coal-searcher going home to Jarrow

Josef Koudelka

Born:
1938, in Moravia, Czechoslovakia.

Education:
1961 Graduated from the Technical
University of Prague.

1961 on:
While working in aeronautical engineering,
Koudelka pursued his interest in photo-
graphy and began to document the life of
Gypsies in Czechoslovakia and Rumania.

1971:
Became British resident; invited to join
Magnum. In western Europe he continued
the documentation of Gypsies started in his
home country.

1971 on:
Apart from Gypsies Koudelka has been
photographing religious and other
festivities and everyday life in Great
Britain and Europe.

Books:
1966 Illustrated with 82 photographs a
book on the production of Alfred Jarry's
Ubu Roi, published by the Prague Institute
of Theatre.
1975 *Koudelka–Gypsies* (Edited by Robert
Delpire).

Exhibitions:
1961 Theatre Semafor, Prague.
1975 Museum of Modern Art, New York.
1976 Chicago Arts Institute.
1977 Zurich Kunsthaus.
Tel Aviv Museum.
Delpire Gallery, Paris.
1978 Stedelijk Museum, Amsterdam.
1979 Exhibition Fototeca, Caracas,
Venezuela.
Musée d'Orange, France.
1980 Camera Obscura, Sweden.

I am wary of making any statements about photography. First of all, they are so open to be misunderstood, and secondly, I do not want to run the risk of being at all inhibited in the future by anything I may say about my work today. Life changes, and I want complete freedom to change myself.

Furthermore, I speak several languages but none in which I feel really articulate. This short text is the result of a collaboration between the editor and myself. When I left Czechoslovakia and had to establish myself abroad, it was difficult for me to talk about my pictures, not only because of the language problem but also because I was not in the practice of discussing my work. I have never thought of myself as having anything significant to say about photography and I have felt no need to be articu-late about it. But recently I have been under increasing pressure to discuss my pictures and so I agreed this once, even though rather reluctantly, to explain how I work, in the hope of reducing the pressure on me to make any further statements. I do not judge other photographers by what they say, but by their pictures, and I want to be judged by the same standards myself.

Some people set out to take photographs knowing what they intend to show. Occasionally so do I, but often I do not know and do not even want to know. I prefer to be surprised by what I see, to discover things for myself.

In my opinion there are no unbreakable rules about taking photographs. Or perhaps there is just one rule – you should take photographs how you feel you should be taking photographs. I am not of course talking about rules of behaviour. These are perhaps impossible to formulate here but simply involve a proper respect for other people. It is enough to say that there are times I would not take pictures, however potentially strong the situation.

Over the last ten years, what has interested me in taking photographs is the maximum – the maximum that exists in a situation and the maxi-mum that I myself can produce from it. Sometimes I may achieve this goal immediately, but usually, for one reason or another, I am just not able to make the most of a situation and so I have to photograph it time after time until I succeed. This repeated effort also helps to reassure me that I have in fact achieved the maximum.

My way of working has largely developed from my early theatre photography in Prague. The director allowed me to work very freely during rehearsals. Moving among the actors on the stage, I was able to photograph the same scene over and over again, but differently. It taught me how to make the most of a given situation and I went on to apply this method in my general work. This was possible because of my subject matter and my basic approach. I have never accepted any magazine or commercial assignments. I do not have any deadlines. I do not need any outside pressure to work. It is very important for me to feel that I am free. I make photographs for myself.

Photography followed after my early interest in certain places, people and their music. It was this experience that came first, and it was only

later that I took my camera with me. Photography has made it possible for me to continue seeing such places and meeting such people.

A large part of my photography has centred around festivities and similar occasions that recur year after year. The plan of events is more or less fixed and so by now I know essentially what is going to happen. I know the actors, I know the story, I know the stage. But sometimes an actor may have an off-day, and sometimes me. What interests me is when we are all at our best. But I also try to be open and ready for moments of accident and improvisation. Sometimes these can result in the best pictures of all.

Naturally I have been influenced consciously and subconsciously by the world in which I live, but I feel that I have learned most about myself as a photographer from studying my own work. I learned from what happened when I was taking photographs. I enlarge a great number of my pictures, not only those which I consider good. Accidents and mistakes are often just as interesting to me. Some of them show me possibilities that I might be able to develop further. I do not like to repeat myself. I want to be open enough to explore all the avenues that I can find. I would like to avoid what I have seen happen to some photographers who have restricted themselves, perhaps unnecessarily, and eventually come to a dead-end.

I have always been very critical of my own work. In Czechoslovakia, to help me evaluate my pictures I had them all over the walls. To me, the test of a good picture was one that survived on the wall, that continued to interest me over a period of time. My present way of life makes such a relationship with my work impossible. I am constantly on the move, I have no ready access to a darkroom and no wall of my own. But that is by my choice. At the moment my life is organized to give me the greatest possible time and freedom to actually shoot photographs. I still need to see my pictures but over the last few years I managed to do very little printing, until last winter when I made several thousand prints which I now study closely whenever I can. Most of them are bad, but I need them.

Since I left Czechoslovakia everything has been directed towards one end: making photographs. It has taken all my energy, but the number of pictures that satisfies me is still very small.

When I came to the West, becoming a member of Magnum helped me greatly, allowing me all the freedom that I need. I have depended on many people who have aided me and without them it would have been more difficult to survive.

For my early work I mainly used a 25mm lens on a single-lens reflex camera but when I felt that my pictures were getting repetitive I turned to a rangefinder model. Now I work with both types of camera. I have always preferred wide-angle lenses and I have never used anything longer than a 50mm lens. I decided years ago to continue working only in black and white. I like to have as much control over everything as I can, and I could see that this was not possible for me with colour.

When I see something which I know may disappear at any second, I don't stop to think or focus or make any adjustment, I shoot it from where I am. First impressions are very important to me. If the situation permits, then I make any necessary corrections. In taking photographs I do not always aim from the eye, it could be from anywhere. If the framing is not exact then I will crop it, though this does not happen very often.

What I have written about here is my approach to photography now and in the past. It may not hold true tomorrow. I do not want to lay down rules for other people and I do not intend to be restricted by any myself. I feel that my life and perhaps my work are changing at the moment, but my basic interests have not altered. Above all, the most important thing for me is to keep on working.

Josef Koudelka has been photographing the Gypsies of Europe for the last 20 years. It is a grand obsession on a scale that is rare in photography and worthy of comparison with Edward Curtis's 30 years of work on the life of the North American Indians.

Before he left Czechoslovakia in 1970, he had worked on this project for 9 years, mostly in the Gypsy encampments of Eastern Slovakia but also in Rumania. Since moving to Western Europe he has continued his work in Spain, Portugal, France, England and Ireland.

Koudelka is totally committed to his self-imposed task. He lives rough and ekes out his slim resources, resisting any temptation to finance himself through magazine or commercial assignments. The freedom to work just as he wishes, and to have complete control over his pictures are, for him, absolute priorities. In the words of his friend Robert Delpire, 'His talent is for living with less than nothing, with the detachment and mobility of the unencumbered man without family and without a roof. With unyielding frugality and self-denial, with indifference to everything accessory, he accepts the need for discipline and goes beyond it.'

But Koudelka dismisses any suggestion of self-sacrifice on his part. He says it would be a hardship to him *not* to be able to work as he does.

He photographs solely in black and white. Colour does not excite him and it does not offer the degree of control that he demands. Developing and printing his pictures has been a constant problem for him, lacking a darkroom. He shoots prolifically and sometimes the exposed films have accumulated alarmingly before he could process them. Today he is better organized, but there is still an immense backlog of work. He will not ease up actually taking photographs, but prefers to press on while circumstances permit.

He studies his contact sheets very carefully and makes a small work-print of anything that interests him. Ruthlessly self-critical of his pictures, he is still keen to learn even from the rejects. He keeps a sharp watch for any sign that his work is lapsing into visual formulas.

Koudelka uses both rangefinder and SLR cameras, with a tight selection of lenses— 28mm, 35mm and 50mm. He has a decided preference for wide-angle lenses and never uses anything longer than 50mm focal length. It is important to him that his pictures are sharp from front to back.

Spain 1971

Ireland 1971

France 1973

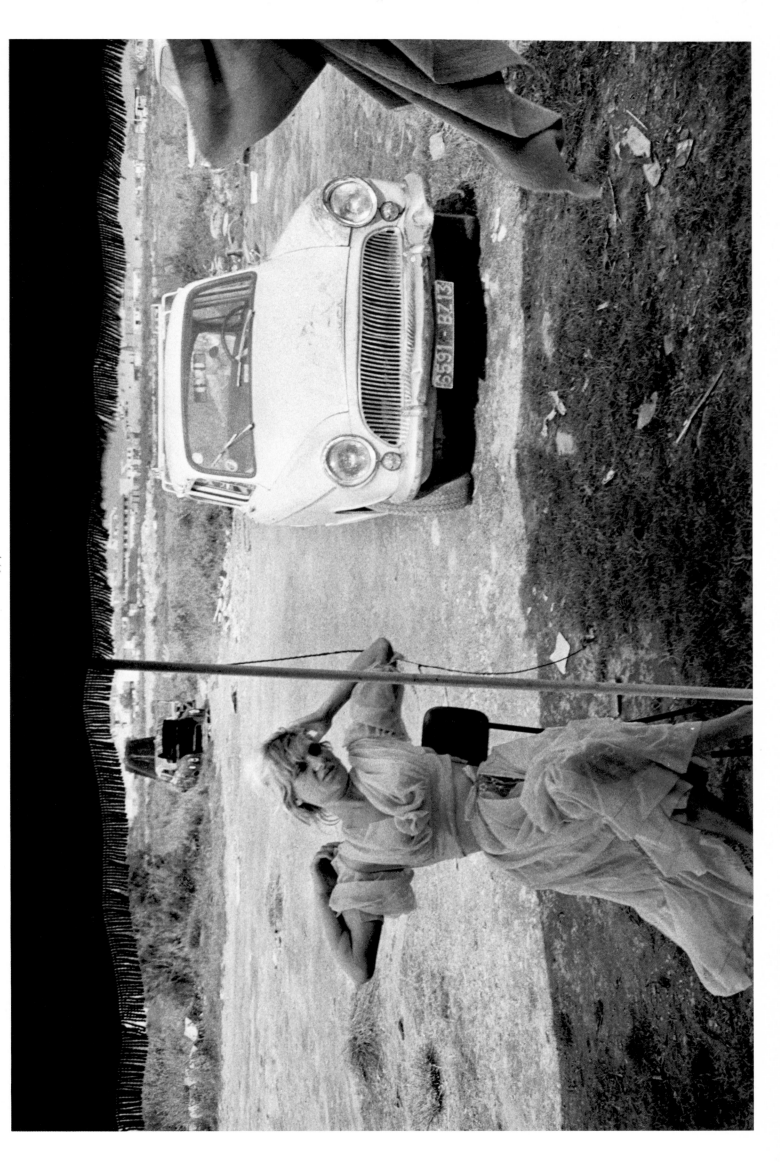

France 1974

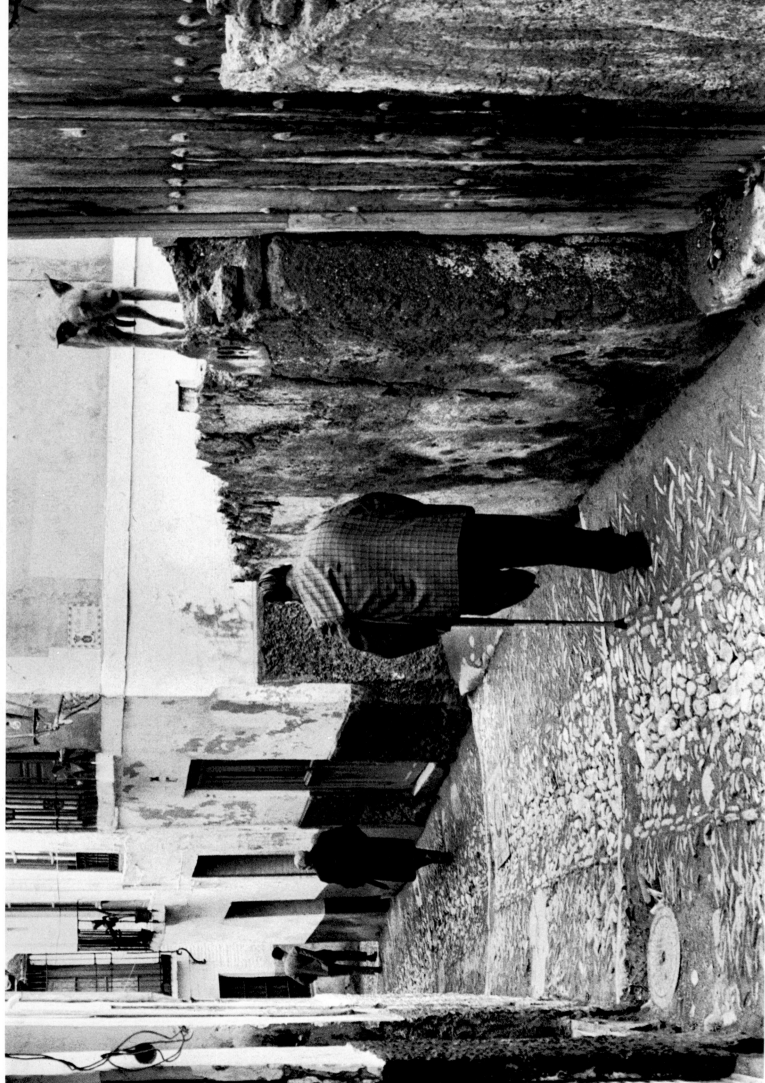

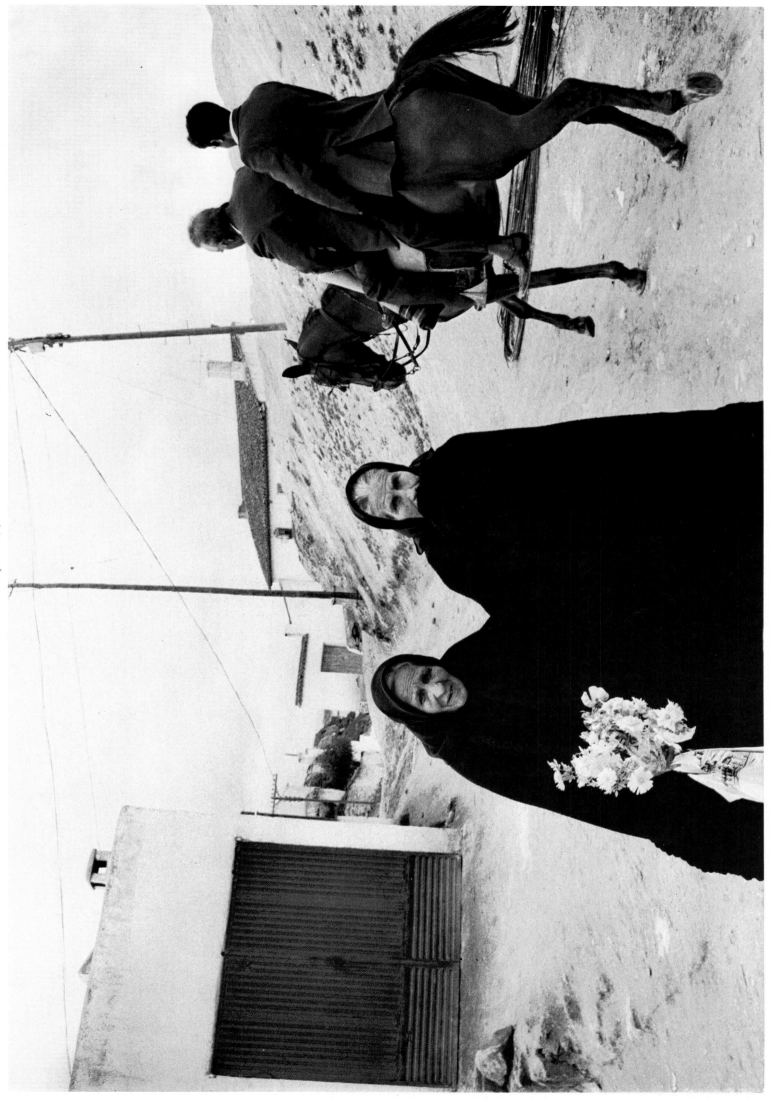

Spain 1974

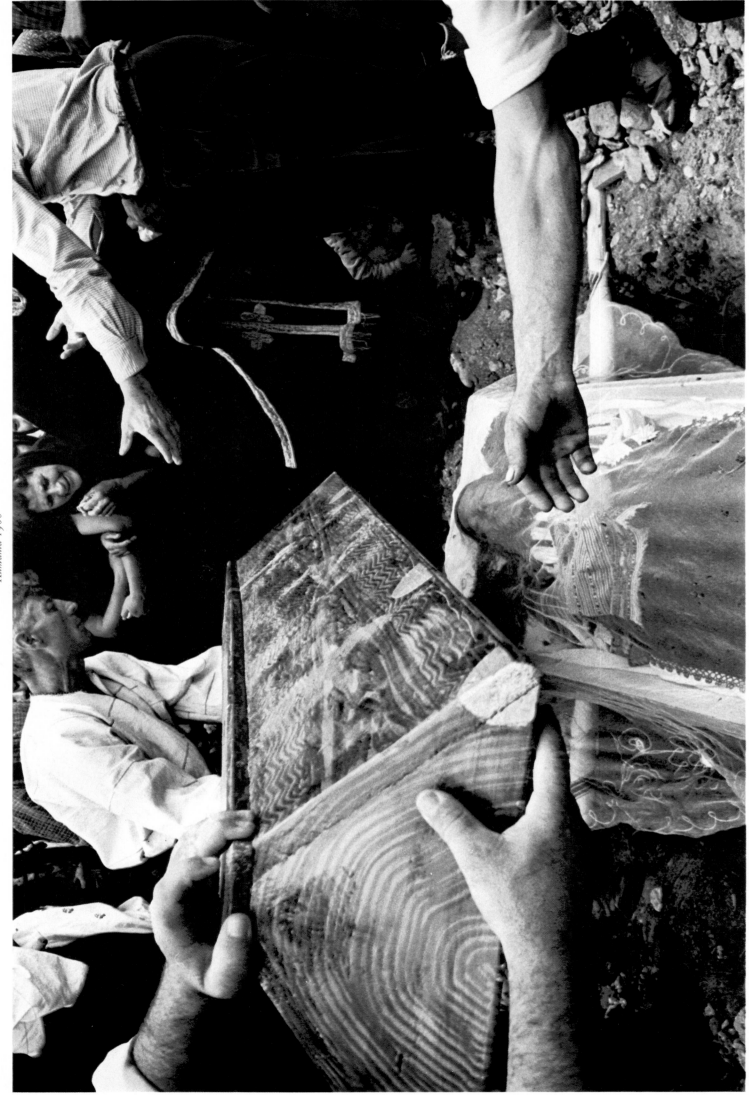

Rumania 1968

Photographic acknowledgements

Title page Henri Cartier-Bresson–
Magnum from the John Hillelson Agency
7 Yajima Galerie–Robert Frank
8 Eugene Smith–Magnum from the
John Hillelson Agency
9 Garry Winogrand
10 Duane Michals
11 Ray Metzker
12 Harry Callahan
13 Bill Owens
14 Kenneth Josephson
15 Lewis Baltz–Castelli Graphics
16 Grapestake Gallery–Richard Misrach
17 Minor White Archive, Princeton
University
18 Pierre Cordier
19 André Martin
20 William Garnett
21 Mario Giacomelli
22 Condé Nast Publications–Irving Penn
23 Pete Turner
24 Rapho–Robert Doisneau
25 Richard Avedon
26 Bonnier Fakta–Lennart Nilsson
(from *Behold Man*, George C. Harrap &
Co, London)
27 Harry Gruyaert
28 Jerry Uelsmann
29 Aaron Siskind
30 Charles Jourdan
31 John Zimmerman–Sports Illustrated–
Colorific
32-43 Arnold Newman
44-55 Burk Uzzle
56 David Gepp
60-67 John Blakemore
68-77 Jill Freedman
78 John Swannell
82-89 David Bailey
90 Tamiki Hakuno
93-101 Hiroshi Hamaya
102-111 Elliott Erwitt–Magnum
112-123 René Burri–Magnum
124 Steve Ettlinger
126-133 Thomas Höpker
134 Richard Rowan
136-143 Ernst Haas
144 Martin Angel
148-155 Heather Angel
156 Cynthia Matthews
158-165 Burt Glinn–Magnum
166-177 Stephen Dalton
178 Michelle Singer
182-189 Joel Meyerowitz
190 F. Blickle
194-201 Don McCullin
202-215 Brassaï
216-227 Lee Friedlander
228 Ricardo Gomez Perez
230-237 Manuel Alvarez Bravo
238-249 Ralph Gibson
252-259 Henri Cartier-Bresson–Magnum
from the John Hillelson Agency
260 Bryn Campbell
264-271 Ian Berry–Magnum

272 David Bailey
276-283 André Kertész
284-295 William Klein
296 Peter Kernot
300-307 Bill Brandt
311-318 Josef Koudelka–Magnum from
the John Hillelson Agency

The Editor and Publishers would like to
thank Sue Davies and the staff of the
Photographers' Gallery, London, for their
help with various problems that arose
during the production of this book. We
would also like to thank Colin Ford of the
National Portrait Gallery, London; John
Hillelson of John Hillelson Agency; Jimmy
Fox of Magnum Paris; Robert Delpire,
Paris, and Robert Kirschenbaum, Pacific
Press Service, Japan, all of whom have
contributed to its realization.